MERVYN
PEAKE

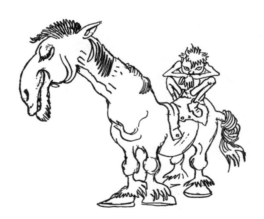

Other books by Malcolm Yorke

Eric Gill: Man of Flesh and Spirit
Spirit of Place: Nine Neo-Romantic Artists and Their Times
Keith Vaughan: His Life and Work
Matthew Smith: His Life and Reputation

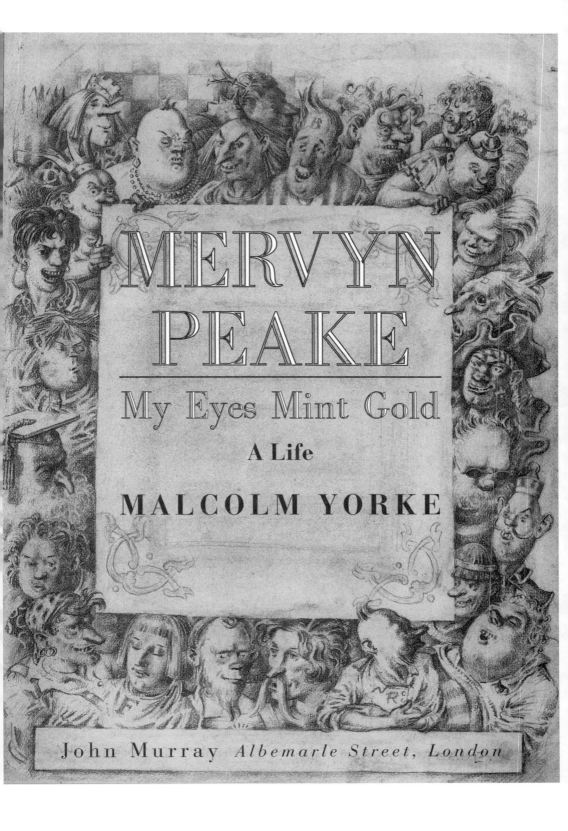

MERVYN PEAKE

My Eyes Mint Gold

A Life

MALCOLM YORKE

John Murray *Albemarle Street, London*

To the memory of my father, Kenneth Yorke (1909–61)

First published in 2000
by John Murray (Publishers) Ltd,
50 Albemarle Street, London W1X 4BD

The moral right of the author has been asserted

A catalogue record for this book is available from the British Library

ISBN 0-7195-5771 2

Typeset in 11/13 pt Monotype Times NR by
Servis Filmsetting Ltd, Manchester

Printed and bound in Great Britain by
The University Press, Cambridge

Contents

CONTENTS

Illustrations

LIST OF ILLUSTRATIONS

(works by Mervyn Peake appearing within the text)

LIST OF ILLUSTRATIONS

Vignettes

ACKNOWLEDGEMENTS

The author and publisher wish to thank the following for kind permission to reproduce illustrations: title page, Christie's Images Ltd; plate 9, Eltham College; plate 14, States of Guernsey Heritage Committee; Guernsey Museums & Galleries; plate 17, Westminster College; vignette p. 71, Chris Beetles; All Mervyn Peake text, drawings, photographs and other materials, © The Mervyn Peake Estate 2000.

Preface

This book celebrates the life and achievements of Mervyn Laurence Peake (1911–68). The life began exotically enough for an English boy in Kuling, China, and ended in a home for incurables in Abingdon, Oxfordshire, but during his brief maturity Peake was astonishingly creative in a variety of disciplines. He wrote four novels, one novella, three illustrated children's books, a drawing primer, short stories, articles, broadcast talks and adapted his own work for radio and television. As a poet he published several volumes of both serious and nonsense verse, and as a playwright had a comedy produced in a London theatre and one on radio. He was a painter with almost fifty solo and mixed exhibitions during his lifetime and some of the twenty-four books he illustrated are considered masterpieces of the genre. In addition he left behind many unfinished or unpublished projects in all of these media. He also found time to be a popular teacher and was a much-loved husband and father. Now, thirty years and more after his death, it seems a good time to look again at the man and his reputation, and to begin a critical assessment of his manifold achievements.

All the arts are subject to the whims of fashion. One minute someone is striding in the avant-garde and the next they find themselves back amongst the poor bloody infantry. The fact that the spotlight has moved on and left an artist in the shadows does not, of course, invalidate his art, it only means it is harder for him to make a living. Peake in his greatest work, the *Titus Groan* trilogy, paid not the slightest heed to literary fads in style and subject matter, and consequently endured some neglect in his lifetime, and it was only after his death that he gained a worldwide following. When writing poetry he adopted a Romantic bardic style which was quickly superseded by a public preference for a drier more intellectual one. In drama he wrote in a manner influenced by Christopher Fry when all that Fry stood for was about to be swept aside by a horde of angry young men, whilst as a painter he continued to produce academically representational works when the

clamour was for abstract expressionism, Kitchen Sink realism or pop art. There was nothing wrong with Peake's art, just his timing.

An artist's recognition depends, ultimately, on how many people buy and read his novels or poems, watch his plays, or pay to hang his pictures on their walls. In modern times the creative genius, like the rest of us, has a mortgage to work off, dependants to feed and taxes to pay. In his later years Peake felt increasingly guilty that he was not earning enough to provide his family with the little luxuries they deserved, and this drove him into areas such as the commercial theatre where his talents were not always best served. I have paid some attention in this book to his commissions and sales in so far as they affected his work and reflected his reputation. Similarly, how each work was received by contemporary critics and reviewers is of interest because this is where sales and esteem are made or lost, and the sensitive creator's spirit encouraged or crushed. I have quoted reviews, superficial and misguided as many of them proved to be, because they were the first reactions to Peake's works as they appeared, and his wife, Maeve, pasted them all into cuttings books, rejoicing in the good and weeping over the bad.

The final chapters pursue Peake's reputation beyond his early death. That it took such an upswing then was largely due to the efforts of his widow. If Peake is the hero of this story then Maeve Gilmore is certainly its heroine, and it seems unlikely that he would have achieved half the things he did without her inspiration, criticism and love. In providing these she sacrificed her own talents as a painter and had to develop new ones in writing.

Today Peake has an international following of enthusiasts who exchange news and views via the Mervyn Peake Society, the *Peake Studies* journal and over the Internet. Many of these are academics writing papers or theses, usually on the three Titus novels. Peake seems to have kept every draft he ever made, each book underwent numerous rewritings in his tiny brown ink or smudgy pencil script and was then typed by professionals, who often had trouble reading his writing so that mistakes crept in and there were yet more revisions. The Titus books have undergone many editions, each subtly different from the one before. All this has meant that those who enjoy tracking down inconsistencies, variations in wording or punctuation or characters' names have found ample pickings. Peake himself was no academic and his wife actively distrusted 'intellectuals' with their textual exegeses and psychological interpretations, but so multi-layered and complex are the novels that they do richly repay such close analysis. I have drawn on

these scholarly sources only where I think they offer insights for the less specialized reader because this book is, after all, intended to be a biography.

The Titus novels (*Titus Groan*, *Gormenghast* and *Titus Alone*) are now available in many different editions (my tattered Penguin omnibus volume of 1983 has been used for quotations), but several of Peake's other works are now out of print and rare. I have tried to give brief synopses of their contents for the benefit of those readers who may not have the originals to hand and in the hope that this might inspire them to track the books down. Similarly, I have tried to quote poems in full where feasible and to offer a representative selection from most of the illustrated works. I have chosen to discuss Peake's books, illustrations, poems and plays under the date they appeared before the British reviewers and public, rather than the year he began to work on them since many took years to come to fruition. This also keeps the chronology simple.

No book of this length is written without a lot of help from other people. The three Peake offspring, Sebastian Peake, Fabian Peake and Clare Penate, have been most generous in their hospitality and in granting me access to their private collections and papers. They have in no way restricted how I have interpreted my findings and any errors in the book are entirely of my own making. In their various ways I have been helped by Victoria Aver, Dr Erasmus Barlow, Professor John Batchelor, Chris Beetles, Jock Bevan, James Boyd, the Revd Anthony Bridge, Veronica Bryant, Vincent Bschor, Harriet Carre, Paul Chown, Michael Codron, the late Quentin Crisp, Richard Dalby, Estelle Daniel, Kate Dessan, Vanessa Engle, Duncan Fallowell, Stephen Furniss, Dr Dermot Gilmore, Sylvia Gilmore, Edith Guille, George Guille, Barbara Hamon, Molly Harridean, Mike Hazelwood, Paul Hogarth, David Jones, Victor Jones, Sara Kestelman, Joan Knoblock, Cecille Koenig, Roger Lascelles, Dr Andrew Lees, Mark McGuiness, Malcolm McKay, Edwin Mullins, Dr John Norcliffe-Roberts, Phyllida Peake, Susan Peake, Tom Pocock, Jenny Roberts, Ronald Searle, Brian Sibley, Hilary Spurling, Frank Surry, Edwin Taylor, Maurice Temple Smith, Pat Toplis, Zena Walker, Marcus Watney, Andy Wilson, Monica Wilson, Sean Windett, and Henry Worthington. I have also had much assistance from the librarians at the Bodleian, Oxford University, The Central St Martin's School of Art, Eltham College, the Imperial War Museum, the D.M.S. Watson Library of University College London, the University of Newcastle, the University of Northumbria, the Royal Academy, and Westminster College.

PREFACE

A debt of gratitude is due to G. Peter Winnington, the editor of *Peake Studies*, who generously supplied me with contacts, crucial information, textual comments and his own bibliographies painstakingly assembled over many years. I have been supported by the Department of Historical and Critical Studies at the University of Northumbria and received a travel grant from Northern Arts which enabled me to visit Sark. My editors, Grant McIntyre, Hazel Wood and Beth Humphries, gave me all the encouragement I needed.

Finally, as ever, I have to acknowledge the crucial research, proof reading and loving support of my wife, Mavis.

Acknowledgements

The author and publishers wish to thank the following for permission to reprint copyright material: all Mervyn Peake text, drawings and other materials, © The Estate of Mervyn Peake 2000; extracts from: letter to Mervyn Peake from Walter de la Mare, reprinted courtesy of the Literary Trustees of Walter de la Mare and the Society of Authors as their representative; letters to Mervyn Peake from C. S. Lewis © C. S. Lewis Pte Ltd, reprinted by permission; letter to Mervyn Peake from Graham Greene, ©2000 Verdant; letter from Laurence Olivier to Mervyn Peake, © Wheelshare Ltd; extracts from *Mervyn Peake* by John Watney (Michael Joseph, 1976), reprinted by kind permission of Marcus Watney; extracts from *Mervyn Peake: a Biographical and Critical Exploration* by John Batchelor (Duckworth, 1974), reprinted by kind permission of the author.

Coloured money

I am too rich already, for my eyes
Mint gold, while my heart cries
'O cease!
Is there no rest from richness, and no peace
For me again?
For gold is pain,
And the edged coins can smart,
And beauty's metal weighs upon the heart

How can I spend this coinage when it floods
So ceaselessly between the lids,
And gluts my vaults with bright
Shillings of sharp delight
Whose every penny
Is coloured money?

Storm, harvest, flood or snow,
Over the generous country as I go
And gather helplessly,
New wealth from all I see
In every spendthrift thing –
O then I long to spring
Through the charged air, a wastrel, not one
Farthing to weigh me down,
But hollow! foot to crown
To prance immune among vast alchemies,
To prance! and laugh! my heart and throat and eyes
Emptied of all
Their golden gall.

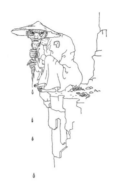

1 Boy, 1911–1923

The first eleven years of Mervyn Peake's life were spent in a middle-class English home, or as near to one as his parents could make it. Each day his doctor father would go off to minister to his patients and his mother would assist him, as well as supervising the cook and the servants. They raised Mervyn and his older brother, Leslie (known as Lonnie), to have conventional Home Counties manners, values, accents and education, and as both parents were Congregationalists they fostered the same Christian beliefs in their offspring. The language of the Bible and the hymns he sang as a boy enriched Peake's adult writing. The family enjoyed their own jokes, puns and word games and were keen readers. Mervyn would go off to his room to read the *Boy's Own Paper* and *Chums* and from an early age he took as much pleasure in the illustrations as he did in the stories. On hot days he might loll in the shade reading *Treasure Island* until he knew it almost word for word, or *Robinson Crusoe* or *King Solomon's Mines*, nibbling McVitie and Price biscuits taken from the red tins in the kitchen. If he tired of reading he could join his brother or friends in the grounds to kick a ball about, play cricket, or ride his bicycle.

The house they lived in was one of a row of six identical semi-detached dwellings with a detached house called Wilton Lodge nearby, all 'built of grey stone in a late Victorian style,' as Mervyn later described them. Each had three storeys with double shuttered windows

and there was electricity, piped water and modern sanitation. As an adult he wrote: 'It is with great love that I remember it, that great grey house with two verandahs, upstairs and down.' The Peakes occupied the fourth in the row, near the communal tennis court. There were flower beds, bushes and exotic trees full of rooks and pigeons whose droppings were a nuisance, and an arbour where the adults from all the houses gathered to chat in the evenings. There was also a chapel and Dr Peake's hospital with its front opening on to the road outside. This had been built in 1861 under the supervision of a young Captain Gordon, later to become General Gordon, of Khartoum fame, using an oriental style with glazed roof tiles and a pottery dragon at each corner.

This style was entirely appropriate since the enclosed space in which it stood, perhaps a quarter-mile long and half as wide, was the London Missionary Society's compound situated in the French Concession of the Treaty port of Tientsin, north-east China.[1] A few yards from their entirely English home the Peakes could step out into a totally alien and sometimes hostile culture. Self-contained foreign enclaves like this were much resented by the Chinese, who had conceded them under force and had no jurisdiction over them. By the time of Mervyn's childhood the prising open of Chinese trade and the free missionary access to the interior had been more or less accomplished and the massacre of missionaries and converts, like that in Tientsin in 1870, no longer seemed very likely – though the younger Dr Peake had had some narrow escapes from Chinese mobs fired up with hatred for the white 'barbarians'.

The small community of exiles was surrounded by a high wall pierced by two manned gatehouses and while Mervyn was young this compound was his playground. Thirty years later, sitting in a Kent orchard watching the apples drop, he drafted notes for a piece of autobiographical writing. He wrote: 'The compound as the centre of China. Whatever happens, I return and I must return to the compound. Now that I shall see China no more I am severed from my youth, I am lost without the long dry compound', and 'the compound was my world, my arena'.[2] He also recalled the dogs, parrots and monkeys that were kept there and in his list of key phrases for this never-to-be-written book he noted 'children throwing dung at each other' – presumably the same young companions he played at unicorns with by sticking a large thorn on to his nose. Other notes recall that their cook, Ta-tse-fu, wandered around sharpening sticks for no clear purpose and allowed Mervyn to watch him kill the chickens. One of the other missionaries' children living in the compound, Andrew Murray, was grateful to be shown by the older and more gifted Mervyn how to draw

pointy-topped waves rather than round ones in his ship pictures. When they later met at school in England, Mervyn continued his friend's art education by taking him round the Tate Gallery.[3]

It was a secure world, but a sensitive boy could create his own thrilling nightmares even here. 'Mortuary' is one of the topics he meant to write about but never did, and under 'Fears' he lists 'the black jersey, the shapes of clothes hung over chair backs, the changeling'. Mervyn's notes also contain the seemingly innocent trigger word 'paperweight', which was a gallstone as big as a goose egg that his father had taken out of a male patient. He also knew that the shed where the family donkey was kept was on one occasion used by Dr Peake and his colleague Dr Lei for a secret midnight autopsy in the interests of research because the deceased man's relatives would have been offended if they knew the cadaver had been interfered with. The two surgeons extracted the liver which weighed 16 pounds and excited Dr Peake's scientific enthusiasm enormously. In his memoirs Dr Peake records laconically: 'the conduct of the donkey was exemplary, but as he was apt to get in the way it became necessary to tether him well to one side'.[4]

Outside the boundaries of the Chinese city of Tientsin were the foreign concessions belonging to the British, French, Russians, Japanese, Belgians, Italians, Germans and Austro-Hungarians, but other nationalities were present as well: Americans, Sikhs, Burmese, Indians, all eager to trade with the Chinese. Tientsin, forty miles from the sea, was still a major trading port for Western shipping coming up the tidal Pei-ho river. The exiles tried to live as if they were at home with their churches, banks, offices, warehouses, hospitals and villas built in Tudor, Greek, art nouveau, Germanic, Victorian and other incongruous styles. There was a law court, police station, library, bowling alley and inside the Gordon Hall, which was built to look like a Scottish castle, was a concert platform for orchestras and choirs. The seventy-room Astor House Hotel catered for visiting westerners, who could promenade in Victoria Park free from the nuisance of bicycles, ball games, dogs or the local Chinese, who were strictly barred unless they were nursemaids accompanying foreign children. There was a theatre seating 300, five tennis courts at the International Club, halls for fencing, boxing and gymnastics and an open-air pool in the French Concession. The Europeans had installed electric trams to run across the city, but motor cars were still rare. In winter they organized skating, sledging and ice-boat racing on the river. There was a Boy Scout troop (which Mervyn joined), amateur theatricals, women's groups, dances, shooting clubs, a horse-race track, even European-only brothels. What

could not be ignored or westernized were the extreme contrasts of the bitter winters when the city was swept by Siberian winds and the hot summers with temperatures soaring over 100° Fahrenheit. Sandstorms blew in from the Gobi Desert and for two days at a time families would be confined behind double shutters fighting the dust which crept in everywhere and darkened the skies. Then there were the irritations of polluted water, the lack of sewers, the scarcity of milk, the mould, the ants which ate the houses and the beetles which ate the books. Above all there were the surrounding 325 million Chinese who seemed to press in menacingly on all sides, alien in language, appearance, culture and beliefs.[5]

Mervyn's brother Leslie was 400 miles away at an austere boarding establishment in Cheefoo (Chifu) by the time Mervyn began to attend his local European day school, the Tientsin Grammar School, situated in the British Concession. It was for both sexes but largely staffed by women – 'Miss Powys . . . elbows', he notes enigmatically. At first he went there by donkey accompanied by a servant, but later rode alone on his bicycle, passing through the teeming city streets. Pupils were drawn from business, customs, missionary and consular families of all nationalities but English was the medium of instruction. His best friend there was a one-eyed Russian boy who lived in a 'fantastic, tawdry gaudy muddle of a flat' and once, as Mervyn passed on his way to a prissy tea party, he spotted this wild creature 'three quarters way up an enormous Venetian blind hanging out into the sun and whooping'. Peake, always an admirer of lawless men of action, declared: 'He is my God.' Other close friends were Ngai Teh, son of Dr Lei, Dr Peake's colleague and Tony Liang, son of another Chinese surgeon who did voluntary work in the hospital. Mervyn's notes on the 'Liangs at home' record that Tony did drawings of animals and had a baseball glove; he also recalls 'The beautiful sister. Wanted to take her hand' – an early stirring of sexual awareness.

The teachers seemed perversely determined to ignore the exotic city outside the school windows, as Mervyn recalled: 'The rickshaws would rattle by in the sun, while we tried to remember the name of the longest river in England, the date of Charles Second's accession, or where one put the decimal point.' He liked the single male teacher who once kept him in detention for his backwardness and then 'I spent the long summer evening happily bowling to him in the big American recreation ground.' While the English imported their cricket and soccer the

Americans had baseball. 'Great men, fifteen feet high at least with clubs to crack the devil's head for ever, dressed up like armadillos. How they could run. From base to base they sped crouching as they ran with their bodies slanting over like yachts to an angle of 45 degrees.'

Whilst Mervyn was at ease in this privileged Western community he was intensely curious about the Chinese who were excluded from it, except as servants. He learned some Mandarin and could still speak it as an adult, claiming it was 'one of his first two languages'. The Chinese world began immediately outside the compound on the Taku Road. Here Mervyn could buy sweetmeats and the beggars and lepers would show him their sores and mutilations. This road led across the European areas and into the ancient Chinese city as it skirted the south bank of Pei-ho river. Along its length street hawkers offered brushes, paper lanterns, cakes, eggs, water-lotus seeds, puppet shows or letter writing. In the crowded Chinese streets corpulent mandarins in silk robes were borne in sedan chairs above the crowds, and one of Mervyn's surviving drawings from about his tenth year is of an old mandarin in voluminous sleeves and trousers. He would pass the long daily queue of Chinese waiting for his father's surgeries, and, at the end of the day, the crowd of verminous beggars who would be admitted for de-lousing, medical treatment and new clothes. One day Mervyn would create another enclosed world of privilege in Gormenghast Castle, where 'mean dwellings swarmed like an epidemic round its outer walls' housing an alien race: poor, short-lived, growing food and offering services to those more fortunate ones inside.

The hospital was the reason why the Peakes were in Tientsin. Ernest Cromwell Peake was born in 1874, the son of missionaries in Ambatovary, Madagascar and the eldest of their ten children. After returning for his secondary education at the School for the Sons of Missionaries (later called Eltham College) he qualified at Edinburgh University as a doctor. He was appointed by the London Missionary Society in 1898 and sent first to Yochow and then three years later to Hengchow (now Hengyang), a city of 200,000 in Hunan province, to set up a centre for Western medicine and to convert the inhabitants to Christianity. At this time the Empress Dowager Tsu-Hsi ruled China despotically and opposed any suggestion of change, especially if initiated by foreigners. Many years later Dr Peake wrote an unpublished account of these years, *Memoirs of a Doctor in China*. In the present book his idiosyncratic viewpoint on events has been taken because it is evident that Mervyn derived many of his own ideas about China from his father. Dr Peake wrote, for example, of this early xenophobic period

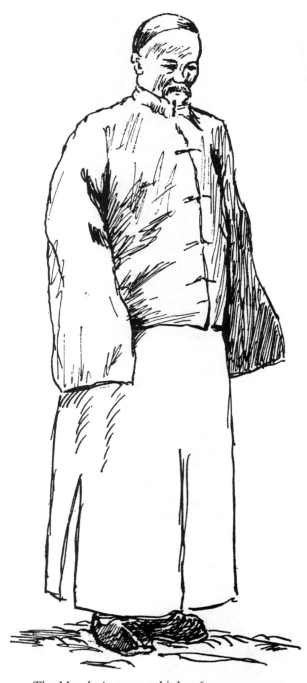

The Mandarin, pen and ink, 16×9cm, *c*.1923

that it 'was indeed the attitude of the whole country. In her proud isolation China adopted a very superior pose, entertaining the utmost contempt for all foreign countries, and for all foreigners within her borders.' It was not an auspicious time to travel alone into a remote area where superstition gripped the minds of the people, who believed Western doctors gouged out babies' eyes and used human flesh to make their medicines. He coped stoically with acute loneliness, mosquitoes, rats, robbers, river pirates, hostility and corruption at all levels of officialdom from the Empress downwards. Everywhere the contrast between the indolent mandarins with 'their torpid bodies and passive minds, and the toiling near naked coolies was evident', but he was willing to treat both – if only they would drop their prejudices and let him.

Dr Peake found Chinese medicine in the hands of quacks who frightened off labour pains or the disease-causing spirits with gongs and firecrackers. They had no concept of sanitation or germ-borne diseases whilst epidemics of dysentery or typhus were conveniently blamed on foreigners' witchcraft. Slowly Dr Peake learned Mandarin and then began to train local assistants in anatomy, physiology and pharmacology; one of them, Lei, became his right-hand man for the next twenty years.

As individuals Dr Peake found the Chinese unfailingly courteous: 'The observance of propriety, doing and saying the correct thing, is esteemed one of the cardinal virtues,' he noted, but, like the rituals in his son's fictitious Gormenghast, the forms had rigidified and lost content – the observance was all, and in Dr Peake's judgement their morality and religion had become separated. But once combined into a mob the Chinese lost all courtesy and were very dangerous indeed so that he had several unpleasant encounters, especially in the Boxer Rising of 1900 when many missionaries, traders and Chinese Christians were killed. Then he had to flee down river to Hankow (Hankou) where he treated scores of the wounded refugees. Once the danger was past he journeyed over the mountains to the resort of Kuling in Kiang-Hsi province (now Jiangxi) for a break. It was there, in July 1903, that he met his future wife and became engaged. On returning to Hengchow he found official attitudes had mysteriously changed once more and he began to get patients, although only males and all of them with scabies.

At the very end of 1903 he travelled to Hong Kong where he married his fiancée Amanda Elizabeth Powell, known as Bessie, who had been born in Wales in 1875 but had moved to London as a girl and then to

Liverpool to be trained as a missionary-assistant. Once they married she had to resign, since the London Missionary Society would not pay two missionary salaries to one family and they knew she would continue to work without pay. Together they travelled seventeen days to Dr Peake's remote medical centre via Shanghai and Hankow just in time for a change in its fortune. A seventy-year-old scholar, Mr Sung, dared to submit to surgery for his cataracts. When this proved successful other blind patients arrived in streams and gradually more came with tuberculosis, malaria, dysentery, cholera, smallpox, leprosy, beriberi, elephantiasis and the most grotesque tumours, all begging for the doctor's magic knife. A keen photographer, Dr Peake began to record the most extreme of these cases and keep them in albums which would one day fascinate Mervyn and feed his penchant for the grotesque. Dr Peake then made home visits into squalid rural villages to treat women in labour, taking his wife to administer the chloroform. His own particular pathological enthusiasm was for research into intestinal parasites picked up in the paddyfields and he wrote this up for his MD thesis, though he almost lost all his papers to boat thieves who stole them while he and his wife were sleeping and threw them away in the river mud as useless.

In March 1904 their first son Leslie was born, but there were complications and the three of them had to return for fifteen months to England where Bessie was treated – she had had bouts of poor health before marriage and before Mervyn was born she suffered the loss of stillborn twin girls. The family was back in Hengchow by April 1907 and heavily involved in building work on a house and the hospital. Four years later they went on summer leave to Kuling in Kiang-Hsi province and on 9 July Mervyn Laurence Peake was born there.

Since 1644, when the Ming dynasty was overthrown, the Chinese had been ruled by the alien Manchus, but once the autocratic Dowager Empress died in 1908 and two-year-old Pu Yi was made Emperor the Chinese, especially those in the south, began to rebel against the remote and antiquated regime in Peking. Fierce fighting between Imperial troops and rebels broke out, particularly round Hankow. Dr Peake, ever the humane man of action, left his family in Kuling and went there to help the wounded of both sides and the civilians caught between them. He and the Red Cross doctors performed their operations in spite of street fighting, shelling and encroaching fires. Once they had to commandeer a private steam yacht to drag the dead and horribly

wounded off river boats which had been trapped in the cross-fire. Looters were decapitated with swords and the heads hung by their pig-tails from the telegraph poles – one of which Dr Peake photographed. After enormous loss of life on both sides the Imperial forces eventually retreated north, leaving the town gutted. The reunited Peakes were able to leave Kuling, though it was not until February 1912 that they reached home in Hengchow. By then Sun Yat-sen was the elected President of the United Provinces of China and 3,000 years of dynas-tic autocracy had come to an end. The Boy Emperor was a virtual pris-oner in Peking, studying with his tutors until 1924 when he was cast out to become a private citizen in Tientsin, his life in some ways parallel-ing that of Peake's fictional character Titus Groan.

Having built up a successful hospital in the south, Dr Peake was transferred a thousand miles north to Tientsin in late 1912. On the way their houseboat was stopped at Tung-Ting lake by a bitterly cold north-erly gale so that they had to pull into the lee of a sandbank and wait for ten days. Dr Peake wrote: 'The food problem became acute. Fortunately one of the last things which had been thrown on board when we left was a crate of condensed milk, and this just saved the sit-uation for our infant son.'[6] But, after a month's rough travel by boat and rail they came, at last, to their new home in the French compound, the one Mervyn would remember for the rest of his life.

The Tientsin hospital had been there since the 1860s and though it was run by the London Missionary Society it was known locally as the Dr Kenneth Mackenzie Hospital, after a successful predecessor of Peake's. It had become badly run down by 1912 so Dr Peake closed it, sacked the corrupt staff and started afresh. Bessie Peake then caught typhus from a patient and nearly died. Eventually, however, her husband began to average over a thousand operations under chloroform per year. One or two of these were sneakily watched by Mervyn, who described how he peered through the window to watch an amputation. He later told a friend 'I didn't mind 'till the thing was off, when they put it on a tray and dumped it by the window, right underneath me. Then I keeled over.'[7] He was to remain fascinated by medical matters all his life, but squeamish and liable to faint when blood or needles appeared.

The town was becoming industrialized and the Chinese were not used to machinery so many amputations of crushed or mangled limbs were needed. There were also scaldings, terrible falls and broken spines; in one sickening case a man's pigtail was caught in machinery and his

whole scalp was wrenched inside out and hung over his face. People with bayonet and bullet wounds inflicted by brigands roaming the countryside arrived in carts and wheelbarrows to join the queues outside the hospital. The bodies of the numerous suicides who had taken opium, nitric acid, eaten serpent dung or swallowed phosphorous matches ended in the mortuary if Dr Peake could not save them, but their vengeful spirits went off to haunt their enemies. One of Mervyn's cryptic notes reads 'The tall Chinaman with the acid face', perhaps a memory of a nitric acid swallower who survived – one day Peake would give his villain, Steerpike, a scorched face like this. Eunuchs with varicose veins, a man with his knee pointing backwards, people with bulging livers, morphia addicts, lepers, men with bullets lodged in their skulls – all sought the attentions of Dr Peake and Dr Lei. In 1922 alone the pair treated 37,671 outpatients and conducted 1,211 anaesthetized operations.

Mervyn took a pride and close interest in his father's work and his first published piece of writing was a short informative article printed in the November 1922 issue of *News from Afar*, a newspaper for missionary children and young English readers. He wrote:

> In the hospital, we have three little Chinese boys, all lame. Two were run over on the railway, and one had a disease of the knee, so he had to have the leg cut off. We have adopted them because none of them know where their fathers and mothers are, and don't want to leave us. One of them helps the Chinese woman who mends the hospital clothes, by turning the handle of the sewing machine for her, but he would much rather play with the other boys. My father does not know what to do with these three boys. One of them, who will never be able to walk properly, may be taught the trade of a tailor, and perhaps the other two might be taught some other trade.

A crude drawing of the three lame boys accompanied this first venture into illustrated prose for a wider public.[8] There were to be many more one-legged cripples in his future drawings and prose, and it is perhaps not surprising that after what he had seen, heard and read of his father's clientele, the blind, obese, deformed, skeletal, ugly and downright bizarre should people his fiction and that they should meet their deaths in a variety of violent ways.

By May 1914 Dr Peake had earned some home leave, but instead of taking the slow boat round the Cape the family went by rail through

Mukden (now Shenyang) and Harbin and joined the Trans-Siberian railway at Irkutsk. Mervyn was just twenty-two months old when he made this trip, so probably remembered little of it, but a family story tells how Leslie climbed down off the train during one of its frequent stops in what he later called 'the wolf-infested wilds of Russia'. The train then began to move and Dr Peake had to fling open a door and reach down to haul in his desperately running son. This story made a deep impression on Mervyn, according to his brother, and the horrors of being left alone on a featureless plain would crop up in several of his stories, *Boy in Darkness* being the most chilling. The family changed trains at Moscow and again at Warsaw and at last crossed the Channel from Ostend. Dr Peake returned to Edinburgh for a year to complete his medical exams and because of the war was then recruited as a doctor into the Royal Army Medical Corps with whom he served on Salisbury Plain and in a field hospital in Belgium. His family, meanwhile, lived in a rented house, 9 Claremont Road, Mottingham, near Eltham in Kent. From here Leslie could attend his father's old school, the School for the Sons of Missionaries, while Mervyn began to explore his native land and got to know his father's parents, now retired from Africa and settled in Dorset. In 1916 Dr Peake was released from war work so he could return to run the hospital in Tientsin which Dr Lei had been keeping going in his absence.

The Peakes returned to China on a Japanese ship, the *Kashima Maruvia*, sailing round the Cape of Good Hope in October 1916, fearful all the way of German submarines. The journey took two months and included a stop-over in Cape Town which Mervyn remembered with pleasure. The two boys were offered the choice of a plain or a brightly painted ostrich egg. Lonnie opted for a plain one and Mervyn copied him, but always, even forty years later, bitterly regretted going against his natural instincts to choose the coloured one. When the family returned to Tientsin in the winter of 1916 there was a worldwide epidemic of sleeping sickness (*encephalitis lethargica*), though Dr Peake does not mention this in his memoirs. Peake's biographer John Watney and others have suggested that Mervyn, who had bronchitis around then, may have contracted the disease, which then lay dormant until Peake's forties when it re-emerged to ruin his life. But this remains speculation.

Apart from developing a rather obsessive interest in all things surgical in Tientsin Mervyn was also experiencing spectacular climatic

extremes which could be stored away in his memory for later use in his mature writing. In summer 1917 the city, which normally suffered from drought, was flooded and by September water was rising a foot each day and creeping up towards the British Concession. By 27 October the *North China Herald* reported that 'Tientsin stands on the edge of an inland sea estimated to extend for 15,000 square miles, of the draining of which there is no possible hope until the spring.'[9] One day Gormenghast would suffer a similarly disastrous inundation. Mervyn noted that in summer the door handles of trains were so hot that they could only be gripped through a piece of cloth and the wonderful relief of plunging his face into the cool interiors of watermelons until his lips were 'gory' and the mush spread from eyebrows to chin. In winter the winds from Siberia meant that furs had to be worn top to toe. These extremes, rather than the temperate climate of southern England where he spent all his adult life, provide the backdrops to many of his fictions, and from his schoolboy readings of adventure stories he added tropical jungles, the South Seas and Arctic ice floes, for example in his story for children, *Letters from a Lost Uncle*.

Mervyn was not only reading and writing but drawing precociously. His brother Leslie wrote:

> It was about 1919 that I became aware that Mervyn was exceptionally talented. One day our parents left us out on the verandah of our house. They gave us pencil and paper, and told us to fill in the panorama. I was so ashamed of my effort compared to Mervyn's, that I bribed him to hold up my copy as if it were his, while I held up his copy as if it were mine. I rather doubt that our parents were taken in, but at least they said nothing.[10]

Their mother certainly would not be fooled because she had spotted her younger son's ability very early and wherever they went she took a supply of paper and pencils for him. At home he spread his sheets and crayons across the big dining-room table and drew whatever he saw or imagined. There were no art galleries in Tientsin and probably no art books in the house, so he was not seeing much naturalistic Western art outside of his comics and illustrated adventure books.

The most exquisite Chinese paintings would not be available to the young artist, but Peake must have noticed secular and religious imagery in two and three dimensions around the city, and watched the Chinese scribes brush-writing their characters: much later, students

commented that he held his brush or pencil vertically, as Chinese cal-
ligraphers and painters do, and as an adult he would experiment with
Chinese brushes and ink in illustrating the poems of Oscar Wilde.
Chinese graphic art would show him that a sinuous line was para-
mount, and realistic modelling using light and shade of no account.
He must also have known his father's photographs of many of the
sculpted mythical beasts – dragons, lions, elephants, warrior gods –
which lined the Spirit Way to the Qing Imperial tombs near Peking.
All these could only have encouraged him to draw freely from his
imagination.

The family continued to travel within China, one favourite summer
destination being Mervyn's birthplace, Kuling (meaning bull-moun-
tain), a popular resort which was cool and mosquito-free and devel-
oped by the English to reflect their needs. Bungalows were spread along
Cambridge, Oxford, and Cardiff Roads, there was a post office, villas
for rent, a Fairy Glen Hotel and even a cemetery. A native village grew
up in 'The Gap' (a flat area between two mountains) to provide goods
and services. To reach Kuling they travelled by houseboat, then steamer
along the Yangtze river, next by cart across hot lush plains and finally
up the tracks and paved steps into the health-giving air of the moun-
tains in palanquins, the adults being carried by four coolies and the
children by two, all the fourteen miles from the river. The mission bun-
galow the Peakes stayed in, Leslie recalled,

> was built of stone and though not large had a wide, glassed-in
> verandah on three sides, and it was here that the indoor living took
> place in the day time. The garden was a steep slope with a stream
> running through, forming at one point a pool for bathing. Tiger,
> trumpet and day lilies were rampant along with hollyhocks and
> sunflowers, while a cultivated section contained tomatoes, cucum-
> bers, onions and various herbs.[11]

One day Mervyn would own something similar on the island of Sark.

Like his father, Mervyn was fascinated by all forms of transport and
his second piece of published writing was inspired by a rugged journey
back to his birthplace in 1919. 'Ways of Travelling' was published,
again in *News from Afar*, in January 1924 when he was already back at
school in England, though he claimed to have written it two years
earlier. It is carefully composed to an essay plan – travel in general
('there are many ways of travelling in the world'); travels he himself has
made on mountain chairs, steamer, junk, rickshaw, donkey, bicycle, a

Peking cart, train and oceangoing ship; then a tidy conclusion ('But the usual mode of travelling is on your feet, and it is generally the most convenient'). The whole occupies one page but there are ten thumbnail sketches to illustrate it and it is proudly headed 'Mervyn L. Peake aged 10½ years.'

The mature Mervyn also made notes on his times in Kuling, writing of the 'myriad steps' they had to be carried up, 'drawing the elephant' (he does not elaborate) and picnics at the Dragon Pool. He was told the cautionary story of the missionary who dived into one pool there and did not reappear; a friend dived and also failed to surface, as did a third. Mervyn was always interested in freakish deaths. He made notes of other journeys too. At the age of seven he visited Peking, and there rode in a motor car and counted one hundred camels. He tried to stroke one of the beasts and very nearly had his right hand bitten off; only the quick action of a coolie saved him. What a loss that would have been! Leslie went to boarding school in Cheefoo on the Shantung Peninsula, a place known as the Brighton of China, and Mervyn made three summer visits there as well as trips to the seaside at Pei-tai-ho (Beidaihe). The city of Shanghai was generally considered the most westernized of all but of his one visit to it in 1922 Mervyn recalled 'A frozen, icy, tinkling horror of mules and motor cars, western houses, and narrow banner-hung hovel streets. A stench of sweetmeats and dung.' He also notes 'Being lost in a Chinese city' and 'Being run over by a tram', but we hear no more of these traumas.

Dr Peake took his camera on these journeys to record his family, native forms of transport, bridges, temples, gateways and the colossal stone statues outside Peking. He took many photographs of Peking itself and penetrated to the innermost courtyards of the Forbidden City after the fall of the Imperial Dowager. Not all his images were benign: he had seen the sack of Hankow and recorded the heaped revolutionary dead of 1911, a near-naked man tied to a pole about to be executed for fire-raising, the severed head, and a pinioned man in a cage suspended by a wooden collar so that his own weight would eventually break his neck. These macabre images, and those of the diseased patients, were accessible to Mervyn, as were his father's tales of his adventures, and when Dr Peake came to write them down in about 1948 he prefaced them thus: 'I am indebted to my younger son Mervyn for the illustrations, which have caught so faithfully the atmosphere of bygone days in a fascinating country.' These illustrations were either not done or they have been lost, but it is clear that Mervyn's memories of China were fresh long after he had left the country and that he drew

upon his father's reminiscences, writings and photographs at will to enrich his own writing.

Dr Peake's yarns were of a China largely ignorant of the benefits of petrol, electricity and steam power and told of women crippled by bound feet, boats with painted eyes to watch out for rocks, men fishing with cormorants and making animal sacrifices to appease the gods. Mervyn would learn that buildings must have grotesque carvings along their ridges so there was no space for a malicious spirit to perch, and a mandarin would have a false wall made inside his front door to baffle the evil spirits because they can only travel in straight lines. His father photographed funeral processions that were dressed all in white, a colour which came to signify death for Mervyn too. Dr Peake explained that domestic idols had sugar put on their lips to sweeten their annual report on the family to the superior gods, and that boy babies might be dressed as girls in order to deceive bad spirits – girls not being worth their attention. Mervyn knew hair was important to the Chinese. They disliked red or curly hair, and feared Dr Peake's blue 'cat's' eyes. Mervyn made notes and sketches of men shaving the front half of the skull bare and combing gum and water into the long back hair until it shone with a high gloss. Many still wore pigtails, though this sign of subservience to the Manchu dynasty was no longer compulsory after 1912. All of this nurtured his lifelong conviction that the world and its inhabitants were very strange indeed.

Mervyn listened to, recalled, and made detailed notes of the travel tales of Laura Beckingsale (1886–1983), a Baptist missionary in Tientsin, a lifelong friend of the family and an Englishwoman in the fearless Freya Stark tradition. She told him of remote country inns where the bugs made every surface a dark shiny brown, the rats 'frol-icked' and eyes spied through every knot-hole. She saw how evil spirits were allowed into Buddhist monasteries once a year only and watched processions of child pilgrims roam the land beating gongs. Vast floods and an exploding ship's boiler delayed her journeys. Mervyn made particular note of how a country girl bitten by a snake had to have a tracheotomy and because she struggled and panicked Laura had to lie on top of her until the girl was exhausted. He learned from Laura (and later used it in *Titus Alone*) the fact that mules travel the narrow mountain tracks by day and the camels by night because the two beasts hate each other, the mule finding the camel's smell offensive. He stored all this away and later wrote it down.

about the price of a railway ticket. Many of Mervyn's later creations in word and line were pipe-smokers like his father. Smith found Mrs Peake 'a little, brown-complexioned lady of great charm and strong character'.

Mervyn was now eleven and there was no problem in deciding on a school: he would go where the male Peakes always went. The School for the Sons of Missionaries had opened its doors on 1 January 1842, but by the time Peake arrived in January 1923 it had moved a couple of times, settled into an ex-naval college at Mottingham, near Sidcup in Kent, changed its name to Eltham College and taken 'Gloria Filiorum Patres' as the motto for its 200 or so boys. His father and six of Mervyn's uncles had attended the school and from 1914 so had his brother Leslie, though they would overlap for only two terms. There were no entrance examinations nor fees, only a medical, for missionaries' sons, though in 1927 the Governors spotted that Dr Peake was no longer in China and made him pay.

On the first day Mervyn was exchanging impressions with another newcomer after lights out in Dormitory A. 'Who's talking?' demanded the prefect in charge, who happened to be Leslie Peake, and when Mervyn confessed he got a filial beating because rules are rules, however pointless. It was his initiation into a whole new and rather brutal protocol, against which he offended many times. The other boy involved in this incident wrote of Mervyn many years later that he 'was always dreamily in trouble. I can see him now walking back to me through the cloisters after a caning in what was then the chemistry lab. He was grinning because he had taken the precaution of wearing pyjama trousers under his shorts. But as he walked, his pyjamas slipped down below his shorts and the master was watching him. Back he went for another whack or two.' This writer also remembered Peake being caned on the hands: 'he showed them to me, ironically enough, in the school chapel during prayers. Blood was oozing thinly in lines across the palms.'[2]

Peake's notes for an autobiography are cryptic in the extreme, but perhaps 'the departure of parents' records the wrench all boarders must feel before being left to sink or swim in their new environment, though Peake was less than ten miles away from his home in Wallington. He must quickly have learned the geography of the place – the Spinney, the Tower, the Long Grass, the Quad, the San, the Grove, the Cellar – and have seen whatever happened 'Behind the chemistry

rooms and bogs'. He settled into the routines of meals in the great King George's Hall, morning prayers and Sunday evening chapel (which on one occasion he was beaten for missing), and the events which marked the school year. In summer the boarders slept in tents on the playing fields; in autumn they ran cross-country races down Muddy Lane; on the last Saturday in June they watched the cricket match against the Old Boys, and on the last Saturday in October spectated the Old Boys' rugby match. Both matches were followed by concerts in the school hall which gave Peake the opportunity to observe 'the O.B whom nobody talked to but who never failed to turn up' and to learn that another who 'worked on perpetual motion was related to the man who found a white leopard'.

In winter the boys left a tap running to make an ice-slide next morning and invented a game in which a senior followed a junior down it, scooping him up and holding him aloft to the slide's end. Slipped in between these fixed points were those unpredictable events that make school life memorable: Peake notes 'The invisible man. The watchers. Jewels inside hooting like an owl. The sleepwalkers. The fire in the small room', but he does not elaborate further.

All the teachers were male but there were women support staff such as Matron, Cook and Housekeeper, all known as 'Ma'. At a lower level were domestic servants with nicknames such as Beauty-Comp, Sour-Grapes and Sweet-as-Sugar. These were the only female contacts except for rare official ones with the girls at the sister school for missionaries' daughters – 'the girls at Sunday Chapel' Peake notes longingly. Minor public schools have their own snobberies and Peake soon learned to look down on the boys of the Menagerie ('Mangag') or lowest form, the 'Day-bugs' and those unfortunate local boys who lived outside the magic walls – the 'Cuddy-Dyes' or Cuds. He was now a member of another enclave, very like that of the Europeans in Tientsin, with its own value system, language, laws, rituals and hierarchy, all different from the surrounding population's.

Peake Minor shared a desk with Harold Smith and in him he found a fellow enthusiast for R. L. Stevenson, the new comics *Adventure*, *Rover* and *Wizard*, cowboy books and sports. Neither was destined to be a great scholar. Harold too had an older brother in the school, Gordon ('Goaty') Smith (1907–90), but like Leslie Peake he kept his distance, the hierarchical nature of school life ensuring the age groups remained segregated. Like the Peakes, the Smiths were sons of north China missionaries who lived in very similar circumstances in Sinchow, Shansi Province, but the two families had not met even when Smith's

father fled to Tientsin in 1911 to avoid civil turbulence. Once school was behind them it was the older brother, Gordon, rather than Harold, who became Peake's closest friend and confidant.

According to Gordon Smith, the school was then in a period of decline, with masters lost in the war, poor food, indiscipline, and bullying prefects who were allowed too much leeway. However, a new headmaster, George ('Rabbi') Robertson, pulled things round and acquired a name for liberalism because he caned on the hand with a rubber pipe rather than on the buttocks with a stick. Like Bellgrove, Titus Groan's headmaster, he had a childish side and launched his model jet-powered boats in the school swimming bath. Another memorable master was Horace Pearson who encouraged the older boys to chat with him over classical records and evening cocoa, but he had little sympathy for Mervyn's obsession with visual art or nonconformity in dress or behaviour. The other staff were the usual Oxbridge bachelors and eccentrics (one small master hid under dormitory beds to see if the boys swore); two of them, the art and English masters, were of particular importance to Peake.

Matthew McIver spotted twelve-year-old Peake's artistic talent in the first lesson he ever gave in the school: 'I dished out some drawing paper and told them to do what they liked. Mervyn Peake did a drawing of a stable with a horse in it which was absolutely brilliant, and I thought that if that is the standard of art at Eltham College they don't need me here.'[3] Later, when the staff were discussing expelling Mervyn for lack of progress in his academic subjects, McIver had the prescience to say to the Head: 'You may be turning out one of our greatest future boys.' McIver had moved art on from the mere drawing of plaster casts but it is difficult to discover precisely what and how he did teach Peake. A colleague recalled: 'The old art master, Matthew McIver, used to say that Mervyn's best works were the ones that had to be cleaned off the wall with a scrubbing brush and pail afterwards. There was no doubt, however of his talents.'[4] This ability to draw smutty cartoons for their amusement must have earned Mervyn more respect from his fellows than any academic prowess.

Already he was looking critically at book illustrations and learning that they could carry as much emotional charge as the prose itself:

I remember the impact of certain illustrations in my schooldays. Turning the pages I would come upon these rectangular worlds, these full page illustrations, charged, some with terror, some with tragedy, suspense or exhilaration – whose haunting qualities have

Requiem, pen and ink, 22 × 17cm, 1928

remained in my mind to this day. There used to be drawings in *The Boys' Own Paper* by Stanley L. Wood. This man was my secret god. His very signature was magic. His illustrations for a serial called *Under the Serpent's Fang* were so potent upon my imagination that I can recall them now almost to their minutest detail – the stubble-chinned adventurer knee-deep in quick-sands, his eyes rolling, the miasmic and unhealthy mists rising behind him – I remember the tendons of his neck stretched like catapult elastic and the little jewelled dirk in his belt.[5]

Stanley L. Wood was a specialist in depicting vertiginous falls, fights to the death, and encounters with savages and wild beasts, often from unusually high or low viewpoints. Mervyn began to sign his own drawings 'Mervyn L. Peake' in tribute. Elements of Wood's dramatic style linger in Peake's mature illustrations to *Treasure Island* and *The Ancient Mariner*.

Mervyn continued to read adventure books outside school hours and to reread his old favourite, *Treasure Island*, until he nearly knew it by heart. Continuing any random passage from it was a game he and his father and brother played round the table at home. As a future writer, he was also absorbing lessons from Stevenson: how crucial weather and time of day are in heightening dramatic tension, how fights can be staged for the maximum excitement and how violent deaths jolt but fascinate the reader. However, there was little hope of applying this knowledge in his English lessons, which seemed to be all about correct spelling, and Peake could never master spelling. Things became more interesting when he moved into classes run by two young brothers, Burgess and Eric Drake, both former pupils and sons of Baptist missionary parents serving in China. They had suffered in the trenches, read the latest psychological and pedagogical theories and were keen to blow fresh air and new ideas through the stuffy staffroom. Eric Drake (1898–1988) was 'a small moustachioed man with a large dome of a forehead, hair brushed sharply back, glasses on his nose and pipe in his mouth'.[6] His erudition was formidable and he was keen to encourage more creative writing, practical drama and a wider selection of reading. He organized a school magazine and regularly produced Shakespeare plays. Gordon Smith, whose family had known the Drakes in China, wrote that 'Eric was especially popular: an intellectual shower-bath, a rucksack carrier, a fly-half who swore like a trooper when damaged, and (something of an awesome phenomenon to most of us) a professed atheist.'[7] With the younger forms

Drake introduced the Playway methods of Caldwell Cook, which involved setting projects and individual assignments, encouraging them to write about their own enthusiasms and to illustrate them – just the outlet Peake needed. He and another boy took a year to create an island and its fabulous inhabitants including beasts, pirates and Red Indians, and today, on Peake's daughter's shelves, is an album dated very precisely 8 November 1927 into which he has copied favourite verses from Walter de la Mare's *Peacock Pie* and illustrated them meticulously in pen and ink. Drake wrote of Peake's efforts many years later:

> His stories were typical 'westerns' and from the literary point of view were not quite as original and convincing as those of the two or three most brilliant boys (they did *not* become authors!) but on the other hand the drawings with which he filled the margins (they used 'Chapbooks' and were encouraged to leave wide margins for illustrations) were quite brilliant in both perception and vitality.[8]

Peake still loved the stories of Stevenson, G.A. Henty, R.M. Ballantyne and Captain Marryat, but he had found a new enthusiasm: 'Mervyn wrote of cowboys not sailors, of prairies not the sea, and of horses not ships'; in one poem he identified himself:

> In my broad-brimmed hat and my trousers of fur,
> I, Black Jim of the prairies![9]

One can see how the rigid manly code and violent action of the Western film and story might have appealed: here was another isolated, hierarchical society surrounded by inscrutable and potentially hostile natives. The villains were as dastardly and the action as bloodthirsty as in Stevenson's pirate stories or those of Sherlock Holmes or Edgar Allan Poe, his other favourites at this time. One day Steerpike would appear out of nowhere, like the murderous baddy in the black hat.

Unfortunately for Peake, after only five years Drake left in 1926 for a two-year drama scholarship at Yale, though master and pupil were to meet again in 1933 in interesting circumstances. It must have been a shock to Peake, who by now realized that he could not concentrate on things which did not catch his imagination 'Knew I was backward in Latin and Arithmetic' and the indignant 'A "B" form boy!' are amongst his autobiographical notes. His spelling was erratic and he struggled to

Summer, pen and ink, 20.5×15.5cm, 1928

pass examinations, even in English. Fortunately he had another route to self-esteem and the respect of his peers.

Eltham was a sporting school and it had its own home-grown hero in Eric Liddell who had been at the school from 1908 to 1911. He had gone on to play rugby for Scotland in 1923 and 1924, and then to set the world record (46.6 seconds) for the 400 metre race in the 1924 Paris Olympics. He could probably have won another gold medal in the 100 metres but the heats were held on a Sunday and it was against his religious principles to run on the Sabbath. The 1981 film *Chariots of Fire* tells the story of this scrupulous sacrifice. Peake's identification with his hero was enhanced by knowing that Liddell had been born in Tientsin of missionary parents. After spending much of his childhood in China, Liddell returned there as a missionary teacher in 1925 to the Tientsin London Missionary Society Anglo-Chinese College on the Taku Road, but died suddenly from a brain tumour in 1945 while serving in Mongolia. His picture appeared in the team photographs which lined the school's corridors, as did pictures of Peake's brother, father and six uncles on his father's side of the family. Soon Mervyn's own image would join them and it hangs there to this day.

There has grown up a myth that Peake was an outstanding schoolboy athlete, but the records do not bear this out. He played for the Chalmers House first cricket XI between 1925 and 1928, but, according to the school magazine, 'at the present is much too careless. This applies also to his fielding.' The school magazine for 1928 gives his statistics: 6 innings, total 14 runs, twice not out, highest score 7; bowling 5 overs, 19 runs, no wickets. In spite of this very mediocre record he won his First XI colours, and cricket remained an interest all his life. He played for his House at rugby and made the First XV in his final year at the school. 'Right centre-three-quarter – did not always concentrate enough on the game, but is a very clean handler and he has a very effective swerve. Tackling not always sure,' said the school reporter. The colours must have meant a lot to him too since his tasselled rugby cap still hung on his easel thirty years later. When he was about eighteen his brother Leslie invited Mervyn to play alongside the Old Boys on a rugby tour of Devon and Cornwall and he apparently held his own with older and heavier men. As an Old Boy himself he played for the Seconds, his captain recalling 'I had no difficulty in spotting him as a very promising wing three-quarter. There was only one drawback: every Saturday morning I had to ring up his mother to make sure that

he was effectively dispatched to his afternoon game.'[10] In the athletics season he hurdled and in 1929 equalled the school high-jump record of 5 feet 1 inch. Already it seemed that he concentrated and performed better alone, or when he did not have to submerge his individuality in a team.

The atmosphere of the school was predominantly hearty, with no place for the aesthete-poseurs tolerated at some of the older public schools. Reading was encouraged but did not stray into modernist areas – the poets were Kipling, de la Mare and Masefield and the preferred leisure time prose Stevenson, Rider Haggard, 'Sapper', Buchan or some equally red-blooded author. Peake seems to have encountered Dickens too and must have found the rambling plots, crisscrossed lives and mixture of comic, violent, tragic and sentimental events to his taste. The settings in fog, by the river, in back alleys, in crumbling buildings and the exploration of specialized groups such as rubbish collectors, circus performers, pickpockets, schoolteachers, or lawyers all had lessons to teach a potential novelist. Dickens' choice of names – Ebenezer Scrooge, Thomas Gradgrind, Uriah Heep, Wackford Squeers – must have struck a chord with the future creator of Captain Slaughterboard, Irma Prunesquallor, Swelter, Rottcodd and Muzzlehatch, and perhaps Steerpike evolved out of Steerforth. Here was another early imaginative experience that would have consequences later.

Mervyn and his circle wrote stories and poems to amuse each other and one has survived: 'The White Chief of the Umzimbooboo Kaffirs', written in his best script and with two drawings.[11] Although it may have been started in China and finished at school when he was about eleven years old, it is not set in China but in a place which now seemed much more exotic to this voracious reader of adventure stories: Africa 'where they speak African' and 'in the year of 1912'. It is the story of Hugh, the son of Mr and Mrs Silver who are missionaries. Mrs Silver is the only female character and rather given to fainting – like Jim Hawkins' mother. After an attack on their mission by Hottentots the parents are apparently killed and Hugh is smuggled away by the loyal surviving Kaffirs and made their chief. They are betrayed by a traitor 'and all their wives and children slain'. A search party finds him and leads him out of the jungle and on to a British man o'war whose crew then help slaughter the Hottentots. Hugh returns to his parents (who are not dead after all) in London and is sent to Eltham College, 'which he thor-

oughly enjoyed and got into the rugby fifteen, and had many special chums'. All are invited to tea and the story ends with three cheers for our hero Hugh, 'The Little White Chief of the Umzimbooboo Kaffirs'.

This story is interesting only because it is by Peake and not some other boy steeped in the jingoism of the *Boy's Own Paper* writing for his own pleasure and to impress his friends. It owes nothing to his life experiences and is composed entirely from his reading.[12] Even the language is almost entirely literary (left for dead, bade him, sallied forth, swarmed down the tree, had by a hair's breadth escaped, without much ado) with the odd schoolboy interjection (things in that line). The spelling though is amusingly personal (bloodcirdling, considrubely, majic, carructors). It is all very politically incorrect by modern standards in its patronizing colonialist attitudes and in how the British gunboat sorts out the uppity 'darkies', but most of his contemporaries had their heads full of similar stuff. If we are looking for what it might presage in his later writing only the casually violent deaths, the exotic setting, the all-male cast of characters and his tiny illustrations seem worth noting.

Mervyn left Eltham College in summer 1929 but no Matriculation or General Certificates are recorded for him in the school archives. He was obviously not university material and one day this would set him apart from most of the other writers of his generation. During his time there he had suffered the usual public school humiliations, for example several rebukes for not working and one for having 'forearms absolutely caked with dirt'. He was sensitive to such criticism and to the teachers' sarcasm but went his own way, concentrating on what engaged his enthusiasm and shrugging off the rest. He may have resented much of the meaningless routine (as he did later in the army) but Gordon Smith thought that, on the whole, 'he was not "against the system", for he was never a political animal, but he hated regimentation'.[13] Brother Leslie insisted: 'I find in so many autobiographies the writer snivels about the unhappiness of his school years, but I know Mervyn thoroughly enjoyed his six years as a boarder at Eltham.'[14] Smith seems to think that overall Peake came through unscathed: 'He was well liked: for his extravagant sense of humour, the general air of piratical gusto he exuded, his notoriety as an artist, and, no doubt, because he was a pleasant and sympathetic person.'[15]

Gordon Smith sums up the school ethos:

there was very little real bullying at Eltham, though there were cliques and pecking orders, and inevitably, much thoughtless

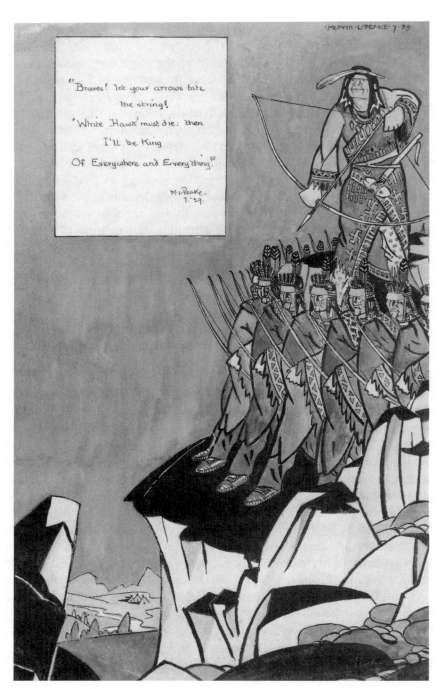

Braves, ink and watercolour, 33×20cm, 1929

unkindness among the juniors. Nor was there much dishonesty or wild indiscipline. Nor was perversion rampant, though our only contact with the fair sex ('the hags') during term-time was on visits to or from our sister establishment, Walthamstow Hall, at Sevenoaks. (The most unlikely boys turned out to have beautiful sisters at 'Snooks'!). On the whole we were curiously unsophisticated and – once we had each settled in – happy. 'Youth, thank Heaven,' as Kipling remarks of a not entirely dissimilar school, 'is its own prophylactic!'[16]

Peake had spent those teenage years with like-minded friends, many of them with Chinese backgrounds rather like his own and with their own stories to tell, but others, according to the school registers, were from African, Asian, Arctic, West Indian, South American, Middle Eastern or South Seas missionary stations and their yarns would add to his sense of the world's variety and strangeness. The school itself had taught him to admire the physically tough and active (like Liddell) and perhaps, by its over-insistence on chapel, to question the orthodoxies of religion – at least after leaving school nobody remembers him suffering any more sermons. When he came to write about the education of Titus Groan in Gormenghast twenty years later he naturally drew upon his own school for models. The Cloisters and the roofscape from the Tower were there and one of the biggest plane trees in England which grew (and still grows) outside his dormitory window was made to flourish horizontally from the Room of Roots and to play its part in schoolboy initiation rites. Gordon Smith recognized Bellgrove as a caricature of Headmaster 'Rabbi' Robertson and his gowned professors as akin to those pedagogues in the smoke-filled common room at Eltham. The repressed sexuality of the Gormenghast teachers may also be a reflection of the tensions felt in the all-male community of Eltham.

Peake had not emerged as a potential academic or medical officer or missionary and there seems to have been no parental opposition to his becoming an artist, just as his parents had not opposed Leslie's determination to qualify as a City accountant. McIver suggested Mervyn enrol at Croydon College of Art, so he began there in autumn 1929.

3 Student, 1929–1933

When Peake left school he returned to his parents' rambling house where there was even more room to set up an easel now that his brother had qualified as an accountant and gone off to work in Malaya. Around this time, according to one writer, Peake took lessons from a local lady watercolourist who told him: 'you start at the top left hand corner and work downwards to the right. After that, you put in the "mystery" by covering the whole picture with Paynes Grey wash.' She also took him to an exhibition of Dutch paintings and tried to steer him past the shockingly unmysterious works of Van Gogh, but Peake stood in awe and instantly elected the Dutchman to his pantheon of heroes.[1]

As a start to his career as a painter Peake enrolled at the Croydon School of Art, two stops east from home on the urban railway line. The Principal was Oswald Crompton and his ten teachers offered mostly applied art courses but also 'Shading from Models, Objects, Casts, and Nature; Practical Geometry and Perspective etc. Modelling, Casting, Drawing and Painting the Figure from the Antique and Life; with the Study of Anatomy as applicable to Art.'[2] A term's full-time admission to all the day and evening classes cost 6 guineas, but Peake did not last a full term and by 17 December 1929 he had submitted Crompton's reference and his folder of work and been accepted by the Royal Academy Schools in Burlington House,

Piccadilly, for a course in painting. Thirty-three other would-be painters were admitted in the 1929 year group. Tuition was 'gratuitous' or free, and he gained the necessary scholarship to help with living expenses: the course would run until December 1934, provided he could satisfy his tutors that he was working hard. In January he began the daily commute into central London, passing the time by surreptitiously sketching fellow passengers behind their newspapers, especially their hands and profiles, which became lifelong objects of fascination for him.

The RA was the most venerable of the dozens of art schools and colleges in the London area. Until 1768, when it was founded, there was virtually no art education in England, then twenty-two artists petitioned King George III for permission to establish 'a well-regulated School or Academy of Design, for the use of students in the Arts, and an Annual Exhibition, open to all artists of distinguished merit'. Their motives were to give British artists some social status; to provide access to a regular market; and to persuade collectors that native art could be as good as the Italian and Dutch and French works they usually bought. Sir Joshua Reynolds, the first President, set a lofty tone by extolling Raphael and Michelangelo in his lectures and by establishing a hierarchy of subject matter for painters. At the pinnacle was the Great Style or History Painting, full of what Reynolds called 'intellectual dignity' and 'heroick virtue', which dealt with mythological, allegorical, religious, historical and literary subjects. This doctrine has never entirely faded from view and Peake himself was set to work by his tutors on a 40 × 50 inch canvas of *Echo and Narcissus* for the Gold Medal competition. Below the level of History Painting came portraiture, landscape, animals, genre (contemporary everyday life pictures), and still life and it was into this tradition that Peake's teachers at the Royal Academy Schools attempted to inculcate him. In this they had limited success.

Joshua Reynolds and those who taught after him took their ideals from the Italian Renaissance masters and from the Romans and Greeks, who had portrayed the human figure in its most harmonious, perfected and generalized form. Reynolds carried the Great Style over into his portraits, adding dignity and stature to his sitters, even if this meant sacrificing something of their individuality and glossing over their imperfections. Peake, however, was by temperament anti-classical: the figure would always be his main subject but he was obsessed by

its disproportions and anomalies, pushing constantly towards the grotesque rather than the ideal form. In both his drawings and his prose he delighted in bodily hyperbole, comedy and pathos, portraying the obese, emaciated, chinless, long-nosed, wry-necked, hirsute, lipless, lame and downright deformed. If Swelter, Flay, Irma Prunesquallor and Mr Slaughterboard walked off the page they would never have been employed in the RA life room. Instead of Raphael and Michelangelo Peake soon turned to Rembrandt and Goya for confirmation that great art could be made from man's blemishes as well as from his aspiration to look like the gods.

By the mid-1920s, just before Peake entered, the Schools (there were separate Schools of Painting, Sculpture and Architecture) were in disarray, particularly that of Painting which had become notorious for its mediocrity. In 1926 the Schools Committee admitted they had accepted poor-quality students, they had no clear artistic direction, they didn't know what they were training students to be – and what's more the Keeper, Charles Sims, had gone mad, then committed suicide. An urgent replacement was needed. The students rebelled against the chaotic conditions in the same year and caused a 'grave emergency'. So Walter Russell was poached from the Slade and made full-time Keeper in 1927 and asked to reform the place. Previously Royal Academicians had been asked to opt for a month in which they would appear occasionally in the studios to teach and criticize, but now they would be appointed for longer periods and be expected to actually get to know the students and their work. Students' hours of attendance would be monitored and they would be admitted on six months' probation. New models were brought in and the classrooms ventilated, though by 1933 the Council still had to admit that 'classrooms and corridors are in a deplorable condition'.

The cramped and antiquated buildings might have been more tolerable if the teaching had been good. The curriculum was the traditional one of drawing from casts of idealized Greek and Roman statues and from models, the copying of Old Masters in the National Gallery, with additional classes in the history of art, anatomy, perspective and the chemistry of paint. Had the statue of Reynolds in the courtyard come alive and stepped down into the School of Painting he would have found all these activities perfectly familiar.

Peake needed to learn these basic disciplines and craft skills, of course, but he urgently wanted to draw creatures which had never been seen in a zoo, landscapes of islands in unknown seas, and extraordinary human beings doing desperate things in exotic locations. He

would get no encouragement for any of this from the solid but conventional Visitors who came in to supervise studio work and life classes. Walter Russell (1867–1949), the new Keeper, was influenced by his friend Wilson Steer, and through him by Impressionism and Constable. Charles Ricketts (1866–1931) still looked to French Symbolism for inspiration; Francis Dodd (1874–1949) who had worked in France and Italy had been at his best as a war artist in the First World War; L. C. Taylor (1874–1969) was best known for his studio interiors; Gerald Brockhurst (1890–1978) was a portraitist and etcher who had learned much from Italian Renaissance painters, and Wilfred Gabriel de Glehn (1870–1951) painted high-toned landscapes and figures much influenced by the fluid brushwork of his friend John Singer Sargent. Tom Monnington (1902–76), the Assistant, was the youngest tutor, a Slade-trained painter, muralist, sculptor and a future President of the Royal Academy. He taught seven hours per week for an annual salary of £300 and years later confessed that he could not remember having Peake as a student. These tutors knew of Impressionism and Post-Impressionism, but the convulsive European-wide developments in Cubism, Futurism, Vorticism, Expressionism, Dadaism, Surrealism and Abstraction meant little or nothing to them, and consequently were not brought to the attention of their students.

Outside and away from the Academy modern art – including English art – had found new ways of doing things and new things to say. After Roger Fry arranged the Grafton Gallery exhibitions of 1910 and 1912 the Post-Impressionists, Cubists and Fauves were known and admired in more advanced circles in Britain, but then came the war and the British avant-garde drew in its horns leaving the Bloomsbury clique of critics and painters to represent Modernism to the British public. Fry and Clive Bell had between them persuaded many British artists and reviewers that the English were, at best, a minor school, and that the keys to the future of painting were held by the School of Paris. Peake was never a reader of theorists or critics such as Fry and Bell, but he certainly impressed fellow students by his enthusiasm for Rembrandt, Goya and Flemish art as he led some of them around the National and Tate Galleries.

It is difficult to discern in Peake's paintings of the next few years any signs that he knew of the more progressive work being done in England by those artists who remained independent of Bloomsbury. Before the war Wyndham Lewis had achieved a Vorticist form of abstraction and

then retreated from it, as did William Roberts and Edward Wadsworth, but whilst Peake was a student Ben Nicholson was ruthlessly stripping away the 'upholstery' of painting until, in 1933, he produced an all-white abstract relief. Nicholson was influential in Unit One and the 7 & 5 Society, groups that were devoted to getting English art away from its romantic literary naturalism. Abstraction of any kind never held the slightest attraction for Peake, but there were figurative artists of a more progressive kind who might have provided new ways of seeing if he had sought them out. Paul Nash's nature-mysticism drew on Surrealism; Graham Sutherland had gone back to Samuel Palmer for inspiration; John Piper looked to the English landscape tradition, whilst elsewhere in the West End galleries and bookshops he could have found the works of Matthew Smith, David Bomberg, Stanley Spencer, Edward Burra or the sculptures of Moore, Hepworth and Epstein. If he did discover these artists he evidently decided not to join them in pushing back the boundaries: his easel painting remained figurative and technically orthodox for the rest of his life.

The young Peake was seeking an identity for himself as well as a vocation. Like most students freed from school uniform he experimented with his appearance, trying on new costumes and roles in Piccadilly or Soho. One summer term he appeared dressed in a full City suit of stiff collar, umbrella and bowler, the kind of outfit his accountant brother might have worn, but the heat and the others' mockery finished that experiment. At other times he tried a pipe, long hair, bright ties, red socks, a red-lined cape and a beard. The *Sphere* magazine for April 1931 showed photographs of him with the caption 'Bohemian. The days and manners of Trilby and *Les Jeunes* are, it is believed by many over, but a greater knowledge shows that they still exist in artistic circles.' But Peake was still wearing very shiny shoes, a tie and V-necked woolly pullover. Only his baggy mackintosh and beret marked him out from the man in the street, together with his canvas, *The Cactus*, tucked under his arm. This unremarkable still life was accepted for the RA Summer Show, though it didn't sell and he never tried to enter again. That year nearly 11,000 others also sent in pictures; only about 1,200 were hung, so he was lucky.

Peake got on well with his fellow students. None of them were to become major painters though Peter Scott achieved a popular success with his bird pictures and Leslie Hurry would become known for his extravagant stage designs. One friendship which persisted was with Tony Bridge, who later married a fellow painting student, Brenda Streatfeild. Gordon 'Goaty' Smith implied that this was a period of

sexual awakening after the all-male monasticism of Peake's school-days:

> It was for him, too, a time of growing independence, when he had to find his own code of morals and behaviour, preferably without hurting the feelings of his parents, of whom he was affectionately fond. Not that he was ever wild or ill-mannered, but 'le jeune homme fait ses expériences', and parents are often doubtful about their son's first relationships, particularly with girls.[3]

There were unexpected outbursts. Smith remembered that Peake wore a silver ring with a large malachite stone 'and with it he once inadvertently almost cut to pieces a man at a students' dance who made a foul remark about a girl'.[4] On another occasion Peake told Smith that he was introduced to a 'Lady Whatsit' who was 'talking the most arrant cock' about art. Suddenly he found that he had leaned over and 'solemnly tapped the ash from my cigarette into the cup of coffee that she was in the course of drinking'. Understandably, the lady stormed out: 'Really, the people one meets nowadays,' she snapped over her shoulder.[5]

He was a lively and attractive young man and presumably several girls fell under his spell, as many were to do later. One, Joan Jolly, met him off the train each morning and walked with him to the Academy. Peake stood just under six feet tall, had thick black hair, heavy eyebrows over deep-set eyes, and a slight but wiry physique. He was adept at clowning, especially doing his Groucho Marx walk, and would quickly lead conversations off into the absurd. The students met in the local cafés in Soho for discussions and flirtations as well as in a coffee shop in Gerrard Street, and the more famous Café Royal where at this time Augustus John, Matthew Smith and Jacob Epstein might be glimpsed amongst the plush and gilt.

Peake settled into a routine: studio work or lectures in the RA School in the morning, then a long break in the cafés, galleries and bookshops in the afternoon; possibly a return to evening sessions in the School, and then home to Wallington on the train. It was a comfortable mixture of the bohemian and the domestic. Wherever he went he sketched, on any surface, gripping his pencil, as Smith noted, 'like a chimpanzee' between his second and third fingers. At weekends and in the holidays he would enjoy tennis parties and social events around Wallington and

From *The Moccus Book*, pen and ink, 27×22cm, 1930

continue to paint the subjects set by his tutors or to follow his own enthusiasms. A couple of pen and ink drawings from this period show he had discovered the work of Beardsley and was experimenting with the balance of suave line against areas of dense black.[6] In oils he tried a portrait commission for one of his father's patients, but as he was going through a Rembrandt phase the result was too murky to please.[7]

Peake was also writing during this period, though many of his friends did not realize this. One ambitious long narrative poem in couplets

which has survived is 'The Touch o' the Ash'. Probably written around 1929, it derives from Robert Service, Masefield's longer narrative poems and all those sea stories Peake read as a boy in the *Boy's Own Paper*, *Chums*, the *Rover*, the *Wizard*, his beloved *Treasure Island*, together with a dash of the supernatural from *The Ancient Mariner*. It begins:

> This is a tale a bo'sun told to me in the *Polar Seal*
> On a night when the deck was a sweep o' green, and the
> pilot was strapped to the wheel,
> And the ghosts of old mariners walked the seas, and the
> gulls shrieked past overhead,
> And he told this true bit o' story to me, till I wished that
> I were dead.
> He said:
> In the days not long gone by, in the coaster, *Gypsy Girl*
> They were trading East o' Suez-ward with a fair
> exchange for pearl;
> And the Skipper was rough wi' the for'ard lads,
> an' cruel 'ard was 'e . . .

What follows is the story of a brutal captain, Bully Shad, who trusses up an old sailor and throws him alive into the ship's furnace (though the ship still seems to have full sails). The sailor's body is consumed but reassembles itself into a figure of ash and then kills his murderer in the crow's nest. In its use of the macabre and in the sadistic killing it prefigures *Mr Slaughterboard* of five or so years later. It is peppered with 'begads' and other archaisms and the odd line trips over its feet, but it is an ambitious attempt at the kind of manly rollicking ballad Peake himself enjoyed. What is strange for an aspiring poet is that he seems unaware that poetry had moved on from Kipling and Masefield – in fact he was as indifferent to Eliot, Pound and Auden as he was to Matisse, Picasso and Ben Nicholson. The Oxbridge intellectuals then dominating poetry and novels could call upon a shared knowledge of European and international travel, languages, the classics, left-wing politics and Freudian psychoanalysis as they anatomized the condition of England, but from all of this young Peake was excluded, and seemed not to care.

He shared his poetry enthusiasms with Goaty Smith. After Eltham College Smith had moved on to University College London, to take an English degree, so he was available for exploratory jaunts round the capital. They also collaborated on a long-running joke book called var-

iously 'The Dusky Birren', 'Moccus', or 'The Three Principalities'. Their Chinese childhoods were reflected in the single-syllable names of the imaginary territories where events take place – Soz, Foon, Chee and the Yellow Plains of Ho. Peake drew a detailed map, showing a road that went nowhere, an area where it is always night and an offshore forest growing in the Mulcted Scoff. The creatures which inhabited these lands were called Mokuses (to rhyme with hocus-pocuses), or Mocuses or even Moccuses, depending on how Peake happened to be spelling that day. Smith described them as a continuation of the monsters Mervyn had created at school. 'Some had long limp necks, some ears like a lynx, some pudgy toes, some incipient wings: but they were not merely amalgams, and their expressions hinted at deeper things.'[8]

The drawings are painstaking, with a mixture of realism in the grass, stylization in the rocks and clouds and downright fantasy in the benignly stupid creatures. Peake always liked tiny detail and almost obsessive neatness in his ink drawings rather than dash and splash. It is difficult to think of any sources in English or European art, but there may be hints of the Chinese stone and bronze sculptures of mythical beasts in his father's photographs in creatures such as the Mastermire, 'a fearsome beast with a beard of fire'. Some are drawn in response to Smith's verses with the poem handwritten in much the way Peake would later organize the pages of *Captain Slaughterboard Drops Anchor* or *Letters from a Lost Uncle*. Smith's verses from which the drawings and watercolours spring are mere doggerel:

> Until the kingcups come again
> the Arapooki is in pain:
> So the Eurasian proverb runs –
> Here are the Arapooki's sons

Today it is difficult to imagine two young males of nineteen and twenty-three spending so much time and ingenuity constructing a similar nonsense world – a world in which the Pleeka, Patti, Maranesa, Spinnled Zale and the Mastermire all appear to be male. This farrago of schoolboyish whimsy was turned down by the publishers Chapman and Hall but continued to be the subject of private jokes in the two men's letters over the next twenty years.

When not engaged on this creation they continued to explore London's delights and somehow Peake acquired a car which he called the Scarlet

The Arapooki, pen and watercolour, 25.5×20.5cm, *c.*1930

Runner and drove very badly. They planned to invade the continent too, as this letter from Peake shows:

> Joking apart, my watercolours are going to be second to none by this time next year. How about a book illustrated by w-colours. Write one on the countryside with them as decorations – The Broads – the Lakes – Ireland – the Hebrides – France – a series. WHOOPEEE! How about chucking everything and protracting our envisaged walk to a matter of three or 4 years – come back full of material and experience an' all an' all. OK? right. Date please. Write soon – a long letter full of your views. Muffin.[9]

In the summer vacation of 1931 they went to France together, having picked Clermont-Ferrand as their centre by randomly sticking a pin in a map. Smith tells how they met at Piccadilly Circus and Peake turned up with 'six inches of scarlet pyjama trailing out of the bottom of his corduroy trousers'.

The first stop was Paris, where they wandered about selecting a world First XV of painters which reveals something of Peake's knowledge at the time:

> After considerable argument we agreed on a list of fourteen that included Rembrandt, Velasquez, Piero della Francesca and Botticelli. Leonardo, I think, was hooker. But we quarrelled about the last member of the side.
>
> 'For the last man,' said Mervyn firmly, 'we must have a stylist. I vote for le Nain. He can play wing three-quarter.'
>
> 'Le Nain!' I exclaimed in horror, 'Goats and monkeys! Don't be daft, he wouldn't even make the Extra C.'[10]

They went off to the Louvre to check, Peake being admitted only after he demonstrated that his pipe was just for show and unlit. He enthused over the *Mona Lisa* and 'On the way out we discovered a magnificent annexe full of Impressionists, and altered our side, quite monstrously, to include both Monet and Manet'.

Where is any mention, apart from Monet, of a twentieth-century painter? And why did they not seek out the commercial galleries where the work of the great Paris-based Modernists might be found? Presumably because they either did not know of their existence, or they were not interested in them.

They found that Clermont-Ferrand 'appeared to be a sort of French

Wigan', which is unfair since neither of them knew anything about England north of Hampstead. 'One night here will be a Plethora!' declared Peake. They explored the Puy area, Peake doing the odd watercolour and flirting with the innkeeper's daughter, whilst Goaty tinkered with his poems 'and tried, unsuccessfully, to persuade him of the philosophic virtues of Wordsworth'. After several more adventures they decided to sleep outdoors under a tree. Two nightingales perched above them and sang enthusiastically until 2 a.m. in spite of the men's shouts and shied boots. At 4 a.m. they packed up and walked to the nearest village which was already awake and serving hot bread and coffee. 'We were young, and in bounding spirits; and we returned to an equally exciting London, which was all ours for the taking.'[11]

They were a couple of middle-class youths with a little money in their pockets and an enormous zest for experience. This expressed itself in public school banter and letters full of Gosh! Gee! Thanks awfully! Off the deep end! Oh Boy! In their world everything was either 'bilge' or the 'toppingest'. 'O BOY ISN'T LIFE GOOD!' Peake exclaimed in one letter. He usually signed off with Muffin or M Leprosy Peake.

In amongst this badinage Peake would insert his latest, very confused thoughts on art and his own plans to become a painter. 'I've decided to "be" a Romanticist in Painting, but am going to combine the guts of Van Gogh with the design of Puvis de Chavannes, and yet keep the suaveness of a Raphael running through stacks of corn that are yellower than yellow in the sunlight.'[12] Around this time – 1932 – he did an oil of a beggar playing a tin whistle. He has no legs, only stumps, evidence of Peake's fascination with mutilation. Not surprisingly, it never sold.

Peake's paintings received their first public showing when a group of students, calling themselves the Soho Group (because they ate in Greek Street) hung forty or so pictures in a restaurant, priced between one guinea and £30. Peake contributed twelve, including his *Cactus*. The exhibition ran from December 1931 to January 1932 and overlapped with another *ad hoc* show by the Twenties Group (all the artists being in their twenties). This was at the Wertheim Gallery in Burlington Gardens, and included such future stars as Barbara Hepworth, Victor Pasmore and Robert Medley. One of Peake's three pictures was called *The Chef* (10 guineas) and one wonders if he had in mind William Orpen's great picture *Le Chef de l'Hôtel Chatham Paris* (1919) which the Royal Academy owned. The *Birmingham Post*

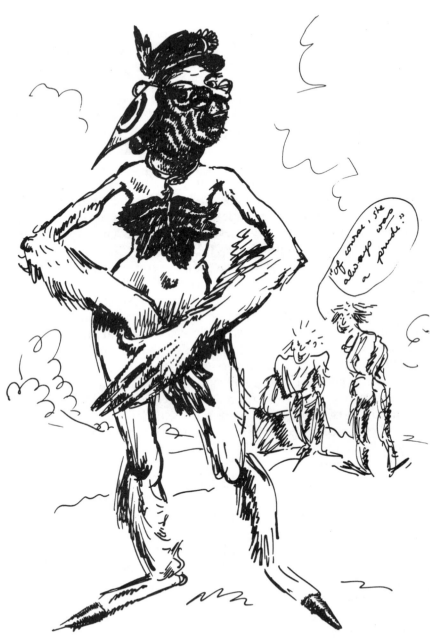

'*Of course, she always* was *a prude*', pen and ink, 24×15cm, *c.*1933

critic thought that 'several pictures including those by Mr Mervyn Peake might well prove excellent investments at their present prices for the discerning speculator'. Excitedly Peake wrote to tell Goaty that when he and two friends had also shown at a café called Au Chat Noir in Old Compton Street, Epstein dropped in and a photographer from the *News Chronicle*. Evidently Peake was eager to sell his work from the start. None of these groups had any ideological coherence: just a desire to spread exhibiting costs.

While still a student he was asked to design stage costumes for a small rep company, the Tavistock, who were putting on *The Insect Play* (1921) by the Czech brothers Čapek. This had two performances in November 1932 and people were impressed by Peake's ingenious designs for the insects. It was his first glimpse backstage and it gave him the ambition to do more.

In spite of these public displays of his work, and the fact that he had won the Arthur Hacker prize of £30 and a silver medal for his 'Portrait study of a lady in evening dress showing arms and hands', his tutors were not convinced of his commitment. As in his schooldays, Peake's attention wandered and his attendances at morning and evening sessions declined, though they had never been good: in his first academic year he managed 184 out of a possible 258 morning and evening sessions. In 1930–31 it was 271 out of 377; in 1931–32 285 out of 378 and by 1932–33 only 197 out of 382. In June 1933 his studentship was terminated, eighteen months early, and he left. By then many of his friends had also gone and he was impatient to spread his wings.

His old English teacher, Eric Drake, and his new American wife had gone to Sark to set up an art gallery and needed help. Peake wrote to Goaty: 'Say I'm off the deep end about the Eric Drake scheme. Isn't it marvellous? Gosh! I'd give my soul to come. Pirates and octopi! O.K., Chief. I haven't heard anything from them myself, so of course I can't write them or anything. From the Drakes, I mean, not the Octopi – now then Mr. Jerome . . .'[13] In the summer of 1932 the two of them went over to explore, and Peake fell in love with the island. Sark would be a very special place for him all his life.

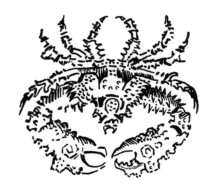

4 Bachelor, 1933–1935

Sark, one of the Channel Islands, is thirty miles from the French coast and about eight miles from Guernsey. It is three and a half miles long and one and a half miles wide, though one day it will become two islands when the fierce seas break through the precipitous ridge called La Coupée which joins Sark to Little Sark. Settlement is all on the 300-foot plateau which forms the centre of the island; everywhere the sea is visible on the horizon or glimpsed down the steep little valleys leading to the indentations and bays below. Romans and medieval monks tried but failed to settle the island and it was only in 1565 that it was colonized by a Jersey nobleman and forty men with muskets sworn to protect it against enemies of the English Crown. The Seigneur, or Dame, is still the leader of these tenant families, but with their permission other settlers have come, attracted by the climate, lack of income tax or death duties and the absence of cars. Only the Seigneur may keep pigeons and an unspayed bitch and there are other laws peculiar to the island (in Peake's time there divorce was not permitted) which are administered by the Chief Pleas Council. In this enclosed world such archaic laws seem to work, much as those in Gormenghast would do under the Earls of Groan.

When Peake arrived in summer 1933 the population of 500 or so earned their living from the sea and the land, or by driving tourists around in horse-carriages and selling them cream teas. For a few shil-

lings, or pints of beer, some Sarkese could be persuaded to sit for artists, but only with their clothes on. It was on this idyllic but inaccessible speck of land that Eric Drake proposed to set up an artists' colony and a modern art gallery.

After he left Eltham School in 1926 Drake had spent two years at Yale on a drama scholarship, but he also found time to be a cowboy in Wyoming, to explore the Rockies and New York, and to acquire an American wife Eloise, known as Lisel, who was a painter and shared his idealism. They published a prospectus and advertised widely to attract others interested in a non-profit-making co-operative dedicated to helping young artists find time and a supportive atmosphere in which to work and exhibit. In it Drake wrote a prose poem extolling Sark's rocks, pools, incredible light and low rainfall (less than Sicily's), as well as locals who spoke a Norman French patois. The possibilities, he claimed, 'are unusually rich for artists with a keen sense of things firmly rooted in primitive nature'. Round the edge was printed their educational backgrounds as if this was a public school brochure: Eric Drake BA, MRST (London, Columbia, Yale) and Eloise C. S. Drake BA (Wellesley, Yale, Slade).

They had no party line except that 'work that is imitative and conventional on the one hand, or merely precious and *snobiste* on the other, is not required'. In their advertisements they quoted Browning's *Pippa Passes*:

> One may do whate'er one likes
> In Art – the only thing is, to make sure
> That one does like it – which takes pains to know.

Victor Hugo, Swinburne and Turner had been to Sark and been inspired by it, so which self-respecting artist could resist? Eventually Drake would draw in some very distinguished artists and visitors from Australia, Italy, Germany, Canada and America; meanwhile he had to begin the enterprise with his wife, two students in their teens and his ex-pupil, Mervyn.

Drake invited Peake to come over and help complete the gallery and to use one of the two new studios above it. In turn Mervyn asked his friends Tony Bridge and Brenda Streatfeild. They were three or four years younger than himself and had to return to the Royal Academy School at the end of each summer vacation, unlike Mervyn who was

Gordon 'Goaty' Smith, brown crayon, 26 × 20cm, *c.*1934

now free to stay on Sark all year if he wished. These three, plus Lisel, formed the original Sark Group which Drake hoped to expand once their work was exhibited on the island and then transferred to a London gallery where it would attract more notice.

There were no contracts to sign, but it was understood this was not a charity: Drake would supply canvas and paints if they couldn't afford them, but once the picture sold they must pay him back. He would also pay them the local rate of eightpence an hour to work in the gallery or the two-acre garden which surrounded it and which supplied vegetables, eggs and goat's milk. In addition they could frame pictures and help with the local potato harvest until their works began to sell.

A modern gallery selling modern art was outside the Sarkese' experience and it needed Drake's diplomatic skills to win them round and stop them sabotaging his scheme and driving him off the island. First he reassured them he would not compete in the cream-teas trade or run boat trips and then he invited the tax-exile residents and the locals to the musical and social events in the gallery as well as to exhibition openings. He even offered exhibition space to the local artists, some of whom specialized in selling tasteful views to the day-trippers – though Arthur Waller, his daughter Margaret Waller, Ethel Cheesewright and William Toplis had reputations well beyond the island. Eventually Drake was accepted enough to be initiated into the island's branch of the Ancient Order of Buffaloes.

In the prospectus the Drakes used careful camera angles to disguise the fact that the Guernsey builders had not quite finished the gallery, but they could assure artists that it was already fire- and damp-proof because it was built of concrete reinforced with blue granite dust. The main space measured 50 feet by 20 feet and the elegant circular stairway in the centre led up to two studios ready for use. Outside, a pink concrete veranda encircled the building, and a roof garden 'offers artists a pleasant rendezvous where ideas may be thrashed out, and not unimportant in Sark – where the latest periodicals may be read'. Ultimately Drake intended to make it a centre for all the arts so he planned a little open-air theatre to be run on the lines of the Community Theater he had studied in America. This did not happen, though in summer 1935 all the artists volunteered to re-enact the landing of monks on the island in the sixteenth century for a visiting French film crew.

Mervyn was put in a nearby tin chalet; then, when they were finished, he was given one of the new studios to live and work in. An early

photograph shows him still quite smartly dressed, pipe in mouth, standing before a canvas of a girl, with a wardrobe and couch-bed as his only furniture. Later still he took lodgings with a Miss Renouf who walked around all day with a parrot on her shoulder, just like Long John Silver, and tamed birds just as Gertrude, mother of Titus Groan, was to do.

He had been offered a unique opportunity to develop his art and himself, free of financial worries, a school or college timetable, or the constraints that come with living at home with elderly parents. First, as Mr Pye was to do later in his novel, Mervyn set out to explore the island itself. This included climbing its most dangerous 300-foot cliff with Goaty and getting into desperate difficulties at the top under an over-hanging boulder 'about the size of a small cottage'. Before inching his way to safety he had muttered to Goaty: 'If you come near me I'll bloody well kill you.' Drake believed he'd attempted it only because he had been warned not to. Later he was to climb one of the cliffs 'with a young cor-morant in each coat pocket pecking angrily at his armpits as he hung'.[1] One of these birds became a pet and defecated all over his canvases. Peake also explored the numerous caves and had his leg gripped firmly by a large octopus which he had to club to death before it would let go. On one beach he found a long-dead whale and cut out some of its verte-brae which he kept all his life and passed on to his children, who now have them in their homes. This seems to have been the beginning of a lifelong obsession with bones; his poems and drawings are full of them.

The Sarkese found him rather shocking, especially in appearance. He was still the London poseur and had let his hair and beard grow long, wore a cape, and went to Guernsey with Brenda Streatfeild to have his right ear pierced and a pirate ring inserted while she had both ears done. They sat side by side sketching at the circus in Guernsey with their earlobes bleeding. He also attracted attention by strolling the lanes twanging a ukulele. Watney says of all this peacockery: 'he thor-oughly enjoyed the sensation caused among both down-to-earth peas-ants and fishermen and respectable middle-class residents'.[2] One Sarkese misinterpreted these accoutrements as signs of effeminacy and said so in the pub whereupon, according to Watney, who could only have heard it from Drake, 'Mervyn put down his mug of beer, and quite leisurely strolled up to the man and let loose such an electric punch that it sent him reeling across the pub and crashing to the floor on the other side. Mervyn, still leisurely, apologised to the publican, finished his mug and quietly strolled out.'[3] One of his cowboy heroes couldn't have managed a cooler exit through the swinging doors of a saloon.

He drank with the locals in the pubs, tried their lethal home-made sloe gin and persuaded them to sit for portraits. On one occasion he had a go at water divining and on another was asked to play in goal for the local soccer team against their Guernsey rivals. He had not played soccer before yet his athleticism between the posts was sensational. He seemed to be crackling with youthful energy in everything he attempted.

Another force that Peake was eager to explore was his own sexuality. There was one local young woman of a very accommodating nature, who would appear in his *Mr Pye* novel as Tintagieu, the open-hearted but promiscuous local tart; according to Drake, 'Mervyn had fallen for her reputation and was baulked by the real girl. Not being serious he rebounded.'[4] To Tony Bridge he boasted that he had seduced a girl on one of the beaches just because nobody else would. Bridge distinctly recalls that at this period Peake's humour was schoolboyishly lavatorial with a preference for the kind of rhymes which begin 'There was a young woman of . . .', and that he drew the odd obscene cartoon. Even the biographer John Watney, who is usually so discreet, admits that Peake was going wild – he sent the same love poem to half a dozen girls at once and was then surprised that on a small island like Sark they found out and were annoyed. Manners in the artists' colony were free and easy and Bridge says they regularly swam in the nude together. Once Drake and his wife shocked the postman who found them sunbathing naked on the front lawn of Seaview, the haunted cottage where they lived, and there are Sarkese who are still convinced today that Mervyn took all his clothes off (except a sombrero) to paint landscapes in hot weather. The group intrigued and titillated the natives no end.

Diana Gardner, who later became one of Peake's students, visited Sark with her brother and saw some of his work in the gallery there. She strolled on and came upon this idyll:

We passed, one afternoon, a group of young people – girls in loose dresses and smocks, and men in coarse-knit polo-necked jerseys or 'guernseys' as they are properly called – taking a 'talking siesta' in rich, uncut hay which was grown for the dainty, cream-coloured cows frequently seen chewing and meditating, tethered face-deep in the silvery grass of the island. Some of the young people lay full-length on their stomachs with chins lifted, while others leaned against a low stone wall. We recognised among those standing the

The Sark Group, crayon and watercolour, 17×25.5cm, *c.* 1934

legendary Mervyn, his pale, narrow face under its high, springing hair, and with rather near-together deep-set eyes. He was wearing a black, high-necked sweater, and his shoulders leaned against the stones. He looked relaxed, chewing a long grass, holding the end of it, his arm raised.[5]

When Peake had been on the island a few months Drake's advertisement attracted a young artist from America called Janice Thompson. She worked on the island and showed her watercolours at the first exhibition in 1933 and again at the Cooling Gallery exhibition in May 1934. Peake pursued her and recklessly went so far as to get engaged to her. This is Eric Drake's account of what followed:

> I asked him what he proposed to live on, and he said his father 'would have to' make him an allowance. I said he was more likely to do so if Mervyn removed his ear-ring, his surplus hair and cape, and I left it at that. Mervyn went off as he was – I had merely eased my conscience.
>
> When his father saw him he took him into his surgery and removed the ear-ring, put him in a 'decent' lounge suit, and sent

him to the barber. Needless to say, there was no allowance, and Mervyn returned to Sark hardly recognisable (but didn't remain so). The girl did the other thing – returned to Boston. She would have been lost in Mervyn's world, as he in hers.[6]

Years later, when he was a published author, Peake received a letter from Janice who was by then married with a child and living in Canada. She had ceased to paint but had published a volume of poetry. He did not take up her offer of food parcels.

None of these athletic or amatory exploits distracted him for long from his main purpose on the island – which was to paint. He produced vigorous landscapes and sea views and in the winter portraits of the fishermen and their daughters all in a freely brushed but rather dark and dense paint. Later he would paint very few landscapes but the rocks and wind-bent trees of Sark cropped up frequently in his book illustrations. Occasionally he crossed to Guernsey and did commissioned portraits there – the few I have seen are very competent indeed, though subdued in tonality. He also painted a dramatic self-portrait, hair tangled, shirt open and gaze wild, which is now in the National Portrait Gallery. Drake must have had high hopes of him, especially when he was asked to paint the Dame, Sybil Hathaway, and her American husband – though whether this ever happened no one now can remember. In a letter to her on 7 November 1933 Drake informs the Dame of his exhibition plans; that Mervyn has just returned from London and 'the Redfern Gallery has taken one of Mervyn's, one of Brenda's, and two of Tony's to show in the meantime, which is pretty good. A number of important professional people saw our show in a private studio in Chelsea, and were agreeably surprised, so we are feeling reasonably confident.' The Dame invited the artists to tea at the Seigneurie and warned the flamboyantly bearded Bridge and the ear-ringed Mervyn that they should be more circumspect and not shock the islanders.

The Dame agreed to open the first exhibition of the Sark Group on 30 August 1933. Sarkese, tax-exiles, the vicar, assorted wealthy summer-house owners such as Mrs La Trobe Bateman, the builders who had virtually finished the gallery and the local amateur artists were all invited. Reporters from the Guernsey newspapers attended and described La Dame's red white and blue outfit in some detail, the teas in the marquee, the sparkling weather and finally the pictures, particularly those of

Mervyn Peake, 'a young man still on the sunny side of twenty-two, whose versatility and imagination place him in a class of his own'. The reporter liked how 'the effect of light which he brings into his pictures makes them vivid, alive and arresting.' More imaginatively he had illustrated Blake's poem 'Tiger, Tiger': 'a thing of dark trees, slumbrous shadows and wicked green light, with, as a centrepiece, a vivid yellow tiger'. Peake had come out well in his first encounter with a reviewer, if only a very provincial one.

Drake had asked each of his four artists to paint a 6 feet × 4 feet canvas to dominate each wall and Peake had produced *Darts*, a picture of two grizzled fishermen (there is a lobster on the seat) in a pub, one of whom complained that he'd been made to look like a monkey. They stand and sit to the right of the picture and one aims across a bright blank space towards an unseen dartboard off to the left – it is a clever compositional device and one he was to use again in his 1939 book, *Captain Slaughterboard Drops Anchor*. It was priced at 20 guineas. He also showed watercolours from his French excursion with Goaty and some black and white figure drawings at 15 shillings. Alongside the Sark Group's efforts were invited artists, including the well-known wood-engravers Iain McNab and Guy Malet.

The following spring, 1–14 May, 'Paintings by the Sark Group' were exhibited at the Cooling gallery in Bond Street. They attracted a lot of press attention, though several reporters seemed to have the odd idea that the Sark gallery was converted from a 'tumble-down fish shop'. The *Daily Herald* interviewed and photographed Peake and reported: 'For a time the young man lived in a barn that leaked. He worked in the potato fields to make enough money to buy food, he fished in the sea, he washed his own clothes, and did many "inartistic" jobs, and he says it was glorious.'[7] He also told them he had run away from London's 'snobbery, inanity, and the herding instinct of artistic groups' in order to put 'guts' into his pictures, so he had obviously been converted to Drake's utopian views.

For the first time Peake came under the scrutiny of a major critic, Frank Rutter, who had set up the Allied Artists' Association in 1908, been an early advocate of Kandinsky and a vocal supporter of the Modernism of Moore and Hepworth. Rutter in his *Sunday Times* review was not impressed by many of the 'dull and derivative portraits' in the show and asked, 'why for example did Mr Peake, who gave us a delightful and truly personal landscape in his luminous *Orchard*, disappoint us so terribly in his portrait of a man in his chair, *Hotton*?' Rutter's own view was that 'he was thinking not so much of his sitter

as of the painting of Van Gogh. Fascinating as the work of this modern master may be, he is a dangerous model for a young painter. The slovenliness and carelessness which appear in some of his paintings are only excused by the genuine passion of Van Gogh's vision. To imitate his superficial mannerisms without his burning and artless temperament leads to mere affectation.'[8] Rutter repeated his advice in the *Christian Science Monitor*, quoting Sir Joshua Reynolds: 'Nature denies her instructions to none who desire to become her pupils' and Wordsworth: 'Come forth into the light of things, Let nature be your teacher.' This, Rutter thought, explained why Peake's and Bridge's landscapes were so much fresher than the figure compositions which 'do not rise much above good students' work. There are dozens of other young artists who can paint heads and figures with equal competence.'[9] This was good, though tough, advice but didn't take into account every young painter's need for a hero to emulate nor the fact that a Van Gogh landscape could be more exciting than any real landscape to a young artist learning his trade.

By the summer of 1934 the fame of the Sark Group had spread and more pictures had accumulated so there was another exhibition of eighty works in the gallery from 21 May to 16 June with the same artists plus lino cuts by Alfred Waldron ('Pip') who had joined them on the island, and woodcuts by Iain McNab. Two important sculptors, John Skeaping (ex-husband of Barbara Hepworth) and Leon Underwood sent works too. The Guernsey newspaper warned its conservative readers: 'Much of it is modern – some ultra modern, and even that which has been described as futuristic.' They showed again from 18 June to 14 July, Peake contributing eleven oils. Many more artists wanted to show in the exhibition held from 1 to 29 September in the same year but again the original four, Lisel Drake, Brenda Streatfeild, Tony Bridge and Peake, provided the core of the show. By now Drake was running an exhibition each month in the season: these were labelled Mixed, Progressive, Conservative or Open, and the Sark Group was not always involved.

Peake spent most of these two years on Sark but there were trips back to London for exhibitions, to see friends like Goaty who was now teaching in Truro, and once in 1934 to paint a portrait of his brother's new wife Ruth while the couple were home on leave from Malaya. Having been let loose on this Edenic island he had sown a few wild oats, lived by his own efforts and created some promising paintings; it was a

period he would remember with affection the rest of his life. This was a different kind of ingrown community from the Tientsin and Eltham ones, but equally hierarchical and bound by rule, ritual and superstition. His little artists' group was surrounded by a potentially hostile Sarkese population, but in the end the break-up came from within rather than from outside. By the end of the 1935 season Peake was ready to leave. Tony Bridge and Brenda Streatfeild were no longer coming to the island (they would marry in 1937), Pip Waldron also left as did Peake's one-time fiancée Janice Thompson. New artists were coming in, particularly the prestigious Stanley Royal, RA and one, Elmslie Owen, who would prove a useful contact later. There were several more exhibitions, but the Drakes' marriage was in trouble and they were soon to split up with Lisel returning to America and Eric reduced to living in one of the gallery studios. The impending war meant fewer visitors and he went into debt and finally closed down in 1938.

Peake claimed he had got on the wrong side of the Dame and was expelled.

He had apparently been a thorn in her flesh for some time. The final straw came when a very old man died and was laid out in the chapel. Mervyn had gone in there with other people and saw this old man lying there with four huge white candles, and covered with a white cloth. The corpse had a long, white beard which was laid out over the cloth. Mervyn looked at this and found it irresistible. So later that night he came back and broke into the chapel and did a quick sketch of the old man; it was all white, with the white candles shooting out their red flames. But unfortunately he was caught breaking out of the chapel and so the Dame expelled him.[10]

Whether this is fact or Peake's fantasy it provides a chilling premonition of his later fascination with the pallid face of a Belsen victim against her white pillows.

One of the artists attracted to the 1935 Sark exhibition had been Kirkland Jamieson, Principal of Westminster School of Art. He evidently did not share Rutter's reservations about Peake's figure work because he offered him a job teaching life drawing. Gladly, Mervyn accepted and left the island, though not for ever.

5 Husband, 1935–1939

Westminster School of Art was founded in 1876 and soon acquired a reputation for progressive teaching. In 1903 it was taken over by the London County Council and moved from Tufton Street to Vincent Square, behind the Tate Gallery, merging with a technical institute which trained students for work in the gas and building industries. Several distinguished artists taught there, including Frederick Brown who then moved on to lead the Slade School to pre-eminence, and later Walter Sickert, Harold Gilman and Nina Hamnett were on the staff. Former students included Aubrey Beardsley, Robert Bevan, Henry Tonks, David Jones, and Tristram Hillier. By the time Peake arrived Robert Kirkland Jamieson was the overall Head of the Art Department, painting was taught by Mark Gertler, John Howard, Elmslie Owen (who had shown with the Sark group) and Jamieson himself; drawing was in the hands of Adrian Hill, Blaire Hughes-Stanton, and E. J. Fedarb; modelling was taught by Eric Schilsky, carving by Hilary Stratton and engraving and animal drawing by Clifford Webb. The prospectus insisted it was a School for Fine Arts rather than Crafts or Applied Art and 'the members of staff are all distinguished artists, each a specialist, selected for their ability as teachers and for their difference of outlook', though they were in fact mostly solid second division journeymen. In one surviving prospectus Peake is shown conducting a drawing class in the cast room, but the timetables reveal he took two sessions on Tuesdays called 'Life

Costume (Watercolour)', and two on Thursdays in 'The Modern Use of Watercolour', neither of which seems to be the best use of his talents.[1]

The curriculum was much the same as at the Royal Academy School and, as usual, there was a high proportion of female students. Full-time five days per week for a year cost £18, but it was possible to attend part-time for very little. Two students, the young Countess of Moray and Diana Gardner, became lifelong friends and admirers of Peake. From the latter we know that this twenty-four-year-old artist who had lived wild on an island and attracted reviews in the national press fluttered a few hearts. 'He gave off a sense of sentient vitality, as if he lived a "little extra", and that his perception and senses were also a "little extra."' For the female students 'here was the perfect Byronic romantic figure: jet black hair bursting upwards from a high forehead and a long narrow face in which were embedded bright blue eyes and sharply cut incisions in either side of a full, yet narrow and sensitive mouth.' His outlandish dress, the odd way he gripped his pencil (which they all tried to imitate) and his light-toned and cultivated voice had them all atremble. 'It is probably now quite obvious,' she admitted, 'that the female students found him irresistible for, apart from his fascinating looks, he always seemed, while sitting beside any one of them, teaching, to be wholly interested in that one alone. It was apparent that he liked women, although he was also popular with the male teachers and students.'[2] His teaching method was orthodox enough: he drew directly on to the students' papers to demonstrate and afterwards they would compare and treasure these little sketches. Life drawings still turn up in sales-rooms with 'Mr Peake drew this' written on them.

When Diana Gardner got to know him better she was disappointed to find he had little or no interest in wider philosophical or political matters: even the Spanish Civil War seemed to have passed him by. 'Neither did he seem particularly interested in analysing or describing anything: it was sufficient for him to feel and experience directly, and then to express these experiences in painting or in poetry. Once he said: "Art is really sex in another guise," but no-one then took the idea up, and he did not pursue it.'[3] Theory, research, scholarship, aesthetics were never to be of interest to him for, as Gardner put it, 'the whole of his mind seemed bound up with, and to respond instinctively to, the artist and artistic expression – direct'.

When he first came back from Sark, Peake returned to his parents' house at Wallington, but he also shared a studio in town with an old

friend from the Royal Academy School, Bill Evans. Gordon Smith came up frequently from Taunton and their gleeful exploration of London's peaks and troughs continued, Mervyn talking with pimps, lonely old pensioners, teenage dropouts and once having to punch his way out of the embrace of a rich young homosexual. They went to the Palais de Danse, where Mervyn observed a young working-class girl:

> Can you not see within that small
> And callow head, a brightness far
> From this dance hall?
> Her evening-dress
> Is splitting like the chrysalis,
> And when she stirs
> A caterpillar moves.

Another of Mervyn's favourite places was the zoo where he drew vultures, lions, antelopes, rhino and baboons in swift lines, capturing their movements.

In the Tate Gallery Smith persuaded his friend of the greatness of Turner by saying 'You're always talking about the qualities of the paint. Why not look at them for a moment just as patterns, like a rug, and then go on to the romantic subject matter from there?' Peake tried it and agreed, 'You're absolutely right! He's a great painter, a great poetic painter!' For Peake the subject always came first and the paint handling second so Goaty's advice to look for the abstract qualities in Turner was a useful corrective. In turn Peake added to Goaty's education by taking him to a squalid in-flow of the Thames 'where, bloated but half-sunk, a hundred thousand French letters floated down towards the sea. I was rather embarrassed, but Mervyn laughed his head off. "Social comment!" he said.'[4] When they were apart, daft letters still flew back and forth, full of puns, plans for the Moccus book, schoolboy ragging and smut.[5]

Peake continued his 'head-hunting' wherever he went, sketching on scraps of paper in cafés, on buses, in pubs and tube trains, but he was also writing poems and this brought him into contact with other poets. One was Dylan Thomas, newly arrived in London from Swansea and already a member of the 'Welsh Gang' gathered around Mervyn's friend Bill Evans. He had just published his first book *Eighteen Poems* (1934) and was still cherubic in appearance, though already broke, randy, thirsty and dangerous to know. His word-drunk poetry had a lasting influence on Peake's own, perhaps not an altogether beneficial one.

They would remain acquaintances for some years, gradually becoming distanced by Thomas' fame and increasingly chaotic lifestyle.

This fast-and-loose bachelor existence received a jolt one day in September 1936 when Peake entered Eric Schilsky's sculpture class on the top floor of the college during the model's break. He picked up some clay and began adding it to a student's armature and this inconsiderate act was observed and admired by a seventeen-year-old student who had enrolled that very day, Maeve Patricia Mary Theresa Gilmore. Her blonde beauty caught his eye and he asked her to come out immediately for a walk in the park with him; when she stammered out a refusal, he insisted she meet him to have tea after lessons were over at four o'clock. One might guess this was a manoeuvre he had tried before with other pretty students. After he left, Maeve's classmates told her that she'd just met the famous Mervyn Peake who was dying of consumption and she decided he was 'the most romantic looking man I had ever seen'.[6] At four o'clock he was waiting for her, wearing his ankle-length mackintosh, and whisked her off to a Lyons Corner House where a female gypsy band was playing 'The Desert Song'. He startled her by saying 'I'd paint a dustbin if I thought it beautiful' and that he should really be at an aunt's cremation 'but there was enough fire here', chat-up lines which might have struck a more experienced young woman than Maeve as well rehearsed.

Mervyn's next predictable move was to invite Maeve to visit his studio. He had now left home for three cheap unfurnished rooms, near the bus station in Hester Road, Battersea. She arrived in her mother's car, driven by the family chauffeur Penfold, who was told to wait outside. The stairs she mounted were painted yellow and vermilion, the uncarpeted floors were strewn with empty and half-full milk bottles and there were paintings and drawings everywhere, including those over the damp patches on the walls: 'faces and landscapes had been woven into them, so that what should have been detrimental was turned into a world of angels and monsters'.[7] There were also rats scuttling above the ceiling. This first glimpse of the squalor of bohemia did not deter this naïve little rich girl; instead she found it 'the most beautiful and the most romantic place I had been to', and she stepped down the stairs and into the car some hours later 'another girl in another clime, never to return to what I thought I knew'.

After that she came back alone, braving the wolf whistles of the bus crews, mounted the stairs and in front of the popping gas fire Mervyn

Maeve, pen and watercolour, 44×19cm, 1936

'did paintings of me: a head turning; a body standing; a half head; an eye; a mouth; a hand; half-draped; half-nude; draped or nude; lying; sitting; asleep; awake; laughing; crying; singing; sulking; pencil; pen; oil; chalk; and over all the nostalgic smell of turpentine. And afterwards, toasted crumpets by the fire, and indifferent tea.'[8]

One time she arrived only to be told by a neighbour that Mervyn was desperately ill in Carshalton hospital. He had been sent home from the school to Wallington where his father had diagnosed acute appendicitis and had him operated upon. Maeve's sickbed visit was hasty: he hadn't told his parents about her existence and they might turn up at any minute.

On another occasion when she stayed in his room overnight they were startled to see the floorboards undulate and to hear a trumpeting from below: on lifting a trapdoor they found an elephant stabled in the warehouse on the ground floor ready for a circus appearance next day. Through the opening they fed it sugar lumps and buns. She realized then that life was never going to be humdrum in Mervyn Peake's company.

When not in their love-nest attic Mervyn showed her the London he had discovered with Goaty, clowning for her on buses, sliding down escalators, ordering camel stew in the cafés – full of the exuberance of being loved and loving. He was still scribbling poems on scraps of paper and sketching everyone he saw. Maeve noticed both then, and later when they were married, that 'the girls he stopped always seemed to have good "bone structure", which eased the small green seed of jealousy, and later on "bone structure" became one of those jokes enjoyed only between ourselves'.[9]

Peake had found another chance to diversify in spring 1936. He had kept all his designs from the Tavistock Rep's *Insect Play* and when he heard there was to be a professional production of it at the Tavistock Little Theatre he dusted them off and took them along to try his luck. The producer, Nancy Price, refused to consider them because she had already engaged a designer so he threw the drawings down, gave his address, and left. She must have been impressed by the gesture and the drawings because the next day she sent for him to start work. To design creatures half-insect and half-human was the kind of task just made for Peake, who had been drawing mutants since his schooldays. So well did he do it that the critics in all the major newspapers picked him out for special praise; the *Times*' feared drama critic, James Agate, commented that 'Mr Peake's brilliant costumes could not be bettered.'[10] An interviewer in the *Daily Sketch* claimed that 'Mr Peake now finds himself

classifying people in trains and buses, as well as his friends, as beetles, snails, butterflies and caterpillars. Which sounds like an unpleasant habit.'[11] One of the actors, Esmond Knight, became a friend of the artist and helped to keep his interest in the theatre alive until eventually Peake attempted to write his own plays.

This success led to a commission for more costumes, for *The Son of the Grand Eunuch*, a play by Albert Arlen to be performed at the Arts Theatre Club – coincidentally the venue for Peake's own play *The Wit to Woo* twenty years later. Maeve helped him make the Eastern-style costumes and watched him paint on the Chinese dragons. He gave his parents a rare night out, inviting them to the opening just before Christmas 1936, and they admired the dragons, though not the play. In spite of these experiences Peake was not asked to do more theatrical work which, given his feeling for dramatic lighting and exotic attire, was a loss.

At last Mervyn took Maeve home to meet his parents, who must have been relieved by her normality after some of his previous girl-friends, and hopeful that her elegant dress sense would get him away from his lurid socks, vivid ties and the masquerader's cloak. She remembered their home as Victorian Gothic, full of 'rice bowls, dragons, Chinese carpets, and ornate brass ornaments'. When she took him to meet her parents he came as a profound shock to the Gilmores.

The solidly middle-class prosperity of Maeve's family derived from her maternal grandfather, Henry Lascelles Carr, a Yorkshire newspaper proprietor, who owned the *Western Mail* and a large share in the *News of the World*. The eldest of his three daughters married Sir William Emsley Carr, which consolidated the family wealth and newspaper holdings, and in 1906 the youngest one, Matty Carr, married a forty-three-year-old Irish doctor who was eighteen years her senior. Owen Eugene Gilmore had been born in Dublin of poor parents and brought up a strict Roman Catholic. He insisted she convert and that their three boys and three girls be brought up in the same faith. Maeve Patricia, the youngest, was born on 14 June 1917 in Brixton where her father had his thriving practice; at that time Acre Lane was in the middle of a solidly prosperous neighbourhood.

After pious schooling by nuns at the Convent of the Holy Child in Hastings, Maeve was sent to a finishing school, the Villa Beata in Fribourg, where with forty other girls of all nationalities she was incarcerated for nine months under the close wardenship of Mother

Superior. Apart from virginal ignorance of the world they all had in common the belief that 'a prince was waiting for us. A dark, fervent, beautiful man, brave, full of knowledge, searching for his princess, to shower her with his un-carnal love.'[12] French had to be spoken at all times and lipstick was forbidden, as were showing the body, solitary excursions, or contact with any local male of their own age, all of which served to stoke their adolescent fires. Maeve developed ingenuity and deviousness in smuggling letters to André, a university student, who admired her and even serenaded her under the dormitory window. She evaded her chaperones to meet him in a pink-lit café and one time they danced, Maeve fearful that such closeness might result in a baby. On the only occasion he kissed her, she fainted. Mervyn's boyhood reading had led him to take 'adventure' as his watchword; Maeve's was obviously 'romance'.

She was allowed to attend sculpture classes in the local École des Beaux Arts where the sculptor tutor asked if he might model a head of her, but being left unchaperoned for a moment he sank to his knees and declared 'Je t'aime, je t'aime.' This man with grey in his beard was obviously not the dark prince Maeve was waiting for and, she confessed, she enjoyed inflicting his humiliation. When she came to write of this period much later she realized she deserved the label 'spoiled child of nature' that one of her teachers had given her. 'An all-engulfing romanticism has been my weakness, and I have passed it on to my children,' she wrote, though she regretted that those children would grow up with far fewer privileges than she enjoyed.

Back home she resumed life as her mother's favoured youngest child, dressing then going down to the kitchen and pirouetting before the cook, the parlourmaid, the kitchen maid and the woman who made the girls' dresses and laundered them, before going off to some smart social event. Her only sadness was that 'my parents were alien to each other'. Her father was silent, introverted, and unable to show love either to his wife or offspring, even to his prettiest and youngest who had been born when he was fifty-five. Nevertheless, he was very ambitious for them all, especially the boys – two of the sons became doctors and the other a farmer. The arts did not seem to him a serious occupation so he stopped one daughter, Matty, from becoming a professional dancer, and only very reluctantly allowed Maeve to attend art school, the expectation seeming to be that she would occupy herself harmlessly until a suitably rich Catholic suitor came along. Mervyn Peake did not fit into Dr Gilmore's plans in any respect. It was obvious to Maeve, however, that she had found the dark prince she had always pined for,

even if his attentions were less spiritual and more physical than she had been taught to expect.

The Gilmores' first reaction was to dispatch Maeve abroad in the hope that this teenage crush on her teacher would wither away. Towards the end of 1936 she journeyed reluctantly, with her sister Ruth as chaperone, to Bonn, to continue her art and German lessons. She lived in Burg Hemmerich on the outskirts with Baroness von Nordeck, was taken to Nazi rallies, and even saw Hitler himself. None of this did she take seriously; nor did she realize the growing war fever's implications for herself or the man she loved. He wrote to her every day, letters full of drawings, cartoons, poems and declarations of passion – all unfortunately lost when the Gilmore house in Chelsea Square was bombed in the war. Maeve returned after six months still not cured, and the Gilmores reluctantly had to agree to an engagement in June 1937.

Peake's adoring female students were astonished when he announced that he was to be married – 'and this news was proffered by someone who had been accepted as a kind of lasting Don Juan! It was an equal surprise to hear that the woman chosen was also at the Westminster – but not known to anyone in the Life Class.' Mervyn introduced them. 'Maeve Gilmore, in a linen smock, Roman sandals, and with her light gold hair scraped back into a knot and pinned, and with two inch heavy gold earrings hanging from small earlobes, could be recognised instantly as an artist's archetypal human being, straight out of a Florentine painting!' She stood frozen and tongue-tied under their jealous scrutiny. 'Later, Mervyn was asked if he thought that he would be faithful to Maeve, and he replied: "I can't imagine life without her," which was ardent enough, but didn't exactly answer the question.'[13]

Peake tried to express what he was feeling in the many love poems which he wrote to Maeve over the years: here he suggests the combination of timidity and sensuality which so attracted him:

> You walk unaware
> Of the slender gazelle
> That moves as you move
> And is one with the limbs
> That you have.
>
> You live unaware
> Of the faint, the unearthly
> Echo of hooves

That throughout your white streams
Of clear clay that I love

Are in flight as you turn
As you stand, as you move,
As you sleep, for the slender
Gazelle never rests
In your ivory grove.

[The manuscript has 'grove' but in her book *A World Away*
Maeve prints this last word as the more suggestive 'groove'.]

When Walter de la Mare wanted to include this in his 1943 anthology
Love (Faber & Faber), the couple went together to Penn to meet the old
poet whose work they had both loved since schooldays. He did not dis-
appoint them.[14] A regular correspondence about literary matters
sprang up and more visits were made over the years.

When the two families, Peakes and Gilmores, finally met for the first
time the fathers found they had nothing in common, in spite of both
having graduated in medicine from Edinburgh University. Mrs
Gilmore on the other hand was friendly and even invited Mervyn to go
along with her, Maeve and Ruth on a continental jaunt in her car
during the summer of 1937. This time she travelled light, but on previ-
ous motoring trips abroad her own furniture and piano had followed
in a pantechnicon. They visited Antwerp, Berlin, Dresden, Prague,
Vienna, Budapest and returned via Paris where they saw the Paris exhi-
bition and presumably Picasso's *Guernica*, which was its outstanding
work of art. Mervyn sketched everywhere and clowned for the camera
whilst Maeve saw it all through a romantic haze. Somehow they
managed to ignore the very unromantic preparations for war which
were going on all around them in Europe.

The Gilmores insisted on a lavish Catholic wedding at St James' in
Spanish Place – the church where Maeve's parents had married – so if
there were to be any religious or social concessions the Peake family
would have to make them. The ceremony took place on 1 December
1937 with Gordon Smith as best man, and Mervyn spruced up and
crammed into morning dress. Because term had not finished they spent
the weekend at Dr Peake's new home, Reed Thatch, at Burpham in
Surrey. He had now retired from practice but retained ownership of his
old Wallington house. From idyllic Burpham the newlyweds returned

to 163 Battersea Church Road, another sparse set of rooms Mervyn had found for his bride. Here he wrote for her 'The Dwarf of Battersea', a mock ballad about a dwarf who had dared to ogle her, 'being a true and truftworthy account of hif death at ye hand of ye repulfive artift Master Mervyn Peake when defending ye moft gloriously beautiful and beguiling charmer Maeve in the year of Our Lord 1937'. It begins:

> There lived a dwarf in Battersea
> (O lend me a tanner!)
> There lived a dwarf in Battersea
> Whose hands were white with leprosy
> (Sing you O to me O)
> And the river runs away.

Later he proprietorially warns off all other rivals:

> And so one and all beware who wish
> (O lend me a tanner!)
> So one and all beware who wish
> Within the sacred pool to fish!
> (Sing you O to me O)
> And the river runs away.

Mrs Gilmore thought this place too sordid for her gently reared daughter who as yet knew nothing of cookery, laundry, housework or budgeting, so in December 1937 she found them a more modern flat in Primrose Mansions, overlooking Battersea Park, and furnished it for them: it was not the last time she would have to help them financially. Eric Drake, back from Sark in autumn 1938 but broke and without his wife, moved into Mervyn's old studio until the lease expired. In the new flat the couple kept two rooms empty for studios: Maeve had switched from sculpture to painting whilst in Germany and was showing real talent. They now had to live on Mervyn's salary from his two days per week at the Westminster and whatever commissions he could gather. One of these was from the monthly *London Mercury* to draw fifteen famous people in black and white. He produced competent rather than penetrating likenesses of such notables as W. H. Auden, Walter de la Mare, Ralph Richardson, John Gielgud, Edith Evans, Margot Fonteyn, Elizabeth Bowen, George Barker, Flora Robson, Peggy Ashcroft, Humbert Wolfe and Graham Greene. Most are shown from

the side or three-quarter view rather than full-face and the eyes are usually averted, a characteristic of much of his portraiture. Peake was at his best when portraying people he knew intimately, such as Maeve, Goaty Smith, or later his children, and his formal portraits in pencil or oils sometimes seem dutiful rather than inspired. Of one sitter, the poet Stephen Spender, Peake wrote to tell Goaty Smith:

> Drew Stephen Spender on Thursday. Do you like his stuff? Some of it is really grand. I think I never read it before . . . Most beautiful person I've met. Utterly Byron and Shelley rolled into one. I was thunderstruck. I thought they only existed in novels, these ivory poets.[15]

By the end of 1939 nineteen of Peake's poems had appeared in respectable periodicals, but he seemed to have little interest in and no contact with the other poets who were setting the literary pace, apart from Dylan Thomas. Those in Spender's circle – Isherwood, Auden, Eliot and Day Lewis – were Oxbridge educated and politically minded, which Peake was not, and he found their work too cerebral for his tastes. Privately though, he envied their popularity, as he wrote in 1939:

> Fame is my tawdry goal, and I despise
> My heart for harbouring that crimson yearning
> For well I know that it will bring no burning
> Beauty before the windows of my eyes.
> For I, unknown, am spun with mysteries
> And all the firmament of stars, my awning –
> And yet I have a love of parrot cries
>
> And cry at night for fame, that spangled thing
> And only on grey evenings of clear thought
> I know that there is nothing sold or bought
> That alters with the selling or the buying –
> Yet now when I stand panting, or am trying
> To launch a frigate line of cargoed thought
> The foul red lips of Fame begin to sing.

Poetry brought in shillings at most, but selling pictures through galleries might supplement the Peakes' meagre income. His first one-man show of thirty-three drawings and twenty paintings at the Calmann

Gallery in March 1938 attracted a great deal of admiring attention, though Maeve felt wounded to see intimate drawings of her carried off to be put on strangers' walls. Most of the reviewers claimed they saw in his elegant line drawings a kinship with Beardsley and some detected hints of Flaxman, Klee, Pascin, Cocteau and Harry Clark ('the greatest illustrator of Poe's *Tales of Mystery*'). Above all they claimed that, for better or worse, he had been trying to imitate the line and simplification of Picasso, which may well be true though the subject matter was in no way related. The tonal watercolours of landscapes were more traditional and there was a solid nude of Maeve but, 'there are so many distractions – of the fantastic and the macabre . . . that it is not easy to see what he is worth artistically', noted the *Times*, reviewer on 7 March. Eric Newton, the respected critic of the *Sunday Times*, found the 'essential queerness' of the pen drawings intriguing: 'it is precisely the seeming contradiction between message and method that makes them worth looking at. The method is approximately that of Beardsley – the delicate fine-spun hairline, conscious of its own grace and flow: the message is one of a mad, inconsequent, and often slightly repellent world of fantasy, full of grotesque humour. Grace and grossness are hopelessly mixed up in these drawings' (13 March). Another critic admired the artist's 'talent for inventing shapes which nature decided, in the best interests of the community, to eschew' (*Liverpool Daily Post*, 17 March), and a couple more realized that these weird pirates and monsters would be better trapped between the pages of a book: 'If a book could be written to which these drawings were suitable illustrations it would be a fascinating but an unpleasant book – a decadent Rabelais' (*Manchester Guardian*, 11 March). The book was already in gestation and would soon be born as *Captain Slaughterboard Drops Anchor*.

On the strength of the takings from this exhibition the couple slipped away for a delayed honeymoon on Sark, where Mervyn introduced his young wife to the pagan freedoms he had so recently enjoyed as a bachelor. They stayed with Miss Renouf and her parrot. An undated poem called 'Sark' is perhaps from this time, though it could apply to all their visits:

> Life beat another rhythm on that island
> As old as her own birth
> We were the island people, and the earth
> Sea, sky and love, were Sark, and Sark, the earth
> While round us moved the swarming of the sea.

In late summer they went to Paris, where they ran into Leslie Hurry, Peake's friend at the Royal Academy School, and Mervyn shamed everyone by spilling ink over the bedclothes and curtains of the lodgings whilst sketching the sleeping Hurry. They returned to another home, this time four large rooms at £90 per annum rent in Portsdown Road, Maida Vale, situated above a couple who had their flat furnished entirely in red. Maeve acquired the first two of her many cats and there was a tortoise roaming around the carpet. From there Mervyn wrote to his mother-in-law to thank her for 'the wondrous socks . . . they make me feel very sprightly and spring-like, and I am leaping about most frolicsome-like and giving little whimsical crys [sic] of delight which do not suit my sinister aspect, but which satisfy my feeling. We

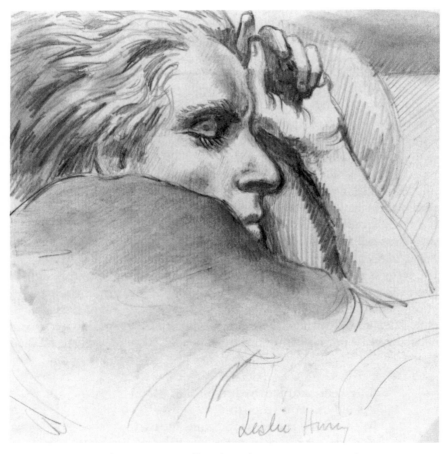

Leslie Hurry, pencil and wash, 17.5×17cm, 1938

have both been painting a lot and Maeve painted a large picture of me'
(undated). Mrs Gilmore kept him in socks for the rest of her life.

For his next exhibition Peake drew upon experiences gained before
marriage when he had made a brief visit to the Rhondda Valley over
Whitsun 1937, perhaps to get away from the Moccus fantasies for a
while and encounter real life amongst the unemployed miners – though
he made no political response to their plight. It is also possible that he
went on Dylan Thomas' recommendation: there was talk of a collabo-
ration on a book about Wales, which came to nothing. As well as
sketching he wrote a poem, 'Rhondda Valley' which ends:

> At every door a ghost; I saw them lean
> With tightened belts and watch the sluggish tide,
> Through the long hours at the riverside.
> Their shoulders prop the lintel-posts at evening
>
> And then, I heard them sing,
> And loose the Celtic bird that has no wing,
> No body, eye, nor feather,
> Only song,
> That indestructible, that golden thing.

When he had a show at the Leicester Galleries in February 1939 the
newspapers reported that he'd stayed in a Welsh doss-house for three-
pence a night in order to get his material. 'I have a highly developed
technique of camouflaging myself,' he told one reporter. Another noted
that on the opening night he wore a bright blue shirt, copper tweeds
and orange velvet tie. Maeve wore simple black but her images domi-
nated the room: he had already done 750 pictures of his wife and aver-
aged at least 10 sketches a week, Peake announced to the press. The
important collector and patron Edward Marsh bought a work and
Mervyn's student, Lady Moray, persuaded Queen Elizabeth to pur-
chase a sketch so that on the first day alone he made £63, with prices
ranging from 4 to 10 guineas. Although the swaggering diversity of his
styles and subject matter in the forty-six drawings on show was noted
by reviewers, several hinted that he would soon have to make up his
mind about just which direction his talents would take.

Maeve had an exhibition of her own at this time in the Wertheim
Gallery. The newspapers made a fuss about husband and wife 'rivals'

and photographed them sitting side by side, drawing each other. They were even interviewed on radio and blued their £6 fee on a meal in the Café Royal. Later, in December 1939, they had a joint showing of works at the Leicester Galleries, where all of the works were the same size and price.

Other mixed exhibitions followed for Mervyn, three of them in 1939, in which he showed works alongside more established graphic artists such as Anthony Gross, Feliks Topolski and Edward Ardizzone ('Satirical Drawings of our Time' in the Delius Giese Gallery, June 1939), and in 'Painters of Fame and Promise' (Leicester Galleries, July) with the senior British painters of the day such as Walter Sickert, Duncan Grant, Graham Sutherland, Paul Nash, Ivon Hitchens and Vanessa Bell. Some of these leading artists were encouraging to Peake, though he was close to none of them, either socially or in his art. He did visit the most controversial sculptor of the day, however. Epstein's seven-foot alabaster figure of Adam had initially received favourable reviews, but then an Australian goldmine tycoon bought it for £750, showed it in a Blackpool fun fair and toured it round sixteen American cities as a monstrosity. Epstein was the favourite target for the philistines: his Oscar Wilde tomb, *Rima*, the figures he carved for the BMA headquarters in the Strand and his *Night and Day* had all been vandalized. Peake's 47-line poem in defence of 'Adam' against 'the bloodless mocker' was published in *Picture Post* on 29 July 1939:

> I have seen this day
> A shape that shall outlive our transient clay
> And hold
> A virile contour when the world
> Renews its crust
> With our decayed and horizontal dust . . .

In gratitude Epstein invited Mervyn and Maeve to his Hyde Park Gardens home for tea. Peake also made contact with Epstein's friend Augustus John, whose work he admired enormously ('I wish I could paint only *one* head as *solid* as any of his!'), and painted his portrait.

As well as producing painting and poetry Peake was continuing to write prose. Some time between 1933 and 1936 Peake wrote a story called *Mr Slaughterboard* about a tyrannically cruel pirate captain and

his misfit crew. This remained unpublished until Maeve included it in *Peake's Progress* in 1978 and it has since become something of an embarrassment to Peake aficionados because of its sadism. Much simplified and illustrated it became Peake's first published book, *Captain Slaughterboard Drops Anchor*, in 1939, so this first version is of considerable interest. It is written in the densely descriptive prose we shall see later in the Titus books and has a leading character equally balanced between murderousness and aestheticism. He and his freakish crew capture a Yellow Creature who is happy to join them on board the *Conger Eel* because he has been lonely on his idyllic tropical island. Instantly the Creature falls into worship of the captain, kowtowing to him like a Chinaman before his Emperor. They sail on for three more years until the ship is impaled on a sharp tooth of rock and has no means of getting off. At this point Peake must have realized he had written himself into a corner and abandoned the manuscript.

As a story it is a failure, but a few aspects deserve comment, especially the outrageous Dickensian names (Tipsy McQuorquandhole, Bloodseye, Whineaway, Mr Croozle Zenith) and the consistently grotesque characterization of the hideous crew. This derives directly from Peake's boyhood reading, especially an eyeless character, Smear, who has aspects of Blind Pew. Later Peake would create another sinister blind being, the Lamb, in *Boy in Darkness*. It may be that, to a visual artist, those without sight, like so many of his father's Chinese patients, represent something to be dreaded. The pirate crew are deformed in various ways, especially the captain who has feet and one hand like an elephant, perhaps from leprosy – a human–animal body which also prefigures Hyena and Goat in *Boy in Darkness*. To modern eyes Sambo the 'nigger' is offensive, as are the easy laughs at the expense of the young gay couple Lamb and Flagg, with their 'rather cultivated voices', Russian cigarettes, dyed hair and habit when afraid of 'clinging together, cheek by jowl'. And what are we to make of the captain's secret sexual terrors?

> Mr Slaughterboard had never been on land in his life, and he had no intention of going. The idea frightened him. He had once seen a picture of a woman too. That also frightened him. The land and women seemed somehow to bring to him the same feeling of dismay.[16]

He prefers to stay with his all-male crew and to kill them for his aesthetic pleasure.

In later works such as *Mr Pye* and *The Wit to Woo* Peake creates an artist figure which gives him scope for satirical comment on things artistic. In this work the Captain turns 'his eyes as tender as a girl's' towards the sunset over the ocean and decides he must drown two crew members in 'the tremendous bosom of the sea' to complete the artistic experience. Slaughterboard's own mother had been buried at sea, which might help explain this human sacrifice. After their deaths he retires to read the classics in his wonderful library (inherited from his father, an Oxford classicist) and to have Smear recite Shakespeare to him. Later, after visiting Belsen, Peake might have reflected on how accurate his insight had been – the humanities had done nothing to humanize the officer class who ran the extermination camps; in such officers an appreciation of art, poetry, literature and music could coexist with extreme sadism, as they do in Mr Slaughterboard.

After the 'artistic' killings Smear and Mr Slaughterboard muse on the process of literary creation with its 'unremitting toil' and on how the writer 'sows the fields' but the readers 'glean the harvest'. Slaughterboard puts it more forcefully:

> 'It is a matter of enjoyable brain sucking,' he said at last. 'Enjoyable brain sucking. And yet if no one sucked the brains it would be sad for the writers. If everyone created, who would respond? Who would buy? The intellectuals are dependent on the intelligentsia. But the intelligentsia are not materially dependent upon the intellectuals. We would live, I suppose Mr Smear, if my library were burned out. Or rather we should still exist, yet if we and all book lovers lost their interest in books, where would the writers be?'
>
> 'In an asylum I should imagine Mr Slaughterboard, for writing is the only thing that keeps them sane. Just imagine the condition of their interiors had they not this safety valve.'
>
> 'Positively rotten,' agreed the Captain, 'positively rotten.'[17]

It is chilling to think that Peake *did* end in an asylum, partly because his writing, particularly his drama, could not find an audience.

This nightmare story was eventually transmogrified into a more benign picture book, *Captain Slaughterboard Drops Anchor*, with a vestigial plot but full-page illustrations and it is tempting to attribute this optimistic change to the presence of Maeve in his life. The ship is now the *Black Tiger*, while Captain Slaughterboard is ugly rather than monstrous and his violence is confined to his language. His crew is reduced to five, some of them bearing character traits carried over from the

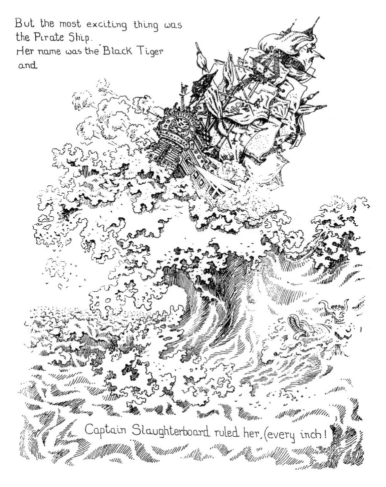

But the most exciting thing was the Pirate Ship.
Her name was the Black Tiger and

Captain Slaughterboard ruled her, (every inch!)

Captain Slaughterboard Drops Anchor (1945 edition). The *Black Tiger*, pen and ink, 25×19cm

Conger Eel's sailors: they include a tattooed man, Charlie Choke, who has Maeve's name and portrait on his left biceps and Goaty Smith's and 'Doc' Peake's faces on his back, and Timothy Twitch who sports a flowery headband and a limp wrist. They spy a Yellow Creature on a pink island, as before, this one with large liquid eyes, floppy ears and the body of an adolescent boy or breastless girl, though curls cover the whole of its lower stomach and no genitals are suggested. After its willing capture the Captain admires it inordinately (the reverse of the

previous version) and soon, because of adventures and battles which go undescribed, there are only the Creature and the Captain left alive. They return to the pink island and settle to a life of idle domesticity with the Creature doing the cooking and both of them fishing in the sea.

The pen and ink illustrations are full of tiny details (hunt the sticking plasters) and art jokes such as the mock-Hokusai wave on the second page; the Heath Robinson mast on page 4; the muscular baroque caryatids on the wheelhouse and the double spread of a jungle which is a cross between Douanier Rousseau and Max Ernst. The hybrid creatures Peake so enjoyed naming and drawing for the Moccus book are there in plenty (Balleroon, Dignipomp, Mousterashe, Hunchabil), but all are friendly, dim and boneless. The text is handwritten in a careful schoolboy hand with Peake's punctuation errors (dont, should'nt) going uncorrected.

The book provoked several hostile comment from reviewers when it appeared in December 1939: 'the illustrations to this, though brilliant, are quite unsuitable for sensitive children' (*Punch*); 'some really frightful pirates and a number of unspeakably odd and revolting creatures' (*Glasgow Herald*); and 'there is a nameless nightmare quality about the portraits of the pirates (half embryonic half turniplike) and in my opinion any child to whom it is given is doomed to weeks of bad dreams if not a course of psycho-analysis in later life' (*New Statesman*). Maeve was always angry at such criticism. As she told John Watney, a future biographer, 'We were in a train and we saw a bad review of *Captain Slaughterboard*. Mervyn didn't mind. He just laughed and made fun of it. But I *hated* the reviewer. I could have *killed* him.'[18]

Neither of them knew anything about children at this time and Mervyn was probably writing for the pirate-obsessed boy he was back in the Tientsin compound. The modern ten-year-old children I showed the book to in my local school were not impressed by the story, pirates being outside their interests, though they discussed at some length whether the Yellow Creature was meant to be male or female. It was evident to these children that some kind of love relationship is implied between the tough sea-dog and the androgynous Yellow Creature. They settle down to domestic bliss with the Creature wearing a short skirt and doing the cooking, then nestling in the crook of the Captain's arm and giving the reader a knowing look with those big Maeve-like eyes whilst nibbling a suggestively phallic banana.

They are still on the island. The Captain would never dream of leaving and can't understand how he used to enjoy Killing people so much. The Yellow Creature does the cooking and can make the most exciting things to eat out of practically nothing

Captain Slaughterboard Drops Anchor (1945 edition). The Yellow Creature, pen and ink, 25 × 19cm

One critic with a psychological viewpoint found penises everywhere in the illustrations: they are concealed, flaccid or erect, in striding legs, cannons, rock columns, pistols, swords, telescopes, candles, bottles, pipes and some of the crew's elongated noses.[19] This visual pun on the nose as penis has a long history in art and caricature, including works by Goya, one of Peake's favourite artists. The profile view of a head is a constant feature of Peake's graphic work and many of his comic figures rely on the oddity of their probosces for effect. The analysis also claims, extravagantly perhaps, that Peter Poop's stuck-on nose made of cork could be a reference to the ravages of syphilis and that the whale lying at his feet in the ship's galley has a brutally severed tail, which

'hints at displaced sexual anxiety if not downright fear of castration'. These features do not strike one on first reading, but the more one looks, the more one finds.

After the coarse male companions of his past are swept away the Captain is left, tamed and disarmed, with the object of his love – rather like Mervyn and Maeve on Sark. The once fierce captain becomes passive and nurturing as he is led around the island, though where the Yellow Creature is shown cooking he reverts to a male stereotype and looks on smugly. The critic's verdict, after pointing out the effeminately balletic poses of many of the characters and how this conflicts with the parading of masculine phalluses, concludes that 'underlying the camp jokes is a fear of the feminine', and it is then we recall the first Mr Slaughterboard's fright at the mere picture of a woman. In spite of the use of the pronoun 'he' in the text it remains unresolved whether the Yellow Creature is really a man, woman or child, as my schoolchildren spotted. To what extent this sexual punning was a knowing continuation of the schoolboy ribaldry that Peake enjoyed with Goaty Smith, and how much emerged uncensored from his subconscious remains an open question. Peake always denied any interest in psychoanalysis and Maeve loathed sexual interpretation of her husband's work.

The seemingly Edenic finale also leaves some questions unanswered. If Slaughterboard no longer enjoys killing but the pair have now 'both become very good with bows and arrows' what are they shooting? Do they eat the 'strange glittering fishes' they spend their days catching? But these are quibbles over an ending which is as near to romantically happy as Peake was ever to offer his readers, and we might see the fish as those he was to refer to in another context a decade later: 'As I see it, life is an effort to grip before they slip through one's fingers and slide into oblivion, the startling, the ghastly or the blindingly exquisite fish of the imagination, before they whip away on the endless current and are lost for ever in oblivion's black ocean.'[20]

Around this time Peake drafted a fragment entitled 'The House of Darkstones' which is little more than notes but it contains a character called Lord Groan on a desert island. It was obviously never going to be a realistic novel – his companion Mr Stewflower is an entomologist obsessed by the Rong beetle to the extent that he has come to resemble it and the two men converse by leaning against each other, back to back. It is evident that Peake had an image of Groan in his mind and he wanted to see where it would take him.[21]

W. H. Auden sat in New York on 1 September 1939 and watched 'the clever hopes expire / Of a low dishonest decade', but Peake had enjoyed

Mervyn's mother Elizabeth, pencil, 23.5×17.5cm, late 1930s

the 1930s and the future looked good to him: he was selling pictures, a book was about to be published and he was making contacts with poets and painters he admired. Then his world began to fall apart. At the end of summer he and Maeve borrowed Mrs Gilmore's car for a trip to see *As You Like It* at Stratford and then moved on to visit Goaty's parents at Chipping Campden, only to be woken by the town crier declaring that England was now at war with Germany. They returned to Maida Vale to find that Westminster College was to be evacuated to the country, so there would be no more work for Mervyn. At the start of October they were summoned to Reed Thatch because his mother, Elizabeth, had had a stroke and was dying. He wrote to Goaty: 'In a way we are all hoping that she will pass away now and not have to go on suffering, when there is no hope. She is frightfully brave and tries to smile when she can, but is fortunately unconscious a lot of the time.'[22] By her bed he drew her with tears in his eyes, perhaps hoping his art might preserve what little life remained to her. As her life slipped away, another one was coming into being: that of the couple's first child.

6 Soldier, 1940–1942

Peake was never a politically minded man but he was a patriot and wished to contribute to the war effort. However, before his call-up papers arrived the only voluntary war work he could find was to issue and fit gas masks, snouty encumbrances which must have appealed to his sense of the grotesque. More informally, that Christmas of 1939 the couple bought as many packets of cigarettes as they could afford: Mervyn then distributed them to the homeless sleeping underneath the arches of Charing Cross station. Maeve wrote, 'About midnight on Christmas morning he returned, empty of cigarettes, but with a young Welsh coal-miner whom he had found in the Arches.'[1] The miner stayed for several days, sang for them, then went off wearing one of Mervyn's suits and never returned. 'It is easy to be cynical,' Maeve commented.

A few days later they packed up the Maida Vale flat and left for Burpham and from there Maeve moved into Littlehampton Hospital where she gave birth to their first child, Sebastian, on 7 January 1940. Dr Peake was present, but not Mervyn who was squeamish and inclined to faint when real, as opposed to fictional, physical events occurred. Mrs Gilmore had set them up with most things the baby would need and sent more knitted socks for Mervyn. They moved into a small damp house in Warningcamp, only a mile from Dr Peake at Reed Thatch, and waited for the inevitable call-up papers to arrive for

Mervyn. The house was reputedly inhabited by ghosts and Maeve thought, 'I always feel that one might jump out at me at any moment', but it never did. Mervyn's time was spent drawing and photographing his new son, and writing. The summons arrived at last, instructing Mervyn, now aged twenty-nine, to report to the Royal Artillery depot at Dartford on 29 July. His career as a painter was now in abeyance. 'To be separated after never having been separated is like losing a limb,' Maeve lamented as she settled into their isolated cottage with a fretful baby and only Mervyn's parting gift, a bicycle, to enable her to reach the shops in Arundel. His poem, 'Troop Train', expresses what so many must have felt:

> The wheels turn over
> And you are gone
> O my little lover
> My only one
>
> Beneath my ribs are the spaces
> Of the plaides,*
> And a blind ocean presses
> Behind the eyes.

> * Pleiades

After shedding his school uniform Peake had expressed his singularity by a decade of flamboyant dressing with his lurid ties, vivid socks, earring and flowing hair, but now he was back to doing as he was told. On his first parade he was ordered by the sergeant to get his hair cut: 'you look like a bloody poet,' he said, to which Peake replied, 'That is exactly what I am' – an answer which would not make his barrack life any easier. Later, when Maeve saw what the barber and quartermaster had reduced him to, she wanted to cry. His army records show that he was 5 feet $10^{7}/_{8}$, inches tall and weighed 143 pounds; his eyes were blue, hair dark brown and his religion was given as Church of England, the army not recognizing subtler distinctions such as his childhood Congregationalism or his present agnosticism. Unlike most public schools Eltham College never had an Officer Training Corps and Peake had acquired no warlike skills. His agility on the rugby field and manual dexterity with a brush did not transfer to drill, handling rifles and reading maps and it was soon clear that he was a disaster as a soldier. The poem 'Fort Darland' shows his feelings:

The Haircut, ink wash, size unknown, *c.*1940–41

Are there still men who move with silent feet?
And droop their thoughtful heads to earth, their hands
Listless along their sides? And are there lands
Where men are quiet in the way they meet?

The limbs my mother bore me know the wrench
That shapes them to the square machine of war.
My feet smash gravel and my hands abhor
The butt-plate of the rifle that I clench.

If my head droops, or my hands are not forced
Into my sides at the exact parade
Upon the asphalt square where men are made
I am insulting England and am cursed.

As I stand motionless today and study
The red neck of the Khaki man I cover
I shall not move but shall defy my body
By dreaming of pale gods that laze in ether.[2]

Nevertheless he stuck it out and after the briefest of training emerged as Gunner Peake 1597577 (a number he used in *Gormenghast* for a boring edict), waving cheerily to his commanding officer on the passing out parade instead of saluting as all the others did.

During these difficult times he kept his spirits up by continuously sketching his fellow recruits, and by starting to draft a novel which would eventually appear as *Titus Groan*, though when he began he had no plans to publish it. 'A mixture of serious as well as nonsensical fantasy began to pour itself out, without object, sentences growing out of their precursors involuntarily.'[3] If the world he inhabited was like a prison then why not escape into a more exciting one where he could make his own rules? It was one way to keep sane.

As Peake completed each section of the story he sent it home to Maeve who had now moved to three rooms on the top floor of School House in the same hamlet of Warningcamp. It was owned by a former cook of Mrs Gilmore's who had retired there and was glad of the company.

Peake tried to offer his artistic talents to the Ministry of Information for propaganda purposes, submitting a series of about twenty-five drawings he did in 1940 purporting to be by that frustrated artist, Adolf

Hitler. The idea was that stock titles would be given a sickening twist as they passed through the insane mind of the Führer – so 'Reclining Figure' shows an executed man, 'Landscape with Figure' has the head of a terrified girl against the background of her burning village, 'Seascape' shows a drowned sailor, 'Mother and Child' depicts a mourning woman with a dead baby in her arms, in 'Dutch Interior' a raped girl lies across a bed, whilst 'Self-portrait' showed the insane face of the dictator himself. They are reminiscent of Goya's *Disasters of War* and his famous etching *The Sleep of Reason Breeds Monsters* would make a suitable title for Peake's work in this series. One wonders about the kind of mind that could conjure up such images in sufficient detail to draw them realistically at a time when the horrors of Nazi occupation were not yet fully known. At first the Ministry was enthusiastic, paid him £150 and planned extensive distribution in South America of all places, but then they cooled off and shelved the project. Peake had photographs taken of the drawings and in February 1941 sent them to Chatto and Windus, who liked them too, but also declined to publish them. He sent copies to Augustus John who replied on 28 July 1942: 'I hope you will find it possible to carry out your project of a series of drawings such as the two you have sent me. So far one has seen little but the comic side of warfare treated by alleged draughtsmen. You, like Goya, are interested rather in the serious side.'

Another source of alternate hope and frustration was his application to be a war artist. At the end of 1939 Augustus John, one of the Grand Old Men of English art and a war artist in the First World War, had written a reference: 'I wish to recommend Mr Mervyn Peake as a draughtsman of great distinction, who might be most suitably employed in War Records.' If this was sent (the original is still in the family's possession), then it was ignored. However, Kenneth Clark, the chairman of the War Artists' Advisory Committee and the most influential man in the British art world, had bought 18 guineas' worth of drawings directly from Peake just before the war began and this was surely a hopeful sign. But nothing came of that connection either, nor the fact that Walter Russell from the Royal Academy School was on the committee.

On 17 January 1940 the WAAC drew up a preliminary list of 123 artists, 51 of whom were given an A grade. Peake was placed on the reserve B list for possible 'drawings'. After hearing nothing for some months, on 22 June Peake suggested he draw German prisoners of war – 'the studies of their heads might well be fascinating historical data, quite apart from the work artistically' – and he was even willing for them

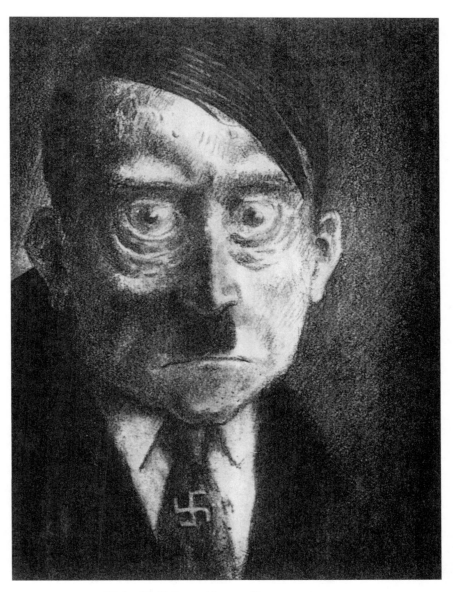

Hitler 'Self-Portrait', pencil, 25×17cm, 1943

not to be seen until after the war. This was blocked. His pleas to O'Rourke Dickey, the committee secretary, became increasingly desperate: on 17 April 1941 he wrote: 'The army itself would be glad to get rid of me for being un-mechanical. I do not fit into their scheme of things at all and they try and find fatuous jobs for me which are quite superfluous.' His suggestion, on 15 April 1942, that he return to the mines of the Rhondda ('as thrilling a subject as I can imagine') came to nothing, probably because Henry Moore was already recording coal workings. He continued to pester Kenneth Clark, the Ministry of Information and the WAAC by phone, letter and visits but it was to be January 1943 before he was offered the peculiar subject of glassblowing.[4]

The air raids on London had now begun and one of the Luftwaffe's approach routes was up the Thames. During a bombing raid the warehouse containing the remaining stocks of *Captain Slaughterboard Drops Anchor* caught fire and all copies not already sent out were destroyed; because paper was in short supply it could not be reprinted until the war was over. Some time in August Gunner Peake was sent to the Isle of Sheppey to help the 12th Light Anti-Aircraft Regiment man a battery. The commander had been told that in the event of an invasion he was to blow up the bridge to the shore and fight to the last soldier; meanwhile they must man the guns and sleep by them.

We have a colourful account by a fellow gunner of Peake's three months there, though it should be read with some scepticism since other squad members tell differing stories: 'It was reported that out of all the men with whom he had shared the short journey from their Training Depot, Gunner Peake was the only man to succeed in losing almost all the personal equipment for which he had signed but a few hours previously.' He was soon removed from the gun team because he had an 'incurable habit of dropping the 60lb fixed ammunition' which unnerved his crew, who soon found his gun aiming equally terrifying. His appearance was incurably sloppy, he could not be trusted on guard duty and he was permanently on punishment fatigues. Eventually he was made a cookhouse orderly and placed alone in a corrugated iron lean-to by the kitchens, 'and there he lived peacefully for the remainder of his short stay'. This experience no doubt coloured his depiction of Swelter's kitchen in Gormenghast. Inside his lean-to he made hundreds of drawings: 'They were brilliant caricatures of many of us, galleons in full sail and discerning sketches of the bombed and devastated landscape in which we existed. There were also some that were

frankly disturbing, grotesque and monstrous figures from depths of imagination we simply could not contemplate.'

One day in October 1940 they were being inspected by a fiery brigadier commander when, 'Staggering and bowed low under a great load of blankets (skeleton gun crews slept in the emplacements; these blankets were the relief crew's bedding) there advanced Gunner Peake. What we could see of him suggested he was clad in his habitual grease-darkened fatigues. For purposes unknown he carried an alarm clock. There was a collective shudder as he was recognised, and trepidation as the Brigadier's complexion darkened to match his hair. In utter silence the dreaded figure drew nearer, passing slowly between Command Post and guns. Abruptly, with ear-piercing clamour, Gunner Peake's alarm went off.'

Peake then ambled off into a gun emplacement, but 'Enemy aircraft were now within range and our guns engaged them. The first salvo brought Gunner Peake from his emplacement like a rocketing pheasant. Blanketless now, head back and thin arms pumping he shot past us and our apoplectic Brigade Commander back whence he came.'[5]

Within days he was on his way to Blackpool where he could do no more harm. Even if this account is highly embellished, the writer's conclusion that 'Quite obviously Peake was not gregarious and in a crowd he was unable to function', seems a valid one. He also suspected that Peake knew full well what he was doing and was not so helpless as he seemed. John Watney's version of this transfer is less colourful: an officer asked which of the gunners could drive and Mervyn's was the only hand raised.[6] He was sent north on 11 October as a driving instructor for heavy vehicles to 228 Anti-Aircraft Training Regiment.

The army's ideal gunner would fall in love with his gun but Peake resented the enforced shift from free artist to slave of the machine, from creator of beauty to destroyer of it. His poem 'Had Each a Voice What Would his Fingers Cry?' proclaims that there is still a feeling man beneath the khaki:

> His fingers that were trained to bind
> The shadows of his mind
> To paper with slim lead
> Grasp grimmer substance than a pencil's measure.
>
> Not cedar but the trigger's steel
> Is what they feel,
> And in a longer barrel
> Lead of as fleet an impulse waits the pressure.

His fingers are, of course, dumb, but like those fingers in Dylan Thomas' remarkably similar poem, 'The Hand that Signed the Paper' they have the power of life and death, though it is not a power they relish:

> Had each a voice what would his fingers cry
> But 'Treachery!'?
> until their shrill pipes echoing up the arms
> Should find and force the tyrant brain to hearken.

Peake was no more credible as a driving instructor than he had been as a gunner since he had no licence, having learned to drive before they were introduced in 1933, and absolutely no knowledge of engines. He was quickly shifted on to painting notices for the barracks, such as THIS LAVATORY IS FOR THE USE OF OFFICERS ONLY, and soon after was promoted to Lance-Bombardier.

Wives were allowed to join the men in Blackpool so Maeve and the howling Sebastian made the long train journey. For a month all three lived in one tiny filthy room in Coronation Street, before moving to two rooms in Bloomfield Road where RAF men were also billeted and they were all cosseted by the two spinster owners. Since his duties were minimal Peake was able to press on with the novel, now provisionally called 'Goremenghast' to hint at its bloody and ghastly contents. Even though Maeve was with him again, he wrote to Goaty: 'Lancashire stinks, and Blackpool, I imagine, is Lancashire's finest example of a cess-pit.' Only the lion in the zoo thrilled him. 'Oh God, I'm sick, sick, sick of it – the perpetual littleness of the life.' He complained bitterly about the dullness of his comrades, the bullshitting and the stupidity of the army in not being able to find a use for his talents in England's hour of need: 'if they put the wrong people in the wrong jobs at the bum-end of the army they probably do the same at the scalp end'.[7] Goaty, who had somehow escaped military service and was teaching in Devon and sharing the odd Home Guard duties with the Bishop of Truro, was a useful confidant for Peake's woes. He was also the only one who could return the scatological banter of the Eltham days, understand the Moccus jokes and put up with being addressed as 'Navel, my old cock! Do you still seeth with mobile leprosy? Do you still enjoy scratching at your silt-sluiced belly?'

In early 1940 Peake had received his first illustration commission from Chatto and Windus: a book of English nursery rhymes to be decorated

for an advance of £15, the same again on delivery and £10 for every 1,000 copies sold beyond the first 3,000. Now in December 1940 while they were in Blackpool it finally appeared. Maeve always thought this *Ride a Cock-Horse* 'the most beautifully produced of the books that Mervyn illustrated'. 'For Sebastian' is the dedication and the frontispiece is a cross-hatched pen portrait of Maeve holding their son in her arms – an intimate start to one of his most idiosyncratic books. The basic drawings are in often densely worked pen line, but bright flat ink colours have been stencilled on to selected details. The rhymes are the traditional 'Rub-a-Dub-Dub', 'Old King Cole', 'Doctor Foster' and so on, but to some Peake has added a macabre *frisson*. In 'How Many Miles to Babylon?' a giant archaic figure looms out of the darkness over the child in bed and Little Jack Horner crouches in the corner of an unfurnished room lit only by a candle. The pink wallpaper is lit fitfully to reveal fishes, birds and flowers, but it is still an isolated and lonely boy cowering there in the wartime blackout. In 'I Saw a Peacock' we have a hint of the East: here an old man squats on top of a needle of rock high above distant mountains and his beard dangles off the bottom of the page. As with *Captain Slaughterboard*, there is more appeal to the frogs and snails and puppy-dogs' tails side of children than to the sugar and spice and all things nice, and the publishers must have wondered if the parents would tolerate such unsentimental stuff. In spite of all the other demands on people's time and attention it received considerable press notice, though not all of it favourable.

The *Times Literary Supplement* reviewer (17 December 1940) liked the way Peake didn't 'draw down' to his intended child audience and claimed that 'nearly all his inspiration is from the last century. The Pretty Maid and her questioner have a satiric air of Thackeray; Jack Sprat and his wife come out of an older and coarser London; and the fine lady on her way to Banbury Cross may be finer, more elegant, less copiously begemmed, but she is still the equestrienne from *Astleys*.' Actually she was Maeve. The *Spectator*'s critic rightly detected a sense of the grotesque and mysterious and thought the illustrator's imagination akin to Walter de la Mare's, 'only more robust'. The drawings 'are pictorial parallels to the dream poetry of *Peacock Pie*. But the strange obscene Goya heads of the three men in a tub, the leer – like that of a comic Mr Rochester – of the questioner in "Where are you going to my pretty maid?" belong to deeper imaginative levels.' And the *Listener* thought those levels should have been left unprobed by Peake's 'astonishing and repellent treatment of our most innocent nursery rhymes . . . the persons he depicts all need psycho-analysing'. The *Librarian* confessed to shock

Ride a Cock-Horse and Other Nursery Rhymes (1940). 'Little Jack Horner',
22 × 15cm

and found the colours bizarre whilst *Nursery World* (4 December 1940) condemned the illustrations as 'nightmarish'; even if they had 'a certain sort of horrible beauty' they ought never to find their way to within a mile of a child.

Even when *Ride a Cock-Horse* was revived in 1972, after Peake's death, the few who noticed it felt obliged to warn: 'A haunting book; best perhaps for children to look at in reassuring daylight rather than on the dim bedtime frontiers of sleep' (*Smith's Trade News*, August 1972) or, 'The book is ostensibly for children but I suspect this will become a collector's piece for the adult enthusiast of the borderline between fantasy and nightmare' (*Islington Gazette*, December 1972). This suspicion proved correct.

The reviews would not boost Peake's finances or morale, but he must have gained some comfort from one letter from a man he had long admired: Walter de la Mare. Peake had written to the older poet on 3 May 1941 and in return received condolences on his Blackpool posting and an invitation to send 'the novel' for reading. On 26 May de la Mare wrote again to say he'd successfully recommended Mervyn's poetry to Chatto and Windus and 'That's my good deed that should suffice for the next twenty five years.' Furthermore,

> I have been engrossed by the Nursery Rhyme pictures again and again, and was sharing them with some friends yesterday. Fantasy, and the grotesque, indeed; a rare layer of the imagination, and a touch now and then, and more than a touch, of the genuinely sinister. [*Handwritten in margin*: Babylon and the baby and mother – so different from what is so good in its own kind as Jack Horner – are touching and profound indeed] But, as I think, not a trace of the morbid – that very convenient word. How many nurseries you may have appalled is another matter. How many scandalised parents may have written to you, possibly enclosing doctors' and neurologists' bills, you will probably not disclose. Anyhow most other illustrated books for children look just silly by comparison.

He ends by hoping Peake will do a drawing to accompany some of his own verses, and agreeing that illustration is not about 'mere reproduction of scene'.[8]

By May Maeve had returned to Sussex with Sebastian. Mrs Gilmore had been bombed out of her Chelsea Square house and she and daughter

Ruth had moved out to live with Maeve's other sister at Stratford on Avon. Mervyn, for whom possessions meant very little, wrote to his publisher of the 'direct hit obliterating everything, in fact as it were the old ladies [*sic*] entire life, for possessions *were* her life however wrongly'. He continued to work on his poems and the novel and wrote to Chatto and Windus to keep them up to date with all the news in his idiosyncratic style and spelling: 'I have become acquainted with a matron – (I mean, by *proffession*, not by natural causes) and she works in a vast home for the blind and has a vast room with a vast table in it. She is the most extraordinary matron (proffessional) that I have ever seen and though treading the brink of fifty seems to cartwheel her way through life like a filly, readjusting a vast white toga of office as she does so.'[9] This Miss Allsop kindly allowed him to 'smack at' her typewriter on her vast table – he was now about two-thirds of the way through the work, or roughly 130,000 words, and thinking of calling it after the hero, *Titus Groan*.

However, it was too good to last and after about eleven months of near normal family life and peaceful creativity the army once more found a round hole for square peg Peake – they would make him a bomb-disposal expert. Accordingly on 6 June 1941 he was transferred to the Royal Engineers, Duke of York's Headquarters on the King's Road in Chelsea. Again he found a way to make himself a liability and was able to spend time outside the barracks with his wife and child, first in a rented room and then in a proper, though unfurnished, studio in Manresa Road which he would retain for the next fifteen years. He could also resume contact with the writers and artists he was just getting to know before the war, Dylan Thomas and Graham Greene being the most significant.

This relatively comfortable period lasted about six months. In the barracks Peake was in the habit of lying on his bed to write and smoke and one day, having broken off and left the room, he returned to find the floor round his bed had been burned through to the joists. He was put on a charge of having wilfully damaged the army's floorboards but escaped with a verdict of negligence. He pleaded that it was possible, but not probable, that his cigarette stub had started the fire when he threw it in a wastepaper basket. Obviously he was too dangerous to have around even though he had been kept away from any actual bomb-disposal duties.

Since he had qualified as an army Draughtsman Grade III some time during this period (there are gaps in the official records) he was sent to the 'School of Survey' on Salisbury plain for a theodolite course, though he did not know what a theodolite was. There he had

a commanding officer who knocked the dottle out of his pipe by banging it on his wooden hand while listening to Peake's explanation that he could only see numbers as female (0,6,9) or masculine (7,1). He was told just to keep out of everybody's way and get on with his writing. In January 1942 he wrote from Salisbury Plain to tell Maeve how much he loved her:

> If when I married you I was in love
> As I imagined at that time I was
> Then what is this new illness? and the cause
> Of my heart crying from its midnight grove
> Of ribs, for, trapped like an alizarine bird
> In the heaving cradle of the bended boughs
> It shakes anew its violent wings and grows
> Maddened the moment that your voice is heard
>
> Either it was not love I felt before
> Or else love grows like fever. I hope it is
> That I was NOT in love, for even this
> May then grow wilder, though any more
>
> Of love seems unimaginable: ah Maeve
> I do not wish more glory than I have
> Can you not quieten this climbing wave?

He must have had infrequent trips home, as his poem 'Leave Train' shows:

> To your loveliness I travel
> Through a bronze and yellow land
> England burns away November –
> Every bough is a lit marvel
> Pointing with a sentient hand
> To where you stand –
> Loveliest ember of the autumn amber.

One consolation for Peake's sense of uselessness as a soldier was to have a sudden popular success on his hands. *The Hunting of the Snark: An Agony in Eight Fits* by Lewis Carroll, with Peake's illustrations, was published by Chatto and Windus as a Christmas stocking-filler in December 1941 at a cost of one shilling, and in a very small format because of paper shortages. It was reprinted before the year was out

The Hunting of the Snark (1941). The Bandersnatch, 18×11cm

and again in 1942, '48, '53, '58, '64, '69, '73 and 1975. Nobody bothered to review such an old favourite but it became an instant bestseller. Peake had found a vision as convoluted and bizarre as his own and he responded well. There is a spurious chase after the Snark by assorted professionals whose names begin with B, as well as by a Beaver who set out

> To seek it with thimbles, to seek it with care;
> To pursue it with forks and hope;
> To threaten its life with a railway-share;
> To charm it with smiles and soap!

Peake's zestful illustrations in pen and ink need more space than the seven by four inch pages afford but they are in the absurdist spirit of the poem. The Bellman's lanky limbs are too long for his clothes and he has a profile like a hatchet; the Beaver is a disgruntled looking creature; the Butcher is obviously dim and is afflicted with large top lip

and quiff, while the Bandersnatch attacks the plump be-spatted, top hatted Banker frumiously. Peake's special rocks, toppling piles of stone unknown to geology, appear several times. This was to remain the standard modern version until Ralph Steadman's lavishly produced but nightmarish etchings appeared in 1975.[10] Peake's Snark drawings, together with those for *Ride a Cock-Horse* and some 'gruesomely realistic new-born babies' (*Tatler*) – presumably sketches of Sebastian – were exhibited in the Leicester Galleries during December 1941 and Peake was given leave to attend the opening and book launch.

Better still, in the same month of December a volume of his own poems came out, several of them having appeared previously in the *Listener*, the *London Mercury* and the *New English Weekly*. Walter de la Mare's advocacy of his young friend's verse to Chatto and Windus paid off and they published twenty-four poems as *Shapes and Sounds*, offering him £10 advance and charging 4s. 6d. per copy. He had suggested that he illustrate his own poems: 'There are poets (no new thing) & artists (still less rare) but the combination *is* rare – in fact there've only been about 3 English ones. Blake, Morris, Rossetti – and I'm mentioning this not in an attempt to squat on heavens throne, Blake on my right hand & Rossetti on my left & Morris twitching between my feet, but because it strikes me that there would be a freshness and a "difference" in such a book.'[11] In the end he provided only a cover which showed he might have been looking at Surrealism, the art movement which yoked together unrelated things in unexpected places. An object, which combines an eye and ear (shapes and sounds) with a sea shell, lies on a step which leads to darkly receding stage flats down which a gowned figure retreats. Perhaps he had seen de Chirico's haunted spaces or the anglicized Surrealism of Nash and Sutherland. The poetry too played with surprising juxtapositions of words and images, weaving fantastic tapestries of words from the drab shared experiences of war.

The book opens with a poem to Maeve ('You walk unaware') but then moves towards more public topics: the bombed city, disaffected youth, the unemployed, the office girl seeking glamour, the sufferings of Europe, and then back into introspective musings on the poet's fear of death, his feelings of separation from others, his *doppelgänger* ('I am forever with Me'), the limitations of his art and the turmoil of his feelings. They are war poems but deal with none of the big issues such as patriotism, heroism or protest – 'I have my battleground no less than nations,' he declares,

> I am ill at ease
> With propaganda glory, and the lies
> Of statesmen and the lords of slippery trades.

The word 'I' recurs constantly as he seeks to survive as an individual in hostile circumstances. The language is highly wrought, spiced with adjectives and fanciful conceits and extended metaphors, many of them drawn from the body – limbs, breasts, bones, muscles, veins, fingers. His reliance on the thesaurus and never saying a simple thing simply means that sometimes the feelings leak away and occasionally he seems to be playing the Surrealists' game of The Exquisite Corpse in which words are inserted at random into an empty but grammatical sentence structure:

> Blood beckons to my hand;
> I am
> Split tree-wise inly from the zestless morning
> To when the fatuous moon pursues
> The daft
> And obsolete ram.

> ('They Move with Me, My War Thoughts')

Most of the poems are in a loose free verse, but at other times he uses quatrains and there is one sonnet.

The reviewers were already aware of Peake as an artist and perhaps came with preconceptions of what an artist's poetry would be like: 'But though the focus and penetration of the artist's eye is often felt in his poetry, the pictorial seldom obtrudes. As a poet he is equally sensitive to sounds,' the *Times Literary Supplement* critic found on 27 December 1941. Another thought that '*Shapes and Sounds* contains some immensely pictorial verse and a great deal of flower imagery. The effect is extremely decorative; but the actual experience around which the imagery is draped strikes me as being somewhat commonplace' (*New Statesman*, January 1942). One mention Peake must have valued was by Stephen Spender in a *Horizon* review of poetry in 1941: 'Mervyn Peake is a poet who impresses me by his sincerity. His writing is technically weak, but there is a genuine feeling for life, and also a genuine personality behind it, combined with a sense of words that is sometimes striking. His poems are enjoyable, and he must be a remarkably sincere and intelligent person.' Perhaps Spender had forgotten that they met when Peake drew his portrait.

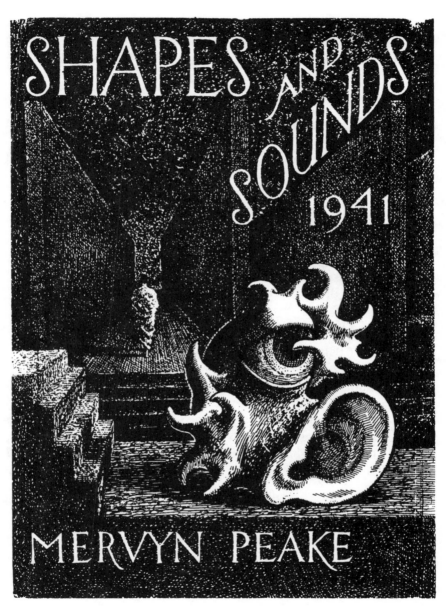

Dust jacket for *Shapes and Sounds* (1941), pen and ink, 22.5×15cm

In some poems one can see Peake continuing his graphic 'head hunting', observing from a safe distance groups of working-class youths ('the trouser-pocket boys, the cocky walkers') smoking on street corners:

> These are the flashy saplings whose domain
> I cannot enter.

He watches a callow girl trying to lose herself in the 'crimson jazz' and the 'marrow of the Congo drums'.

> Her neck supports a brittle
> And thoughtless miracle
> Deadened with chalky pollen.
> A cigarette
> Like a white stamen with a burning anther
> Is drooping from the flower tropical
> That has two petals
> Of dead, wet scarlet.

('Palais de Danse')

The 'Rhondda Valley' poem he reprints here shows him describing from the outside the tough work and domestic lives of unemployed miners. This sense of being at a distance and unable to connect with others' deeper feelings recurs in several poems – 'They Move with Me, My War Ghosts', 'What is it Muffles the Ascending Moment?' and above all in the powerful 'Is There No Love Can Link Us?' in which he asks:

> Is there no love can link us – I and they?
> Only this hectic moment? This fierce instant
> Striking now
> Its universal, its uneven blow?
> There is no other link. Only this sliding
> Second we share: this desperate edge of now.

Like all artists he is aware that his paints and words scratch surfaces, that if he could only see, hear, feel and express what is beneath and beyond then his art would be dealing with the eternal, as he says in 'If I Could See Not Surfaces':

If I could feel
My words of wax were struck
By the rare seal
Of crested truth,
Then would I give bold birth
To long
Rivers of song.

The blessing of the artist is to see art in everything ('I am too rich already, for my eyes / Mint gold'), but it is also his curse and his burden ('For gold is pain, / And the edged coins can smart, / And beauty's metal weighs upon the heart'). Sometimes he longs to fling it all away:

To prance! and laugh! my heart and throat and eyes
Emptied of all
Their golden gall.

('Coloured Money')

The *Listener*'s critic pointed out that 'in his imagery (feathers, worms, skulls, shells, tides and blood), in some of his phrases ("the trouser pocket boys, the cocky walkers"), and in his liking for an unaccented syllable to end a line, he often recalls Dylan Thomas'. Peake was not the only one to echo the lush and loose verse of his Welsh friend. An informal grouping of poets opposed to the cool cerebral precision of prewar Auden and Eliot called themselves the New Apocalypse and gloried in wildly surreal language and exuberant imagery very similar to Peake's. They too esteemed the works of Thomas, as well as George Barker, Edith Sitwell, Gerard Manley Hopkins, D. H. Lawrence and a poet Peake certainly admired ('very good I think'), Thomas' friend, Vernon Watkins. Their work appeared in three anthologies in 1940, 1941 and 1945, though Peake belonged to no group and was not included in any of them.[12] They have not stood the test of time and are now largely forgotten.

In March 1942 the army sent Peake to Clitheroe in Lancashire where there was a transit camp for oddities they didn't know what to do with, amongst them a regiment of black Americans. Wives were not allowed and Maeve stayed on in West Sussex, receiving his letters and poems of

love and the growing novel chapters which she piled beside her bed, ready if there was an air raid to run with the baby, the nappies and the manuscripts. She was now pregnant again and had moved once more to another part of Burpham into a primitive thatched cottage, 94 Wepham, at the end of Dr Peake's garden. Peake wandered the hills in his ample spare time, sketching and writing poems. When the time of the baby's birth approached Peake asked permission to be with his wife, but he had just had some leave and was told 'No. What's so new about having a baby?' His response was to forge a pass and to go AWOL, hitching a lift in an army lorry heading south. He arrived just after Fabian was born on 2 April 1942 and was able to accompany mother and son back to the cottage for a weekend. Maeve detected 'a tenseness and a sense of withdrawal, that was shared and only partly shared. Perhaps for the first time in our lives that we were not one. Was it the alien world that deprived one? It was certainly no loss of love. It grew and grew, but the world had intervened. A feeling of something amiss.'[13]

Reluctantly Peake went back to his unit and faced his punishment, though he never spoke about what form it took. This imposed conformity was beginning to wear him down and he told Goaty of the moment of crisis which soon followed: 'I bent down to do up my bootlace when I suddenly realised that I could never obey another order again, not ever in my whole life.'[14] Peake had experienced, like so many others in wartime, a nomadic existence far from his new family; his privacy was invaded, his sexuality curtailed, his daily life made a round of pointless drudgery and ritual, and he had found no fellow spirits to share his enthusiasms. The army's efforts to erase the personal identities of its recruits and to make them obedient, devoid of memory and imagination had been resisted by Peake, but at a heavy mental cost. He had learned the hard way that in a crisis he was neither a man of action nor a leader, unlike his father or the heroes in his childhood books, and that for him war was not a matter of heroics and pluck but largely consisted of boredom, loneliness and humiliation. What skills he had and could offer were either rejected by the War Artists' Advisory Committee, or mocked by the officers who set him to paint lavatory signs. He wrote

> My brain is webbed like water with slow weeds,
> These days I cannot trust it. Here within me
> A civil war makes idiot of my paltry
> Skull-circled arbiter.

The golden nostalgia of the summer sunlight
Is mockery.

('They Move with Me, My War Ghosts', 1941)

Maeve received a telegram to say that he had suffered a nervous break-down and had been sent on 27 May 1942 to the Military Hospital Neurosis Centre in Southport. His symptoms, he told Goaty, were 'sleeplessness at night and tired all day (ironically) – irritable as a bereaved rattle-snake and apt to weep on breaking a bootlace'. He was particularly irked by having no pockets in his hospital issue sky-blue trousers – 'the most dreadful thing that can happen to a man'. He told his publishers, Chatto and Windus, that at least now he could have a bath and be spared parades: 'Good old neuroses – but perhaps not (he added as his pen shot out of his fingers as of its own volition and he took a bite out of the table).'[15]

As part of his therapy he was encouraged to continue sketching his fellow patients and to keep on writing his novel – perhaps it is no coin-cidence that he was then working on the chapters where Sepulchrave goes mad and thinks he's an owl. Soon he was able to write on the final page of an army exercise book 'End of Book One (at last) Southport, 24 July 1942.' He also made a bamboo recorder and learned to play it well enough later to accompany Maeve on the piano. He told Goaty: 'The plaintive, woody, reedy, dryad timbre of the thing tears the souls off your feet.'[16] Four months passed in Southport until, on 14 September, the army gave in and released him to the Army Reserve, in other words sent him home to Maeve. His final discharge would not be issued until 30 April 1943, when the cause given was 'Ceased to fulfil Army Medical Requirements'. Army records show that his military conduct during his twenty-six months' service with the colours was 'Very Good'.

7 Illustrator, 1942–1945

By 5 October 1942 Peake had recovered sufficiently from his psycho-logical troubles to be employable again. This time someone must have taken a little trouble to find a task more in keeping with his talents than gunnery or bomb disposal and he was sent to the General Productions Division (i.e. propaganda) studios of the Ministry of Information, then based in London University's heavily guarded Senate House. He lodged nearby in Store Street and took Goaty Smith into the canteen at the Ministry for breakfast, airily waving a security pass on which he had drawn 'a very small elephant with a very large navel'. He was given three months' probation but on 30 January 1943 this was terminated, as Elmslie Owen reported to the War Artists' Advisory Committee: 'Embleton, the head of the studios here, made it clear to me that this decision in no way reflects on Peake's ability as an artist. It is simply that his highly individualistic style does not fit him for the type of work which is done in the studios here, which is primar-ily "Commercial" in character.'[1] Of course, Peake did plenty of 'com-mercial' work during his career, but perhaps he was still unable to take orders or be a team player.

This Elmslie Owen, who had replaced O'Rourke Dickey as the WAAC Secretary, was a friend of Peake's from the Sark Gallery days and an ex-colleague at Westminster College and so it is not surprising that after interviewing Peake he was able, at last, to offer him a commission. This

was to make drawings and a painting in a glass factory, for which he was to receive 35 guineas, third-class travelling expenses, £1 maintenance per twenty-four hours away from home or 6s. 8d. for an absence from home of more than ten hours. All works would be censored and remain the property of the Crown. In an internal memo of 15 April Owen confirmed that Peake had completed these drawings and that his two months' deferment was now up, but that he would be asked to do three more months at a fee of £162 10s., 'to carry out a painting in oils of the manufacture of cathode ray tubes for radio location, and thereafter to do drawings of factory subjects to be specified later'. Peake then had a medical to see if he should return to the army but he was found unfit to serve and when he was discharged on 30 April he was free to fulfil this commission. For weeks before this there had been a flurry of letters between civil servants and the WAAC because neither knew whose responsibility it was to ask for his release should he be passed fit to resume soldiering. In June it was found the army hadn't notified the WAAC officially of his discharge, and in November they discovered that Peake had never formally acknowledged acceptance of the commission but simply gone off and got on with it so that the money originally set aside had now been reallocated. The two paintings he finally submitted were valued at only £80 so he was asked to earn the balance of £82 10s. by doing ten drawings of the de-briefing of RAF pilots. His reply to this was delayed because he was laid up in 94 Wepham with a scalded foot and the letter had gone to the Manresa Road studio in London. The RAF then fussed about whether it was safe to let him into an aerodrome, but he finally received his clearance and began to work. The bureaucrats continued their tetchy crisscross of memos and it was the end of September 1944 before Peake received his full fees.

There are at least twenty-two glassblower studies in oils, watercolour, pencil, pastel and mixtures of these, now distributed between the Imperial War Museum and Manchester City Art Gallery. The latter home is appropriate because the glass factory was Chance Bros Ltd of Spon Lane, Smethwick.[2] The sketches are fragmentary, swift impressions of workers' movements with colour notes added. Later Peake worked these up into oils showing the workers in the lurid light of the furnaces 'gathering' molten glass whilst holding protective masks between their teeth; inflating their cheeks to the size of grapefruits as they blew, and 'lowering to the mould'. In others he showed the stages in which cathode ray tubes for radar sets were made in a kind of comic strip, or by including twenty graceful figures on the canvas stage at once demonstrating the processes simultaneously.

Peake saw the whole operation in choreographic terms: 'It is a ballet of glass. It is the ballet of dark hours; furnace of heat. It is the ballet of sweat. The ballet that not one of these deft craftsmen knows for such. Rough-clothed, rough-headed, drenched with sweat, they are yet as delicate as dancers.' He was fascinated by the skill of each man: 'he is the lyric juggler, half fire-lit angel, half cheek-blown gargoyle'. Here was the mixture of grace and grotesque which he so loved and would deploy in the Titus novel he was still tinkering with. Any denizen of Gormenghast would have felt immediately at home in the factory as he described it: 'Darkness, brickwork; hall after mammoth hall, pseudo archaic, absurd, begrimed, impressive, sinister; a setting for some film of gloomy passion. The grey spaces, ponderous gates, and ugly towers. Crumbling and obsolete in every corner. In this huge womb fires roar.' This prose-poem ends with a thought on sand:

Far from gull-wailing strands, it has become the burning mother of transparency. Sand. No longer the fast sky; the coughing wave. Girdled in a fast greyness of masonry, welkined with crasser substance than the clouds, it has found its purpose. And from its huge transmutation lucence breaks.[3]

Inevitably, these impressions were later concentrated into a poem, 'The Glassblowers,' published in 1950.

On the way home to London from the factory Peake called in on his old patron, Eric Drake, who was in Leamington Spa working for the Camouflage Directorate devising ways of making factories look like ploughed fields, and vice versa, to fool the German bombers.

Britain's bomber and fighter crews were under severe strain maintaining their raids on Germany, as Peake saw for himself on the second part of his commission. He was given access to an RAF station, perhaps Biggin Hill, and allowed to draw the crews as they relaxed and as they reported back on their missions. He produced around twenty-six items, all very skilful realistic reportage – there was no scope here for the kind of imaginative metaphors he'd made of the dancing glassblowers. The sketches give a poignant glimpse of these short-lived haggard-faced youths smoking, donning gas masks, bundled up in life-jackets and boots or sleeping fully dressed where they fell on the floor or slumped between two chairs. These are sympathetic works, though the final big oil *Interrogation of Pilots* is a banal disappointment. Eight

figures are huddled around a table at the far end of a bare gloomy room and in the foreground another airman pours a drink. The Imperial War Museum rarely puts it on display and even loyal Maeve thought it 'very untypical of him or his work'.

While he was away Maeve was bringing up the two boys in Wepham as these same bombers flew out and back over the Downs and American troops marched past the gate, pausing sometimes to give the boys a toy car and chewing gum or Maeve silk stockings, and to speak to her of their yearning for home and their own wives and children. Sebastian was now taking notice of his little world, sitting behind Maeve on the bicycle, exploring his grandad's surgery with the huge gallstone paperweight, and running to meet his father returning on leave and being allowed to wear his army cap. In bedtime stories Mervyn conjured up pirates and explorers or embroidered the old classics: Peter Rabbit tended to end up on Littlehampton beach having adventures just like Sebastian and Fabian. On one occasion the whole family went to row on the River Arun and Sebastian fell in and almost drowned, being rescued and resuscitated at the last moment by passing scullers.

Besides recording the war effort Peake made his small contribution to the discussion on what the country should be like after it was all over. Professor C. E. M. Joad was a well-known member of the radio programme *The Brains Trust*, famous for his catch-phrase 'It all depends what you mean by . . .' He introduced himself to Peake and asked him to illustrate his book *Adventures of the Young Soldier in Search of the Better World* published by Faber and Faber in July 1943 as a slim volume on poor wartime paper.

The targets of this heavily satirical book have long gone, and if it is sought out at all then it is for Peake's illustrations. The Soldier, who is public school and Oxford educated (and therefore unused to asking questions), goes on a kind of Pilgrim's Progress and encounters various grotesque creatures who advance arguments about why we are fighting and theories on how the postwar world should be run, which are then shown by Joad to be false. The cast of characters includes Captain Nick who has horns and a tail, the Reverend Hateman, Mr Ultra-Red, Mr Escapegoat, Officers of the Blood and Vengeance League and a Disembodied Voice. Contemporary political, economic and moral debate was not Peake's usual reading fare but he makes a workmanlike attempt in a mixture of pen line and hatching to give Joad's ideas flesh.

Illustration for *Adventures of the Young Soldier in Search of the Better World*
(1943), pen and ink, 20×12cm

His women dancing in the utopian future of continuous pleasure and the group of clergy are masterly in their ridiculousness; Peake was always good at sending up people who took themselves too seriously. Others remain an uneasy mixture of deadpan realism (the Soldier) and mad fantasy, but then so do Joad's arguments. The kind of book which fitted into a soldier's knapsack, its debating points perhaps helped to bring in a Labour government at the end of the war. It rapidly went into five editions and appeared in America too. Some of Joad's sour visions of the future may eventually have filtered into Peake's own dystopian vision in *Titus Alone*. However, this work alone would not make his reputation as a serious illustrator.

Nor would Quentin Crisp's *All This and Bevin Too* (Nicolson and Watson, 1943), a shabbily produced booklet on inferior paper. Crisp was an artist's model, dabbler in all the arts and the most outrageously camp man about Soho and Fitzrovia. Maeve remembered him as 'a startling sight in the drabness of wartime and immediate post-war Chelsea, with flaming red hair and one long red finger nail on the index finger of his left hand'. When I came to draw him in the 1960s he was still a startling figure, clothed or unclothed (though now his hair was lavender). At that time, Maeve recalls, he 'was much abused and insulted as he walked down the King's Road' and this homophobic prejudice did not change much even after he gained fame with his auto-biography *The Naked Civil Servant* in 1977. It could be that the mincingly effete but highly intelligent Dr Prunesquallor is Crisp's distant relative.

Crisp sometimes drew dust jackets for publishers and his cynical approach provides an interesting contrast to Peake's earnest attempts to 'slide into the soul' of the writer he was illustrating. Crisp claimed:

I learned to handle books so that they fell open at the murder and, even when this did not happen, I was soon able to read through them rather than read them. The narrative evaded me but the style in which it was written told me what kind of reader it was intended for. Once I knew this, designing the cover became simple. If my eye was caught by the words, 'Her eyes filled with tears and her bosom rose and fell,' it was obvious the book was meant for women (pastel shades, dark-haired heroine with shallow cleavage); if the novel had been written for men it would have said, 'Her huge breasts shuddered with emotion in their strait-jacket of pink satin.' (Dark tones, red-haired heroine with deep cleavage). If in three hundred pages there was no mention of breasts at all, the

volume must be a documentary (no illustration) or for children (bright colours, mouse-haired heroine with NO cleavage).[4]

The art editor of one of his clients, Nicolson and Watson, told Crisp that now was the time to get into print because 'though there was a widely advertised paper shortage, publishers would issue any old muck'. He therefore set out to write some forty-eight satirical limericks at the expense of government officialdom which could never find the right work for the right person – a subject with which Peake must have sympathized. Crisp was a witty man, but this was hardly heavyweight stuff and it did not stretch Peake's talent or reputation when he gave in to Crisp's persuasion:

> I decided to try to ensnare Mr Peake into illustrating it. He was at that time the most fashionable illustrator in England. In spite of this he frequently sat in the Bar-B-Q in Chelsea and was not in the least inaccessible. When talking to him I allowed it to seem that Messrs Ivor Nicholson & Watson had already commissioned the book and he declared himself willing to illustrate anything that was certain of appearing in print. These words had hardly issued from his lips when I leapt up and ran all the way to Manchester Square to tell the publishers that Mr Peake was dying to illustrate a book I had written. They expressed their interest in anything Mr Peake chose to work upon. Running to and fro and making a series of statements that seemed increasingly positive but could never be used against me was much harder work than writing the verses. These only took two afternoons. That was as it should be. It was certainly not the writing but the chicanery that ensured publication.

One takes this tale with a generous pinch of salt, but it seems a fair assessment of Crisp's work and also shows how desperate Peake (who was *not* the most fashionable illustrator) must have been for any commission at this time. Crisp went to Hatchard's bookshop in Piccadilly to see his stapled booklets on display and 'To my delight there was a man staring at the uppermost of these, this, however, turned out to be Mr Peake.'[5]

Crisp repaid, in part, his debt to Peake by writing an article, 'The Genius of Mervyn Peake' comparing him favourably with Blake as an illustrator-writer and concluding perceptively that Peake should concentrate on writing: 'Peake's most personal quality is a strangeness

verging on dreadfulness and, if this is expressed in painting, a certain ludicrous quality is always liable to creep in; the eye begins to vomit sooner than the ear – far sooner than the mind.'[6]

In spite of the slight nature of the verse John Batchelor, an earlier biographer, considers that Peake's illustrations have been unfairly neglected: 'The drawings of the poor anguished kangaroo seeking to imitate a whole series of other quite different creatures in order to receive employment are drawn with detail, care, and a poker faced literal-mindedness which suits the tight form of the limericks.'[7]

At last, in June 1942, Peake received a request to illustrate a great literary work which would demand full empathy as well as the extension of his technique. He rose to the challenge magnificently. Harold Raymond at Chatto felt sorry for Peake after his breakdown and tried to cheer him with the suggestion that he illustrate Coleridge's 1798 masterpiece, *The Rime of the Ancient Mariner*, 'about as Peake-ish a subject as we could think of'. But he wondered about the paper shortage: 'How and when and on what we could produce the book, God only knows but if you fell for the idea, we could start collecting old envelopes, bun bags and tram tickets now.'[8] Peake's eight drawings for the poem, published in 1943 for 5 shillings with further impressions in 1949, 1971 and 1978, were to establish his reputation as one of Britain's best illustrators.

Gustave Doré (1832–83) had set the standard for *Ancient Mariner* illustrations in his lavish 1875 edition and Peake was well aware of it. The forty or so images in Doré's version were wood engravings on unusually large blocks reproduced by electrotype. He drew directly on to the face of the wood with pen and brush and then left it to professional cutters to engrave the images so, unlike Peake's ink lines, the final marks we see are not the artist's own. Doré, like Peake's early hero Stanley L. Wood, was fond of unusual viewpoints – from below, mid-air, beneath the sea and so on – as well as extreme effects of space and chiaroscuro. Some of his images retain their imaginative power, but to modern tastes the fancy dress of the wedding party, nude water sprites and the over-sweet angels and spirits are cloying. Doré's style was baroque and elaborate whereas the poem is stark and in the simplest language. Not that it needs simple-minded literalism either, of the kind later offered by William Strange's etchings, or Duncan Grant's bright but uninspired settings.[9]

Peake does not show the wedding guest; instead *we* are held by the extraordinary Mariner with his glittering eye, his skinny hands and

ALL THIS
AND BEVIN TOO

QUENTIN CRISP
With drawings by MERVYN PEAKE

One Shilling net

Dust jacket for *All This and Bevin Too* (1943), pen and ink, 21 × 14.5cm

long grey beard – a haunting image which stays with us as we read on. Peake's 'nightmare Life-in Death' woman is vastly superior to Doré's version, combining the come-hither eyes and lips of a whore and the empty nose of a syphilitic – and then one notices she has skeletal hands and ribs. As Peake would later tell drawing students: 'The most luxuriant tresses are anchored to a bone.' This was omitted from the first edition as too ghastly. The dying albatross is also an astonishing composition, its wings occupying the top and right sides of the page's rectangle, a centrifugal sky in the middle and a distant iceberg like a skyscraper in the bottom left corner. The designs are elemental, stripped down compared to Doré's excesses, but with the surfaces textured by thousands of tiny ink strokes. The hatchings became overworked in places and one can see in the originals (which are twice the reproduced size) that he scratched out with a razor blade or used Chinese white and began the build-up anew – the seeming insouciance of Peake's line was not so easily achieved as it sometimes appears.

The book came out in December 1943 at the end of the busiest year of Peake's career so far. It was very well received and he must have been particularly pleased by praise from other writers. Walter de la Mare probably had an advance copy; he wrote on 20 November 1943 to say he found the Mariner 'a haunting derelict, in all conscience, out of the depths of what is called the Unconscious simply, I suppose, because so few of us pay any heed to its strange denizens and so seldom listen to those faint but still urgent voices audible there – or have forgotten their languages.' Peake's illustrations created 'a definite and unforgettable imaginative masterpiece' and changed his own reading of the poem.[10] Much later, on 20 June 1959, C. S. Lewis wrote to Peake from Oxford to thank him for his copy:

The Mariner himself [facing p. 6] has just the triple character I have sometimes met in nightmares – that disquieting blend of the venerable, the pitiable, and the frightful. But at the same time – thanks I suppose mainly to the position of the arms – the horrid *representation* is a graceful *thing* (I give no praise to picture or story which does not fulfil both demands).

Paradoxically, for Lewis, 'the very lines which make the Mariner a hideous and rigid *man* simultaneously make him a *shape* as charming as a beech tree'.[11]

Peake seems to have had time to slip in an unremarked exhibition of drawings and paintings at the Calmann gallery during 1943, but

The Ancient Mariner (1943). 'The Nightmare Life-in-Death was she',
pen and ink, 21 × 13cm

essentially he had spent the year on *Titus Groan*, the WAAC commissions and in establishing himself as a promising ilustrator. The novel was almost finished and in May he submitted it to Chatto and Windus, whom he now regarded as 'his' publishers. His editor, Harold Raymond, was not as impressed as Peake had hoped and would consider it only if it was drastically cut. Peake felt he had spent three years trying to excise its excesses and could cut no more, and so the manuscript was returned to him in June. It was a blow, but soon after this Graham Greene, who was working part time as an editor at Eyre and Spottiswoode, suggested that he look at the novel, so hope was revived.

One evening Peake was taken to a Soho pub by Dylan Thomas and introduced to Kaye Webb, later the editor of Puffin Books but then working for *Lilliput*, a well-illustrated magazine devoted to cheering people up during wartime. Later she recalled: 'I found myself staring at a long, thin, disorderly-looking man, with intense eyes and very black hair, who was both excited and embarrassed by the introduction and immediately tried to brush it off.' From then on she frequently commissioned him to illustrate stories, poems, nursery rhymes and articles right up to the May–June issue of 1953 when he illustrated extracts from Evelyn Waugh's *Love Among the Ruins*. One night Kaye and Mervyn waltzed together down a moonlit and deserted Regent Street.[12] She also published in the magazine a Bill Brandt photograph of Mervyn sucking his pipe, spookily lit from below. Later, in 1948, Ronald Searle became Kaye's third husband, and she strenuously promoted his amazing talents until he became the main rival to Peake as an illustrator in the 1950s, but during these war years Searle was having a hideous time at the hands of the Japanese. Peake had learned that his brother Lonnie had also been captured in the fall of Singapore, and like Searle was being held in Changi jail.

Another useful female contact made in the Café Royal during this period (Maeve was presumably home in Wepham looking after the boys on these occasions) was Kay Fuller, who produced the radio broadcasts Peake made in 1947. She was in the company of Michael Ayrton, an artist with even more diverse talents than Peake. Fuller described Mervyn:

As a man, he was as rare and strange as his physical appearance. Although his manner was gentle, he gave one the impression of barely keeping in check a constant flood of restless energy. His talk was highly fantastical and he had his own sort of humour

which was not always easy to follow and was occasionally quite abrasive. He was always full of some project or other which he would describe in detail and with great enthusiasm, but on the other hand he was by no means wrapped up in himself. He was equally ready to hear about one's own preoccupations. It was not easy for him to understand how anyone who might be doing more congenial things could become trapped in a large organisation like the BBC. Such a compromise was unthinkable in his own case, whatever the material pressures.[13]

She noted too how generous he was in giving away his drawings to all and sundry.

Peake still kept on the battered old number 3 Trafalgar Studio in Manresa Road. For £78 per year this provided a cheap bolt-hole when Maeve came up to London. The building was decaying and condemned but the whole north wall was glass (and therefore impossible to black out so no lights could be shown) and the space was barely warmed by a wood-burning stove. Across the corridor was a small room with gas cooker, bath and a makeshift bed. Dylan Thomas periodically occupied one of the downstairs studios and their friend the painter John Grome another. The Peakes and he would occasionally club together to hire a life model.

When possible Peake would rush to spend periods with the family at Wepham. Mrs Gilmore, now an invalid, was looked after by Maeve's sister Ruth in Stratford whilst her husband had moved away to Corsham to be a doctor to the quarry workers there. During this post-breakdown period Peake felt under pressure and at times this must have shown in depression and irritability. On 31 December 1943 he wrote to Maeve to apologize for his mood the day before and to make a New Year resolution: 'I am so sorry. I am making a great effort in 1944 to put you first and be more reasonable . . . 1944 is going to be a great year for us all.' Later in the year (4 July) after a V2 rocket raid on London, he complained to his 'most loved, most lovely, most dear' that 'these flying robots have mucked the phoning arrangements up' and to encourage her with her paintings, which he was getting framed. 'I am thrilled about your stories, my own heart-throb,' he tells her. Maeve was trying writing on her own behalf after acting for so long as muse, sounding board and critic for her husband. She was the better educated and more widely read of the two but he still maintained something of

The Ancient Mariner (1943). 'I shot the albatross', pen and ink, 21 × 14cm

the tutor–student relationship as he encouraged her creative endeavours: 'I have such faith in you as an artist of the first stature, potentially a magnificent artist in your own right.' For her colour and vision he had 'nothing but love and admiration' but he ventures to advise: 'Your vision is personal, powerful and challenging and I hope that you will give it its maximum chance of expression through tedious care over the placing of your objects on the canvas. No great picture is produced without a concentrated effort at finding where a shape should go to have its greatest effect.'[14] This compositional adroitness was of course one of his own great strengths as an illustrator. To her diary Maeve confessed, 'Mervyn has felt that I am jealous of his success and I may have given him a just cause to think so – though I can think of nothing more horrible.'[15] Living in the country with slatternly neighbours and 'the butcher at the door with his wooden tray of hideous gore' was getting her down. She passed the time reading Dostoevsky, Strindberg and Greene's *The Power and the Glory* but it did nothing to soothe her nerves: 'We've had some difficult days – or rather days in which I have not been easy for Mervyn to understand – nor I myself for that matter.'[16]

Eventually, in spite of the continuing danger from bombs Peake found a studio flat at 70 Glebe Place, just off the King's Road, Chelsea, and brought his family to live there. They had a stove and a raised gallery on which the four of them slept. The rent was £250 a year for the large cold rooms, but they had space to paint and friends such as Goaty, Dylan Thomas and John Brophy could come round for coffee and to chat. Once they played Graham Greene's malicious game of randomly telephoning people from the phone book and spinning them some unlikely yarn. Greene's efforts reduced them to terror, while Mervyn announced he was a chimney sweep coming to clean the chimney; when the telephonee denied having a chimney he said not to worry he'd bring his own.[17]

Soon the boys began to attend a nursery school at the end of Glebe Place and their parents could get on with painting. As the Peakes began to explore Chelsea they would have seen pasted up on local cinemas the yellow, black and mauve poster Mervyn had designed for the Ealing Studio film *Black Magic* with Sidney Toler as Charlie Chan. This was another attempt to boost their always exiguous finances. In a letter Mervyn told Maeve that a man came from an advertising agency to ask him to do two drawings of two wireless valves for 6 shillings an hour. Peake said it would take four hours and he'd do it for £4, and then he'd do more but 'nothing under a fiver', which 'might more than pay for

the rent'. He had even been desperate enough to try for another war artist commission. On 28 February 1945 the WAAC held its 176th meeting and the minutes record: 'This artist wishes to be considered for a commission, in China if possible, but if not he would like to do paintings of evacuees on the Continent. It was agreed that the Committee could not grant such a commission.'

Another venture to raise money was a June 1944 exhibition of paintings in Peter Jones department store in a room next to the haberdashery department. Most of the customers ignored it and others, to Maeve's fury, laughed at it, but the *Sunday Times*' respected critic, Eric Newton, found many of the works 'darkly morose or morbidly fantastic' and thought that Peake 'paints with a good deal of power but never with serenity' (18 July 1944). Maurice Collis in *Time and Tide* (8 July), found it 'a comprehensive exhibition . . . as if Mr Peake had put all his cards on the table and invited the public to tell him what was his winning suit'. Collis evidently believed this to be his drawings, particularly one of 'extraordinary excellence', *Man Holding a Flower*: 'I point to that one. It is an ace of trumps. He can make his fortune by it.' Collis bought a picture and began to collect Peake's line drawings, then in November invited Peake to lunch and introduced him to the illustrator and artist Feliks Topolski. Collis soon became a close family friend and invited Peake to illustrate his next book, *The Quest for Sita*, which would be published by Faber and Faber in 1946.

Maeve tells a curious story about the Peter Jones exhibition – though with her usual nonchalance about detail she recalls snow on the ground, which is unlikely in June of a very hot summer. Peake had hung a self-portrait: 'Mervyn had a face that belonged to another age. Cadaverous, romantic (women thought it beautiful), haggard and wild. He had painted himself with a paintbrush through his teeth, as a pirate might hold a cutlass, or a gypsy dancer a rose. It was a painting of bravura.'[18] On the night after the opening they were woken by a rattle at the letterbox and the screams of Sebastian, who was convinced he'd seen an old woman peering into his window. Mervyn opened the door to find that 'a wire had been stretched across the door, which would have cut a thoughtless throat, but he had withdrawn in time, and on the doorstep was a loaf of bread made into a face – currants (predictably) for eyes, and through where should have been the mouth a paintbrush'. Dirty collars full of congealed bacon-rinds were also pushed through the letterbox. The police were called and reported that 'The widow of an R.A. who had seen Mervyn's self-portrait, had hated it so

vitriolically that she could only think of doing harm to someone who, in her eyes, had desecrated *art* and her husband.'[19]

Some time in August 1944 Maeve was seriously ill and had an operation on her sinuses, probably made worse by infected tonsils. She recovered in Groombridge nursing home with 'Doc' Peake, her mother and sister Ruth constant visitors, though Peake remained in London writing agonized letters, telling her on 12 August, 'this trial, which will so soon be a memory for you – in a few hours – may mark the point at which you breath [*sic*] in the pure gusts of a new life – your energy and enthusiasm triumphant'. When three days later she was still in pain: 'your bravery has made me appreciate and love you more my little invalid'. On the 17th he gave her a gift: 'as a symbol of how I feel after these initial years of our life together I want you to accept this wedding ring – the emblem of our second and it seems to me, our deeper marriage'.

Late in 1944 a volume of Peake's own nonsense poetry, *Rhymes without Reason*, was published by Eyre and Spottiswoode, a firm he referred to as 'Migraine', which he derived from Eye and Spot. They offered him a retaining fee for 1945 and 1946 on condition he did two books each year and no illustrations for other publishers. He was relieved to accept this offer since he'd finished the *Quest for Sita* drawings for Collis and wanted to revise his novel: Greene had persuaded him it needed brutal cutting.

Must poetry make sense? Poetry, like Proteus the old man of the sea, can change its form at will and sometimes it just lets its hair down and plays the fool. Lewis Carroll and Edward Lear were the benchmarks for the peculiarly English genre of nonsense poetry and many have tried it since; even T. S. Eliot. Spike Milligan is the current Boojum of nonsense verse, a denial of logic and realism that reached wider audiences through the Goons on radio, Monty Python on television and earlier, during the 1950s, enjoyed a vogue in the Theatre of the Absurd. Peake had always enjoyed frolicking in verse with Goaty Smith and in 1944 the publishers let him have his head in the thirteen honestly titled *Rhymes without Reason*, each with a lurid four-colour illustration. 'All Over the Lilac Brine' is typical:

> Around the shores of the Arrogant Isles,
> Where the Cat-fish bask and purr,
> And lick their paws with adhesive smiles
> And wriggle their fins of fur,

Rhymes Without Reason (1944). 'All over the Lilac Brine',
watercolour, 23 × 18cm

With my wife in a dress of mustard-and-cress
On a table of rare design,
We skim and we fly, 'neath a fourpenny sky,
All over the lilac brine.

This is accompanied by a picture of the pair adrift on an upturned table with the wife pointing a huge telescope at her husband's bulging bottom, like a McGill seaside postcard. The colours are intentionally gaudy and the pictures show a menagerie of fantastic crocodiles, cats, whales, giraffes, tigers, jaguars, camels and walruses. In the final picture a brilliant sunset dwarfs three tiny figures, who sing:

Sensitive, Seldom and Sad are we,
As we wend our way to the sneezing sea,
With our hampers full of thistles and fronds
To plant round the edge of the dab-fish ponds;
Oh, so Sensitive, Seldom and Sad –
Oh, *so* Seldom and Sad.

John Betjeman, who thought the whole book outstanding, announced: 'I have bought more than one copy, particularly for the last poem' (the *Star*, 13 December 1944).

These verses are fun, but not hard to imitate because, like a game, they follow rules. They are rhyme-led, so one word suggests another not by meaning but by sound (fronds–ponds), adjectives are inapposite (sneezing sea, adhesive smiles, fourpenny sky, lilac brine), the rhythm strong and alliteration heavy. However, syntax is always maintained together with a strict verse form, such as the ballad metre or couplets, both of which lend a spurious semblance of rationality and order. Peake confessed:

Again! Again! and yet again
I find my skull's too small
For all the jokes that throng my brain
And have no point at all

No point, no deeper content, lies below the surface – this is not disguised truth-telling, nor satire or irony; it is the pyrotechnics of word play itself which gives us pleasure.

Elsewhere Peake put up a good defence of nonsense (which he always spelled 'nonsence' in his notebooks) in general:

Madness can be lovely when it's the madness of the imagination and not the madness of pathology. Nonsense can be gentle or riotous. It can clank like a stone in the empty bucket of fatuity. It can take you by the hand and lead you nowhere. It's magic – for to explain it, were that possible, would be to kill it. It swims, plunges, cavorts, and rises in its own element. It's a fabulous fowl. For *non*-sense is not the opposite of good sense. That would be 'Bad Sense.' It's something quite apart – and isn't the opposite of anything. It's something far more rare. Hundreds of books are published year after year. Good sense in many of them: bad sense in some more – but *non*-sense, oh no, that's a rarity, a revelation and an art worth all the rest. Perhaps one book in every fifty years glitters with the divine lunacy we call nonsense.[20]

Peake had child readers in mind, perhaps his own sons, but the adult reviewers of *Punch* and the *New Statesman* liked it, especially the illustrations. It received more notices when reissued in 1974 but most thought it derivative of Lear, Carroll and Belloc and only the *Junior Bookshelf* in October of that year was unequivocal: 'A generation which has not been confused by the artist's undeserved reputation for macabre eccentricity will accept this book for what it is, a major picture book and a collection of splendid and memorable poems.'

Around the same time Peake had been working on a humorous book for adults. *Prayers and Graces: A Little Book of Extraordinary Piety* contains quotations collected by Allan M. Laing and opposite thirty of them Peake uses a simple unshaded ink line to create satirical caricatures of clergy, peasants, children, African 'natives', old maids, Scotsmen and other oddities. He shows a mastery of caricature. The book is fun and deservedly became a bestselling stocking-filler when published by Gollancz for Christmas 1944. It was not demanding to do and Peake was probably glad of the 2 guineas a drawing he received. However, having neither a business head nor an agent, he got no royalties from the 40,000 copies sold that Christmas. But by then his financial position had eased somewhat. Mrs Gilmore had died that year and left her daughters each a generous shareholding in the *News of the World* which would bring in an annual dividend.

Spring 1945 saw the publication of *Witchcraft in England* by Christina Hole (or Christ-in-a-hole as she was known within the Peake family), a book Peake had been working on intermittently for Eyre and Spottiswoode since his 1942 posting in Lancashire, which perhaps explains the different styles and media used in the illustrations. The

fifty-five pictures display a mixture of sizes and techniques: pen line, brush line, ink wash, close hatching, solid blacks or any combination of these, as if Peake could not make up his mind on a coherent style. The captions do not always have a clear connection to the pictures: it looks as if he had drawn some ugly individuals or huddled groups and they had been slotted into the text later. Some are very slight and others tightly worked and powerful.

By this stage of his life Peake's preferences were becoming set and clear: he needed implements with no resistance which he could pull towards himself such as pens, pencils, charcoal, pastel, litho chalk, felt tips, brushes, and later biros and ballpoints. He had no interest in tools one had to push and which offered resistance such as those used in wood engraving, lino cuts, woodcuts, or elaborate print processes like etching, engraving, lithography, monotypes or screen printing. The tool had to be as near a writing implement as possible so that transference of idea to page was rapid and easy. He was the master doodler and at his best with a simple pen line reproduced by line block.

Witchcraft in England is a learned and well-researched book written in measured prose in spite of its ghastly revelations of mass hysteria, witch 'swimmings', superstition and persecution. Peake's illustrations are more lurid, full of gnarled faces and fitfully lit scenes of violence as if he had truly felt the terrors behind the facts and quotations. To John Batchelor 'the effect is of author and artist working steadily against each other, the author stripping witchcraft of its magic and the artist putting the magic back.'[21] One reviewer wrote of 'powerful drawings, varying in style, but almost uniformly gruesome' (*Illustrated London News*, March 1945). Others agreed: 'If you want to know why witches were once feared and hated you have only to look at Mervyn Peake's illustrations' (*News Chronicle*). The *Daily Herald* wrote of 'shudderingly sinister pictures' and the *Observer* reviewer clearly found them convincing: 'the drawings have such a frightening realism as to leave no doubt in the mind that witches *do* exist and *that he has seen them*'. 'The diablerie has profoundly engaged his imagination, and the consequence is a set of illustrations such as we are not often privileged to have in an English book,' noted *Country Life*. Two reviewers made shrewd connections to other artists that Peake himself would have acknowledged: the *Spectator* critic wrote of 'the macabre Daumier-like power' of Peake's drawings and the *Birmingham Post*'s view was that 'If Mr Peake's drawings suggest that he has studied such diverse draughtsmen

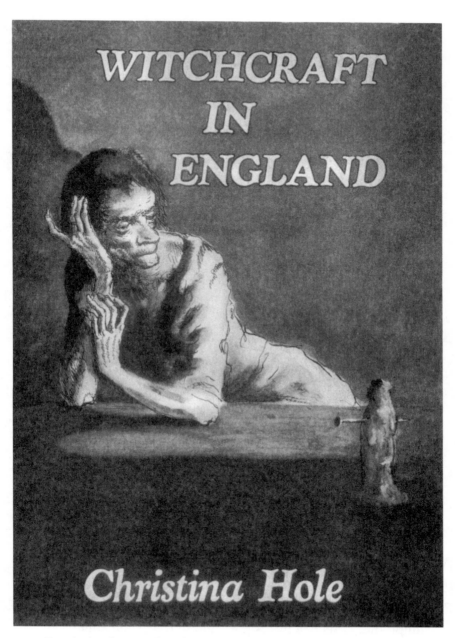

Dustjacket for *Witchcraft in England* (1945), pen and watercolour,
23×15.5cm

as Rembrandt, Goya and Rowlandson, that is not to suggest that he imitates them. On the contrary he is an original artist of uncommon skill'.

After Peake's death the book was reissued (Batsford, 1977) with revised prose and a treatment of the pictures which his admirers considered an 'outrage'. By then the publishers had lost the originals and the drawings were reduced from fifty-eight to a mere twenty-eight Captions were omitted, their relationship to the text was mangled, they were cropped, put in a different order and their washed backgrounds cut away. Peake fans were urged to boycott the book and it was remaindered.[22]

Since his demob the war had not impinged much on Peake's attention but when VE night came on 8 May 1945 he and Maeve managed to arrange babysitters for the boys so that they could join in the West End celebrations. Maeve remembered dancing up Piccadilly, doing the knees-up and 'laughing, crying, being kissed, kissing, until our voices were hoarse, our eyes closed with sleep and weeping, our feet swollen with dancing on the hard road. Everyone loved everyone.'[23] With the dropping of the atom bomb on Japanese cities the war in the East came to an end in September and they heard that Mervyn's brother Lonnie had survived his ordeal as a POW. It was time to take stock and count back in the friends who had been scattered by the conflict.

In 1944 Eric Drake had left Camouflage and gone to join his brother Burgess in China, where they used their knowledge of the country and language to spy on the Japanese. After the war Eric returned to London, wound up his Sark gallery and in October 1946 married a lady called Jenna Bruce with Mervyn as his best man. He then took off again to teach English in Chinese universities for the British Council. When he was expelled by the Communists he went on to teach in Australia for the rest of his career, though he maintained a lively interest in the achievements of his most famous ex-pupil. His brother returned to English teaching and became a family friend of the Peakes. Peake's companion on Sark, Tony Bridge had fought in North Africa and the six years away from an easel had ended his artistic ambitions. Ordained in 1954, he kept in touch and later visited the Peakes in Kent, where he shocked Maeve by arguing theology with her local Catholic priest. Her own faith had been under some pressure, especially during the war, as she confided to her diary: 'I do believe in God – but I believe that people could convince me logically that God

did not exist, nor has ever existed – but with my heart and my soul, and myself, in my mind I do believe. I cannot understand the reason for pain and suffering, and I do not understand the justice of the retribution which mankind reaps for the sins of Adam.'[24] She was baffled by the 'over-riding presence of pain in the world' and later, as she saw and felt more pain, her doubts grew.

A month after the war was over its full horror hit Peake. He was asked to visit Germany and Belsen concentration camp, a painful episode that will be dealt with in the next chapter. Now he welcomed home another camp inmate: in autumn Lonnie Peake arrived at Glebe Place in a taxi. Imprisonment by the Japanese had reduced the strapping rugby player's weight to six stones and Maeve set about feeding him up – fortunately, as an ex-POW, he was given double rations. He had to wait several weeks for a dock strike to end so he could get a boat to Canada to be reunited with his family, who had fled there to escape the war.

After the war's end came Peake's first reissue, always a flattering moment for an author. The first edition of *Captain Slaughterboard Drops Anchor* had been a victim of the blitz but in 1945 Eyre and Spottiswoode reprinted it, adding flat pastel colours to whole pages or selected witty details. These were pink, yellow, blue, grey and one touch of green on the Saggerdroop's loincloth, which suited the illustrations well. The book went into two editions, then was out of print until 1967.

Around this time Peake received a commission from the publisher, John Murray, which should have been one of his triumphs: it was to illustrate Dickens' *Bleak House*. Here was a book which combined the sinister and the comic, love and hate, murder, mystery, darkness, greed and callousness and had the same expansive prose style Peake was employing in his Gormenghast novel. From the wash, pencil, charcoal and litho-chalk portraits of the characters he completed it seems as if he would have rivalled Phiz and Cruikshank as a Dickens interpreter, but somehow the scheme fell through and we are left with might-have-beens.[25]

Peake had a studio and was painting again but once more the year had been dominated by his writing and illustrating. His exhibition in the Leicester Galleries in October–November 1945 consisted of forty-one drawings he had completed for his friend Maurice Collis' book *Quest for Sita*. He also showed at the Adams Gallery and the Arcade Gallery

and Maeve had an exhibition at the Redfern. Peake still thought of himself as a painter and he would exhibit many times more, but there was a disquieting feeling abroad that his talent was now best seen in graphics and illustration and that the long war period without easel painting had halted his progress. The RAF oil painting had been ordinary, the 'Glassblowers' was mannered, and he seemed out of touch with contemporary English art without having found a subject matter and style that was entirely his own.

Cut off from other European art centres, particularly Paris, art in Britain had turned inwards. Piper, after a period of abstraction, had begun to celebrate the English landscape and architecture whilst Sutherland continued to build on the heritage of Samuel Palmer and other earlier Romantics. Both were employed by the WAAC to celebrate and record civilization under threat and the bombed cities. Paul Nash had always been in pursuit of the *genius loci* but during the war transferred his attention to planes and mysterious tableaux involving sunflowers and *Golden Bough* myths. The younger painters such as Vaughan, Minton and Ayrton followed their seniors in celebrating English landscape, often moonlit, tangled and mysterious. These painters became known as the Neo-Romantics, but if Peake had any affinities with them it was more in his haunted prose and romantic poetry than his paintings.[26]

Even those who loved him most came to have doubts about his painting. Maeve wrote of his exhibition at the Adams Gallery in 1945: 'he had a habit of painting over his canvases so that any which were not sold were completely metamorphosized, and the shapes beneath became the shapes to dominate the new painting. Strange, that above all things that he did he wished to be a painter, and I think it was perhaps the medium in which he was least sure.'[27] John Watney also thought that 'it can be argued that although painting was his first love, it was not his real forte: his sense of colour was sometimes weak, and the draughtsman and illustrator in him always outshone the painter. He was looked upon no longer as an up-and-coming painter but as an established illustrator of the first importance.'[28] Tony Bridge, his fellow student and Sark friend, came to the conclusion: 'I don't think he was ever really a very good painter. He had an amazing facility, and when he could do a thing very easily, he didn't value it very much; if a thing came hard, as painting I think did, he automatically thought this must be really what he should do, because it was difficult.'[29]

The year 1945 had been another busy time for Peake with his family now reunited, his illustrations in demand and painting resumed. Eyre

and Spottiswoode had, provisionally, accepted his much-revised *Titus Groan*. In June of that year he travelled to war-devastated Germany, an experience that was so crucial to his development that it deserves a chapter to itself.

8 Reporter, June 1945

In the summer of 1943 Eyre and Spottiswoode had commissioned Peake to illustrate *Household Tales* by the brothers Grimm. He had to produce seventy black and white drawings, plus one colour spread, for a fee of £150. He enjoyed this task and wrote to Goaty to say he wanted to 'change the cross-hatching stuff I've used so far. I think it'll be the best thing I've done so far in illustration.'[1] The tales are full of a freakishness which chimed neatly with Peake's imagination: dwarfs, talking sausages, hunchbacks, changelings, giants, devils, wicked stepmothers, witches whose noses touch their chins, serpents, one- and three-eyed women, and everywhere characters who slip back and forth between animal and human form. Noses grow uncontrollably, dying men set seemingly impossible tasks for their sons, and men and women perish by fire or drowning, are eaten by dogs, hanged, chopped up by axes, rolled in spiked barrels or dance to death in red-hot iron shoes. To help the heroes or the virginal princesses there are servants as treacherous as any Steerpike, and others as faithful as Flay. The society is strictly hierarchical, with peasants and woodcutters at the bottom and tyrannical kings at the top, and it renews itself by offering a princess in marriage to the prince or youngest son who most cunningly performs the tasks set by her father. It is a pre-industrial world of rituals and taboos which, if neglected, bring down terrible consequences on the transgressor. All this takes place in an elemental northern European

landscape of castle, river, plain, forest, cave, hovel and mountain which echoed Peake's non-classical imagination. The parallels with the Titus books are clear.

As usual these illustrations were made in direct response to the text, not historically researched in the methodical way Otto Ubbelohde had used for the superb 1907 German edition in the *Jugendstil* style. However, when it appeared in 1946 none of the reviewers objected to this: they thought Peake and the Grimms a perfect match. One curious exception was his new friend Maurice Collis, whose *Quest for Sita* he was also working on, who wrote: 'Mervyn Peake is so extravagant and wild, so full of a whimsical compassionate humour, that Grimms' Tales, though they call for some of his gifts, hardly extend his talent' (*Time and Tide*, December 1946). He thought that Peake would have been better employed on *Gulliver's Travels*, *Erewhon* or *Don Quixote*, but unfortunately no publisher ever took up these suggestions.

Household Tales (1946). 'The Nose', pen and ink, 12×12cm

Peake was given a chance to visit the home of the *Household Tales* and the Grimm brothers in summer 1945. Those who knew Peake were convinced that his experiences in Germany that June changed him as a man and as a writer. John Watney wrote: 'This last act of the war was to have a more profound effect on him than the rest of his wartime experiences put together.' Maeve too noticed a change in him: 'He was quieter, more inward looking, as if he had lost, during that month in Germany, his confidence in life itself.'[2] He promised in his letters home that he would tell Maeve about his visit to Belsen when he returned, but he never could and channelled his feelings into his works instead. She wrote: 'during that month the sights and sounds of Germany must have damaged him more than he ever said, except in his poems and writing in *Titus Alone* many years later, and his drawings'.[3]

On 11 April 1945 Maeve wrote in her diary a list of the paintings she wanted to do – of the boys, the cats, even her first nude – but this seemed self-indulgent in a war-torn world: 'At times too I feel that one cannot stay outside events that are passing now in Germany – the multitudes of homeless people – can one just say "I am a painter" and leave it at that? I can think of no practical way in which I can help such unthinkable multitudes of wanderers.'[4] She must have discussed this with her husband because he wrote from Germany to assure Maeve that he was holding to their joint resolution:

> You know that I will do all that is in me to do what was in our minds when we decided, through your insight that it was for me to make records of what humanity suffered through war. I will not forget the reasons which prompted me to try and go where people suffer. I will miss you desperately, but I will be proud to do something which we both believe in.[5]

They must have confided their intention to Kaye Webb, their friend on *Lilliput*. This magazine was amusing and escapist but was linked by Hulton ownership to the more serious journals *Picture Post* and the *Leader*. Charles Fenby edited the *Leader* and Webb must have mentioned Peake to him at a time when he had on his desk Peake's still unpublished 'Hitler' propaganda drawings. Fenby was also being badgered by an ambitious nineteen-year-old would-be war correspondent called Tom Pocock who wanted to be sent to Europe to report the last

phases of the war. Fenby decided to team them up, with Pocock writing the reports and Peake illustrating them.

Their first application in April to the bureaucrats in Senate House was turned down – the *Leader* was not a high-priority journal so they would have to make their joint trip when the war was finished. Pocock, however, wangled his way across the Channel and reported from Europe for some weeks as the Allies rolled towards Berlin. The German army capitulated on 7 May and by the first week in June the two ill-assorted men had the necessary papers to go. Pocock later became a distinguished Fleet Street journalist and biographer, but he now admits he was too inexperienced for this assignment and didn't know how to direct his companion towards newsworthy subjects. He had not met Peake before but thought he might have seen him around prewar Chelsea 'in his dashing Bohemian dress – beret, cloak and ear-rings' or later dining with Maeve at the Blue Cockatoo restaurant. He knew Peake was his elder by fifteen years, married to a pretty wife and father of two children, and when Pocock went round to the Trafalgar Studio in Manresa Road he found him 'a lean, slightly stooped man with black, sprouting hair and a narrow deep lined face in which dark troubled eyes were set close. His manner was friendly, slightly diffident; gentle but also masculine. One could sense that he had been an appallingly helpless soldier – he was reputed to have saluted with his left hand when he remembered to salute at all – and as our preparations progressed it became obvious that the little disciplines and formalities of military life, which I took for granted, were, to him, bewildering irrelevancies.'[6] Pocock took over the management of the expedition and Peake merely packed his artist's materials of paper, charcoal and pencils. He took no colour and planned to work up his sketches when he returned home.

Pocock was being paid 5 guineas a week for his efforts and presumably Peake would receive something similar, but money was not a problem since travel was free – there was always an empty seat or two on aircraft or in a jeep, and they could eat in army messes and stay at war correspondents' camps, often in requisitioned hotels. They flew from the airstrip at Northolt in an RAF Dakota to Paris (Peake's first flight) and stayed at the hôtel Scribe (near 'L'Opera 'ouse' he told Maeve) which was the American press camp. They had been told to report on the US 15th Army rather than on British troops, who were already being covered by more glamorous and experienced war correspondents.

Peake found Paris drab and full of Americans, though the women still wore exotic hats and the night clubs and brothels were open. They visited a couple of seedy cabarets where Peake drew the band, a Negro drummer and topless showgirls. He reported home that he'd been to a dozen art galleries and pinched the catalogues to show Maeve when he returned. The best was of 'one of my favourite painters of whose work I have seen so little – Pascin – the one and only Gabrielle Pascin. There were about three which took my breath away. Painted very thinly they blushed, as it were, with subtle pinks and blues and umbers and fawns and lichen greens.' Presumably he means *Jules* Pascin (1885–1930), a Bulgarian member of the School of Paris and specialist in female nudes.

From Paris the pair flew to Mannheim and then journeyed by jeep to Wiesbaden. He saw the Rhine valley, which he described to Maeve as 'alive with castles . . . It was Grimms' Fairy Tales – a legendary thing', but there were sunken boats in the river and refugees pushing handcarts on all the roads. The further they penetrated into the defeated Germany, the more they felt the hatred of the population.

> One young heavily built German we passed gave us a look of the intensest malice and clapped his hand to his hip as though to draw a symbolic revolver. The children put out their tongues or jeer and whistle. It is a new thing for me to see hatred so manifest. I also saw a boy whose face looked about 16 but whose hair was grey, who was hobbling down the steps of the town-hall-looking building with a crutch and only one leg.

He drew a youth in lederhosen: 'it was the complete bully, rather puffy, impregnated with the whole spirit of Nazidom' and a woman recruit, 'a huge specimen with a mass of yellow gold hair'. Fraternization with the Germans or the streams of displaced persons was forbidden but their hostility and refusal to meet his gaze, or their openly vicious stares, began to depress him. Pocock felt it necessary to carry a Luger pistol on their outings round the devastated towns. Mervyn's propaganda 'Hitler' drawings were coming to hideous life before his eyes.

As a diversion they were sent to Aachen where the bones of Charlemagne were to be restored to the cathedral by the US Army. Peake didn't take this too seriously: 'The golden sarcophagus containing the remains of Charlemagne (12th century saint?) (sort of German King Arthur) was brought from hiding into the Cathedral – and there were Tom and I and four high ranking American officers sitting in the

front row along with the Bishop of Aachen (in his glad rags) watching
old Charlemagne brought forth. Also a Hand of Gold, in which Ch's
actual scull [*sic*] was supposed to be – and in another Golden Arm (sur-
prisingly like the arm of a golden giant giving the Nazi salute – was the
actual arm (so they say) of the old boy. They certainly took him to
pieces!!!'

Aachen was one of the most badly damaged of all German cities,
having been subject to heavy street fighting and siege. The hotel they
were directed to was 'down the only street not choked by rubble and . . .
the only house with glass in the windows'. They were followed by
unseen watchers on their excursions into the ruins and soon retreated.
One sign of hope was a visit to the first school to open again free of
Nazi indoctrination. They sat in with a class of six- to eight-year-olds
reciting nursery rhymes, Mervyn at the teacher's desk drawing the back
of her head and the faces of her pupils. He reported to Maeve:

> What struck me so much was that they were so obviously happy
> and possible to mould into a healthier outlook and conception of
> life than would have been the case had we not won the war . . . one
> feels like putting the blame on the teachers who allowed their text-
> books to be riddled with totalitarian propaganda – for everything
> seems to depend on the first ten years or so – after that the outlook
> has to such a great extent been formed for life.

He must surely have been thinking of his own healthy children as he
watched these pale and ragged German ones.

By now the two of them were settling into more of a team. Pocock
observed that his companion was introspective and homesick, con-
stantly writing to Maeve, and did not mix with the other men they met
in the army messes. On the other hand, Pocock thought, 'he had the
gift of establishing friendship' because people found him gentle and
easy to approach and his sketching drew them to him. He also gained
the impression then, reinforced later, that Peake was avid for recogni-
tion and single-minded in his pursuit of it. Peake told Maeve: 'I like
Tom very much. He is completely unsophisticated – almost like Goaty
in some ways. A bit deaf which is rather annoying at times. But I still
think he's got a flair for journalism.' The pair were kitted out with
impressively glossy boots they'd purchased in Bond Street and Peake
flaunted a red scarf which he'd picked out of a deserted cupboard in

Wiesbaden to jazz up his khaki battledress. From the US army stores he had acquired fourteen pairs of socks, new shoes, a canvas bag and a rainproof field jacket. In spite of these bargains he was getting very fed up with Americans, as he told Maeve: 'Exquisite darling . . . How exciting to know you're not American – I've had so much of them and so many of them couldn't be more pleasant and friendly but oh God how dull and how wearying the voice gets. I suppose they think the same about us.'

The Americans suggested that their next assignment should be to cover the first war trial. They took a jeep through Cologne where, Peake wrote to Maeve, 'in the city I smelt for the first time in my life the sweet, pungent, musty smell of death. It is still in the air, thick, sweet, rotten, penetrating.' He was impressed that 'out of the blanket of ruins rears up the fantastic double-spired front of Cologne cathedral . . . a tall poem of stone with the sudden, inspired flair of the lyric and yet with the staying power, mammoth qualities and abundance of the epic'.

Four Germans were accused of murdering an American airman who had machine-gunned their village then parachuted from his damaged Liberator bomber. The main accused was a thirty-five-year-old crippled tailor called Peter Back and, after due process of law, the four men were condemned to hang. Peake sat close enough to observe their tears as the verdict was read out. He thought the proceedings fair and 'made a lot of drawings of the German witnesses as they came in and were cross-examined'. He also drew the portly lawyer who defended Back and sought to explain the way his background had warped him and that 'to know all is to forgive all'. Peake felt the awfulness of a life being on trial: 'there but for the grace of God go I'. To Maeve he tried to explain: 'There seemed a skin over the tragedy, though it seemed no less tragic to me because he is guilty and was obviously a petty tyrant of the meanest kind . . . one could see by his tiny lipless mouth, his black close-set eyes and mostly bald head'. For Peake a man's physiognomy not only reflected his character but determined it too. An hour before going to draw Back in his condemned cell he wrote: 'It seems terrible and I feel horrible about it, in a way, but it seems to me as a record of the typical, merciless Natzi [sic] it may be of some kind of value. However wicked the person one feels the loneliness that a condemned man must have.' The two Englishmen were taken along the stone prison corridors and Back's cell door swung open. He sprang to attention and was told that the British artist would draw his portrait. Mervyn got him to sit down and sketched as quickly as possible.

It was quite absurd as well as poignant to see the way he obeyed every order almost before it had been given – moving about stiffly like a dummy, his paralysed leg moving with him and as it were dictating a stiffness to all the rest of the body. My drawing him made no kind of impression on him in the sense of pride being hurt or anything of that kind – it was I should think a relief from the monotony of his cell – he stood like a piece of wood, absurdly stiff and motionless as though about to be shot. His intelligence couldn't be very high for when I gestured with my hand for him to turn his head a bit more to the right, he turned himself completely around like an automaton and faced the wall.[7]

They turned down invitations from the Americans to see the four criminals hanged, though other reporters and photographers were not so squeamish and a five-page illustrated account of the executions appeared in *Life* magazine.

As a civilized interlude between two grim experiences they visited devastated Hamburg where the Old Vic company were touring *Richard III*, *Peer Gynt* and *Arms and the Man* to the Allied forces, performing in a theatre that had survived fire-bombing. Pocock was related to Sybil Thorndike, one of the stars, and Peake knew Joyce Redman, a supporting actress. Laurence Olivier and Ralph Richardson shared the male leads. Peake was allowed to sketch from the prompter's box and afterwards go backstage to draw the cast. Olivier posed in his King Richard costume looking like a vicious rooster with his comb-like hat and false beaky nose – a drawing which ended on the walls of the Garrick Club. Peake admired the costume dagger Olivier was wearing, only to be shown its silver swastika: it had been the ceremonial dagger of an SS officer. Later he would remind Olivier of this friendly encounter when he wanted a play of his own, *The Wit to Woo*, to be produced and preferably acted in by Olivier and his wife, Vivien Leigh. This ENSA company had just returned from a visit to Belsen where they had performed *Arms and the Man* for the soldiers and medical staff. What they found there had deeply sickened them all. A descent into this hell was to be Peake's next assignment, 'without which I will not feel my conscience clear'.

Before he went he wrote to Maeve:

It is in my mind to do this work I set out for and I feel in a way that I am beginning to get its implications into some of the drawings

Laurence Olivier as Richard III, black chalk and grey wash,
34.5×28.5cm, 1945

already. Probably in Holland I will see the horror of malnutrition
and the result of cruelty. Interesting and important as this work is
I know that I am really a painter, a painter of what is to me beau-
tiful which has nothing to do with the passing phases of history,
but makes use of such things, when they apply, to something
deeper in myself, something which I think has a permanent value
. . . these things which will become part of a history book in years
to come. Art is more than history – it is a living, breathing, self-con-
tained and permanent statement of beauty – and I suppose that is
why I look back at the black piano [one of Maeve's paintings] as
something big and more important than all those things here.

Such detached idealism was about to be severely shaken.

After the British Second Army had crossed the Rhine in spring 1945
they received a warning that typhus was rife in the nearby concentration
camp of Belsen. On 15 April troops entered the camp and were appalled

to find, in round figures, 60,000 prisoners in huts meant to house 4,500 and 10,000 unburied corpses. Between 400 and 500 inmates were then dying each day from starvation, tuberculosis, oedema, enteritis and typhus. Within two days the camp was evacuated and a hospital set up in the former guards' barracks. Then the mass burials in pits began, and were completed by 28 April. On 19 April Richard Dimbleby broadcast his outraged account to the British public, sparing them none of the sickening details; in another broadcast, one month later, he confessed that the experience would change him for life. By the 20th the Royal Army Service Corps had taken over administration and set up five kitchens, though many of the inmates could tolerate only the smallest amounts of food in their shrunken stomachs. Next the filthy prison huts were burned and their inhabitants de-loused with the help of the Red Cross and Quaker Relief. Ninety-seven volunteer medical students arrived from London and by 11 May the daily death rate had fallen to 100. On the 19th, only one death was recorded. At the end of May the London medics were replaced by Belgians. In total 45,000 had died in this hideous prison between 1942 and 1945, 13,000 of them after liberation. By September 1945 the last inmates were able to leave and on the 6th the camp was closed and the trial of forty-five of its captured guards began.[8]

The War Artists' Advisory Committee quickly realized that this horrifying place needed to be recorded and sent Leslie Cole, who had already recorded atrocities inflicted by Greeks on Greeks after the German withdrawal. Now he drew the German guards being forced to collect the bodies of their victims and convey them to the death pits. The horrors were photographed and so widely reported in the world press that politicians and others, such as the Old Vic Company, had begun to make Belsen almost a popular place to visit.

Peake arrived at the camp on 20 June after Cole had left. By that time the squalid huts had been put to the torch, the dead buried and a clean orderly hospital established with Belgian staff. Nevertheless it was a profoundly disturbing experience. Pocock dropped him off at the gate in the morning to be dusted with insecticide and then went off to swim and sunbathe, 'thinking there would be no horrors to describe so many weeks after its liberation'. He picked Mervyn up about six hours later in a big Humber staff car and saw that he had done numerous sketches and drafted a poem, which he asked Pocock to read. Next day Peake too went to lounge in the sun on the white lakeside sand near Plon and to write his daily letter to Maeve:

Yesterday I was at Belsen of which I won't write but will tell you of when I return. It has made a very deep impression on me. I went into what were the SS barracks and are now hospital wards and saw some of the victims. I think I could only do justice to what I felt in the most powerful poem I have written – certainly it would have to be finer than anything I've done otherwise I would not want to write it as it was most poignant and heart-rending. To be sitting here the next day in a dream-idyll of a place seems strangely ironic.[9]

Overnight he had arrived at a position close to Vladimir Nabokov's: 'Beauty plus pity – that is the closest we can get to a definition of art.'

The poem, 'The Consumptive', was indeed one of the most powerful he had written though it is as much about his own guilt at his intrusion as it is about the dying girl's suffering. He continued to revise it so that it now exists in several versions, varying in length from 28 to 41 lines, but central to each is the dispassionate artist who continues to see painterly possibilities even as he watches the girl cough out her last painful breaths. It begins:

> If seeing her an hour before her last
> Weak cough into all blackness I could yet
> Be held by chalk-white walls, and by the great
> Ash coloured bed,
> And the pillows hardly creased
> By the tapping of her little cough-jerked head –
> If such can be a painter's ecstasy,
> (Her limbs like pipes, her head a china skull)
> Then where is mercy?
> And what
> Is this my traffic? for my schooled eyes to see
> The ghost of a great painting, line and hue,
> In this doomed girl of tallow?

He seemed to have in mind a Whistlerian 'Symphony in White' and noted too the colour contrasts as the eyes like black water 'shone in their wells of bone' in the white garden of her face:

> And very wild, upon the small head's cheekbones,
> As on high ridges in an icy dew,
> Burned the sharp roses.

He fears that he will be unable to feel and remember her agony – 'am I a glass that grief can find no grip?' – and wonders whether his anger and pity will dull and the nightmare pass. He vows:

> Though I be glass, it shall not be betrayed,
> That last weak cough of her small, trembling head.

Later he wrote another poem on the same theme, 'Victims', which concludes that deaths like these are hard and terrible:

> In twisting flames their twisting bodies blackened,
> For History, that witless chronicler
> Continued writing his long manuscript.

Peake's drawings are moving because of their harrowing subject matter – it seems presumptuous to pass judgement on them as art. The dying girl with her bulging but unseeing eyes could only be looked at in profile as he sat at the foot of her bed, and the full-face wash drawing 'Belsen Victim', showing the huge eyes, cropped hair and exposed teeth, must have been drawn after he left the camp but while his impressions were still vivid.

Other artists had made deathbed sketches, notably Egon Schiele and Claude Monet of their dying wives, and we know that Peake had sketched his own mother in her last hours. Monet admitted to his friend Clemenceau, of his picture *Camille Monet on her Deathbed* (1879), 'I caught myself, with my eyes focused on her tragic temples, in the act of automatically searching for the succession, the arrangement of coloured gradations that death was imposing on her motionless face. Blue, yellow, grey tones, who knows what else? That was the point I had reached. Nothing is more natural than the urge to record one last image of a person departing from this life. But even before I had the idea of recording those features to which I was so profoundly attached, my organism was already reacting to the colour sensations, and in spite of myself, I was involved by my reflexes in an unconscious process in which I was resuming the course of my daily life.' The pursuit of colour sensations was, Monet wrote, 'my day-long obsession, joy, my torment' and it had overcome his compassion.[10] Monet carried the guilt of being an artist first and a grieving husband second for the rest of his life. But Peake's nameless Belsen victim was a

Girl dying of consumption at Belsen, a month after the Burning,
ink and wash, 40×32cm, 1945

stranger who had given this foreigner no permission to sit by her bed and make art from her last moments of agony. His eyes 'mint gold,' whether he wishes them to or not, 'and beauty's metal weighs upon the heart'. Peake's poem records his moral dilemma with considerable delicacy.

Curiously, this guilt was inherited by Peake's son Sebastian who wrote: 'Expunging complicated feelings of guilt about the way in which my father had accepted his visit to Belsen, when he could have turned away on being dropped at the gate on that dark day in 1945, was almost an obsession with me for over 20 years.' He read all the Holocaust literature and systematically visited all the camps – Belsen, Treblinka, Auschwitz, Chelmno . . . After a time, he concluded: 'However well intentioned my visits were essentially an emotional kind of voyeurism. I felt very ambivalent about my father's work at Belsen because my admiration for his total genius does not excuse the circumstances of his visit.'[11]

Peake, perhaps sensing that he had created something out of the ordinary in his poem and the drawings of the dying girl, confided to Maeve his thoughts on the rest of his work:

I have been thinking a great deal about my painting too and Groan. Somehow I feel that when I start them both again it will be with terrific gusto. I think the curious restraints which Leslie Hurry mentioned, will be flung to the winds and that I will break out into a great and glorious rash of work in the way that you have done (interrupted by dinner gong). Groan I feel could grow giant, imaginative wings, flare out majestically, ludicrously, fantastically, earthly, gloriously into creation, unlike anything else in English literature. Sweet Maeve I long for our meeting and our first kiss.

He reported that he had passed near some of the places Maeve had known before their marriage. She had tried to contact her former German hosts only to learn that Burg Hemmerich had been burned down to its Roman wine cellars and that her best friend there, Waltraut, had died of kidney failure, though the Baroness survived. After Belsen Peake seems to have lost interest in his trip, or perhaps he became depressed by the sights he had witnessed and the continuing rancour of the defeated native population. The tour resumed with visits to the German battleships and U-boats sunk in Kiel harbour, then on to the prisoner-of-war camps in Schleswig-Holstein which contained up to half a million Wehrmacht troops and SS concentration camp guards,

but Peake did little sketching. Nor did he when they moved on to Amsterdam and Brussels, from where he flew home with a sigh of relief. In a land of hatred he had missed Maeve's love and his letters were full of his longing for 'your brown and corn coloured hair, your hazel gold eyes, your top lip that curls like a petal and your other lip that is so plump and kissable'. Her twenty-eighth birthday had occurred while he was away and he promised they would have another on his return: 'May I be at all the other ones, and may that mean at least 60 more of them. I will still love you when I become the dirty habited old man you picture I will become.'

Before he could get down to painting and writing, Peake had to work up the German drawings for publication. On 30 June the *Leader* published an account of the travels entitled 'Hitler's Problem Children' with Pocock's words and Peake's drawings. The article recounted the continuing acts of sabotage and revenge by young German hooligans and the hope the two men had felt when they visited the schoolroom in Aachen. Peake's drawings showed the children's lesson, but also a Nazi

17 years, charcoal, 38×32cm, 1945

youth lounging nonchalantly against the concentration camp posters asking 'Wessen Schuld?' (Whose Guilt?) In the 14 July edition, four of Peake's slight cabaret sketches and a weakly drawn street scene accompanied the article 'Paris Celebrates' by R. C. Knight. Solider and more humane were the ten drawings of British soldiers (some from Peake's own time in the army) which accompanied 'European Notebook' by Tom Driberg in the 4 August issue. When Driberg later married, Peake gave him one of these as a gift. Perhaps the editor, Charles Fenby, thought he hadn't got his money's worth from these few drawings and Pocock's single article and there were no more commissions from the *Leader*.

Peake was probably relieved to turn his back on the war and concentrate on his own work. This would now have a sharper, pessimistic edge, his portrayal of evil no longer spun from his reading and dark imaginings but from experience; and it would be all the more credible for that. He had seen a murderer, felt real loathing directed at himself, walked in cities bombed to rubble and seen women die in a camp built to exterminate whole races. It would be impossible to hold some millenarianist belief that mankind could be reformed by an appeal to reason. His new view would filter through into such works as *Boy in Darkness* and *Titus Alone*.

9 Novelist, 1946

Maurice Collis (1889–1973) took an Oxford degree in history and then spent a long time as a civil servant in Burma before returning to England and emerging as a novelist, dramatist, painter and art critic. He wrote seventeen books between 1934 and 1949 and began to keep diaries in 1949. In these, Peake features as a friend and collaborator. Collis' invitation to illustrate his *Quest for Sita* (Faber and Faber, 1946) came after he had been impressed by Peake's drawings in an exhibition. A free adaptation of the Sanskrit epic, the *Ramayana*, this book tells of the abduction of Sita from her husband Rama by the 'decacephalous monster' Ravana to be a member of his gynecium in the Kingdom of Lanka (Collis was as fond of abstruse words as his illustrator). Rama, with the help of a monkey army and the godly vultures, Jatayus and Sampati, rescues her. This basic story is framed by one about the peasant girl Swallow and the Emperor's son, who were Sita and Rama in a previous incarnation.

Peake chose not to illustrate the story's fabulous events literally but to invent decorations which combine Indian eroticism and Chinese ornament, though curiously the first drawing does not appear until page 44, with thirty-one in the next hundred pages. The hand-made paper, buckram binding and printing are very rich for those austere times and Peake must have enjoyed the challenge – it was the nearest he came to a *livre de luxe* in the French manner. He invented a new

style: a single flowing voluptuous outline for the hairless dancing nudes, contrasted with knots of intricate detail in headdresses and earrings. He had fun inventing a naked contortionist and a female acrobat hand-standing on a skull and, unusually for Peake, there are male nudes too, impossibly muscular giants pulling bows, tumbling off their wild horses pierced by arrows and flinging themselves around like saints on a baroque ceiling. Evil dwarfs, fantastically armoured monkeys and grotesque oriental beasts which might be distant cousins to lions or Pekinese dogs have been concocted from his Chinese memories, together with an oriental sage wringing water from his beard.

The cool eroticism and air of elegant decadence have obvious parallels with Beardsley's work, but more recently Cocteau had invented a similarly sinuous line to depict the naked body. For Peake it was a one-off style suitable for no other book, but a highly successful one. The *Sunday Times* reviewer thought 'words cannot convey the airy, free, emphatic calligraphy of Mr Peake's astonishing line drawings' and the

Quest for Sita, 1946. Contortionist, pen and ink, 27×21cm

Listener found that 'Mervyn Peake's delicate and sinuous line draw-ings . . . are very effective when illustrating the more grotesque aspects of the story, when his malicious invention seems to have no limits'.

This supernatural world of talking beasts, gods, magic events and erot-icism Peake must have found a welcome alternative to the crepuscular and tormented one he was creating in his own work. It had been such a long struggle to conceive and write the Gormenghast book because he had been shifted around England so much, but all seemed well when his friend Graham Greene offered to read it with a view to publication by Eyre and Spottiswoode. Imagine, then, Mervyn and Maeve's devas-tation when they received the following undated letter on Reform Club paper:

Dear Peake,
You must forgive me for not having written before, but you know it's a long book.
I'm going to be mercilessly frank – I was very disappointed in a lot of it and frequently wanted to ring [*sic*] your neck because it seemed to me you were spoiling a first class book by laziness. The part I had seen before I of course still liked immensely – though I'm not sure it's gained by the loss of the prologue. There it seemed to me one entered a long stretch of really *bad* writing, redundant adjectives, a kind of facetiousness, a terrible prolixity in the dialogue of such characters as the Nurse, Prunesquallor and sentimentality too in the case of Eda [Keda?] and to some extent in Titus' sister. In fact, frankly again – I began to despair of the book altogether, until suddenly in the last third you pulled yourself together and ended splendidly. But here you were so damned lazy that you called Barquentine by his predecessor's name for whole chapters.
I am hitting hard because I feel it's the only way. There is immensely good stuff here but in my opinion you've thrown it away by not working hard enough at the book – there are trite nov-elettish phrases side by side with really first class writing. As it stands I consider it unpublishable – about 10,000 words of adjec-tives and prolix dialogue could come out without any alteration to the story at all. I want to publish it, but I shall be quite sympathetic if you say 'To Hell with you: you are no better than Chatto' and prefer to take it elsewhere. But at least I can claim to have read it

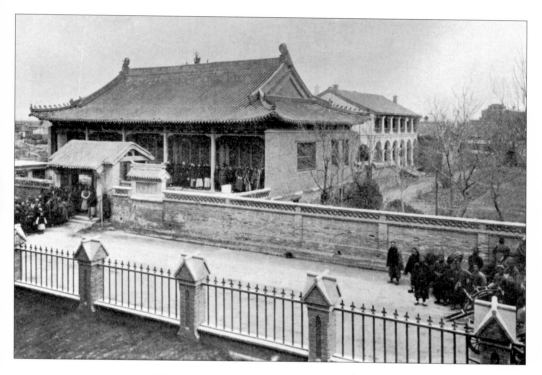

1. The Mackenzie Hospital, Tientsin, 1912

2. Men's ward at the Tientsin Hospital

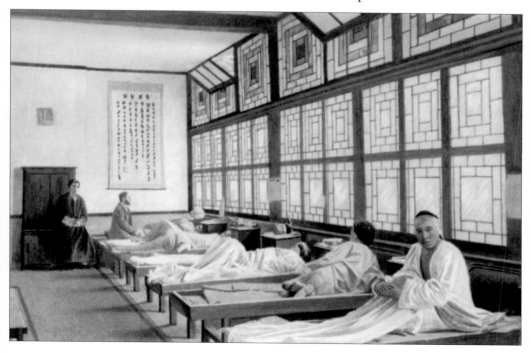

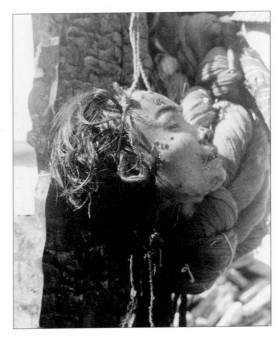

3. The severed head photographed by Dr Peake in Hankow, 1911

4. The mountain resort of Kuling

5. Mrs Peake with Mervyn and Lonnie at Poole, Dorset, 1915

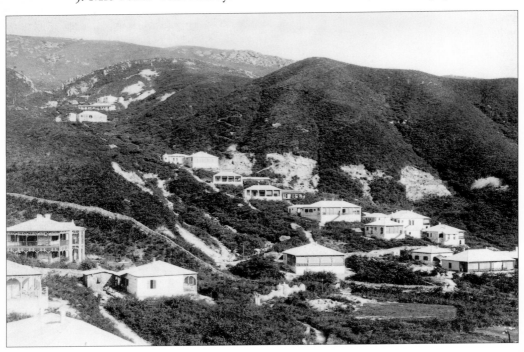

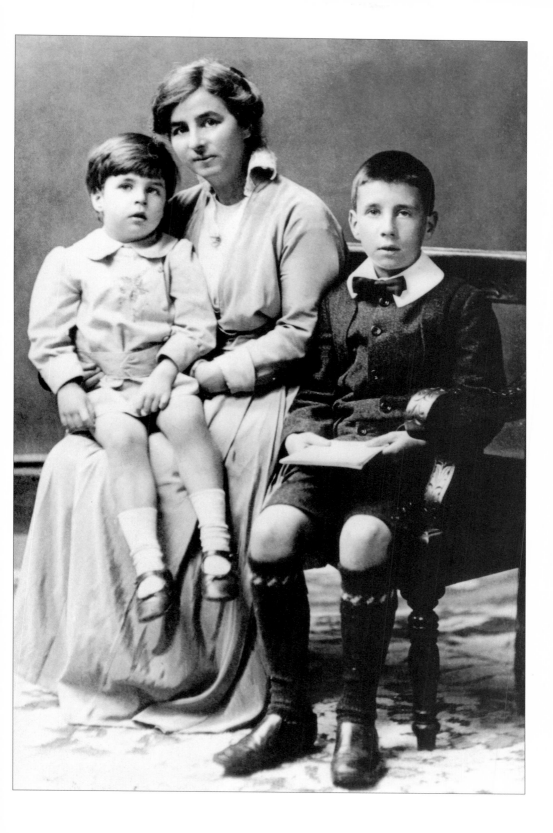

6. Mervyn (*right*) with Lonnie, *c.*1918

7. Mervyn with his father, Tientsin, *c.*1920

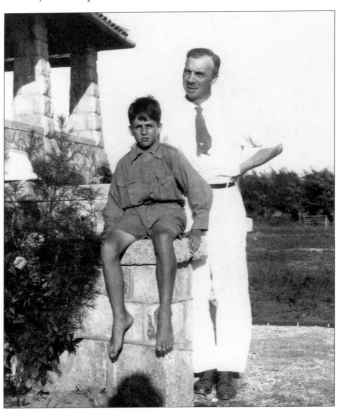

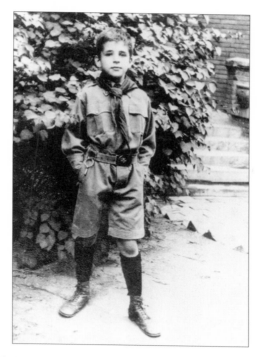

8. Mervyn as a Cub Scout, Tientsin, *c.*1921

9. Eltham College Rugby XV, 1929. Mervyn is second from left in the back row

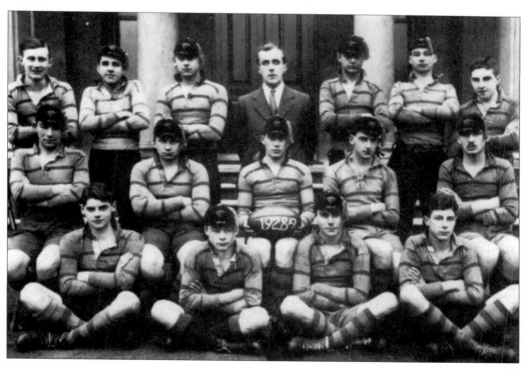

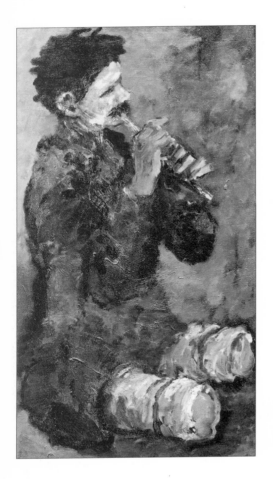

10. *Man with Stumps Playing Pipe,*
oil on canvas, 92 x 52cm, *c.*1932

11. *Hotton,* a Sarkese fisherman,
92 x 60cm, 1933

12. *Old Man and Child,* oil on
canvas, 69 x 86.5cm, 1933

13. Mervyn in the studio above the
Sark Gallery, 1933

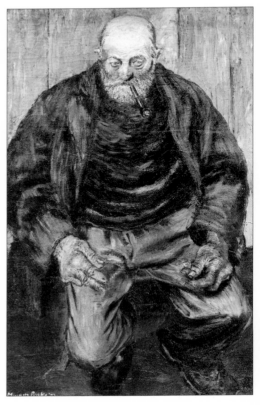

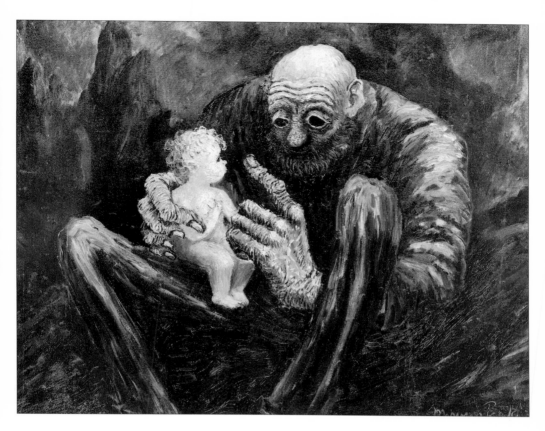

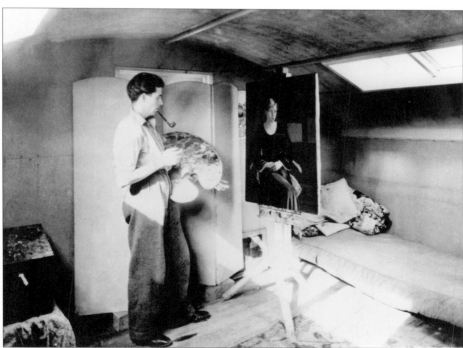

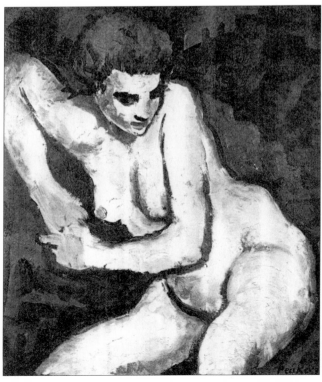

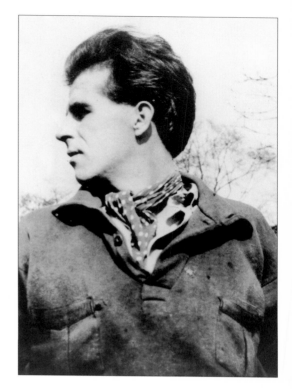

14. *The Avenue, Sark*, oil on canvas, 60 x 40cm, 1934

15. Study of Maeve, oil on canvas, 75 x 63cm, 1937

16. Mervyn *c.*1937, not long after he first met Maeve

17. Mervyn and Maeve on their wedding day, 1 December 1937

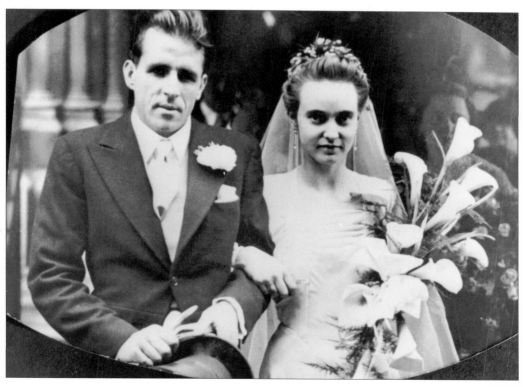

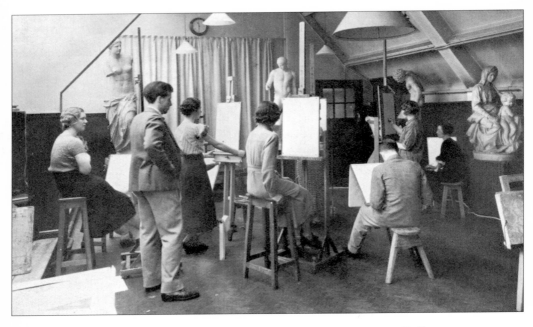

18. Mervyn's drawing class: from the Westminster College prospectus for 1937–8

19. Maeve and Sebastian at Warningcamp, summer 1940

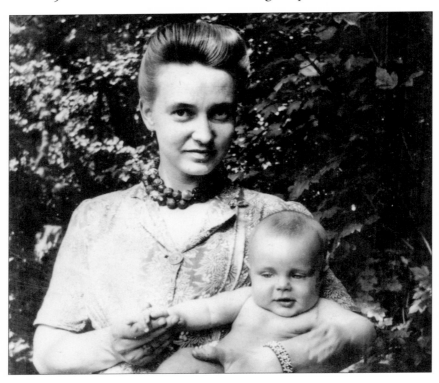

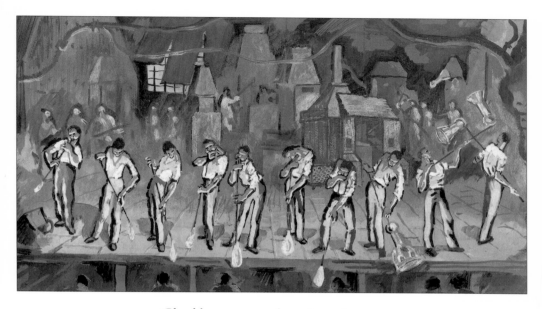

20. *Glassblowers*, gouache, 38.5 x 69cm, 1943

21. Drawing in Germany, June 1945

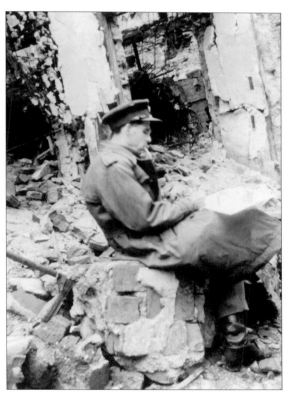

22. *In a Soho Bar*, oil on canvas, 75 x 60cm, 1944

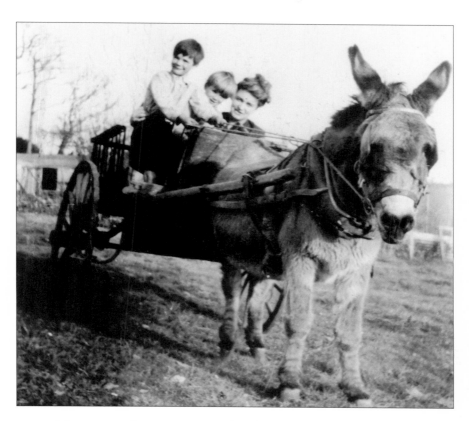

23. Sebastian, Fabian, Maeve and Judy the donkey on Sark, *c*.1948

24. Mervyn with Clare, Sark, 1949

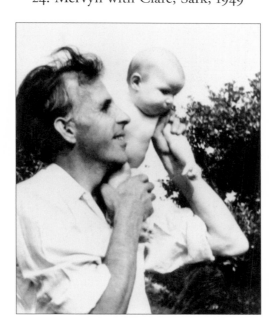

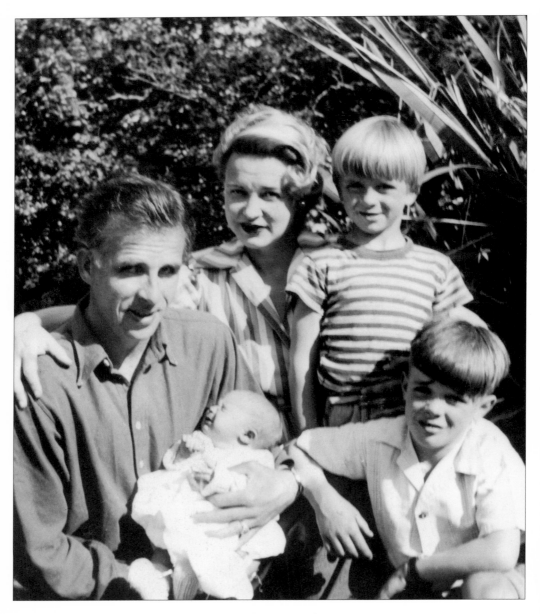

25. The Peakes on Sark, 1949

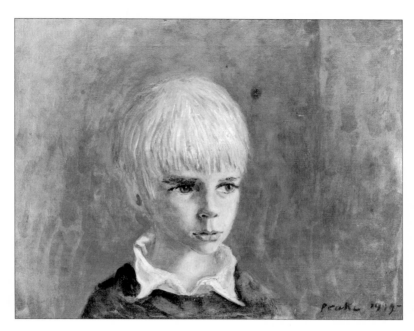

26. Fabian, oil on canvas, 41 x 51cm, 1949

27. 'Goaty' Smith and Mervyn, 1953

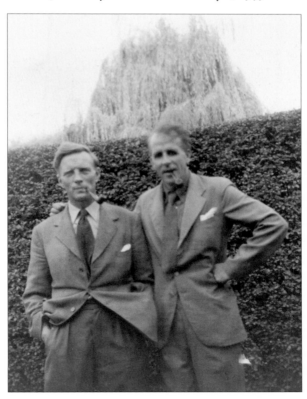

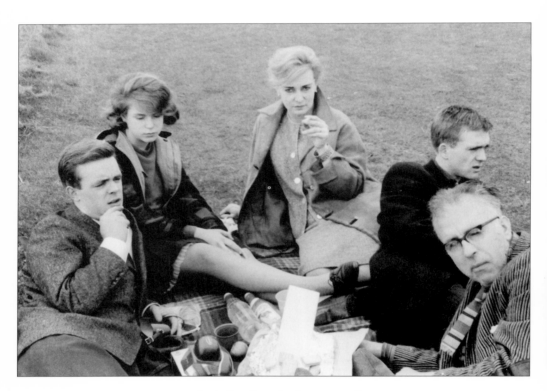

28. A family picnic *c.*1957–8

carefully and do beseech you to look at the MS again. I began by putting in pencil which can easily be rubbed out brackets round words and phrases which seem to me redundant, but I gave up after a time.

Write and let me know how you feel about all this. If you want to call me out, call me out – but I suggest we have our duel over whisky glasses in a bar.

Yours Graham Greene[1]

Greene's opinion had to be respected: he was older and a novelist established in both popular and critical esteem and when Peake reluctantly got down to it, with Goaty's help, he found that wielding the blue pencil was actually a creative rather than a destructive exercise. He later said that a third was cut away from the twelve volumes of manuscripts and it had to be typed five times, so many amendments did he make.

As he wrote, Peake had drawn the characters in the margins as an aid to seeing them in his mind's eye and hearing their voices, so now he suggested that he provide portraits, full-face and profile, of all the major characters. After all, he had spent many hours illustrating other men's books so why not his own? Peake's publisher wisely rejected this offer on the grounds that this would set the book apart from all the other adult fiction in a kind of 'ivory tower'. When Matthew Smith, the painter and Peake's Chelsea neighbour, received his complimentary copy he wrote: 'Not to have illustrated it is alone a stroke of genius!'[2] Anthony Burgess, a fellow novelist and Peake admirer, later concurred: 'This strange book, like Wyndham Lewis' novels, has the kind of three dimensional solidity which we often find in pictorial artists who take to words: it is so intensely massive, even ponderous, that illustrations would have been supererogatory.'[3] If most Peake enthusiasts now accept that the book is better without Peake's drawings, then it is not surprising that they also want to do without some of the awful illustrations and covers by lesser artists which have been foisted on the book in later editions.

J. R. R. Tolkien put forward an argument against the illustration of fairy stories which would apply equally well to the Grimms' *Household Tales*, *Quest for Sita*, his own *Lord of the Rings* and indeed the whole Titus Groan trilogy:

If it [literature] speaks of *bread* or *wine* or *stone* or *tree*, it appeals to the whole of these things, to their ideas; yet each hearer will give to them a peculiar personal embodiment in his imagination.

Should the story say 'he ate bread', the dramatic producer or painter can only show 'a piece of bread' according to his taste or fancy, but the hearer of the story will think of bread in general and picture it in some form of his own. If a story says 'he climbed a hill and saw a river in the valley below', the illustrator may catch, or nearly catch, his own vision of such a scene; but every hearer of the words will have his own, and it will be made out of all the hills and rivers and dales he has ever seen, but specially out of The Hill, the River, The Valley which were for him the first embodiment of the word.[4]

Peake might have agreed with this Platonic view in theory, but he would have been out of work if he had followed it in practice.

Eventually, after six years of work the book, now entitled *Titus Groan,* achieved a publishable length of around 200,000 words and was

Quest for Sita, 1946. Buffoon, pen and ink, 27 × 21 cm

launched on 22 March 1946. After several variations along the way the story's plot finally went like this: Gormenghast is a vast castle set outside real history, geography and climate. Clustered round its crumbling walls are the clay dwellings of a peasant breed of Bright Carvers who are admitted to the castle grounds only once annually, when all but three of the carvings they have worked on all year are ceremonially burned. Those who live within the walls are ruled by an elaborate but empty set of rituals established generations before, but no gods are evoked or placated by these tedious observances – Gormenghast is a moral vacuum the gods have long since left. The melancholy Sepulchrave, 76th Earl of Groan, and his wife Countess Gertrude are the titular rulers and it is on the day when their son, Titus, is born that the book begins. By the last chapter Titus is eighteen months old and the stultifying society he was born into has begun to disintegrate badly: 'something was changing – changing in a world where change was a crime'. There has been speculation that Peake took the name of his hero from *Titus Andronicus*, the bloodiest of Shakespeare's plays, but people forget that one of Peake's favourite artists was Rembrandt, whose only son was called Titus.

Steerpike, a seventeen-year-old kitchen boy with 'a disrespectful nature', emerges to scheme for his advancement by manipulating Sepulchrave's twin sisters, Clarice and Cora, into burning Sepulchrave's beloved library so that he, Steerpike, can appear to rescue the Earl's entire family. Several violent deaths occur: the Earl's valet, Flay, murders Swelter the obese cook; Sourdust the Master of Ritual is burned to death; Sepulchrave himself goes mad and is eaten alive by owls, and Titus' peasant wet-nurse, Keda, sees her two lovers fight to the death with knives and then, after giving birth to an unnamed girl (the Thing) she jumps over a cliff. Surviving these convulsive events is Fuchsia, Titus' lonely teenage sister who feels the attraction of Steerpike's energy but is repulsed by his brutality. Her protector is Dr Prunesquallor, a rather camp wit with a good heart and brain but burdened by a silly spinster sister, Irma. Flay is exiled for throwing a cat at Steerpike and the Countess remains aloof from most events (including the raising of her son) which do not involve her cats or birds. There are minor characters such as Nannie Slagg, a hermit, a gardener, and a poet. The book opens and closes with someone who has taken no part in the action, Rottcodd, Keeper of the Bright Carvings – his name derived from 'Doctor' backwards, a joke Peake's father would have appreciated.

The story is punctuated by four ceremonies or tableaux, each of which goes wrong in a different way – a christening, a gathering in the

library, the Dark Breakfast and finally the Earling which makes the infant Titus the 77th Earl of Groan. Ominously, he does not perform his ritual duties correctly. Much of the book had been expository, establishing a setting and opposed characters who would need a sequel to work out their conflicts. After all, the eponymous hero had yet to speak so the whole book might be seen as a prologue to his life story, which Peake thought might stretch into old age and occupy many volumes. The final two paragraphs tell us:

Through honeycombs of stone would now be wandering the passions in their clay. There would be tears and there would be strange laughter. Fierce births and deaths beneath umbrageous ceilings. And dreams, and violence, and disenchantment.

And there shall be a flame-green daybreak soon. And love itself will cry for insurrection! For tomorrow is also a day – and Titus has entered his stronghold.

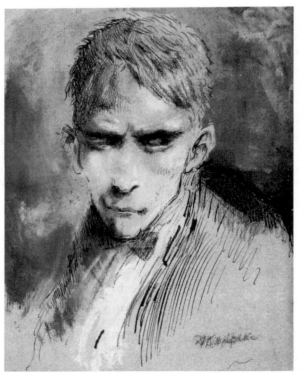

Steerpike, ink, pen and wash, chalk, 26.5×21cm

Peake was persuaded not to add 'Nevertheless' as the final word. Asked to provide a blurb he suggested the teasing: 'The Life of Titus Groan, it is, and is not, a dream.'

This book and its two sequels are the reason for Peake's cult following. He attracts the kind of reader who can enjoy Dickens' leisurely opening to *Bleak House* where he describes 'the implacable November weather' and the fog rolling up the Thames, or tolerate Hardy's delineating Egdon Heath for a whole chapter at the start of *Return of the Native*, and so can relish a book which begins: 'Gormenghast, that is, the main massing of the original stone, taken by itself would have displayed a certain ponderous architectural quality were it possible to have ignored the circumfusion of those mean dwellings that swarmed like an epidemic around its outer walls,' and then goes on for five more pages of exposition before a character speaks. Other readers will slam the book closed and never return.

These impatient non-readers would miss the quirky details as well as the operatic sweep of events. For example, Peake deliberately teases us with his arcane vocabulary: circumfusion, calid, propinquital, recrudescent, rabous, achromatism, abactinal, ullage, gyre, polliniferous, daedal, amaranthine, chasmic – presumably all dug out of his thesaurus. Then there are the conceits: here is Swelter's voice: 'the habitual truculence of his tone and manner had today altered to something mealy, to a conviviality weighted with lead and sugar, a ghastly intimacy more dreadful than his most dreaded rages. His voice came down from the shadows in huge wads of sound, or like the warm, sick notes of some prodigious mouldering bell of felt.' There are sharp phrases: 'a ruby like a lump of anger,' and sentence-long charcoal sketches: 'The light that seeped in a dull haze through the window dragged out as from a black canvas the main bone formation of Mr Flay's head, leaving the eye sockets, the hair, an area beneath the nose and lower lip, and everything that lay beneath the chin, as part of the night itself. It was a mask that hung in the darkness.' Some observations are almost as condensed as a haiku: 'The chestnuts whitened with dust and hung their myriads of great hands with every wrist broken.'

There's all manner of word play to enjoy from Nannie Slagg's neologisms, through Prunesquallor's facetiousness, to the twins' music-hall malapropisms:

'You ought to have more pride than that, Cora. I have, although I'm gently manured.'

'Mannered, you mean,' said her sister 'You *stupid*.'

The blubbery Swelter attracts hyperbole: 'that he bled profusely could prove little. There was blood in him to revitalise an anaemic army, with enough left over to cool the guns. Placed end to end his blood vessels might have coiled up the Tower of Flints and half way down again like a Virginia creeper – a vampire's home from home'; while Irma Prunesquallor's bony hips are seen as 'capable of balancing upon their osseous shelves enough bric-a-brac to clutter up a kleptomaniac's cupboard'. Perhaps this mockery of his own characters is what Graham Greene meant by Peake's facetiousness of tone.

The reader might relish the deliberate jolt of anachronism – the castle and its society appear medieval or like the Hunan province Dr Peake toiled in, but the dress in the author's drawings and descriptions is Victorian. There are no politicians, soldiers, scientists, lawyers, businessmen, shopkeepers, newspapers or theatres but modern safety-pins, injections, medicines, celluloid, teacups and scones, liqueurs and even a sociologist creep into the text. However, nothing plugs into an electric socket. Above all there is a constant generosity of imagination so that even when it does not further the plot there are grace notes such as this when Steerpike has courageously climbed to the vast roofs of the castle and begun to look around him. Between observing the twins on the trunk of a tree growing horizontally from a castle window and the poet about to recite to the indifferent air:

He had seen a tower with a stone hollow in its summit. This shallow basin sloped down from the copestones that surrounded the tower and was half filled with rainwater. In this circle of water whose glittering had caught his eye, for to him it appeared about the size of a coin, he could see that something white was swimming. As far as he could guess it was a horse. As he watched he noticed that there was something swimming by its side, something smaller, which must have been the foal, white like its parent. Around the rim of the tower stood swarms of crows, which he had identified only when one of them, having flapped away from the rest, grew from the size of a gnat to that of a black moth as it circled and approached him before turning in its flight and gliding without the least tremor of its outspread wings back to the stone basin, where it landed with a flutter among its kind.

In this terminally crumbling society the arts and sciences have withered away, though amongst the ruins are halls once used for theatres, observatories, museums, concerts and dancing. The Bright Carvings

are doomed to the fire or an unvisited attic; the poet is heard once a year only, and though both Sepulchrave and his daughter are readers they use books only to escape from their claustrophobic official roles. A few old paintings are confined to Fuchsia's private garret and the twins have decorated the Room of Roots to no avail. The frustrating role of the artist in an indifferent world is a theme in several of Peake's books and it is a minor strand here. More fundamental is the theme of how individual freedom and identity might be achieved if one refuses to accept the function one has been assigned by the community. Does one change society from within, or reject it and leave? The hero and the villain are united in this existential search whilst the 'Thing' has an extreme animal freedom which dooms her to exile from her species – unlike the Yellow Creature, she cannot be domesticated. Titus' restless quest for selfhood runs through the whole trilogy.

Titus Groan was written during the war but is not about war and has no clear social, moral, religious or political message to offer. Peake was agnostic about religion by now and indifferent to politics, though if he bothered to vote it would probably have been for the Tories. In an England where the Labour Party had just been swept to power Peake provocatively puts these sentiments into the mouth of his villain, Steerpike: 'Don't you think it's wrong if some people have to work all their lives for a little money to exist on while others never do any work and live in luxury?' And he calls for 'Absolute equality of status. Equality of wealth. Equality of power' while 'methodically pulling the legs off a stag-beetle one by one'. However, the stagnant conservatism of Sourdust is no more attractive an alternative.

One of the book's first readers when it appeared was Gordon Smith, who promptly wrote a long 'Epistle to Mr Peake' in mock-Pope couplets, dated 9 March 1946. It identifies itself as:

> These tribute rhymes, with spavined iambs strown
> To celebrate the Coming-Out of Groan.

And continues:

> Were I a critic (which, God knows, I'm not)
> I might hold Theories: of Point, or Plot,
> Characterisation, Narrative Method; Style;
> Consistency; and 'Was the Thing Worth While?';

Influence of Dickens, Symbolism; fear;
Or 'Mr Peake and Gothic Atmosphere'.
But fortunately I need not employ
Such jargon, meaning only to Enjoy;
And recognise as quite enough that you
Have done exactly what you wanted to:
Built up a World that lives, and holds with power,
And told a tale, and taken your happy hour.
The drink's emetic, but it isn't sour.

Then ends:

My love to Maeve, and to the Dreadful Two,
Sebbie and Faded – which leaves none for you.

Titus Groan was now at the mercy of the professional reviewers, who were not all as friendly as Smith. Some were cruelly dismissive and had misread the book entirely. 'Let Gormenghast remain *sui generis*, an astonishing conglomeration of wry and writhing shapes . . . overwritten and remorselessly overcharged', urged the *Observer*; 'a mixture of bizarre and baroque writing leaves the reader fascinated yet stupefied . . . perhaps a fanciful legpull', thought the *Yorkshire Post*; 'Peake writes in bad tautological prose . . . his humour is no more than facetious . . . a large haphazard gothic mess', sneered the *Spectator*; 'Exceedingly tiresome . . . but diabolically clever, sometimes unhealthily so', the *Evening News* admitted; 'A tome of turgid verbosity . . . for dripping phantasmagoria it would be hard to beat', wrote the *Star*'s critic; 'This book is a cobwebby candle-lit escape from life', said the *Daily Herald*, and 'It represents an enormous, if psychotic, labour of pictorial imagination, redolent of hatred of the human condition, without even bitter humour, and disgust without gusto', claimed *Our Time*. The *Times Literary Supplement* critic thought it was not quite a novel: 'His flow of fancy is too little impeded by the restraints of the intellectual purpose, not to speak of the ordinary traffic of a sentiment of humanity . . . It is a fancy bred for the most part in the eye alone, seldom in the head, and hardly ever in the heart.' Even some fellow writers were unsympathetic. Howard Spring wrote in *Country Life*, '*Titus Groan* has not any ruling motive, any notion that lends coherence to the turgid struggling parts, any creation to which the impressive chaos tends', and C. Day Lewis in the *Listener* claimed he had to resort to the blurb to find out what was happening: 'Laughter is mirthless in

Study for Swelter with kitchen urchin, ink, pen and wash, 31×21cm

Gormenghast, moons are gibbous, eyes are gristle . . . the inhabitants are as grotesque as their names . . . There may be many readers who will find that, for them, the illusion is sustained throughout and a poetic truth conveyed by it. I hope it may be so, but I doubt it.' One reviewer, Edward Shanks, in the *Manchester Dispatch*, thought it far too long and while Peake's drawings could make his flesh crawl by their use of the macabre and grotesque, his prose failed to do so. Shanks' must have been the first review the Peakes read; Maeve was hurt and furious whilst Mervyn had to be persuaded not to send a telegram saying 'Shanks a million!'

Others, like Charles Morgan in the *Sunday Times*, sat on the fence:

to write of this book is an exciting and dangerous exercise. Its merits and demerits are so extreme that they divide consideration of it into tight compartments. By concentrating on one of these compartments one might give a false impression of the book's being a young masterpiece; by concentrating on another, an equally false impression that it was to be dismissed as slovenly, pretentious and absurd. Seldom have the unusually good and the unusually bad been so mingled in one volume.

Similarly, R. G. Price in the *New English Review* enjoyed it, but 'whether it is the exuberant springtime of a great writer or the first and last product of a freak genius in a blind alley is uncertain'. Maeve kept these indifferent reviews and pasted them in her scrapbook with hatred seething in her heart.

Fortunately, other critics agreed with *Vogue* that it was 'the most remarkable and individual novel published for some years'. The *Daily Telegraph* compared it to *Northanger Abbey*, and the *Manchester Guardian* admitted Peake had given a 'nightmare reality' to his monstrous castle and its inhabitants. *John O'London* had reservations about the 'laboured irony' but overall liked 'the teeming fertility of the author's invention which impels us to read on'. The *Birmingham Post* reviewer found it as enchanting as early Disney fantasies, so had obviously misread it. Peake must have been pleased to see a few professional writers rallying to praise him. Henry Reed said frankly in the *New Statesman*: 'I do not think I have ever so much enjoyed a novel sent to me for review.' He wondered if there was some contemporary satire in it which he hadn't spotted and Keda reminded him too much of Miriam, the hired girl in *Cold Comfort Farm*, but otherwise he found it an impressive first novel. So too did Elizabeth Bowen in the *Tatler*, who

thought it defied categorization: 'it is certainly not a novel; it would be found strong meat as a fairy tale. Let us call it a sport of literature, one of those works of pure, violent, self-sufficient imagination . . . poetry flows through his volcanic writing; the lyrical and the monstrous are inter-knotted in his scenes, in the arabesque of his prose.' Shrewdly she predicts it 'is not likely to have a purely neutral effect on any reader: this book must be either rejoiced in or disliked . . . I predict for *Titus Groan* a smallish but fervent public . . . such a public will probably renew itself, and probably enlarge, with each generation.'

Peake's friend Maurice Collis gave it a rave review in *Time and Tide*: 'what the reader is asked to do is watch, not think . . . watch and be hypnotised, and always surprised'. He concluded that it was 'unique in our literature, [there is] no other story to which it can be compared: no evident source from which it springs'. This was not a view taken by other reviewers, who struggled to find sources for a kind of book they had not encountered before. They evoked comparisons with Bunyan, Peacock, Dickens, Webster, Dostoevsky, the brothers Grimm, Edward Lear, Swift, T. F. Powys, the film of *The Cabinet of Dr Caligari*, the etchings of Piranesi, and most frequently of all with Rabelais. Some on this list must have come as a surprise to Peake, who had probably only read the Grimms, Dickens and Lear.

The word 'Gothic' had been much bandied about by the English reviewers and when *Titus Groan* was published in America in October 1946 it had the subtitle 'A Gothic Novel'. This catch-all term can be applied to a fifth-century tribe, thirteenth-century French cathedrals, eighteenth-century English novels, the nineteenth-century paintings of Fuseli, twentieth-century horror films, a typeface and an extrovert style of dress and make-up. It has proved less than helpful in assessing Peake's works and he always claimed never to have read anything by Walpole, Radcliffe, Beckford, Lewis, or any other of the 'Gothic' novelists satirized by Jane Austen in *Northanger Abbey*. The *Chicago Tribune* reviewer, like so many others, picked up on the subtitle: 'despite Bram Stoker's *Dracula* and Richard Marsh's *The Beetle* there has not been anything really Gothic in the novel for many decades . . . it is authentically Gothic despite the fact that it has no ghosts and no supernatural horrors of any kind, though crime and horrors of the dark souls abound in *Titus Groan*.' The *Hartford Courant* thought it a pastiche which 'achieves at times a kind of prose poetry, at others a hilarious parody of the Gothic novels. But is it conscious or unconscious?'

The *New York Times* reviewer said it lacked the sadism and erotic symbolism of a true Gothic novel but was 'refreshingly pure in the midst of indifferent commercial literature'. Under the headline A TALE OF DEEDS DONE IN A NON-EXISTENT ENVIRONMENT BY HUMAN ODDITIES The *Washington Star* recommended the work 'but only to those who have a Gothic taste for it', and the *San Francisco Bulletin* found it essentially unclassifiable: 'this self-styled "gothic novel" is about as strange a fruit as you've ever tasted'.

Several reviewers had strong reservations about Peake's concern with atmosphere at the expense of plot. The *Saturday Review of Literature*, for example, thought the book entirely composed of atmosphere: 'The book is filled with it, crowded beyond capacity, dripping at the pages with it; it is dark, dank, musty and moist, antique to the point of decay . . . let us grant Mr Peake the unquestionable virtuosity of his achievement, the inexhaustible piling of detail upon detail inside the frozen second of time, the poetic spurts of language apparently antiqued. Being done, it is an amazing thing to behold, even if amazement is the only tribute we may offer.' The *New Republic* critic wrote that 'the stage is more important than the actors; it is a drama of props . . . it is as if the whole spectacle took place under water'.

Others liked it but wondered if it was an allegory, perhaps on recent Nazi events with Steerpike as Hitler. A very few Americans gave it rave recommendations: the *Chattanooga Times* declared it 'the most remarkable, the most ridiculous, the most magnificent novel of the year'; the *Milwaukee Journal* promised that it 'offers a rich reward to anyone who exercises the patience and imagination to stay with it', whilst the *New Yorker* loved this 'gorgeous volcanic eruption of baroque nonsense'. The elation the Peakes must have felt on reading these transatlantic eulogies would be severely punctured by Orville Prescott in the *New York Times* on 8 November. He hated everything about the book and said so in the most savagely destructive terms. 'In England this bewildering extravaganza seems to have been welcomed with more effusive critical raptures than is customary even amongst the notoriously kind-hearted English critics,' he noted, but this 'pretentiously tedious' book stood no chance in America because 'it plods where it should soar, groans where it should sing. Reading is an exhausting business.' There are a few good scenes, he acknowledged, but you have to dig deep for them 'through masses of slag and dirt' and 'grotesque and ponderous prose . . . Tortuously involved and repetitious sentences, ornate and fantastic figures of speech, twine and twist

Study for Fuchsia, pen and ink, 18 × 13.5cm

like the tentacles of an octopus. Sometimes a dark sort of poetry illuminates the fog and a grim humor strikes occasional lonely sparks, but to little avail.' Overall, 'it tries desperately to weave spells, but it fails to enchant'. Strangely, no critic took Peake to task for his flimsy and sentimental sub-plot involving Keda nor commented on his rather clumsy attempt in 'The Reveries' chapter to use the interior monologue technique derived from James Joyce or Virginia Woolf – it was left to the academic specialists to point out these flaws much later.

Then Peake received an unexpected letter from America. Eric Drake's former wife, Lisel, was now married to a Viennese physician and running a sanatorium in Miami as well as teaching marionette drama at the university there. She owned a hotel in Monte Carlo and a villa on Cap d'Antibes. On 4 December 1946 she wrote to 'Dear old Muffin' to say she had read his book, which reminded her of Dürer or Holbein's *Dance of Death*.

> Titus Groan is a remarkable piece of writing, every page is thick with pictures, nobody but a draughtsman like yourself could have written such a book with so much imagery crowded into every sentence. It is a wonderful piece of writing, and just misses being great stuff. Why? Because it doesn't really lead anywhere, and none of the characters seem to reach a resolution of their mental problems. There are too many loose ends left untied.[5]

Like so many of the professional critics, she had not realized that this was only the first episode in a story which Peake envisaged would unfold through many volumes, the next of which he was already working on.

Soon Peake had a chance to communicate directly with a few of those people who had bought the book and fallen under its spell when he took part in a radio broadcast called 'The Reader Takes Over' recorded on 20 June 1947. He could be heard on the North American, the Pacific, the African and the General Overseas Service – but unfortunately not by any British listener. The discussion was chaired by his friend the writer John Brophy and all the other panel members were very supportive, including his friend Kay Fuller and the painter Merlyn Evans. This talk is worth quoting at length because it is Peake's only known dalliance with the theory of authorship. When questioned about his purpose and method in writing *Titus Groan* he replied, 'Well,

the purpose perhaps I could talk about a little; the method – there's hardly anything to say, in that I had no method. I had no preconceived plan; I really wanted to make a kind of pantechnicon book, in which I could shove in any mental furniture, however horrible – or however beautiful – if I could do so.'

He continues:

> I suppose under the heading of method would come this business of trying to make one's character talk. The actual characters, the look of the characters, I think, would be considered very bizarre and grotesque; and the difficulty of making them speak in the same world, as it were, as that in which they appear physically. In other words, if they have a certain colour, say they are a kind of dark green or pale blue, physically, as against the normal grey, then their voices have to be either dark green or pale blue, and *that* I found awfully difficult. One of the things I did was to make drawings of them and check the things they said by the drawings, trying to imagine if that kind of remark could possibly come from that sort of terrible mouth, for instance.

Evans asked if Peake's inspiration came from 'the collective unconscious of analytical psychology, or whether it comes from some external agency'. Peake was having none of this fancy stuff: 'Well, no, I don't know the first thing about analytical psychology . . . And no, I can't claim anything like that; it was really a case of self-indulgence, the whole book – I enjoy the fantastic – I enjoy the fantastic and the sheer excitement of having a sheet of white paper and a pen in one's hand and no dictator on earth can say what word I put down – I put down what I want to put down.' He denied having a preconceived plan to work to, but found that 'by setting a book in a more fantastic place, it gives more scope to one's imagination. One can put down anything, as long as one – I don't know if it was Browning – someone said that you can do whatever you like in art as long as you know that you really like it – and that is what takes a lot of hard thinking, hard feeling, to know – as long as one really knows one likes it and can do it.'[6]

A passage where Sepulchrave's body is devoured by owls in the Tower of Flints was then read and Peake explained: 'What I tried to do in the book was to introduce passages of writing that were, as far as I could make them, diametrically opposed to this grotesque horror writing, to act rather as a refrain or a melody, so that the reader . . . I suppose so that the reader shouldn't get too . . . er, well, I don't know

how to put it.' He evidently meant that he was offering periods of lyric relief between the scenes of violence.

A panel member suggests these interludes are 'pure poetry', to which Peake responds: 'Well, er, well, I'm awfully glad you liked it. I thought that in parts . . . I think that the word poetry is the one I appreciate, because I found that I was actually writing in five-feet lines over a large part of the book – in other words, when I was most excited by what I was writing (sounds rather awful doesn't it?), I was writing rhythmi-cally; in other words, the higher the tension, the more I found myself writing in poem rhythm rather than prose rhythm.'

Evans suggests that many of the characters are neurotic but Peake will have none of it, perhaps remembering his own time in the Neurosis Centre at Southport and his treatment at the hands of the psychiatrists there:

Well, on the word neurotic: I feel that these days people talk a lot about neurosis and that people are neurotic; quite apart from the fact that there's been a war and a lot of mental trouble has ensued; but I feel in a very large number of cases it's more that the idea of extreme individualism, perhaps in the Dickensian sense, is classified under that heading. I mean in the old days they talked about a strong personality; now they talk about a psychological kink.

Finally there came the vexed question of literary form. Did he have any form in mind when he was writing?

Peake answered:

No, none at all. I agree with Brophy that there are these two kinds of books, one of which is on the classic side, where there is the mould – the mould which one accepts, then pours one's words into. The sonnet, in that sense, is classic. And there's the other, which is not, I think necessarily a formless thing – it can be just as formed, but it creates its own form and its . . . When I say that I didn't know its form, I knew for instance what the thing wasn't going to be; I knew the mood rather than the form, the total mood of the book I wanted.'

Brophy: But you didn't make any detailed survey that you were to work to?

Peake: No. If one took a rather stupid parallel: if I was going from London to Edinburgh, I would know what stations I would

be passing through, but I wouldn't know what people would come into the carriages.[7]

In his transcript we can hear the genuine voice of Mervyn Peake: modest, hesitant and unwilling to venture into hypothetical discussion about the psychic or literary origins of his own work, but with a total commitment to making his creation as new and as true as he could.

He was equally unpretentious in a brief essay, 'How a Romantic Novel Was Evolved', published in 1949. Here he suggests that the origins of *Titus Groan* were in his playing about with pencil and paper: 'a mixture of serious as well as nonsensical fantasy began to pour itself out, without object, sentences growing out of their precursors involuntarily'.[8] He saw all his art in the same free-flowing way, but that did not mean it came easily or that it was totally unrelated to the real world. In an introduction to a volume of his drawings he tries to explain this:

After all, there are no rules. With the wealth, skill, daring, vision of many centuries at one's back, yet one is ultimately quite alone. For it is one's ambition to create one's *own* world in a style germane to its substance, and to people it with its native forms and denizens that never were before, yet have their roots in one's experience. As the earth was thrown from the sun, so from the earth the artist must fling out into space, complete from pole to pole, his own world which, whatsoever form it takes, is the colour of the globe it flew from, as the world itself is coloured by the sun.[9]

Good or bad reviews notwithstanding, the book had sold its first English print run of 2,000 copies by the autumn, and the second also sold out, but then fashions changed. It was not until 1968 that it appeared again in hardback and, crucially for a new audience, in paperback, and by then the story had grown into a trilogy.

Nineteen forty-six had been a wonderful year for Mervyn with the launch on two continents of the Titus book which would ensure his lasting fame; publication of *The Household Tales* and *Quest for Sita*, which consolidated his position as a leading illustrator; the issue of a teaching booklet, *The Craft of the Lead Pencil* (yet to be discussed) and work going well on the next Titus book, which was to be called *Gormenghast*. He was thirty-five and, excuse the pun, at his peak.

10 Family Man, 1947–1950

In its Christmas edition of 1946 *Picture Post* ran an article 'An Artist Makes a Living' with Peake as its subject. Its author calculated that 10,000 people in Britain claimed to be professional artists, but of these no more than 700 painters and 30 sculptors could live by the sale of work alone; most, like Peake, had to teach, do commercial work, illustrate books or have private means. A dozen society portraitists might earn around £10,000 a year and a few established artists command £250 for a canvas, but the average oil painting in a London gallery fetched from £30 to £60 before the dealer took his one-third percentage. From the remainder the artist had to pay for studio rents, materials, model fees and time off to peddle his work round galleries. Typical of these was the thirty-five-year-old Peake who 'ranks not as a top liner, perhaps, but as an established artist nevertheless, whose works are in the collections of such fastidious buyers as Sir Kenneth Clark and Sir Edward Marsh'.

'His pictures sell at anything from £30 to £60, and he considers it normal that, at his last exhibition of paintings, he sold eight pictures out of twenty-five.' The writer concluded that 'a painter of Peake's standing – the standing of an established and serious artist – can consider himself lucky if he makes more than £500 in the course of a year'. The accompanying photographs show Peake ransacking junk shops in Chelsea for old canvases to re-use and taking them into the shabby

Trafalgar Studios. He is quoted: 'If I put gesso on this old canvas and start a new picture, I may finish it in a month. Then I may sell it for £40. Some day. If it's a good one. If I'm lucky.' Other photographs show him drawing in the littered Glebe Place living room alongside Maeve, and doodling with Sebastian and Fabian on his knee.

This article had evidently been prepared a long time before publication because by the summer of 1946 Peake's circumstances had changed. He had lost impetus as a painter during the war as events forced him to concentrate on writing and illustration. It would be a decade before he had another one-man show and by then he was a marginal figure in British painting. Now, with the war over he had the immediate problem of reducing his cost of living and increasing his income in order to support his family. A return to Sark appeared to be the solution, as well as fulfilling their need for an 'island where life was lived at a tempo unmolested by cleverness', as Maeve put it.[1] Mervyn went over in August 1946 to prospect and wrote back enthusiastically that he had found a place and 'people are so friendly and glad we are coming. I'm sure everything is going to be wonderful for us.'[2]

Le Chalet had been built for a rich English widow who was used to servants. It had twelve large rooms, three small ones and a studio as well as an enormous wild garden with a pond and a view out to sea, but it lacked electricity and all water had to be pumped from a well in the garden. It had been badly neglected by the German officers who had used it as their headquarters during the occupation of the island from June 1940 to 1945. They had camouflaged it grey and their office names were still painted on the doors. This part of the village between the Manoir and the old mill had been the invaders' quarters (many of the houses were left empty by the fleeing English residents) and dotted round the island were flooded bunkers, rusting gun emplacements and lookouts. At £80 a year for a 99-year lease it seemed an ideal place for family life.[3]

The Peakes packed up Glebe Place but kept on the Trafalgar Studio in Manresa Road to give Mervyn a London base when seeing publishers. The four of them and the cat sailed from St Peter's Port, Guernsey to their new home, though their belongings did not arrive until the next day and for the first night they had to sleep on the bare floor. These belongings were few, mostly pictures and books which were a problem to ship and carry up the hill from Le Creux harbour, reputedly the smallest in the world.

They set about furnishing the place from jumble sales, Maeve being particularly proud of a 10-shilling pine kitchen table which became the centre of family life in all their subsequent houses. There were few gadgets and no luxuries. The local boys who soon made friends with the Peake sons recall the place as spartan and that the numerous nude drawings of Maeve on the walls made a big impression. Sebastian was sent to the two-teacher, all-age school just round the corner, next to the tiny loaf-shaped jail and it was not long before Fabian joined his brother so that their parents could get on with painting or writing in peace. In winter pupils were served Horlicks while they huddled round the log fire and listened to Uncle Mac on the wireless, and Mervyn wrote his novel wrapped up in bed each morning. One of the shorter things he worked on in this happy and productive period was a ballad called *The Rhyme of the Flying Bomb*, assimilating some of his memories of the London blitz. On completion he lost it, and it didn't turn up again until 1962.

At weekends or in the summer holidays the family would have breakfast in bed together and then picnic in Dixcart or Derrible Bays, or bicycle to the Venus Pool to bathe, Mervyn, who seemed to have renewed energy away from London, consistently clowning to amuse his brood. On stormy days he would take them to see the waves that pounded the rocks or tore into the Grand Greve below the Coupée. They acquired a thirty-year-old donkey called Judy who was given the freedom to stroll indoors whenever she felt like it, and a little cart to pull when she didn't. Peake had always loved donkeys since he rode to school on one in Tientsin. A dozen ducks from the vicar were installed in the pond, though nobody liked them, or their eggs. A palm tree was planted in front of the house; this thrived and later played a part both in *Mr Pye* and in a short story.[4]

In the evenings they all listened to *Dick Barton Special Agent* on the battery radio and when the boys were in bed and the oil lamps lit Mervyn would work on his illustrations while Maeve read Dickens or Evelyn Waugh to him. Slowly they began to make improvements – electricity came, they painted the exterior white and added a roofed veranda. Though they always pleaded poverty they took over a local girl, Gracie, from the previous owner to help in the house and to babysit when occasionally the two of them went out to a dance in the village hall, to have a drink at the Mermaid or Dixcart pubs, or to attend one of the beach parties organized by the English residents. But usually the adult Peakes kept to themselves and made little lasting impression on Sarkese society as a whole.

Mervyn would see some changes since he had lived on the island in the 1930s. The new Maseline Harbour was nearing completion after the interruption of the war; the dangerous ridge connecting Sark to Little Sark had been given a road and railings by German POWs supervised by the Royal Engineers, and the prewar tourist industry had collapsed, though many ex-service people were arriving to take up the cheap housing and enjoy the freedom from income tax. Several were artists, though none in Mervyn or Maeve's class. Eric Drake claimed his gallery had been a brothel during the German occupation (the Sarkese deny this) but it had now been sold and turned into the shop and post office which it still is today.

Like his occasional visitor Goaty Smith, Mervyn was a good teller of bedtime stories and he adapted one of these in an attempt to make money. A children's writer often creates the kind of tales he or she

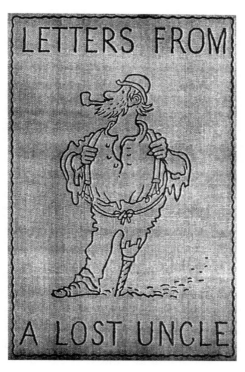

Letters From a Lost Uncle (1948). Cover, pen and ink
on grey board, 18×12cm

would like to have read in their own childhood and in *Letters from a Lost Uncle* Peake includes all the elements he'd enjoyed in Stevenson, Ballantyne, Defoe, Melville and other writers of adventure yarns: a resourceful man-of-action hero on a dangerous quest who kills savage beasts, eats strange foods and battles through outlandish terrain in the tropics and the Arctic. He is given to rough curses ('Bash my blubber! Pickle me!') and schoolboy puns ('Hairy-Bleary-Alice' for aurora borealis) and claims to be bad at writing and good at drawing. There are no soppy girls in the book, and the story purports to be a bundle of fourteen letters addressed to an unnamed nephew, who thus becomes the reader himself. The mixed class I read it with agreed it was a book for boys, though both sexes thought the illustrations 'brilliant'.

This is a sophisticated idea for a book but the format is deliberately amateurish since the Uncle can only draw in pencil (ink would freeze in the Arctic) and type strings of words which he then snips up and sticks on the pages. Part of the verisimilitude joke is that he and his clumsy companion, the turtle-dog Jackson, keep spilling coffee, gravy, blood or dirty water on to the letters. Visually, the way images and words are blended is very inventive though Peake was disappointed when Eyre and Spottiswoode brought it out in 1948 because the drawings had lost crispness in reproduction, the typed strips showed up grey against the page and the original price of 7s. 6d. was crossed out and 3s. 6d. substituted. The publishers sent a grovelling apology. The posthumous 1976 and 1977 editions did nothing to correct these faults, though the cover of brown paper with a stamp and string round it is very effective in the first of these.

The story tells of the unnamed Uncle's worldwide search for the White Lion, but before finding it he tells his own story. He began his restless life by running away from his cradle to Finsbury; then he avoided school because 'I drank so much ink on the first day that I was seriously ill until I was old enough to leave.' More running away and eating to make himself ill got him through several years until he married an ugly woman. She objected to him keeping rats and insects in the lounge, so he was on the run again. He roamed the world fighting and eating all manner of beasts one of which, a swordfish, bit off his leg but he replaced it with the now dead fish's sword. This also becomes a weapon and is used in several ingenious ways to save his life.

On his travels the Uncle acquired a kind of Man Friday in the bizarre form of a turtle-dog (with human hands) he calls Jackson. This abused creature is dumb, sickly, maladroit and constantly in need of rescue; moreover, with its headscarf and long neck, it looks remarkably like his

abandoned wife. Uncle hammers nails into its shell and then hangs his typewriter, camera and luggage on them.

After several adventures the two find themselves in a white mound which is not snow but the White Lion itself. Like the white Lamb in his later story, *Boy in Darkness*, this fabulous creature is blind: 'His huge gold eyes were quite empty looking, for he was past his prime and was ready to die.' Uncle follows it into 'a cathedral of glass with twenty thousand spires' where before 'a vast and silent congregation' of Arctic animals it mounts its throne of ice. 'And then it happened. He reared up on his hind legs, opened his great jaws, spread his paws as big as white hassocks against the air and with a roar that set the high spires jingling – froze to death. He had become ice. He had crystallized.' My class of children were quick to point out the parallels with C. S. Lewis' Christ-like lion, Aslan, dying in the frozen country of the White Witch, but of course Peake's book predates *The Lion, the Witch and the Wardrobe* by two years. Peake obviously intended this to be something more than a literal death from cold – does the White Lion symbolize the Christian God dead and frozen in the churches, or even the death throes of the British Empire? Uncle says: 'I was all aglow inside with what I had seen', but the vision has no effect on his behaviour since he merely sharpens his sword-leg, curses Jackson and sets off to fight and eat more beasts.

Children are intrigued by the visual and verbal jokes in this book, but so are critics with a psychoanalytical turn of mind. They find it politically incorrect in almost every respect. To Alice Mills, for example, Uncle's orchid-filled pipe and rigid sword-leg are aggressively phallic; the portrayal of the wife is anti-feminine and there is something sinister in all the spilt fluids. She finds hints of homoeroticism in the Uncle–Jackson relationship, just as she did with Captain Slaughterboard and the Yellow Creature, and she makes a reasoned case for both.[5]

In an encounter with a huge white polar bear Uncle is unable to use his phallic leg because it embraces him: its hairs 'like those at the end of a dressing-gown cord, smothered my face'. He knows how bears kill people: 'They take them in their huge white hairy arms as though they are going to kiss them and then they hug them to death.' If this isn't a child's fear of smothering mother love, then what is it? In *Titus Alone* the hero flees from the embraces of Venus for much the same reason. And what too is to be made of the obsession with devouring flesh, of the ravenous filling of Uncle's empty interior and his early self-poisonings? In dredging up motifs from his subconscious Peake often achieves

startling and unpredictable effects, and he may also be revealing more of himself than he intended. None of these undercurrents were spotted by the original reviewers who thought the book 'delightful', 'original' and 'entertaining'; one speculated that it had been inspired by Baron Munchausen – a distinct possibility since there were negotiations afoot for Peake to illustrate this mad classic, but they came to nothing.

After illustrating a book in pencil Peake felt he could write another about the medium itself – *The Craft of the Lead Pencil* (Wingate, 1946). This slight volume is now of interest for the prose rather than the illustrations which, apart from one, are surprisingly weak. It is one of his rare statements of aesthetic belief. 'To make a drawing,' Peake tells us, 'is to record an idea, real or imaginary, that can only be given permanence by marks on paper.' His intention is to teach the craft of drawing because without craft, art cannot exist. The advice is practical enough: get to know what pencils can do, stare long and hard before you draw and avoid the 'manually precocious' and the dead photographic replica. 'The aim is to be *expressive*' of what it was that interested you in the humble loaf or the centaur in the quicksand. 'It is for you to leave the spectator no option but to see what *you* liked; the curves, or the jagged nesses; the outline shape, or the shadowy patterns.' There follows some elementary advice on line, shadow, proportion and rhythm: look for structure, the skull beneath the skin, Peake says, for 'the most luxuriant tresses are anchored to a bone'. Most of the book reads as though he is writing for a bright child, but in one paragraph he offers an insight into his own practice in drawing (and language): 'Do not be afraid to exaggerate in order to convey the real intention of your drawing. With beginners it is an almost universal failing that they understate the dramas of nature – the angles between the head and the body – the twist of the torso on the hips – the contrasts of light and dark, the straining branches of a tree.'[6] This is almost an expressionist manifesto, and one can see in his own graphic works how well he practised what he preached.

In 1948 there was third reprint of his *Hunting of the Snark* and in autumn the prestigious Folio Society published an edition of *Dr Jekyll and Mr Hyde* with black and yellow illustrations by Peake, who used a Chinese pen. This is nobody's favourite and even his fans tend to agree with the *Book of the Month*'s reviewer (February 1949) who thought it 'not a successful production. Mr Mervyn Peake has contributed two-colour line drawings in yet another technique of his, and one which I

Illustration for *Dr Jekyll and Mr Hyde* (1949), ink and brush, 20×11.5cm

find far too thin and sketchy. They certainly have some Hyde in them, but I wish they had more Peake.'

Next year appeared *Thou Shalt Not Suffer a Witch* (Methuen), a collection of short stories by D. K. Haynes which opens with a thief being locked into an iron collar before being stoned unconscious. He wakes in time to watch a severed head being impaled on a spike and spends the next hours watching a fly crawl over its eyes and into its mouth before he is released. After that the stories turn even nastier, with witches being drowned or burned to ashes, a rat tortured with a hot poker, deliriums and so on. They are in the macabre tradition of Poe and presage the short stories of Roald Dahl, but lack the fiendish plotting of either. Later Mervyn told a friend that he didn't like the stories and considered them 'cruelty for its own sake' – a revealing remark when one remembers the cruelty and violence in his own prose works.[7] Peake's illustrations show wretches in extremes of misery modelled in painstaking cross-hatching to create form and darkness. There is one of a snarling rat and another of a staircase curving away to infinity with

a solitary dog in the exact centre of the picture, both of which are out-standing. His pictures are superior to the author's prose, a situation that was to occur several times more in his career.

With the next commission from Eyre and Spottiswoode, *Treasure Island*, there was a perfect match – it was, after all, the very book he knew by heart and had lived with since his childhood days in Tientsin. Stevenson wrote of it: 'women were excluded . . . it was to be a story for boys; no need of psychology and fine writing', and acknowledged the inspiration he had derived from Poe, Washington Irving, Defoe and Kingsley.[8] It is a book peopled by maimed men with missing legs, eyes and fingers and by page 30 there have been three violent deaths, with many more to follow. The villain, Long John Silver, is youngish, respectable looking, cleanly and well dressed, even married – which makes him all the more sinister and plausible. There were lessons Peake could learn from this in his continuing development of Steerpike in *Gormenghast* – another persuasive scoundrel with admirable courage and quick intelligence who is surrounded by grotesques.

Peake's first depiction of Silver as a big-jawed man smiling at his parrot helps Stevenson to lull our suspicions, but how he degenerates in later pictures as he tugs Jim along by a rope in his jaws or wipes his bloody knife on a wisp of grass! Several illustrations here are as good as anything Peake ever did – look for example at the plunging figure of Israel Hands or the crew facing the setting sun, each fringed with light. The variety of mark and texture he achieves without ever resorting to a simple outline is astonishing. The family were coerced into posing for many of these works: Sebastian pretended to hide in a barrel to eaves-drop and Ben Gunn's shapely legs are surely based on Maeve's. When *Treasure Island* appeared in October 1949 their efforts were rewarded by some enthusiastic reviews from Stevenson's countrymen: 'in these drawings fear, terror, evil and humour are captured and transfixed' (*Glasgow Evening Herald*), 'His drawings – tense, eerie, and dramatic – abate nothing of the power of the narrative' (*Scotsman*).

The reviewers then ignored the Heirloom Library's 1950 simplified version of J. D. Wyss' *Swiss Family Robinson* which was sold through Marks and Spencer stores. Peake's black and white drawings of wild animals have some dash and spirit and the soft watercolour ones show yet another style he mastered, but the book was bodged in its design and never became a classic. Curiously, in an echo of his Sark experience, it gave him the chance to paint a beached whale. Another book Peake worked on during 1947–48 on Sark was not published during his lifetime, which is a shame as it showed him devising yet another

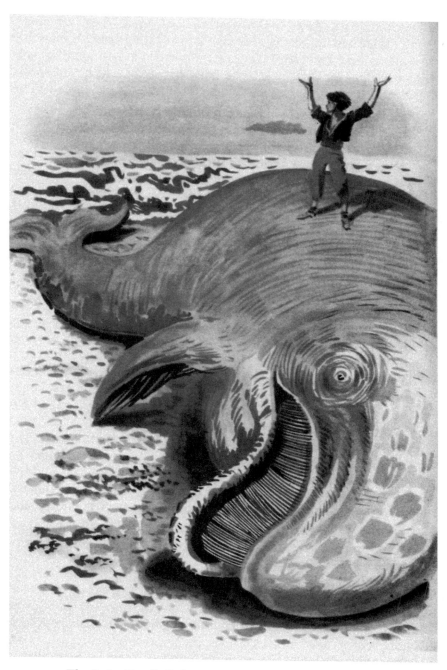

The Swiss Family Robinson (1950). 'The stranded whale',
watercolour, 21 × 13.5cm

technique. He was asked to illustrate some of the short early poems of Oscar Wilde but the paper shortage and printing restrictions at the time meant they were shelved and only appeared in 1980, published by Sidgwick and Jackson in a trade edition together with 200 special copies in slipcases. Maeve provided an introduction and explained the technique used: Chinese brush and solid ink tablet. Mervyn's father had brought them back from a fourteen-month trip in 1946–47 to Hong Kong, where he'd acted as relief superintendent in the Nethersole Hospital while the doctors were on leave after their wartime internment by the Japanese. By now Dr Peake had finished his Memoirs and needed to feel useful; he wrote to Mervyn saying how stunned he was by the modernity of this 140-bed hospital after his own experiences of making do in Hunan and Tientsin.

The use of the thick but pointed Chinese brush was a new skill in Peake's repertoire and made for bolder designs than his previous mapping pen hatchings. A touch both flowing and precise, like Chinese calligraphy, was needed and the resulting black and white image could have no half-tones, no corrections, no fiddly elaboration. Some of the Wilde illustrations are outstanding: the old Pan in raddled profile, Pan again sprawling amidst a blitz of flickering marks, Madonna Mia whose simplified features must owe something to Matisse (and Maeve), a raven, two owls and a gaunt bittern show Peake venturing into new territory. Other compositions are equally daring ways of filling a rectangle such as a crucifixion with the page almost empty except for the half-profile of a hanging figure on the right margin, and a picture of Christ in portrait form but showing his back as he deserts his followers. The final 'Requiescat' drawing shows a girl (perhaps Wilde's sister Isola who died aged eight) in her coffin with the layers of earth above her and live roots creeping in. These melancholy, sexually ambivalent and mannered early poems by Wilde are enhanced, indeed outmatched, in interest and artistry by their illustrations, which deserve to be better known.

Peake found other methods of raising money on Sark: he painted the inn sign for his local pub, the Dixcart (ten playing cards); designed book jackets, drew advertisements for Jamaica Rum and a series of fifteen or so for the Brewers' Society showing pubs as social centres for activities such as darts, cricket, bowls, dominoes and gossip with not a woman in any of them. The originals for these (now in the Bodleian Library) are about 9 inches wide, but when printed would be reduced to as small as 2 inches; it would need considerable technical know-how

on Peake's part to prevent loss of detail. These were profitable, £100 a time, but he gave them up on a matter of principle when asked by some realist pedant to move a tree he had shown too near the pub, or because, as he told Kay Fuller, he was asked to make the people look more jolly. According to Sebastian Peake, his father also designed the logo for Pan paperbacks and asked Graham Greene whether he should accept a £10 fee or a farthing royalty on every use of it. Unfortunately, Greene advised taking the fee on the grounds that the imprint was not likely to survive, so another source of regular income was lost.

In February 1948 Peake wrote to Maurice Collis to say he was having to apply to the Royal Literary Fund for a grant to see him through the writing of *Gormenghast* and would Collis give him a reference? He would also be trying Elizabeth Bowen and Charles Morgan because they had written favourable reviews of *Titus Groan*. What he did not say was that he had received an advance of £150 but had spent the whole of it on an amethyst bracelet and a Georgian seed pearl necklace, earrings and bracelet set – all in need of expensive repairs. As Maeve later wrote to her daughter: 'perhaps it illuminates a little our

Thou Shalt Not Suffer a Witch (1949). 'Where had they gone?',
pen and ink, 15 × 10cm

attitudes to money, and why perhaps we didn't always have enough of it!'[9] Peake was working as never before but not becoming any richer for it, though there was now another urgent reason to increase the output: Maeve was pregnant again.

Just before she died Maeve wrote an account of the birth on Sark of their third child, Clare in May 1949. She tells how after Dr Hewitt, the island's doctor, had confirmed the pregnancy they asked the boys to guess what their big secret might be. New bicycles? Red Indian outfits? penknives? a pig? they suggested and when they were told it was a baby 'the sense of anti-climax was almost tangible I'm afraid. They were neither boys with strongly developed maternal instincts.'[10] The cleaner, Gracie, left immediately since she couldn't stand babies but next day a French-speaking Moroccan, Mohammed Ben Ali, known as Armand, took her place and also took over the gardening. Maeve continued to

Treasure Island (1949). 'There all hands were already congregated',
16.5×9.5cm

paint in her studio and to cycle round the island and insisted she wanted to give birth at home rather than go to Guernsey. When a nurse was hired from an English agency for ten days, Mervyn and Fabian went with a horse carriage to collect her at the harbour. Sister Kilfoyle was enormously fat, had been seasick and took an instant dislike to Mervyn. Nor was she impressed by the house, with its pump water, lack of electricity, and germ-laden cats, ducks and a donkey. Sister Kilfoyle was used to working with the 'gentry' and the Royal Family were her great passion so the Peakes were a great comedown. Mervyn called her Sister Tinfoil, though not to her face. The baby did not appear on time so Tinfoil subjected Maeve to hot baths, rapid climbs up and down stairs, castor oil, brisk walks outdoors and a jolting carriage ride to Little Sark. On the night of 24 May things began to move. Mervyn was ordered to warm a blanket on the Aga but only managed to burn a hole in it, so he was told to get on with his writing. Dr Hewitt arrived for an early morning birth on the 25th and after a time Mervyn appeared. 'She looks rather like Churchill – all babies do,' he commented and was ejected by Tinfoil. He went off and did a painting of three kindly monsters called 'The Birthday Breakfast' then was turned out yet again for bringing germs into the room and not wearing a face mask. At last Tinfoil departed to more genteel clients on the mainland and a local, Winnie Tosh, appeared to look after the baby.

The Sarkese were either Methodist or Church of England, two sects that did not mix easily. Roman Catholics were rare and the islanders seem not to have known of Maeve's faith. She was determined to have Clare baptized and wrote to a priest in Guernsey asking him to perform the ceremony so that Clare 'would be transformed from a little heathen into a God-fearing Catholic at the drip of a drop of water. In my bedroom.' Though the seasick priest arrived with a face the 'colour of gangrene and his temper only slightly better than an outraged orangutang', according to Mervyn, he performed the ceremony and was trundled off back to the harbour. Burgess Drake, Mervyn's old schoolmaster, was Clare's absentee godfather. Soon after they took the baby to show Sebastian at his school in Guernsey and he was as unimpressed by the new arrival as Fabian had been.

Peake drew his new daughter repeatedly, just as he did the boys, Maeve, the donkey and anything else that caught his greedy eye. Eventually he had enough drawings to publish a collection, *The Drawings by Mervyn Peake* (Grey Walls Press, 1950), though the publishers neglected to return his originals. In a high-flown introduction he wrote that a drawing should have authority, derived both from the

chorus of tradition and from the single voice of the individual. In a master's drawing the terms 'classic' and 'romantic' are irrelevant; intellect and passion are on a knife edge, in 'equipoise'. From this the finest artists develop their own style: 'it is as if they paint, draw, write, or compose in their own blood. Most artists work with other people's blood. But sooner or later aesthetic theft shows its anaemic head.' Ultimately one has to go it alone, in prose as in drawing: 'For it is one's ambition to create one's *own* world in a style germane to its substance, and to people it with its native forms and denizens that never were before, yet have their roots in one's experience. As the earth was thrown from the sun, so from the earth the artist must fling out into space, complete from pole to pole, his own world which, whatever form it takes, is the colour of the globe it flew from, as the world itself is coloured by the sun.' Modestly he acknowledges that 'what I have said bears little relation to what I have done' in the drawings which follow.[11]

This publication provoked John Berger, a painter turned influential Marxist critic, to send Peake a fan letter:

> I am not an autograph hunter – nor an habitual gusher – but a painter and writer myself. My enjoyment of these drawings, however, is without connivance. I find myself looking at them over and over again with the excitement of a child continually re-examining the talisman in his pocket. It is real.
>
> I am certain that they will endure – and although I know very well that such statements are embarrassing I feel compelled to say so – perhaps because I guess that your work is outside the current fashion and therefore does not receive the praise it deserves.
>
> Your Introduction – in our anti-humanist cuckoo-land of abstractions warmed and cheered me.[12]

Berger must have been impressed by the sheer range of people Peake was interested in: clowns and acrobats, grotesque society hostesses, his children, spivs, jazz drummers, cabaret acts, prostitutes, blind beggars, Christ and his mockers, monsters, nudes, a dead mouse and, of course, Maeve. Amongst this multitude five of the Belsen drawings made a shocking impact. Pencil, wash, chalk, pastel and Chinese brush were used in a variety of styles from painstaking realism (the mouse) to cartoon mockery of rich matrons, with perhaps the only constant characteristics being a use of dramatic chiaroscuro and the absence of straight lines. As he writes in the introduction, he is trying in each for the elusive miracle: 'And why should we be satisfied with less than this

when the paper stage is set afresh each day, stands bare for all to take, to strut, to mime upon, to creep or float across; the spangled somersault – the dove-grey dawdle?'

Peake was asked by Kay Fuller to give two talks on the BBC Pacific and African services about the ways in which an artist and an illustrator saw things and he travelled over to the mainland to record these in April and May of 1947. In the first he claimed 'we do not see with our eyes, but with our trades' – compare the ways in which poet, farmer, carpenter and a child might look at a tree, for example. The only blind person is the one who sees everything in purely functional terms, as a dog might – so a yellow chair is to sit on, not 'a glory in the brain of Van Gogh'. He continues:

As I see it, or as I want to see it, the marvels of the visible world are not things in themselves but revelations to stir the imagination – to conduct us to amazing climates of the mind, which climates it is for the artist to translate into paint or into words. When I say the marvel of the physical world, I do not mean to curtain off the sordid, the horrific, the ghastly. The world includes the whole physical and spiritual alphabet from the A of distilled glory to the Z of vileness.[13]

He explained that the cramped conditions of barracks had forced him into illustration rather than painting: 'From this time onwards, I became fascinated by the whole idea of illustration and saw what work I could of the great illustrators – Rowlandson, Cruikshank, Bewick, Palmer, Leach, Hogarth, Blake; and the Frenchman Doré, and the German Dürer and Goya the Spaniard.' This is an odd list (why Samuel Palmer? where is Beardsley?) And where are the great masters of his youth such as Charles Ricketts, Rackham, Heath-Robinson and Dulac? What too of those older ones then still alive, like Henry Batemen, E. H. Shepard, Eric Fraser and Cyril Webb? The only twentieth-century illustrator Peake ever paid tribute to was Stanley L. Wood of *Boy's Own* fame and it seems that, as with his knowledge of painting, there were large gaps. However, there were still lessons to be learned from the Old Masters he names:

I began to realise that these men had more than a good eye, a hand, a good brain. These qualities were not enough. Nor was their power

Treasure Island (1949). 'The coxwain . . . plunged head first into the water',
pen and ink, 17.5×9.5cm

as designers, as draughtsmen. Even passion was not enough. Nor
was compassion, nor irony. All this they must have, but above all
things there must be the power to slide into another man's soul. The
power to be identified with author, character and atmosphere.[14]

With some feeling he confesses: 'It is fatiguing, exacting work.
Fatiguing not only because if one sets oneself a high standard the
very technique sucks up one's energy, but fatiguing also because of
the imaginative expenditure required if one *illustrates*, in the full
meaning of the word.' This does not mean taking the text at face value,
producing

literal drawings which do not interpret or transmute the words
into another medium, but merely repeat what the author has just
said. They underline the surface of the story or poem. They make
no attempt to capture the 'colour' of the writing.

One might say that books have different smells. *Wuthering Heights* smells different from *Moby Dick*, *Green Mansions* smells different from *Tristram Shandy*. The Book of Job, smells different – very different – from *The Fall of the House of Usher*. It is for the illustrator to make his drawings have the same smell as the book he is illustrating. Most celebrated book illustrators impose their celebrated techniques upon whatever book they are illustrating, graft upon it as it were their famous mannerisms to the discomfiture of the fastidious reader. The French, particularly the contemporary French artists, are the worst at this sort of thing – but possibly they would call their drawings embellishments rather than illustrations. All the same I find it essentially insensitive, however beautiful the book production may be, to couple fine works of literature with the alien and haphazard burgeoning of the finest artist – haphazard in the sense that they are not interpretations of the text, but manifestations of the artist's personality ... In book illustration the artist must not only synchronise all the aesthetic elements with which the pure painter has to juggle, but he must have, over and above this, the power to identify himself with another personality – that of the author he is interpreting, and also with the mood of the book. He must have, in other words, not only an imagination but a pliable one – a wide one, one that is sensitive to the music and the overtones of words, that miraculous coinage. He must slay his own ego in order to relive. He must have the chameleon's power to take on the colour of the leaf he dwells on.

This must explain Peake's radical switches in style between one book and the next. He concludes that the illustrator cannot live his life amongst books but must go out into 'the grist and throb of life' and head-hunt with his busy eye and pencil.

As an illustrator Peake perforce spent a good deal of his time with other people's books, sliding into their souls, but he was not really a bookish man. As Sebastian noted: 'My father was not a great reader, but possessed many books.' He claims to remember Joyce, Cervantes (the Doré version), Zola and Flaubert in the family collection, but possibly these were Maeve's since she read more widely amongst European writers. Mervyn's library is now in Clare's possession and it is full of standard illustrated works on the Old Masters but contains not one theoretical

book – no Clive Bell, Roger Fry, Eric Newton, Kenneth Clark, Herbert Read or any of the other English critics who kept the debate about Modernism on the boil. As Clare said, 'Oh no that wouldn't be in his line at all.' There are no critical works about poetry or the novel either – no T. S. Eliot, F. R. Leavis or I. A. Richards, for example. He seemed to read poetry avidly and remember it by heart, but lacked the stamina or time necessary to get through a long novel apart, perhaps, from Dickens and those swashbuckling books he had loved in his youth.

Peake was impatient of all theory, analysis and research, and this included scientific knowledge: things could not be seen objectively but had to be passed through an imagination before they were real for him. Sebastian confessed that, 'I am afraid the countryside in its technical specific sense, as a place made up of species identified with scientific detachment did not figure in our lives – and as far as I can remember I never was taught to differentiate between types of tree, bird, crop or mineral.'[15] As a family they also took a certain perverse pride in their

Treasure Island (1949). Old Pew, pen and ink, 16×10cm

lack of mathematical ability, so the boys were already behind their con-
temporaries in the village school in this and needed extra tuition. A
picture emerges of an instinctual rather than an intellectual man –
impulse spurred him into action and the experience underwent an
extraordinary transformation in his mind as he invented an appropri-
ate form for it. As his character Mr Pye says, 'To try to understand is
never to understand. Either everything is understood at once, by the
heart, or it is never understood at all.'[16] He was impatient with imposed
structures, whether in school, army or college, and with religious creeds
and literary genres; only in his painting was he conventional.

In spite of their relative poverty the Peakes maintained a middle-class
lifestyle with Gracie, then Winnie and Armand to help with house-
work, gardening and child minding. When electricity was eventually
installed they had a telephone, which aided business negotiations and
helped them keep in touch when Mervyn had to go to London, but
otherwise it was a life of few luxuries. The two boys made friends
amongst their Sarkese schoolmates and wandered freely about the
caves, woods and beaches with them. One day Fabian and a couple of
the neighbouring Guille brothers experimented with matches and
destroyed a valuable haystack. They hid in nearby pigsties but were
found, and confessed. The Guilles were given a sound thrashing and
their father paid compensation to the farmer. Mervyn, perhaps remem-
bering his own fire-raising in the army, was more forgiving and his
father, there on a visit, paid the Peakes' share. George Guille recalls that
they all collected German cartridges and exploded them with hammer
blows or by tossing them in bonfires; and that they climbed cliffs, bar-
racked the films shown in the village hall, sailed a rubber dinghy in
flooded bunkers, caught frogs, and played with the bow and arrows
Mervyn brought back from London to the peril of the neighbours. The
young Peakes attended the annual fête in fancy dress and were briefly
tamed and spruced up in ties when Princess Elizabeth visited the island.
 During the terrible winter of 1947–48 when the island's generator
failed Mervyn rose early and built the boys an igloo on the lawn,
leaving a window in which he placed a lifelike portrait of an Eskimo.
Mervyn was something special to his sons and their friends since he
could belch from A to Z in one breath. He was also as boyishly reck-
less as they, once firing an arrow directly upwards only to see it plunge
to earth mere inches from Fabian. Sebastian recalls his father telling
him a macabre story of how Red Indians executed enemies by tying

their legs to springy saplings and ripping them in half. 'Walking along cliffs, my father would sometimes pretend to slip at the very edge of the precipice and scare my mother senseless, then spring back onto the path unharmed,' he writes; at other times his father made antlers from branches and charged them like a stag. He taught the boys to skim stones and did them a special drawing of pirates or cowboys every Sunday when the Sarkese forbade all activities except churchgoing. Somehow he had acquired a skull and half a human skeleton and to it he added whale vertebrae and bones of sheep and rabbits picked up in the fields. He and the boys would half bury these bones and call Maeve to come and see the 'body' they had discovered. Each week he would ingeniously disfigure the cover girl on *Picture Post* before passing it on to the vicar, whose wife wondered why the editor always chose such ugly women for the front page. It was evident that Peake was himself nothing more than a boy again on Sark, full of a daft vitality and joy in living: it was a very happy family time.

In summer 1948 the poet Louis MacNeice, his wife and daughter intended to stay with the Peakes for a fortnight. He and Mervyn had probably been introduced by Dylan Thomas. MacNeice was going through a difficult middle age, but it was his wife Hedli who quarrelled with Maeve, and the daughter Bimba who was victimized by the boys. All were relieved when a telegram arrived calling MacNeice back to the BBC after a mere three days. Later MacNeice referred to the Peake boys as 'the blue-eyed thugs'.

Sebastian admits he was a difficult and demanding child and that it was now and then necessary for his mother to whack him with a hairbrush and at times his father had to hold Sebastian's head tight between his knees and spank him until he calmed down. It must have been with some relief, as well as sorrow, that his parents sent him away terrified to school in Guernsey in September 1948. He was aged eight and had to board at Les Vauxblets College, run by the Christian Brothers. He recalls bitterly: 'some were sadists, others latent homosexuals or other oddities who didn't do a great deal for my general education in any subject as far as I can remember. Becoming champion in two highly intellectual subjects, weight lifting and roller skating, was about the apex of my achievements.' He could have continued at the all-age school on Sark but his parents considered boarding school was the norm for their social class, whatever misery it caused the children. His parents ignored Sebastian's ill-spelt pleas to come home to escape the bullying, canings, cold showers, silent meals and awful food. One sadistic brother 'chose me to grasp Jesus' suffering at Easter by being given

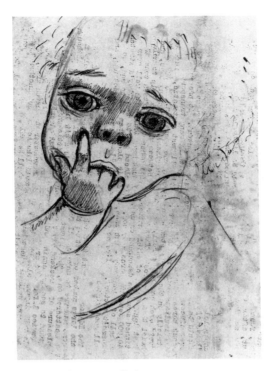

Clare, pencil, 20×14cm, 1949

holly leaves to wear, next to my skin under my shirt, which he ground into my chest with vigour'. Fabian joined him for two terms because Maeve was still determined to have her children raised as Catholics and this could not be done on Sark.

There were other drawbacks to living in this apparent Eden. There was no real culture or like-minded people to bounce ideas off and when Mervyn was away Maeve felt isolated and claustrophobic, especially in the winter when the gales howled and Sark could be cut off from Guernsey for a week at a time. Living was cheap, but then it was expensive to fetch work from London and return it to the publishers. Their time was up. Mervyn wrote to Maurice Collis: 'Islands should be left to the imagination. That is where they flower . . . we are all longing for England again – London is a necessity.'[17]

Peake did return to London frequently and it was perhaps on one of the these trips that he met Ronald Searle, freshly returned from his

Japanese imprisonment and eager to start out as an illustrator like Peake. They were invited to dinner at Kaye Webb's Hampstead flat. Searle writes:

> I remember being somewhat intimidated by this chap with a rather lowering brow that slightly belied his gentle manner. I don't remember much about the evening after all these years and I don't suppose I had much to contribute to it, still trying to come to terms with civilisation and being rather in awe of this elderly, erudite, rather impressive figure, who was already – what I was then hopefully fighting to be – an established graphic artist, who also wrote brilliantly.[18]

Peake sent a copy of *Titus Groan* round to Searle's lodgings in Tite Street: ' I read the book and it came as a shock to me. A revelation in fact. I thought it was fascinating, but above all I was overwhelmed by the incredible imagination behind the images. And in the end I think I preferred Mervyn's writing to his drawing, which always left me a little uneasy (I had the same problem with Michael Ayrton).'

Soon after this Searle married Kaye Webb and realized that Peake was actually rather timid: 'She told me of an embarrassing (for him) occasion at a dinner party she had given, when Mervyn, who apparently detested fat, had managed to slip some hated morsels from his plate into a handkerchief. Later on in the evening during the chat around the sofa, the inevitable happened. Having totally forgotten the fat, Mervyn pulled out his handkerchief and the fat hit the mat. Although no-one else thought anything of it, Mervyn was totally devastated and left early. I remember him being slightly unworldly, slightly intimidating, but gentle.' Searle went on to be the dominant illustrator of the period, imposing his style on the public – something that Peake never achieved.

To his wife's admiration, and surprise, on one of these trips to the capital Peake actually did something practical by writing to the Borough of Kensington and Chelsea and getting on to their housing list. Soon they were offered a maisonette in Embankment Gardens; Peake went to look at it and in September 1949 they were on the move with Nannie Tosh lending a hand to get them settled. They simply left Le Chalet and most of its contents; it had not occurred to them to let it or sell the remaining lease.

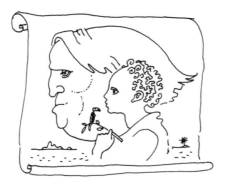

11 Householder, 1950

Most of *Gormenghast* was written on Sark; indeed during the great flood which makes the eponymous castle a virtual island parts of it were given names of the island's features such as the Coupée, the Silver Mines, Little Sark and the North Headstones. Physically and psychically Gormenghast expands in this book until it must have exceeded the whole of Sark in its extent, so it became inevitable that its name should be the title, rather than 'Titus in Umbra', 'Boy among Shadows', 'Chiaroscuro', 'Titus in Chaos', 'Titus and the Cockatrice', or any of the other titles Peake tried out first.

Maeve remembers the book growing daily, the nine varied notebooks filling with drafts, rewrites and doodles: 'I longed to know how the people in it were progressing, sadly, tragically, humorously, over life-size friends.'[1] The characters seem to have come off the page and moved into Le Chalet with them: as Peake wrote to Collis: 'Really what can be as exciting as setting a scene and peopling it? To be in *half* control of them, that is the thing. Like the human race one's characters must have free-will without undue interference from the Authorjehova.'[2] He also confided his ambitions: 'Quite simply, is one to risk failing at big things, or be sure of success in small things? If the word "artist" has any meaning at all it means the former . . . after all what would a model of the great pyramid look like on one's mantelpiece. A paperweight – just something else to dust.'[3]

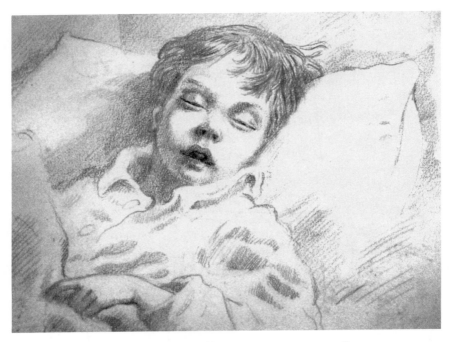

Child Asleep, pencil, 25.5×34.5cm, *c.* 1947–8

When the manuscript was submitted in September 1949 Eyre and Spottiswoode were delighted with it and offered a 15 per cent royalty from the start. Earlier Peake had noted: 'Short of a best seller there seems to be no money in books, either illustrating or writing – none that is, over and above paying the grocer coalman etc.'[4] *Gormenghast* was his hope for a bestseller. They needed the money now to escape from 12 Embankment Gardens where things had quickly begun to turn sour with the neighbours. To Collis he lamented: 'But O to get away from this flat where every footfall sounds like a hydrogen bomb explosion to the people who snarl at us through the bannisters as we pass their landing'.[5] Everything, including Clare's pram, had to be carried up three flights and it gave Mervyn neuritis. Collis paid them a visit and recorded in his diary that Mervyn 'is a man of great imagination and talent, wild-eyed, dirty, laughing, bankrupt, incompetent in money matters and delightful to meet'.[6] The tensions of this time appeared in a letter that Peake wrote home from Edinburgh where he was researching possible Jekyll and Hyde locations with the playwright Rodney Ackland: 'Please try again to have faith in me – I would like to be

worthy of it. If you can risk it, will you unburden your sadness to me from now on. I will not let you down if I can help it. It is only when I am very tired I can't deal with our problems. When I have failed you it has been sad for you. But let us try again.'[7]

This second Titus volume begins in a poetic style which links it to the ending of the first. We are warned that this is to be a struggle between a typical child's itch for freedom and the Groan dynasty's need for a conforming heir:

Titus is seven. His confines, Gormenghast. Suckled on shadows; weaned, as it were, on webs of ritual: for his ears, echoes, for his eyes, a labyrinth of stone: and yet within his body something other – other than this umbrageous legacy. For first and ever foremost he is *child*.

A ritual, more compelling than ever man devised, is fighting anchored darkness. A ritual of the blood; of the jumping blood. These quicks of sentience owe nothing to his forebears, but to those feckless hosts, a trillion deep, of the globe's childhood.

The gift of bright blood. Of blood that laughs when the tenets mutter 'Weep'. Of blood that mourns when the sere laws croak 'Rejoice!' O little revolution in great shades.

Coincidentally, in 1948 as Peake was writing this, the House of Windsor had acquired an heir, Prince Charles, who would also have to struggle to find a balance between his private needs and his ritualistic public role. Later the Queen Mother would purchase two Peake drawings for Charles' nursery.

In *Titus Groan* Peake had learned his novel craft, set his scene and assembled his dramatis personae. Now in *Gormenghast* we are ready for action and there is plenty of it within the three interweaving plots. Firstly, Steerpike is now in his mid-twenties and scheming to ensnare the naïve Fuchsia; to replace Barquentine, the one-legged 'wrinkled and filthy dwarf' who is Master of Ritual; to sadistically humiliate and kill Titus' twin aunts, and to challenge Titus as head of the dynasty. Secondly, Titus is isolated and restless in his symbolic status, truanting from his duties, bored by his schooling and increasingly obsessed by his foster-sister, Keda's bastard daughter, called The Thing – 'something that would no more think of bowing to the seventy-seventh Earl than would a bird, or the branch of a tree'. She is an insubstantial wild thing of the woods lacking language and is traceable to the Rima figure in W. H. Hudson's 1904 novel *Green Mansions* and Epstein's controversial sculpture of her

in Hyde Park.[8] A third, tenuously related and wholly farcical strand, is the elderly Irma Prunesquallor's search for a mate amongst the forty professors of Titus' school. She takes Bellgrove, the noble failure of a Head, and they achieve a flawed but loving relationship – perhaps the nearest thing to a successful marriage Peake ever portrayed.

Peake's prose is as rich as plum pudding and there are some fine set pieces; the seasons revolve poetically, snow, fire, storm and flood playing their dramatic parts. The violence is extreme – for example, Steerpike murders Barquentine by fire and drowning but is himself badly disfigured. He and Fuchsia embrace in the fresh earth of Nannie Slagg's grave but he fails to seduce her. Steerpike's plans go further awry when he is seen by Titus, Flay and Prunesquallor dancing and crowing over the skeletons of the twins and playing their ribs like a xylophone. Titus is roused to 'throbbing lust' by grappling the naked Thing in a cave but she is then immediately struck dead by lightning. After Steerpike's betrayal the isolated and unloved Fuchsia contemplates suicide, but then dies accidentally of drowning. Steerpike is finally cornered and stabbed to death by Titus, now aged seventeen, who is both his opposite and yet, in his rebelliousness, Steerpike's ally in breaking up the status quo. At last Titus, the romantic rebel, having rid Gormenghast of its enemy and become the populace's hero and Earl, feels free to leave it and rides away in tears with the Countess' voice in his ears:

'There is nowhere else,' it said. 'You will only tread a circle, Titus Groan. There's not a road, not a track, but it will lead you home. For everything comes to Gormenghast.'

If the tragic action is played for all it's worth so is the comedy, especially in the first half of the book. No reader will forget Irma's padding out of her bony bosom with a hot-water bottle; the moonlit courtship of Bellgrove and Irma interrupted by the naked Professor Sprod in full flight; the death of Deadyawn who crashes vertically down on to his skull and remains upright as premature rigor mortis sets in; the philosopher who denies the existence of pain until his beard is set alight, and so on. All these episodes contain that cruel streak we have remarked on before – the characters are humiliated, mocked or casually disposed of but we still laugh. Less extreme, and more touchingly funny, is the account of the young Titus being joined in his punishment cell by Bellgrove and Prunesquallor, who revert to boyhood and play marbles with the unloved and lonely boy.

*

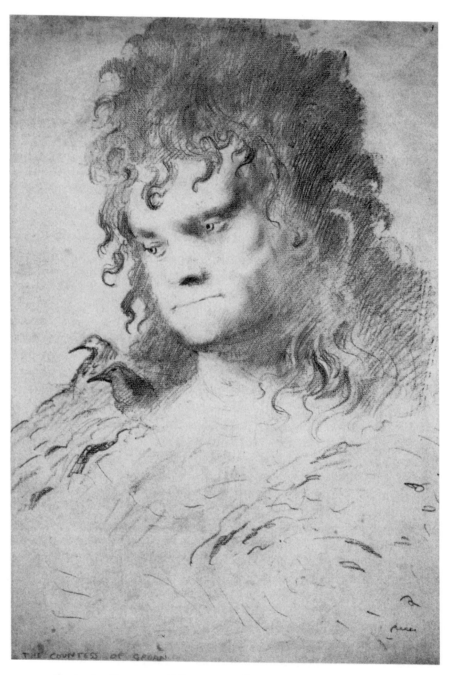

Gertrude, Countess of Groan, pencil, 47×30cm, date unknown

Stylistically the book is an advance on *Titus Groan*. The time scheme has been tightened up, though the characters still seem to age at different rates. There are no stream of consciousness passages this time, but an extended daydream of Titus about colours and anachronistic pirates and redskins together with a night dream by Prunesquallor get us away from chronological prose and into another surreal dimension. The vocabulary is less arcane now, though there are *frissons* when 'testicles' are mentioned and 'bleeder' is used as a swear word – they seem oddly vulgar even in this world full of the vilest evil. Sometimes flurries of rhetorical questions work up tension a little too obviously ('Was it to hide away some drama that it [the foliage] arose there, so sheer and so thick? Or was it the backcloth of some immortal mime? Which was the stage and which the audience?') and occasional *longueurs* of description. More seriously the 'Thing' sub-plot fails to come off because she is insubstantial not only physically but psychologically: the nature mysticism attached to her seems to come from a different book than Steerpike's cold ruthlessness.

Peake is never at his best when writing about direct sexual matters: nobody has intercourse or loses their virginity (unless Irma did?) and any feelings of arousal are always frustrated. Titus, after wrestling with the near-naked Thing, sees her callously wiped out by lightning; we are then told, unconvincingly, that 'he had become a man'. Prunesquallor's sexual identity remains blurred though he shares some affectations with Captain Slaughterboard's crew member Timothy Twitch and the dapper Mr Pye, but surprisingly, given Peake's own lack of contact with adolescent girls, Fuchsia's frustrated sexuality and 'crush' on Steerpike develop in a credible manner. Titus is now of marriageable age but there is no sign of a middle or upper class in Gormenghast from which a suitable bride could be recruited. Girls are absent and there is no sister school to the one the boys have to board in – and one wonders just where the Countess sprang from since the boundaries have always been closed.

One theme which occurs repeatedly in Peake's *oeuvre* is the status and function of the artist. Here, unexpectedly, this is attached to Steerpike, the Faustian villain with all the talents: like Mr Slaughterboard he decides to kill 'upon aesthetic considerations alone'; he carries his stolen poison in a 'beautiful little cut-glass vessel' chosen for its symmetry which excites him into walking round the room on his hands; and he decides to murder Barquentine with a candlestick because it offers 'that deceptive simplicity which is the hallmark of all great art'. He sings, dances, mimics, and makes music on a bamboo pipe – though his playing has a cold perfection, 'brilliant and empty'.

Even when dancing over the corpses of the twins, 'this throw-back to some savage rite of the world's infancy', the link is made to artistic creativity: 'he had given himself up to it for those few moments, in the way that an artist can be the ignorant agent of something far greater and deeper than his conscious mind could ever understand'.

For Peake devotees there are the usual pleasures of in-jokes about his schooldays. Old Elthamians can recognize little Sprod and see their own Head in Bellgrove launching his model boats and leading a tetchy bunch of pipe-smoking untidy bachelors who bore their pupils silly and fail to notice their dangerous initiation rituals in the great tree outside the classroom window. They bicker in the staff-room but outside move *en masse*:

> Like rooks hovering in a black cloud over their nests, a posse of professors in a whirl of gowns and a shuffling roofage of mortar-boards, flapped and sidled their individual way towards, and eventually *through*, a narrow opening in a flank of the Masters' hall.

Other fragments of autobiography surface: Titus faints at moments of crisis, just like his creator, and is carried in a bamboo palanquin to his very Chinese-style Birthday Pageant as Peake was to Kuling. There may also be fragments of Peake's reading embedded in the text. As one critic pointed out, the similarities between the themes of *Hamlet* and the themes of *Gormenghast* 'are striking: castles as prison – murders – madness – revenge – above all the alienated heir'.[9] Gertrude's name may come from the same source and Fuchsia drowns like Ophelia. But surely Flay surviving in the woods is very near to Stevenson's Ben Gunn, and could Steerpike and Titus, one coldly logical (but mad) and murderously keen to acquire power, and the other instinctive, emotional, confused and anxious to relinquish power be derived from the Jekyll and Hyde characters Peake had so recently drawn? The book is so dense that it provokes endless speculation of this kind without the loss of any of its power.

By summer 1950 the book had still not been published. Peake wrote to Collis to say the boys were coming home from their Guernsey school for the holidays and that he was now working on a play, but that the *Gormenghast* launch had been postponed to autumn by a bookbinders' strike ('damn them'), and 'the autumn will probably bring a general Election – or another war or something to completely flatten out my poor old mammoth of a non-topical tome'. When it was finally

launched, it was not with the fanfare Peake had hoped for. He complained to Collis about 'those stupid Eyre and Spottiswoode nit wits' who had failed to publicize it: 'It seems to me that publishing houses are full of amateurs. The heads of the houses may be alright but the poor book has to filter its way through such weeds of dreary amateurdom before it hits the public – or *misses* it . . . One seems to write for such a tiny public. Perhaps it will grow.'[10]

Then the reviews began to appear, with the usual lazy clichés: *Gormenghast* was 'Gothic' fantasy, weird, nightmarish and so on. Collis did his friend proud in *World Review*, saying of the Titus books: 'the two taken together are an integral whole and amount to a literary feat, to which it would be hard nowadays to find a parallel'. The *Punch* critic too was impressed: 'this is the finest imaginative feat in the English novel since *Ulysses*, even though *Ulysses* is, of course, much the greater book'.[11] Many others were baffled and the sales were nothing special. Peake was particularly hurt by a review by Michael Sadleir in the *Sunday Times*. He complained to Collis: 'I do not mind the most pongent [*sic*] criticism if it is *real* criticism, but I must say that his pert manner of writing and his general dismissal of my five years of work show him to be somewhat of an unimaginative and shallow specimen of homo sapien [*sic*]'. Perhaps he had a grudge? Anyway:

> I decided against silent dignity and wrote to him yesterday – thus:
> Sir,
> I am deeply impressed by the penetration of your review. You are indeed a force to be reckoned with.
> M Peake

To Collis he adds: 'sometimes the lofty and detached dignity that is so esteemed is merely fear of making enemies. I am slowly coming to the belief that it is necessary to one's soul to make enemies. It is a *positive* attitude.'[12]

It is salutary to jump forward in time to 1968 when *Gormenghast* was reissued one week after Peake's death. Now, too late, the reviewers almost without quibble found the book to be a masterpiece. 'Peake sustains a beautifully controlled, objective prose which gives complete coherence to his imagined world' (*The Times*); 'From its opening sentence, it has the authority, the massive swell and fall which mark a master of the form' (*Financial Times*); 'A masterpiece, human and grotesque' (*The Tablet*); 'a brilliant tour-de-force, and the invention is of a high order' (*Irish Times*); 'The author writes with the flair and

feeling of a good poet. Even sentences dense with minute visual detail are animated by energetic syntax and striking imagery' (*New Statesman*). A friend, Rodney Ackland, asked in the *Spectator*, 'How is it possible, one asks oneself, that such disparate elements – gothic horror, poetic fantasy, allegory, romance, race memories, and wild slapstick, reminiscent of the Crazy Gang and Beachcomber's Narkover – can have been welded into a work of such shapeliness, rhythm and unity?' (20 December 1968).

The *Financial Times* reviewer (2 January 1969) made a useful comparison with Peake's fellow fantasists who were competing for a similar readership:

> *Gormenghast* is a great book. It is also horrible, macabre, grotesque, disgusting, and, in particular, poetic. Peake's prose is more than unlikely, it is impossible – but it works . . . We might single out three 20th-century Romance trilogies, and place them side by

Dr Prunesquallor and Irma, from the *Gormenghast* manuscript, pen and ink, size and date unknown

side: C. S. Lewis' 'space fiction', Tolkien's *Lord of the Rings* and Peake's trilogy. Seen thus, Lewis has the least realised literary world, the least powerful imagination, the most clear and para-phrasable allegorical meaning; Tolkien's world is much more self-contained and convincing, his imagination more sustained, but still his books speak to us, if not of literal truth to life, certainly of things morally recognisable by us. Beside these Peake is seen as more morally enclosed, more self-sufficient and infinitely less able to be related to anything outside the world of imagination. There is a sense for this critic that moral values only evolve as the book progresses and that its complexity defies allegorical explanation.

The *Oxford Mail* (5 December 1968) reviewer found it 'strange to reflect that the generation that took to Tolkien has not yet taken to Peake. It still may.' And, of course, it did, eventually.

In summer 1950 Mervyn took his two sons to Sark for a holiday and in September the Peake family escaped their hostile neighbours of Embankment Gardens. In the summer they had seen a newspaper advertisement for a Georgian house at Smarden, halfway between Staplehurst and Ashford in Kent and had fallen in love with its huge apple orchard, the lean-to conservatory, the neighbouring woods and the fact that there was a tin studio at the back. Tony Bridge and his wife lived not too far away. It cost £6,000 but they had nowhere near this sum, even with a recent bequest to Maeve from her mother, so they went to see a bank manager for a loan. Maeve later confessed: 'I think we thought that it was some kind of gift that the bank was making to us. It sounds incredible but we knew absolutely nothing about money matters. I remember my sister Ruth asking, "Do you know what you're doing darling?" and I replied, "Yes," although I suppose I didn't.'[13] Only slowly did it dawn on them that the capital as well as the interest had to be paid back, but by then it was too late.

On their return from Sark the boys were enrolled at the local Smarden school as day pupils. Sebastian was now eleven and in his sixth home. When they moved in with the cat, pine table, pictures and books they were aided by their cleaner from Embankment Gardens, Mrs Bull, whose husband occasionally babysat for the children and so was known as Sitting Bull. Soon after they arrived John Grome, an old prewar artist friend, turned up with his pregnant wife and was offered accommodation in the tin studio, which he occupied for a year. As they prepared to

Mervyn's father 'Doc' Peake at Burpham in the 1940s,
pen and ink, 31 × 17.5cm

celebrate their first Christmas there with Maeve's sister Matty and her
ex-actor husband Henry Worthington they heard that Mervyn's father
had died at Burpham on Christmas Eve aged seventy-six.

With the coming of spring, spirits lifted. There was a local cider
maker, gypsies camped beyond the woods and the family gathered
apples, plums, pears and mushrooms from the orchard and let the
grazing for sheep and pigs. They were woken by bird song and they
went for picnics. Mervyn played for the village cricket team with some
success. Grome remembers Peake at this time: 'For him it was quite
natural to come out into the garden, do an about-turn, and return
instants later with pencil and pad to draw you all as you sat having
lunch with the family under a tree. He would enjoy reading the day's
work to you after supper in the evening.'[14]

Peake commuted to London through sprawling suburbs which gave
him time to observe in an Ogden-Nash-like manner:

I always cast a Mental Wreath
Upon the lines at Thornton Heath
In pity for the dead who climb
The train each morning in which I'm

He also wondered:

Oh why is Streatham Common
And Balham so elite?
Because on mats in Balham
You always wipe your feet –
While through the halls of Streatham
One carries half the street.

Trains to London were infrequent and the service unreliable so
Maeve spent some of her family money on a beaten-up Wolseley car.
This became another source of expense since it rarely finished the
journey intact and on one occasion the roof blew off over a hedge. On
a shopping expedition to Ashford they were asked by a policeman for
their insurance. Maeve recalled:

The policeman had never heard of people who had never heard of
insurance, and road tax and licences. We were told to go to the
nearest police-station, and our story was so ludicrous that we were
let off whatever it was that we should have been guilty of, on con-
dition that we armed ourselves with all the civilised impedimenta
such as little round discs on the front of the car to prove that we
were worthy, and bits of paper for insurance to prove that we were
even worthier.[15]

Peake was working all hours and on all fronts. He travelled up to
London two days each week to teach; he had begun a play called *The
Wit to Woo*, and the novel *Mr Pye* was under way, both written with an
eye to profit. He was always preternaturally creative but now he felt
under pressure to make money from his efforts because the bank was
pressing for repayments on the house loan. On 4 April 1951 the Peakes
received what Maeve thought the most beautiful letter that ever came
through their letterbox. Mervyn stood in the hallway at Smarden and
read it out with tears in his eyes. The Royal Society of Literature had
given him one of its £100 Heinemann prizes for *Gormenghast* and *The*

Glassblowers, a collection of thirty-five poems which Eyre and Spottiswoode published in 1950. He was in distinguished company: Vita Sackville-West, Bertrand Russell and John Betjeman had received this award in previous years and Patrick Leigh Fermor gained the travel writer's prize for his *Traveller's Tree* alongside Peake. He invited Collis to the ceremony to see him looking bashful and confided: 'the actual pocketing of the envelope is a thing that needs hours of practice. At what moment to start the up-swing of the furtive forearm? Whether to look like a sick eagle as one misses one's footing and collides with the potted-palm or whether to do nothing of the kind. No-one seems to know.'[16] The politician R. A. B. Butler presented the prize on 26 June, though he had not taken the trouble to read either of Peake's publications. The Peakes did nothing so prosaic as repaying part of their mortgage but spent the money on a quick trip to Paris where they stayed in the hotel Oscar Wilde had died in, but were savaged by bedbugs. It seems unlikely that they would have sought out the *art brut* and *tachiste* works then dominating the French galleries.

Another boost, this time to Mervyn's ego rather than his finances, came some years later. C. S. Lewis, author of the Narnia books and many others, wrote on 10 February 1958 from Magdalene College, Cambridge, to apologize for not having found the two Titus books before and to say 'Thank you for adding to a class of literature in which the attempts are few and the successes very few indeed.' He had no time for those asking for the currently fashionable 'slice of life' books because:

to me those who merely comment on experience seem far less valuable than those who *add* to it, who make me experience what I never experienced before. I would not for anything have missed Gormenghast. It has the hallmark of a true myth: i.e. you have seen nothing like it before you read the book, but after that you see things like it everywhere. What one may call 'the gormenghastly' has given me a new Universal; particulars to put under it are never in short supply. That is why fools have (I bet) tried to 'interpret' it as an allegory. They see one of the innumerable 'meanings' which are always *coming out of it* (because it is alive and fertile) and conclude that you began – and ended – by *putting* in that and no more. If they tell you it's deuced leisurely and the story takes a long time to develop don't listen to them. It ought to be, and must be, slow. That endless, tragic, farcical, unnecessary, ineluctable sorrow can't be abridged. I love the length. I like things

long – drinks, love-passages, walks, conversations, silences, and above all, books. Give me a good square meal like *The Faery Queen* or *The Lord of the Rings*. *The Odyssey* is a mere lunch after all.[17]

This is a gracious tribute from a fellow writer who came to the creation of myth from a very different background. Peake, with very little formal education and scarcely any knowledge of philology, history or world literature on the scale that Professors Lewis and Tolkien had, nevertheless became their co-equal by drawing on his own exotic upbringing and his own imagination, as jumbled and diverse as the clutter in Fuchsia's attic. Now he was pillaging that store as never before in an attempt to keep solvent and support his growing family.

12 Poet, 1950–1953

In his will Dr Peake left his two houses, Reed Thatch at Burpham, and the larger Wallington dwelling jointly to his sons. Leslie chose Reed Thatch and Mervyn's first thought was to sell off his inherited Wallington property in order to pay off the bank loan and so fully own the Grange at Smarden, because they were continually falling behind on the £300 per month repayments. However, the Wallington house was being used for boarders and they could not be immediately evicted. The Peakes took them to court and won. As the tenants left, one by one, the house became vacant, but then no buyer could be found for it. Meanwhile the Grange was sold at a loss and they continued in debt to the bank until Mervyn's brother stepped in and paid off the last £1,000. The whole family were then obliged to cram into the 40-foot-square Trafalgar Studio in Manresa Road where Maeve and Mervyn painted and slept. During the holidays the boys bedded down in a small room across the corridor whilst Clare slept in the studio in a tent made from two of her father's canvases. By the end of the year they had decided to bring Sebastian back from his loathed Mayfield boarding school and Fabian from his prep school and move into the unsaleable Wallington house. The boys were sent to a local Catholic grammar school and so the family was united again. Mervyn informed Gordon Smith of the change of address – 'Goaty, you lop-eared, cross-eyed, gangrenous moron, where the bloody hell have you been hiding your

withered body' – and reminded him that this was the family home: 'Yes, Wallington, where the Dusky Birron was born. Perhaps he will bloom and fructify – NO, NO, FRUCTIFY, I said.'[1]

Number 55 Woodcote Road, Wallington, had at least a dozen rooms including six bedrooms, a conservatory, huge attics and a large garden with an old air-raid shelter where later Sebastian thrashed his drum kit and had parties. 'It was like going into a church,' Maeve thought, but now they could have separate studios rather than having to paint in the same room as they had at Manresa Road, though that was still retained as a London base. Maeve ran the house, children's parties, and Hallowe'en nights with an extrovert panache; Mervyn now seemed to play second fiddle on social occasions. However, the house was expensive to maintain and a long way from their artist friends: Maeve recalled bitterly: 'In the seven years we spent in this Outer Siberia I can think of only two people to whom we talked.'[2] Suburbia oppressed her: 'There was a nothingness, more than the claustrophobia of being surrounded by sea' as in Sark. They soon had the place covered in pictures, many drawn straight on the plaster of the wall, but one incident still rankles with Sebastian, who heard of it from his mother: 'We had children's parties for Clare, and one mother on fetching her daughter looked at the paintings and drawings everywhere, and said, "Oh that's funny, I dabble too."'[3]

Mervyn was once more at the centre of his family, drawing them, conjuring and clowning to amuse them: Sebastian remembers him glueing a 10-shilling note to the pavement by the bus stop so they could watch from the front window as their stuffy neighbours tried to pick it up. Kit Peake, Lonnie's son who had lodged at Glebe Place for six months on their return from Canada visited his cousins during holidays from his boarding school (his parents were back in the East) and remembers Mervyn as loving such boyish pranks: he was 'always on the verge of laughter . . . but I seem to remember that before he really let himself laugh he had looked towards Maeve for some signal. He seemed to want the OK. It struck me that he was a little subservient.'[4]

In spite of Peake's established reputation as an illustrator, challenging book commissions were not forthcoming during this time of financial need and he had to take what scraps were offered – dust jackets, logos, vignettes, portraits of authors for book covers, and advertisements. The *Leader* magazine, *Radio Times*, *Encounter*, *Elizabethan* and *Housewife* all took odd drawings. In May 1950 he did some subtly

coloured illustrations for Kay Fuller at *Lilliput* of four nursery
rhymes,[5] but it was an area he had already conquered in *Ride a Cock-
Horse*. In 1952, he worked on one story book for children, *The Book of
Lyonne* (Falcon Press) written by his old schoolmaster and Clare's god-
father, Burgess Drake. It is dedicated to Sebastian and Fabian, then
aged twelve and ten and probably grown beyond it because its hero Pip
is aged seven. The story concerns his talking, lion-shaped pyjama case
and other talking toys Torpus and Hangdog, Dr Pwing-Pwing, Ba-Ha,
Munk, Rubbaduk and so on, all of it sub-Pooh and a little twee, with
winks from the writer over the child's head to the adult reader. There
are none of the disturbing depths and sexual ambiguities of Peake's
own *Captain Slaughterboard* or *Letters from a Lost Uncle*. However, he
did a professional straightfaced job on the illustrations with ink line
drawings and eight limited colour plates. The pictures are certainly less
patronizing than the prose, but are not remarkable. The same could be
said of his illustrations to another rather sentimental book, *The Young
Blackbird* by E. C. Palmer (Wingate, 1953). It was worrying that the

Illustration for *The Book of Lyonne* (1953), pen and ink, 11 × 10cm

illustration commissions seemed to be drying up when he was at the height of his powers and a lot of talented younger men were competing for the work.

Peake still regarded himself as a painter and he worked regularly in his studio, but in this thin period he must have felt increasingly sidelined – as indeed must Maeve, who also remained steadfastly figurative, though with her own fantasy elements added. Support came from neither the Arts Council nor the British Council, both crucial makers of artistic reputations in this postwar period. He joked that the only way to get more attention would be to put rubber stamps on the soles of his shoes and walk the streets leaving BUY MORE PEAKES printed on the pavement behind him. But if his oils were out of fashion then his drawings still commanded respect and in March 1951 thirty-nine were shown at the Waddington Gallery, Dublin. The catalogue had an introduction by Maurice Collis and the prices for these pictures of his children and strangers ranged from 10 to 23 guineas. This was the year of the Festival of Britain and though Peake was not one of the sixty artists invited to submit canvases, or one of its hundred designers, he did do a series of drawings for a short Festival film in which Peter Pears sang a setting of a Shakespeare sonnet. For a time this tenuous link gave Peake hope that the Titus books might become an opera with music by Benjamin Britten, but nothing came of it beyond his rough sketches of characters and stage settings.

New stars were rising in the art world and rumours circulated of disturbing things happening in New York, though they were not to make their full impact in Britain until a Tate Gallery exhibition of 1956. In 1949 *Life* magazine called Jackson Pollock 'the shining new phenomenon of American art'. With his late 1940s drip paintings, he had been released from the burden of European art history by Surrealism's 'automatic writing' in which the artist's hand gestures and records without his conscious control. Pollock declared in 1951: 'The modern painter cannot express this age, the airplane, the atom bomb, the radio in the old forms of any past culture. Each age finds its own technique.' And that technique seemed to mean spontaneity – the canvas was a skid mark recording the collision of the artist with his materials. In London Francis Bacon talked of working direct from the nervous system, leaving a trail of paint as a snail leaves slime. Peake, however, was still using the academic skills acquired at the Royal Academy School, making smallish oils of conventional portraits, figures and

people in pubs or restaurants, though rarely landscapes. Some time in the 1950s he began to paint the monsters and grotesques he wrote about, but they were private fantasies, often in dark paint, and they had none of the terrible power of Bacon's *Three Studies for Figures at the Base of a Crucifixion* (1944). Peake also created a series of young male figures in conical hats which seem heavily derivative of Picasso's Pink Period *saltimbanques* and parallel to his teaching colleague, Cecil Collins' depictions of holy fools. His greatest skill was undoubtedly drawing in pen, pencil or brush on paper and the Central School in Holborn now employed him to pass this on to a new generation of students.

In 1950 the Principal, William Johnstone, a renowned teacher, appointed Peake to the large Department of Painting, Modelling, Etching and Allied Subjects. In 1951 Morris Kestelman took over its leadership and became Peake's lifelong friend. Others there whose reputations Peake would already know were Leslie Cole who had been to Belsen, Merlyn Evans, Victor Pasmore, William Roberts, Keith Vaughan (who also taught book illustration with Gertrude Hermes) and Anthony Gross. Later Patrick Heron, Roger Hilton and Cecil Collins joined for varying periods. These were all better artists than his former Westminster College colleagues and, like Peake, many were part-timers supplementing their irregular incomes as painters. One, Paul Hogarth (born 1917), an illustrator who would eventually eclipse Peake in popularity wrote: 'I admired his work immensely, especially as a book illustrator. I thought his work so refreshingly original when it burst upon us during the fifties.'[6] They shared an early love of Stanley L. Wood and had a mutual friend in Ronald Searle. Hogarth, who had communist connections in Eastern Europe, took Searle with him on a drawing trip in Yugoslavia in 1947 and eventually did all the paperback covers for the novels of Graham Greene, travelling to each exotic location.

Mervyn's teaching timetable varied from year to year but usually he did a couple of days each week and sometimes evening classes. He taught general drawing and life drawing, usually sharing the class with Kestelman, Gross, Roberts or Collins. After the war there were more male students in art colleges, some of them ex-servicemen and others recruited from outside the middle class who had dominated the arts when Peake was a student. One former pupil has given an account of a life class with Peake, who was now conventionally if casually dressed: with 'a shock of greying hair, deep-set, "haunted" eyes and a sensitive and ascetic and masculine face, he seemed to be a throwback to the

William Roberts, pencil and wax crayon, 30 × 23cm, probably early 1950s

London Bohemia of the 1920s'.[7] He entered classes 'quiet as a ghost'. Paul Hogarth, who sometimes shared or swapped a class with Peake, also found him subdued: 'He was a somewhat shy, withdrawn personality but was much respected by the other members of the staff.' Evidently the flamboyance and extroversion of the Westminster College days had left him and he was no longer a pint-after-the-class tutor, though he still had a following amongst the women students and was known for his habit of shuffling up close on the 'donkey' drawing bench when instructing them.

He still taught well. His student, John Wood, recalls that 'Except for smoking a few cigarettes, he was inactive in the class until some drawing had been produced by the students. Cecil Collins usually set the model's pose, with Peake's approval. Then Peake walked along behind the row of donkey stools and, briefly scrutinising the work done, selected a student to instruct.' This was orthodox enough, but 'in a few moments he had produced a brilliant line-drawing of the model's head. Then, taking a 2B pencil, he drew the head again, this time in bolder strokes, with the modelling and the shadows emphasised.' Wood found they shared an enthusiasm for the works of Poe and *The Diary of a Nobody* and Peake, always generous with his work, gave Wood drawings and signed books as well as inviting him and his sister back to the Trafalgar Studio where he read work in progress on the third Titus volume.

Later Wood visited Wallington where a writer-babysitter called Aaron Judah had now taken up residence in one of the attics. The three men discussed *Ulysses* and then Mervyn had a rather trenchant comment to make about Tolkien's *The Fellowship of the Rings*, which had just been published. He described it as 'rather twee' and mildly mocked the character of Goldberry, Tom Bombadil's lady-friend, as 'precious' – which proves that Peake was well aware of his better-selling rival. He always resented the critics' habit of linking them, thinking that Tolkien wrote primarily for children whilst he wrote for adults. Tolkien's creation relied on magic and supernatural props, which Peake's fantasy world never did. In the real world Peake showed less interest, responding punningly to a discussion at the Central School of the Korean War: 'The only Korea I'm interested in is my own.'[8]

As a prose writer Peake's best performances were over the 1,000-page marathon of the Titus trilogy, but now and again he kept in trim with short story sprints. Although they have various dates this may be the

place to consider the range of those collected in *Peake's Progress*. 'Weird Journey' was published in 1948 in a magazine called *Harvest* to a set theme of travel. Peake chose to interpret this experimentally as dream travel rather than a literal journey. It opens: 'Once upon a time theory . . . I fell wide awake' and ends 'no longer fast awake I turned over in the great bed and fell wide asleep,' which echoes Dylan Thomas' 'once below a time' – the inverted cliché trick. The aunts and uncles, the prawn-coloured villas and deckchairs by the sea are all Thomas territory too, though the vision of 'some midnight cellar full of splashing water where the backs of soft beasts rose intermittently above the cold surface, and occasionally some wet and yellow head that mewed and sank again' is all Peake's own. The narrator's snakeskin shoes carry him inexorably back along his own footprints towards a dreary childhood, the faceless teacher of algebra and the faceless pipe-smokers in suburban gardens. This nightmare image of the blank eyeless face is one he had already used for Smear in *Mr Slaughterboard* and would use again in *Titus Alone*.

'The Connoisseurs' was written after hearing two men at a party discuss whether a vase's beauty depended on it being genuine rather than a fake. This simple idea gave Peake opportunity to poke fun at the art world's pretensions. Both men are 'fastidiously groomed. Their hands were very similar, soft and rather womanish' and there are echoes of Prunesquallor's affectations in their talk. The story was published in *Lilliput* in 1950,[9] next to an article on the senior painters of Paris who had survived the war (Matisse, Picasso, Braque, Rouault, Chagall, and so on) and who did not seem to have any immediate rivals in the younger generation. Peake worked the story up into a skit with an added character, Mrs Hollow, who confounds the effete aesthetes Mr Forge and Mr Splice by smashing the supposed Ming vase with a poker. A slight piece, but done with considerable comic verve, it was transformed into a one-acter which the Smarden Amateur Dramatic Society put on in the village hall in 1952:

It was an exciting evening, particularly for Sebastian and Fabian who sat on the front bench. In his pride and excitement Sebastian kept turning round and shouting, 'My father wrote this play!' Mervyn was preoccupied with the necessity of making a speech thanking the society for putting on the play. The name of the Society's secretary was Fielding-Mould. 'I know I shall call him Moulding-Field', Mervyn kept saying as he went over the speech. But all was well.[10]

The smashing of a vase has been traced as a recurring symbol in the Gormenghast rituals and elsewhere in Peake's work,[11] and it appears yet again in 'Same Time Same Place', a short story published in 1963.[12]

When Mervyn and Maeve were visiting one of their favourite Lyons Corner Houses they saw a solitary woman sitting nearby. Peake made up this story from their speculations about her. A twenty-three-year-old man who is fed up with his home, his father's nicotine-stained moustache and his mother's nagging flees the house ('I sent a pink vase flying') and takes a bus to the Piccadilly Corner House in search of glamour. He finds himself seated opposite a lone woman and during only eight subsequent meetings in the same place falls madly in love with her and asks her to marry him. She always insists he leave first so he never sees her standing up. They arrange to meet at the Register Office in Cambridge Circus but his bus is held up in traffic outside so that he can see into the office window. There are the wedding guests – a bearded lady, a giraffe-

Cecil Collins, pencil, 38 × 28cm, mid-1950s

{223}

man with a neck like a walking stick, a tattooed man, and a man with a goat's hoof for a hand – all Peake's nightmare freaks. The bride trots like a dog across the floor and is placed on a high stool so her long dress conceals the fact that she has no lower body. The narrator flees to his stuffy but safe home and does not leave again, having decided 'I know what is best for me.' So the poor princess never gets the chance to be transformed by a kiss and the young man, unlike Titus, rejects the possibility of sexual maturity and crawls back into his womb-like home. It is a bleak vision, and so is the next one, 'Danse Macabre'.[13]

This is a ghost story developed from one Mervyn told on Boxing Day to his family assembled round the fire. As in 'Weird Journey' and 'Same Time Same Place', this has an unnamed first person narrator and, like the latter, describes a failed relationship. The man tells how his wife has left him because, though they are still in love, they cause too much hurt to each other. One night he wakes to see his dress clothes come out of the wardrobe, assemble, and float through the window to nearby woods. The second time this happens he follows and sees his empty suit meet and dance with an ice-blue dress. At a dinner party he meets his wife, who is wearing the dress, and learns that she too has had the same nightmare. They leave together but an evil force takes over their clothes and rushes them to the woods. Later he stumbles back to his room, sees in the mirror that he has no feet, hands, or face but on the bed lie himself and his wife and 'we were both dead'. Like all good ghost stories this has a plausible setting, striking visual effects and a good punch line. In the tradition of Poe, it predates Roald Dahl's exploration of the same borderland between the ordinary and the macabre.

Not only was Peake writing short prose pieces as the inspiration took him, but he wrote poetry too – perhaps as many as 200 poems in total over the years. Many of his verses appeared in magazines and anthologies, some of them prestigious, others ephemeral. In Peake's files a 1939 poem confesses 'Fame is my tawdry goal' and another undated one reveals his ambitions to be taken seriously as a poet:

> I am almost drunken with an arrogant
> Madness of desire to follow in the line
> Of England's poets who have raised high shoulders
> Over the crowd, and cried mysterious words
> Of deep and coloured music

The kind of poets he admires are those who have 'yearned for beauty with hot groan' and

> Whose eyes
> have in the grass-blade seen immensities
> Of emerald light, and in the beggar child
> The tragic splendour of a ragged world.

This reflects his admiration for Blake who saw 'a world in a grain of sand' and perhaps for Wordsworth's poems about the rural poor and vagrants, but the strenuously rhetorical language is closer to Dylan Thomas' *hwyl* – the emerald light, tragic splendour, coloured music, hot groan are certainly not from 'the real language of men' which Wordsworth called for in his Preface to the *Lyrical Ballads*. With his thirty-five-poem volume *The Glassblowers* (Eyre and Spottiswoode) published in May 1950 Peake made his bid to raise his own shoulders above the crowd.

The poems date from the 1930s onwards but display a consistent 'voice' and view of the world. The title poem is based on his war work for WAAC (his painting of glassblowers is on the cover) and the Belsen poem reappears. Predictably there are love poems to Maeve and others about the misery of their wartime separation, but doubts about the persistence of love are also expressed, as in 'Love, I had thought it rock-like':

> I had thought that it stood
> But it slithered like sand;
> I had thought it founded
> Like a city on stone –
> But it was thistledown
> Or the touch of a wand.

Or 'All Eden was then girdled in my arms':

> Within so small a noose my girdling arms
> Held you, my sweet, and yet the noose was doom –
> Doom in the brain, doom in the ringing limbs
> When branches broke and a gold bird flew home.

John Batchelor said of these poems: 'Peake had a strong marriage: witness the dedication to his wife of *Shapes and Sounds* and the pathos, expressed in some of the poems, of separation from her when he was serving as a soldier. But he was by temperament a sensualist and a Bohemian, and the marriage was often under strain. In *The*

Glassblowers, dedicated to his life-long friend Gordon Smith, some of the stresses of the marriage get into the poetry.' He cites the poem 'O, this estrangement forms a distance vaste':[14]

> Knowledge of failure damns us where we stand
> Withdrawn, lonely, powerless, and
> Hand in hand.

But the final line shows that, whatever the strains, they are still united. All marriages have their ups and downs and one of the great ups for Peake was the experience of parenthood:

> Grottoed beneath your ribs, our babe no more
> May hear the tolling of your sultry gong
> Above him where the echoes throb and throng
> Among the rafters of sweet bone.

And elsewhere, of holding his son in his arms, he writes: 'I had not known that such duress/ Of thorny sweetness fell to fatherhood.' One poem, 'Features forgo their power' might be about the death of his mother, or the Belsen girl again, whilst 'Are you love's spokesman in the bone?' appears to be a rather lame comparison of toothache and the pains of love.

Apart from the family subjects and the rawly confessional poems he was still 'head-hunting' amongst the lower classes. In 1949 he had published a kind of prose poem, 'London Fantasy', full of his hunter's thoughts about 'such a scene as haunts the brains of madmen, a delirium of heads and frames and hands, a cavalcade hardly to be suffered for the very endlessness of its inventive fantasy',[15] and several poems here continue the theme, including one about the murder of a 'strawberry blond' prostitute in Piccadilly, and one on

> The empty-pocket boys who ask no quarter,
> For whom no childhood sings, and no hereafter
> Rustles tremendous wings.

'Sin', though not a good poem, spells out a belief we have seen embodied everywhere in his prose – that warped bodies inevitably house warped minds, so a character's physique is his destiny:

His head and hands were built for sin,
As though predestined from the womb
They had no choice: an earthish doom
Has dogged him from his fortieth gloom
Back to where glooms begin.

That skull, those eyes, that lip-less mouth,
That frozen jaw, that ruthless palm
Leave him no option but to harm
His fellows and be harmed by them.
The beast his marrow feeds must wander forth.

What people looked like was therefore important and worth a lifetime's study. Both Peake and his wife were very conscious of their own physical comeliness and sought to enhance it with eye-catching clothing.

Other poems celebrate the creative process itself, or call us to seize the day and live life to the full ('To live at all is miracle enough') but the best things in the collection are those which appear simplest. Here for example is a short poem with no straining after poetic effects but which has something important to say:

The vastest things are those we may not learn.
We are not taught to die, nor to be born,
Nor how to burn
With love.
How pitiful is our enforced return
To those small things we are the masters of.

Batchelor thinks this the equal of anything in Frost, a writer to whom Peake had written a glowing tribute in his poem 'Robert Frost'. Consider also this miniature gem in which he seems to be regretting the evanescence of his art:

The paper is breathless
Under the hand
And the pencil is poised
Like a warlock's wand.

But the white page darkens
And is blown on the wind
And the voice of a pencil
Who can find?

We might add two other successfully pithy examples which were not included in the book: one a light-hearted exercise, the other perhaps more grounded in experience:

> I heard a winter tree in song
> Its leaves were birds, a hundred strong;
> When all at once it ceased to sing,
> For every leaf had taken wing.

('Conceit')

And the second:

> Love so imperilled is
> By words within its boundaries
> Stalking:
> However rare the cadences
> There's death in talking.

Here he has dropped the well-worn imagery of water, sun, moon, fire, stone, bones, and the use of an adjective for every noun which over-embroider many of the other poems. The humour which characterized the man and the prose writer is entirely absent in this volume, as if he believes real poetry has to be solemn. Missing too are political or relig-ious musings, though underlying it is a kind of nostalgia for a golden past, both his own and mankind's. The forms are traditional ones – quatrains, cinquains, *terza rima* and so on.

The reviewer in the *Listener* (6 November 1950) detected echoes of John Donne in Peake's work, perhaps a reference to the extended con-ceits, and thought

> as a painter in words he is almost too literary . . . the diction of his longer poems is inclined to be an opaque and elaborate partition between poem and reader. But look closer; and it becomes a frame. The virtue of this poetry is that in spite of difficulties it had to be made. It hits on tremendous themes and denounces them in a post-card. 'To live at all is miracle enough,' 'The vastest things are those we may not learn', 'Each day we live in a glass room,' are not great poetry . . . but we feel that the poet has genuinely reflected on his own experience.

The poet Alan Ross in the *Tribune* (June 1950) thought this volume showed how much Peake had improved since *Shapes and Sounds*. However, he was 'certainly not a poet on the grand scale or with original gifts of technique or language; but sensible, realistic and usually clear'. Only Richard Murphy in the *Spectator* (June 1950) came down off the fence and gave the book an unequivocal welcome. The book 'contains verse that has been well made, and at moments one feels that a new fire of language and vision has been kindled, that "the air is full of gestures suddenly lit"'. Peake 'has looked for simplicity and force of diction to make the language directly serve the sense, and has everywhere avoided ornament for its own sake . . . It is unique chiefly in the weirdness and vitality of the poet's fancy. At least the first volume of Mr Peake's poetry has shown more than promise, it has given us some intimations of poetic power.' Though, of course, it was not the first volume.

With the passing of half a century it is possible to assess Peake's poetic achievement in a wider cultural context. John Batchelor thinks:

> As a poet MP can be seen poised somewhat awkwardly on the cusp between a late flowering of Romanticism in the late 1930s and early 1940s and the emergence of the dry, academic, anti-Romantic poetry of the 1950s. The poets of the 1950s who were associated with what became known as 'The Movement' – Amis, Davie, Enright, Gunn, Elizabeth Jennings, Larkin, Wain – detested everything that Dylan Thomas and now such forgotten figures as the alliterative Ulster poet W. R. Rodgers stood for. What Dylan Thomas and Rodgers have in common with Peake is a lack of literary self-consciousness – they are not dons, they are not deep poetry readers and critics and university teachers, they are bards.[16]

It is indeed difficult to see any common ground between Peake's delicate lyrics and Larkin's acerbity. Peake's habit of wearing his heart on his sleeve would come to seem embarrassing to this later self-mocking, ironic, and coolly cynical generation. Or it would have done if he had continued to write, but the poetry dried up after this collection. More would be published in anthologies both during his lifetime and after, but all of these poems were written before 1950. It is a mystery why his poetic voice fell silent.

No poetry anthology would solve the family's financial problems, but perhaps a popular novel and a play in the West End might? Peake began working hard at both, but Maeve noticed he seemed to need more sleep than formerly, and there were occasional tremors in his hands.

13 Amorist, 1953

Peake hoped to make money by writing a shorter comic novel, to be called after its main character, *Mr Pye*, though he would not compromise by lowering his standards or by following the growing fashion for realistic novels with disgruntled working-class heroes. He was simultaneously at work on a third Titus book and drafting his play *The Wit to Woo* since illustrating commissions had dried up. He had suggested to publishers that he tackle *Don Quixote* and *Baron Münchhausen* – even medical illustrations – but all had fallen flat.

In the middle of his *Mr Pye* manuscript he broke off to summarize his financial position, presumably for his own benefit, and it makes depressing reading: 'have had very poor year. No books to illustrate. Have had to live largely on Maeve's money . . . Impossible to part with children . . . Maeve paying for Smarden. Dad's will Maeve's name.' Then he goes back to trying out names for his hero: Gideon Gull, Daniel Fruit, Melchior Flick, and titles: Duty and the Beast, The Enthusiast, Dare to Be a Davis, Well, Really!, Commando Pye, all these in brown ink interspersed with doodles and a portrait of Sebastian posing in his underpants.[1]

The new work was not meant to compete with the Titus books in scale, being a mere 250-odd pages long and it would be grounded in his knowledge of a real place, Sark, rather than involving him in the creation of a whole new community, geography and climate. It would be

comic and satirical in tone with a few barbs to puncture the pretensions of the religious or artistic poseurs and the Sarkese themselves. It was written quickly in a light accessible prose with no arcane vocabulary or long descriptions and he provided each chapter with an illustration – the only adult book of his own to be so decorated. These drawings are in a linear, unmodelled style with a deliberately broken outline seemingly effortlessly drawn with a thin brush and ink, but one can see from the use of white gouache on the double-sized originals that this effect was striven for. Cartoon-like, they are reminiscent of Evelyn Waugh's own illustrations to his *Black Mischief* (1932). There is also a flavour of Waugh's black comedy and his concern with religious issues, but other critics have suggested T. F. Powys' *Mr Weston's Good Wine* (1927), H. G. Wells' *The Wonderful Visit* (1895) and Agatha Christie's *The Moving Finger* (1943) as possible sources for some of the book's elements. The publishers of the Titus books, Eyre and Spottiswoode, were disappointed by this radical change of style and content and turned it down, but Heinemann published it in 1953, priced at 12s. 6d. for the hardback.

Mr Pye is a short, portly figure with a sharp nose, rather like the filmmaker Alfred Hitchcock. In his fastidiousness, asexuality, verbosity and liking for the good things in life he is also reminiscent of Prunesquallor. He takes a one-way ticket to that 'strange wasp-waisted ship of stone', Sark, intent on converting its inhabitants to belief in his God, the Great Pal. On landing he is met by his gruffly masculine landlady Miss Dredger; quickly she succumbs to his relentless courtesy, charm, practicality and total conviction in his mission and becomes his devoted helper. He insists that she invite her enemy, Miss George, to come and live with them as a start in his campaign to root out all jealousy and meanness from the island. The contrast between the two women, one lean and faithful, the other gross and ridiculous, echoes that of Flay and Swelter. For the first half of the book Mr Pye gets all his own way as the local residents and the Sarkese themselves fall under his spell. Only Tintagieu the voluptuous local tart ('mistress of many and the property of none') treats his mission with some levity and her admirer, the dithering, stammering artist Thorpe, cannot make up his mind.

Mr Pye begins by exploring the wasp-waisted island like a woman's body, 'treading its bony back' so that soon 'he had forced his way to the very core of what made the island into Sark, and Sark into the island.

Mr Pye (1953). Mr Pye and Miss George, brush and ink, 6×9.5cm

He had wormed his way into her dank, primordial caves; had stared his fill at her emblazoned flanks; had dived, a pear-drop in his mouth, into her cold April tide; had sat for an hour upon a fallen tree and drunk his fill of the sweet Dixcart Valley.' Then he reconnoitres the natives:

'My, my you are a strapping fellow,' he would cry out to some bibulous hulk. 'I am delighted to meet you.'

'Oh you are, are you, eh, you fat little porker,' the hulk would reply 'B—— you.'

'Indeed?' said Mr Pye. 'But that's a very naughty thing to say. How old are you? Now, now, now, – don't tell me you're shy. A great big fisherman like you – Now I tell you what. I could make use of a strapping fellow.'

'Oh you could, could you?'

'Oh yes indeed, with that raw, that magnificent frame. You are quite quite fundamental.'

And Mr Pye tells the dumbfounded oaf: 'I know that your muscles were built for Love, not Cruelty.'

One wonders if these ribald innuendoes were put in partly for the benefit of Gordon Smith, since they continue in much the same tone as their letters.

Pye plans a spectacular event during a night-time picnic on Derrible Beach attended by the whole island in which the colossal Miss George will be lowered through a hole in the cliffs in her nightdress to represent rebirth into faith (after visiting this chasm one realizes what a terrifying ordeal Peake had imagined for her). This epiphany fails because a putrid whale drifts onshore to disperse the picnickers with its stench ('The shock for the congregation had been cruel. From the summit of metaphysics and the essence of love they had all of a sudden been woken to the beastliness of physical decay'). After this débâcle Miss George hates Pye for the indignities she has been made to suffer. From now on his grip on the islanders begins to loosen, though Miss Dredger remains faithful.

Wings begin to sprout on Mr Pye's scapulae which baffle even the Harley Street surgeons he consults. Miss George glimpses these, recoils, falls down the stairs and dies. Mr Pye's own reasoning is that if they grew because he has been excessively pious they will retreat if he sins. At first he commits acts of mere naughtiness and spite, but soon he begins to worship the devil with the aid of a goat – a precursor of the one in *Boy in Darkness*. As a consequence the wings disappear but horns grow on his forehead. In an act of self-humiliation he goes bareheaded amongst the locals at the island cattle show. They are outraged but a stratagem of Tintagieu's sets them off hunting him round the island while she hides him in the prison building. As the bloodthirsty mob close in she provides a horse and carriage for him to drive through them and head pell-mell towards the Coupée, the narrowest part of the island. Pye's wings grow apace as he gallops so that when the horse and carriage crash over the cliff he is able to soar up and away out to sea, to the astonishment of the pursuing residents.

In the Titus books Peake had created an alien world, but one in which the inhabitants were pushed and pulled by credible human emotions such as jealousy, ambition or devotion. With *Mr Pye* the setting is an actual place which Peake had trodden yard by yard, but into it he has introduced supernatural events (growing feathers, horns, flying) over which the characters have no control. 'Magic realism' was originally a term applied to German paintings in the late 1920s and only much later was it used to describe the novels of such South American writers as Borges and García Márquez or, later still, those of fabulist writers in English like Angela Carter and Salman Rushdie. Had the term been in circulation in 1953 it would undoubtedly have been applied to Peake's mixture of the real and the impossible.

Peake wrote this novel with a very clear map in his mind and, like Gormenghast, Sark would assume the status of a character. He is specific about the island's buildings, roads, climate, caves, cliffs and wind-bent trees; for the author, as for Mr Pye, 'It is just the right size. It will do very nicely.' Like Gormenghast it was self-contained and free of twentieth-century clutter like aeroplanes, motor cars or trains (though it had telephones and radio). Its social structure of tax exiles from England, inbred locals and raucous day trippers (DTs) lay open to satire and one suspects that Peake enjoyed paying off a few old scores in his cast of characters. Today's Sarkese offer strong but conflicting opinions about who the originals are for Dredger and Miss George and will tell you the original Tintagieu now lives on Guernsey. However, his plot could not credibly encompass the autocratic Dame of Sark, nor the vicar of the local church who would both have had something to say about the activities of any real Mr Pye, so they were left out.

Peake's attitude to the Sarkese is mocking: they are drunk, half-witted (Ka-Ka was named Gaga in the original draft), dirty (Pepe), superstitious, foul-mouthed (Pawgy) and likely to turn into a lynch mob. His early oil paintings depicted them in much the same way. Only Tintagieu redeems this picture and she is that oldest of clichés, the tart with a heart

Mr Pye (1953). 'The island sparkled from a night of rain', brush and ink, 6×9cm

– exactly the stereotype his friend Dylan Thomas was soon, in 1954, to introduce into the tight little community of *Under Milk Wood* in the shape of Polly Garter. Tintagieu is named after a wave-lashed rock stack in one of the bays of Sark which Peake had painted as long ago as 1933, so perhaps she is meant to represent the very elemental forces of the island itself. She is certainly earthy ('the morals of a monkey'), living for and by physical love and mocking the spiritual kind offered by chaste Mr Pye. In this she acts as a foil to the sexually frustrated English spinsters Misses Dredger and George, and only she recognizes that what Dredger feels for Pye has a physical rather than a spiritual basis.

Trailing Tintagieu wherever she goes is the stammering artist, Thorpe, who never completes even a drawing, let alone a picture, and who is rumoured to be colour blind. He is unsure whether he is for 'atmosphere', Cubism, Expressionism or 'synthesis': obviously Thorpe is one in whom 'aesthetic theft shows its anaemic head'. Peake was working at the same time on his play *The Wit to Woo* whose hero, Percy Trellis, is forced to assume the persona of a flamboyant artist, October Trellis, perhaps of the Augustus John type, full of bluster and big gestures. In both cases this allows Peake to mock the art world which seemed not to be affording him the respect he deserved. Sally Devius asks if Trellis is '"abstract" or "extract"? Cubist or tube-ist? A figmentist? Or pigmentist?' and Kite, the manservant, advises his master (who wouldn't be seen dead in the company of a real artist) that to imitate one he has only to be as simple, self-absorbed, merciless and horribly mannered as a little child, 'and when in doubt, sharpen your pencil'. The theatre audience, knowing the playwright to be an artist himself, would see the fun in these sallies, but how are readers meant to react to Thorpe's bitter disillusion? He tells Pye:

'These theories about Art, they are all absolute n-nonsense . . . Can't you see the whole thing is an organised racket? The p-painter digs his heart up and tries to sell it. The heart specialists become interested, for the thing is still b-beating. The hangers-on begin to suck the blood. They lick each other like c-cats. They bare their fangs like d-dogs. The whole thing is pitiful. Art is in the hands of the amateurs, the Philistines, the racketeers, the Jews, the snarling women and the raging queers to whom Soutine is 'ever so pretty' and Rembrandt 'ever s-so sweet.'

Working himself up further (this is his only big speech in the book) he continues: 'What do the galleries know? They are merely m-merchants.

They sell pictures instead of lampshades and that's the only difference. And the critics – Lord, what *clever* b-boys they are! They know about everything except painting. That's why I came out here to get away from it all. The jungle of London with its millions of apes. I came out here to find myself, but have I done so?'

Peake had travelled that route and for those same reasons. But perhaps he could also answer with Thorpe:

'Of c-course I haven't. For artists need competition and the stim-ulus of other b-brains whether they like it or not. They must talk painting, b-breathe painting, and be c-covered with paint. That is the kind of man I would talk to. A man c-covered with paint. And with paint in his hair and paint in his brain and *on* the brain – but where are they, these men? – they're in the great cities, among the m-monkeys where they can see each other work and fight it out, while as f-far as the public is concerned they might as well be knit-ting, or blowing bubbles . . .'

This tirade could only have been written by a very disenchanted man. It is not surprising that the vision of a perfect picture, 'a painting unlike any other painting – yet in the tremendous tradition of the masters', afforded to Thorpe at Pye's picnic never gets put on to canvas. It would have been 'five overlapping rectangles with holes in them. Three zigzags black and grey. A kind of leper whiteness – the paint all thick and crusty – I'll mix the stuff with sand. And no moon. No atmosphere. Just the core of it all. The heart of bone.' That it never appeared is no great loss since it sounds like a poor imitation of William Gear or a fifth-rate Ben Nicholson. We might also recall that in Gormenghast the carvers (no painters are mentioned) make masterpieces which finish either on a bonfire or in a remote attic. Overall, then, Peake has not given the creative artist a very enviable role in his fiction, and one suspects that by this time he had begun to lose confidence in his own talent as a painter.

Peake's parents were missionaries sent by their employers to bring Christ's message to the pagan Chinese. Mr Pye is a self-appointed mis-sionary to heathen Sarkese and, judging by his hymn-singing, a Christian, but also a very peculiar one since he is attached to no church, carries no bible, conducts no rituals, quotes no scriptures and his God can just as easily be addressed as 'this Alcoran, this Ly-King, this Vedas, this Purana, this Zenavesta, this Shaster, this Zantama, this Mormon, or, as Mr Pye would call him, this Great Pal'. Christ is not

mentioned, nor the Virgin Mary, saints, or the crucifixion, and one wonders how Maeve and her devout family responded to all this. Much later, in *A Reverie of Bone* (1967), Peake was to state his belief that love transcended all churches:

> How foreign to the spirit's early beauty
> And the amoral integrity of the mind
> And to all those whose reserve of living is lovely
> Are the tired creeds that can be so unkind
>
> There is a brotherhood among the kindly,
> Closer and defter and more integral
> Than any brotherhood of aisle or coven
> For love rang out before the chapel bell.

John Watney tells us that Peake 'accepted the existence of God as a fact . . . but he did not appear to need church ministrations, he had no interest in dogma and ceremony, but believed in kindness and charity because he was more concerned with the human predicament than with religion'.[2] Both poem and biography seem unequivocal, but in *Mr Pye* that message of charity is muffled by ambiguities.

Mr Pye (1953). Thorpe and Tintagieu, brush and ink, 7×9.5cm

Mr Pye strides into the community like one of those gun-slinging strangers with no past who appear in the Wild West stories Peake loved as a boy. His effect is jarring and death and destruction follow wherever he brings the message of love from the Great Pal. As he embarks for the island there is 'one sudden and quite extraordinarily offensive oath from one of the sailors who had suddenly slipped and broken his leg'. Later the violent death of Miss George is treated as a comic set piece, while the incarceration of an innocent local in a lunatic asylum, the breaking of a man's ankle, another death from a fall off the mill, and the plunge down the cliffs by a horse and a carriage in the final pages are all attributable to Mr Pye's presence – or perhaps to the intercession of the Great Pal who, Pye assures us, is everywhere and in everything, even a biscuit. Pye's Pal is as sadistic as the God of Job in the way he afflicts his servant with wings and horns to humble his spiritual pride, though he does offer him an escape route at the end.

Evelyn Waugh had also been casual in his disposal of minor characters for comic effect, for example the schoolboy Tangent in *Decline and Fall* (1928), who is shot in the foot by a starting pistol, has his leg amputated and then dies. But Peake goes far beyond this callousness here, whilst in the Titus books one has only to remember the ghastly fates of Swelter, Sepulchrave, Flay, the twins, the Thing and Fuchsia to realize that the author enjoyed snuffing out his creations in spectacular ways.

Beneath the comic surface of this novel lies a cruel stratum, but the more serious question of evil receives superficial treatment. At first Pye's sins are trivial (like Fabian he set fire to a haystack), until he begins to visit a goat and tinker with devil worship. We may recall that Peake had already illustrated two books on witchcraft. Evidently he intended to treat this more provocatively and have Pye lead the goat into the church wearing a golden crown, but wisely he dropped the idea because it would have skewed the whole tone of the book.[3] Really sickening soul-rotting evil would have to wait until *Boy in Darkness*.

Mr Pye attempts to deal with some serious issues in a light-hearted way, but in the end it leaves us baffled. Is Peake primarily endorsing pagan amorality by showing us Tintagieu rising naked like Venus from the foam? Is Mr Pye's message of love flawed in itself, or does it fail to catch on because it is carried by a flawed messenger? How do we interpret the final scene where Pye flies away? Is it an apotheosis, or a craven escape from a dreadful mess? Sark is left more riven by hatreds than

ever, Miss Dredger's devotion has counted for nothing, Thorpe's vision has failed and only Tintagieu ('complete as an acorn') emerges with her pagan way of life intact.

Peake contemplated a different ending, as we can see from his note-book: 'When he starts flying from the Coupée, he realises that he has done good but for the wrong reasons, and his thought is overheard by God who had not thought of that – but now withdraws his pardon, so that Mr Pye falls into the sea half way between Sark and Herm and some time later the huge sodden wing of some outlandish fowl is found washed ashore in the Greve de la Ville.'[4]

The reviewers offer no help in resolving these questions since most ignored the book on publication, which must have been a bitter blow to the Peakes. The *Times Literary Supplement* (6 November 1953) reviewer was among those who didn't know how to classify it: 'Like Mr Peake's previous novels *Mr Pye* is an oddity. Is it a fantasy? A story of the supernatural? A tract? Or just a joke? In any case it is highly entertaining and sometimes more.' It was very soon remain-dered and seemed doomed to oblivion, though it deserved much better since it was carefully crafted, funny and, in the Derrible picnic, Mr Pye's sermon from the veranda, and the Wagnerian finale had set pieces as good as any he had written, while the dialogue sparkles as nowhere else in his *oeuvre*. Hope revived a little when he was asked to pare the book down and make a 30-minute script from it which BBC Radio broadcast on 10 July 1957. He cut away most of the flesh from his story and left a skeleton plot with characters who had no space to develop. Oddly enough he retained Ka-Ka, the inept cook, and Pepe, the scratching youth, though neither has any influence on events. The day trippers disappear and Miss George becomes Mrs George, which spoils the original picture of her as a surly and virginal spinster. Tintagieu becomes Tanty and her sexuality is tamed; the whale does not spoil the picnic; and Mrs George descends the cliff safely. The feathers sprout as before ('these little wings are sent to try us') as do the horns, but only Mrs George dies and nobody suffers injury. Miss Dredger is in on the final scene and closes the play with the sickly lines: 'My darling – gone. Oh, the tears of it. Oh, the splendour. Soar up, sweet chief, forever through the moonbeams. Your sailor won't forget you.'

There was a good cast, Francis Dillon was the producer and music was composed for it by Malcolm Arnold, but the whole thing as reprinted in *Peake's Progress* is a faint shadow of the novel. Maeve went to rehearsals and the family all listened to the broadcast, except

Mervyn himself who was, appropriately enough, back on Sark at the time.

The book was reissued twice more after Peake's death. In 1969 the new firm of Allison and Busby issued it in paperback and it received widespread, though mainly brief and superficial, notices in the press (one reviewer was impressed mostly by how closely Peake's face resembled George Orwell's). In 1972 Penguin reissued it, still with the original illustrations. Reviewers wrote of its whimsicality, fantasy, freewheeling crazy gaiety, unflaggingly perfect mock-Edwardian style, and its enchanting but unlikely story in which 'Mr Pye himself is a dear little flight of fancy who settles round the reader's heart like a pleasant poultice'. They more or less agreed that it was 'an agreeable confection' or 'very silly but all good – and mostly clean – fun'. John Batchelor took its theology more seriously and thought: 'though less interesting than the Titus books *Mr Pye* is not a negligible work, though one can understand how its balance of satirical sharpness and evangelical fervour might have left its first audience untouched'.[5]

What brought it back into popular focus was an excellent television version, starring Derek Jacobi, which was made on Sark in the summer of 1985 and shown the following year, to favourable reviews. The islanders loved taking part, and the money and attention the television company brought to the island saved that summer's tourist season. The actress playing Tintagieu made a reasonable stab at the local dialect and the whole performance stayed very close to the book.

Peake continued to journey in from Wallington to teach part-time at the Central School and to stay over occasionally in his London *pied-à-terre* in Manresa Road. Dylan Thomas no longer came round to borrow money, or a bed or a suit, because he had died on a lecture tour in America, but others did, some of them unknown to Maeve. During my research several interviewees mentioned Mervyn's 'little affairs' but none was willing or able to substantiate these. As Michael Moorcock put it: 'Women certainly fell in love with his sheer beauty. And then with his charm. And then with his wit. And then they were lost.'[6] However, one lady's diaries leave little doubt about their mutual attraction.[7] She was a painter whose maiden name was Cynthia Fuller but who painted and exhibited her work under the name of Francine and was twelve years older than Peake. Her Dorset-based family were

enterprising and musical and during the First World War she and her three sisters (with a brother as chaperon) toured America singing English folk songs; and at the invitation of the President they sang twice at the White House. She married, at the age of twenty-two, a solicitor thirteen years older who then paid for her to study at the Slade School of Art. She was thrilled to be amongst creative people of her own age with her own enthusiasms and took off her wedding ring as a gesture of independence. However, she became pregnant and had to leave. Her husband died in 1948, before she met Peake, though just where and when this meeting happened is not known. She refers to him first in her diary for 19 April 1953:

MP comes sometimes – like a passionate wind or a strange dark bird. I am enveloped and enchanted by him. It is a strange friendship – though that is hardly the word for it. Our time together is never long enough for our minds to meet. They glance at each other through mists of unknowing. Whether they are frightened of breaking through – or whether what we give each other on those brief occasions is enough – I don't know. His play has been accepted by Kay Hammond and John Clements. It is called 'The Wit to Woo' and it will be put on as soon as the play they are in now has ended . . .

 May 13 1953

I am missing Mervyn a great deal – that strange man who seems to love so when he is with me and can then so completely vanish. It makes me full of doubts about myself during his last visit – and about the next if there will ever be one . . .

 July 9th 1953

During my difficult, busy two weeks when Ilse [the friend with whom she lived] was away, Mervyn phoned me and came. I was against it at first but Rosalinde [her actress sister] said 'don't say "no" – never turn away from love.' And I'm mighty glad I took her advice for it was one of the most beautiful times we have ever had together. We stayed in the sitting room and there was no hurry over our luscious love-making . . .

 August 23 1953

Mervyn came last week for a brief while. I took him this time into the Studio but had no time to get myself into his world. He could not stay long as he had to meet someone in his Studio to talk about some drawings he may do for television . . .

September 19th 1953

I've had a lovely visit to Mervyn's Studio. He was off in a few days with his family to Sark for a holiday. He gave me a photo of one of his paintings and wrote his name and 'love' upon it which surprised me. When we were walking down Kings Road together afterwards we ran into Paul [her nephew, Paul Dehn, a poet, critic and scriptwriter]. Mervyn made a quick getaway and Paul invited me to dine with him. We ate smoked salmon and chicken in a little restaurant nearby and Paul seemed intrigued by finding us together. I did not say much, merely changed the subject to 'Paul' which then fully occupied him.

Francine exhibited at the London Three Arts Centre in December that year and during the two-week show took charge of the gallery a couple of times – 'an excellent time for letter writing'. She records in her diary for 12 December: 'One day as I sat there, I looked up and saw Lisl and Mervyn entering together. I must have gone quite white for he said I was not looking well. Lisl described how she had phoned for me and when she said she was going to see me Mervyn asked if he could go along too. He liked my new painting.'

These secret and intermittent meetings would continue for three more years until Mervyn became either indifferent or too ill to cope.

14 Traveller, 1954–1956

In 1954 the 1,238 unsold copies of Peake's children's book, *Captain Slaughterboard Drops Anchor*, were remaindered by Eyre and Spottiswoode, and he was told that the chances of finding a new publisher for the book were not high. It was an ominous sign, though the disappointment may have been alleviated a little by a commission from an unexpected direction.

An Englishman working for Swedish radio, Paul Britten Austin, wrote *The Wonderful Life and Adventures of Tom Thumb* as a textbook for English language students. He needed an illustrator and thought of Peake, as being quintessentially English. Peake obliged with twenty-three illustrations and a decorated capital letter for each chapter opening. The first book, issued in 1954, was a success and he did a second volume along the same lines. The appropriately small book (14 x 9.5 centimetres) has tiny drawings in pen and ink with shading, but no cross-hatching. Lively and humorous, they show Tom's various narrow escapes, and have fun with the contrasts in scale and perspective the story lends itself to.

Earlier, in 1945, Zephire Books, also of Sweden, had commissioned Peake to illustrate *Alice's Adventures in Wonderland* and *Through the Looking Glass* to be published as one volume. As with *The Ancient*

Mariner Peake had a worthy text and a master illustrator, in Tenniel, to pit himself against and he rose to the challenge. In all he did 100 drawings in time for the 1946 publication (Maeve reading *Candide* to him as he worked), though for copyright reasons the book was not available in England or America. It was not until 1954 that Wingate brought it out in London with one or two minor alterations to the drawings and a Foreword by Malcolm Muggeridge in which he claimed that there had been sixty-six other illustrators of the Alice books between Tenniel in 1865 and Peake. Of Peake's drawings Muggeridge wrote: 'They expound, as well as embellish, the text to which they belong – and expand it specifically in terms of this curious and tormented age.' Each generation, Muggeridge claimed, got the Alice it deserved: 'Thus Tenniel's Alice is as self-assured, even as arrogant, as Queen Victoria, whereas Mr Peake's is a bit of a dead-end kid.' Perhaps he was right: Mabel Lucie Atwell had provided a saccharine little Edwardian miss in 1910 and Willy Pogany's Alice has bobbed hair and a flapper's skirt in a 1929 edition.

I suppose the late twentieth century deserves Ralph Steadman's *Alice Through the Looking-Glass* (MacGibbon and Kee, 1972), an extravagant production in which the double-spread black and white pictures swamp the text. Alice now has breasts, spectacular blonde hair and a

Alice's Adventures in Wonderland and Through the Looking Glass (1954).
Alice, pen and ink, 7 × 11cm

wardrobe like that of a catwalk model, whilst the drawings are full of contemporary in-jokes referring to pop music, politics, television, art, football and fashion. Its strenuous trendiness and lavish production make Peake's version look mean, old-fashioned and small-scale, but Peake is truer to the text and does not try to upstage it by calling attention to his own genius. Steadman also illustrated *The Hunting of the Snark* (Michael Dempsey, 1975) with bravura etchings and ink splatterings almost as inventive and barmy as the poem itself. They are also darkly foreboding in contrast to Peake's 1941 Snark drawings, which are as lighthearted and literal as one can be with a poem of this degree of weirdness.

Graham Greene agreed with Muggeridge's 'dead-end kid' judgement and wrote to Peake: 'You are the first person who has been able to illustrate the book satisfactorily since Tenniel, though I still argue as I think I argued with you years ago that your Alice is a little bit too much of a gamin.'[1] But she's a gamine with the knowingness of a Balthus nymphette or a Nabokov Lolita, with the Yellow Creature's come-hither eyes and a tendency to show off her bare legs. One critic thought her 'an infant Bardot, peering through the grasses like a sultry puma'. This is a post-Freudian version of Alice, even if Peake would have disclaimed any knowledge of Freudianism. The drawings are a masterly combination of hatching and line, but not usually in the same picture – the hatching goes up to the margin of a form but the final outline is absent. Peake is especially good, as one might expect, with the grotesques – the Caterpillar smoking his hookah, the malevolently sneering Cheshire Cat, the Carpenter whose face is hacked out of wood, the ferocious Jabberwock, and the weary White Knight with drooping moustache – unfortunately the nearest he was ever to get to drawing Don Quixote.

Maeve's cuttings book contains no reviews of the 1954 edition and soon it went out of print. Bitterly Peake wrote to Greene: 'I have just rung up Wingate to ask them why no bookshop in London has my Alice. None will have it. I am rapidly qualifying as the arch untouchable.'[2] Not until the 1978 reissue by Methuen did people really begin to take much notice of it, and by then of course Peake was in his grave.

In a broadcast Peake made that year called 'Alice and Tenniel and Me' he admitted that doing the 67th edition of Alice might seem 'a redundant occupation', and of Tenniel he said: 'He is inviolate, for he is embedded in the very fabric of childhood memories. It doesn't seem to matter that his superb powers of invention are to some degree negated by a dreary technique.'[3] Peake commented: 'It's a somewhat

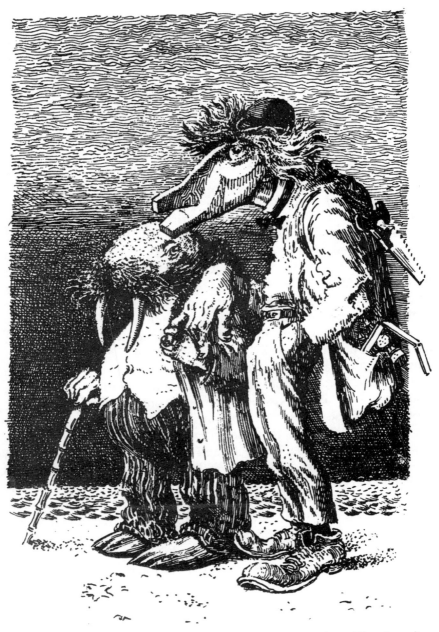

Alice's Adventures in Wonderland and Through The Looking Glass (1954).
The Walrus and the Carpenter, pen and ink, 17×11 cm

sobering thought when you realize that the more vivid the description of the characters or scenes as they rise up under Lewis Carroll's pen – or under anyone's pen for that matter – the more *vivid* they are, as I say, the less they *need* illustrating. It's the unanswerable paradox. The more vivid the author, the less need there is for the artist and yet, at the same time, the more vivid the description the more the artist's pen will itch for ink.' He was aware of the public expectation that illustrations should not disturb, a view 'in the last resort, dictated by neurotic parents who don't realize that their children are much tougher than they are themselves. I have often found that children love to look at pictures and drawings which the parents consider *ought* to be frightening.' He gives the example of the command: 'Off with his head!' which makes adults think of literal executions: children do not see these implications at all and simply enjoy the absurdity of a head separated from its shoulders. And why, he asks, shouldn't he make the ugly Duchess and Mad Hatter be really ugly and really mad? For, 'in Alice there is no horror. There is only a kind of madness, or nonsense – a very different thing'.

Peake told the radio audience that he went out in London looking for models for the characters: they were all there and needed only a little adjustment. 'The Mad Hatter was almost perfect, but not quite. I saw him in a telephone box at Charing Cross. The Red Queen, or nearly the Red Queen, bumped into me in Holborn Underground. I all but heard her cry, "Off with his head!"' The actress Margaret Rawlings sent him a sharp postcard: 'Hey! Hey! Mr Peake! It was not the Red Queen who said "Off with his head!"'

A commercial flop of 1954 was *Figures of Speech*, published by Victor Gollancz. This had initially seemed a good idea: Peake took twenty-nine clichés ('Getting down to brass tacks,' 'I could have kicked myself', 'Put that in your pipe and smoke it', etc.) and illustrated them in as ludicrous a fashion as he could in pure cartoonist's line. The party game was to guess what they were and answers were given at the back of the book. However, people wouldn't play and it was soon remaindered – a fate that was now becoming depressingly familiar.

One curious commission in 1955 was to decorate *Men: A Dialogue between Women* by Allegra Sander, translated from the French and with a prefatory letter by Graham Greene, who probably suggested Peake be involved.[4] This is a supposed conversation between an older woman and her younger friend who begins by declaring, 'He's got a mistress, so I'm going to take a lover.' The older replies: 'No, no, my dear girl! One does these things for pleasure, never out of spite. In the

matter of infidelity, one great advantage that women have over men is that they take it so much more seriously. Men are often very unhappy because it has merely become a habit with them.' And so the book goes on to examine the relations between the sexes with Gallic cynicism. Peake supplied two vignettes and a full-page illustration, all of them in the single flexible line reminiscent of that he had used for *Quest for Sita*. Two show a waist-length and the other a full-length nude of a slim young woman with a gamine hairstyle, earrings and an air of ease in her nakedness. They are slight yet match the urbane text beautifully, but it was not a popular book and did not gain him a wider audience.

Peake's own dalliance with Francine continued, though intermittently, and it was clear she did not threaten Maeve's prime position in his life. No matter how far he strayed, he assured Maeve in one poem:

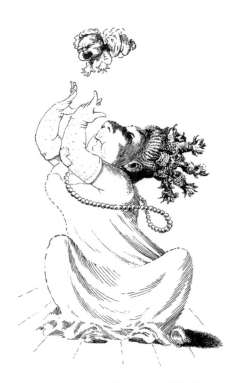

Alice's Adventures in Wonderland and Through The Looking Glass (1954).
Duchess and baby, pen and ink, 20 × 14cm

Out of the chaos of my doubt
And the chaos of my art
I turn to you inevitably
As the needle to the pole
Turns – as the cold brain to the soul
Turns in its uncertainty;
So I turn and long for you.

Francine recorded in her diary on 13 January 1954:

After lunch Mervyn phoned – 'could he come round?' Like a dark bird he flew into my Studio and on the floor, in front of the fire, we escaped the world . . .

March 27 1954

Mervyn rang up. There was a chance he would be able to come round that night – though after all, he couldn't. But just hearing his voice did me good. It is over a month since I went to his Studio – and if so many weeks can pass, I fear he does not care any more and my age stands between us. [She was then fifty-five, he forty-three.]

July 2nd 1954

There has been a long silence around Mervyn so in desperation I sent a card (a photo) of one of my 'heads' in an envelope for him at the Art School asking, in a noncommittal way for him to phone me. This he did – but I was out. Since then, silence again. I hope he'll try again on Monday when I shall stay around here.

July 23 1954

He did phone and I went to his Studio but there was not the excited breathlessness overwhelming me. He was feeling hot and sticky; and troubled by the loss of a new hat he had just bought; and I was disappointed in his looks and reacted to his mood. So I wonder when and if he will phone again.

He did not phone. There is no mention of Mervyn for the rest of the year and her 1955 diary is totally blank.

In the search for an income to support his growing family, Peake began to turn to other media. In 1955, Independent Television made his story *Letters from a Lost Uncle* into a twelve-part series for children, starting in November of that year. Peake wrote new words and made a fresh set

of large ink drawings with sharper definition than the original pencil ones so the cameras could pan across them as the story was read by an actor. Television was in its early days and this was about as sophisticated, and cheap, as could be managed. John Watney tells this story: 'Mervyn would prepare about twelve large drawings every week, and when they were complete he would catch a train from Wallington to Victoria, and then a bus to Aldwych. On one awful occasion, he left the whole portfolio of drawings on the train. It was never found again, and he had to return to Wallington and spend the next two days and nights, almost without sleep, re-doing the lost drawings, so that they could be rushed to Aldwych in time for the next screening.'[5] For each set of drawings he received a generous fee of £100, but most went to help repay the bank loan. Having made the contacts in television he tried to interest them in a programme for children to be called 'Just a Line', which would show on forty-two cards just what a line could be made to do, but nothing came of it.[6] However, these experiences inspired him

Men: A Dialogue Between Women (1955). Illustration, pen and ink, 18 × 11.5cm

to buy a television set himself and when he was exhausted from his enormous work-load (the third Titus book was coming along and he was working on several plays) it helped him unwind. He was an emotional man and Clare remembers his eyes watering when there were poignant moments in TV plays, or in films or books.

A BBC producer had the bright idea of sending an artist, writer, archaeologist, naturalist, historian, photographer, and perhaps one or two more specialists to Yugoslavia to record their impressions for a television programme. Watney says Peake was employed as the writer, and Maeve claims he was the artist, but whichever it was he did a lot of sketching and no writing has survived beyond his letters home describing the terrifying bends on the mountain roads. The party set off in April 1955 during Peake's Easter holidays from the Central School. He wrote to Maeve: 'Yesterday in the dusk, with the pallor of pink light suffusing the mountains that are always looking down in silence, a group of little urchins galloped down to the sea below the windows of the hotel and had a fight, using long palm boughs as weapons, which they swung at each other. I made a few quick drawings of them which I would like to work into something.'[7] But he never did, and the programme didn't materialize either, though a few drawings were used in a children's show on which he was briefly interviewed. On the trip he sketched nuns, peasants and a white-haired old prophet who threatened Peake with a knife for drawing him. The tour ended in the best hotel in Zagreb, where Mervyn had his first bath for three weeks. He filled the tub, sank in and dreamed a while, then pulled the plug and let the water drain away, only to find that his clothes were floating round the floor because there was no connection to the outlet pipe.

Besides watching television he was still listening to the radio, and now began to write for it. A 30-minute drama *The Eye of the Beholder* was recorded in October 1956 with Paul Scofield playing an artist, Jarvis, a kind of spokesperson for Peake's views on the function of art. It was broadcast on 18 December 1956 by the BBC Home Service and at Christmas in America – the only one of his plays besides *The Wit to Woo* to achieve a professional performance.[8] A vicar commissions the artist to paint a Nativity after ignoring the protests of his bickering and philistine wardens and congregation. But how is the artist to avoid the clichés of Christmas cards and how can his art relate to Christianity? At the unveiling Christ is seen to be in a space rocket, to the delight of a small boy but to the moral outrage of the adult congregation. Years pass, and by then they find the mural 'nice' and 'soothing', to the chagrin of the artist. The vicar's consolation is that one in a hundred

might come along and 'it will set his thoughts careering'. The artist's two main enemies are shown to be the conservatives who oppose innovation during his lifetime, and the complacent who eventually take the sting out of the new by passively accepting it and failing to see its real challenge – Peake gives the example of Van Gogh's *Sunflowers*. Overall it is a competent Christmas drama without being innovative or profound.

Also for radio he adapted *Titus Groan* into an hour-long play, which was broadcast on the BBC Third Programme on 1 February 1956. This attempt to get a gallon into a pint pot called for drastic cutting of the novel; indeed he was still cutting it as the actors were performing in front of the microphones. He made Gormenghast itself the narrator in a poetic style reminiscent of *Under Milk Wood*. He also eliminated the Keda sub-plot, allowed Sepulchrave to survive, and made Steerpike bite Swelter's wrist when he was being molested, which is a useful piece of motivation for both characters' subsequent actions – in the novel Swelter's pederasty is only hinted at. All the dialogue was new and the plot rattled along, helped by sound effects and music by Arthur Oldham: each character had an identifying tune. For Peake cognoscenti it is fascinating, but one wonders what the listener with no previous knowledge of the book made of it. There would be a similar problem when *Titus Groan* and *Gormenghast* were televised in 2000.

John Watney wrote of the 1950s:

> He seems to have entered a doldrum period. However hard he worked, and he was working harder than ever, he could make little or no headway. The trouble was that his genius for illustrating was not wanted and the audience for his writing had not yet grown up. If anyone ever lived out of his time, it must surely have been Mervyn Peake. Had he lived earlier or later, he would have found appreciative audiences; as it was, his own generation largely ignored him.[9]

His children's books with their pirates and polar explorers no longer appealed to the postwar youngsters growing up with television and an increasingly Americanized culture. In illustration he was faced with two problems: firstly too many of the books he was asked to illustrate were second-rate and therefore had no shelf life in which to make his

name; and secondly, when he was given a classic to work on the public resisted his versions because they loved the original illustrations to Carroll, Stevenson, Grimm or Coleridge with which they had grown up. Others in this increasingly crowded field such as Ardizzone, Ayrton, Minton, Vaughan, Fraser, Jacques, Hogarth, Searle, Topolski, Hoffnung, Thelwell, Keeping and Gross were mostly London based and better connected and so attracted regular commissions from book publishers and magazine editors. Foreigners such as the American Saul Steinberg and Frenchman André Françoise were also in vogue with English editors. Peake was not an aggressive salesman of his own talents, which did not help either.

Peake was teeming with ideas in all the media during the mid-1950s, but frustratingly, only one major work emerged, a prose piece, *Boy in Darkness*. Eyre and Spottiswoode asked Peake to write a novella-length story for a volume to be called *Sometime Never: Three Tales of the Imagination*, the other two contributors being John Wyndham and William Golding. This came out in 1956 and attracted some favourable attention, including a science-fiction Nebula Award for the American paperback edition. A year after Peake's death, his story was reissued by the publishers Allison and Busby in another trilogy alongside stories by J. G. Ballard and Brian Aldiss in a volume entitled *The Inner Landscape*. A school edition of Peake's story alone was published by Wheaton in 1976 and more recently the story was illustrated by P. J. Lynch and issued as a children's book by Hodder (1996). Peake fans can have no complaints about unjust neglect of this book.

It opens in familiar territory: this is crumbling Gormenghast and the unnamed Boy is obviously Titus Groan, 77th Earl, still chafing at the meaningless rituals he has to endure. He is now fourteen – an age which is passed over without detailed comment in *Gormenghast* – and he has just been exhausted by some particularly joyless ceremonials on his birthday. He decides to escape and uses Steerpike's old stratagem of shinning down a rope. Once clear of the city he comes to a slow-moving Lethe-like river where he is surrounded by grey dogs with 'bright and acid yellow eyes'. Silently they urge him into a skiff and he crosses the river.

From the second chapter onwards the style and genre change radically and elements of fantasy are introduced that would have been intolerable in the world of Gormenghast. The Boy is now on a dusty colourless plain where he encounters first a Hyena-man and then a Goat-man, both abject slaves of the blind and evil Lamb who lives underground in abandoned mine workings. Circe-like, the Lamb

transforms all humans into animals, though 'the whole process of transmutation was of so occult a nature that even the Lamb found it impossible to know what it was that killed them and what it was that kept them alive'; it certainly does not involve any recognizable science in spite of the story sometimes being classified as science fiction. Now the only survivors of his experiments, the Hyena and Goat, plan to take the Boy to him, which they manage after seventy pages of squabbling. On the final page the Boy stabs the Lamb, who turns out to be white wool through and through with no blood, brain or organs; the two man-beasts revert to human shape; the Boy recrosses the river where 'on the far side his adventure had melted from his mind', and he regains his 'immemorial home'.

Originally Peake thought of giving this story the subtitle 'The Dream' and indeed it does have the warped time and space of phantasmagoria and the random motiveless violence of figures in a nightmare. One reviewer described it as 'the sort of nightmare you have when your liver is upset and the mussels were high and there's thunder about – only worse'.[10] If its origins were an actual dream, like Coleridge's 'Kubla Khan', then it is perhaps pointless to ask what the author meant by it, but that has not stopped commentators producing fanciful exegeses. One of the most plausible is that Peake is imagining a crippled world inhabited only by mutants – a theme treated by his fellow author John Wyndham in *The Day of the Triffids* (1951) and in the television serial which gripped the nation in 1953, *The Quatermass Experiment*. The Cold War divided the world, an atomic war was then a much discussed possibility and 1956, the year of the story's publication, was also the year of the Suez débâcle and the invasion of Hungary, but if these events were on Peake's mind he was not the kind of writer to tackle political matters head on.

Walter de la Mare corresponded with Peake on 29 January 1954 about writing: 'don't you think one finds oneself dishing out the same little obsessions over and over again?' Peake certainly had an obsession with maimed and hybrid creatures, as he confesses in this poem from *The Glassblowers*:

> It is at times of half-light that I find
> Forsaken monsters shouldering through my mind.
> If the earth were lamplit I should always be
> Found in their company.

Even in sunlight I have heard them clamouring
About the gateways of my brain, with glimmering
Rags about their bruise-dark bodies bound,
And in each brow a ruby like a wound.

Another poem from this period, 'The Three', also gives us a glimpse of fabulous creatures occupying alien lands deep in the author's brain:

> The Three:
> The first
> Withering with thirst:
> His eyes
> Are lakes; he lies
> In burning sand –
> There is no one to hold his dusty hand.
>
> The Three:
> A nectar
> In a cut goblet's glitter
> Stands by the second;
> There is no sound.
> His eyes
> Scour his gold domain for Paradise.
>
> The Three:
> The third
> In softest cell
> Leaps, froglike at each yell
> His eyes
> Glitter with spears
> And dance like fireflies.

John Batchelor found *Boy in Darkness* the most blasphemous of Peake's works insofar as it perverts Christian iconography. 'This is a horrifying creation, and much of its *frisson* derives from its obvious association with the Paschal Lamb. This Lamb has the qualities of Christ in reverse: it takes men and turns them into beasts, it is soft, delicate and childlike in its manner and wicked in its soul, where Christ was masculine and commanding in his manner and innocent in his soul, and it can destroy with its will.'[11] It could be added that the crown of bones, the candles, the throne and the planned Last Supper add to the sacrilegious trappings. It would be interesting to know how Maeve reacted to this story.

The Antichrist Lamb is certainly more creepy with its dazzling whiteness, soft hands and musical voice than the other two horror-comic grotesques, and its lack of sight, like Blind Pew's heightens its menace. Now that we have lost our belief in, and hence our fear of, those devils with pitchforks grilling the damned in eternal flames we seem to need new demons to give us the shudders. The Lamb fits into the tradition of vampires, ghouls, werewolves, zombies and the undead that have haunted the pages of Romantic fiction and feed off Christian symbolism and theology without in any way being part of it.

If this is meant as a good versus evil morality then its values are even more ambiguous and muffled than in *Mr Pye*. The evil is palpable enough, but where is it opposed by virtue? There is a God-shaped void at the centre of the book. The boy is ethically neutral and passive, even literally unconscious, for much of the book and survives only by quick thinking and by stabbing the Lamb with a sword – a stratagem worthy of Steerpike himself and one which hardly makes him a Christian figure come to redeem the damned Goat and Hyena. If his crossing of the river is meant as a rite of passage into adulthood, as some commentators have suggested, then why does he forget the whole adventure at the end, and what acquired wisdom does he take back to his ancestral home and his tedious round of duties?

Other, more mundane questions could be raised. Why is the blind Lamb surrounded by books and candles when he can see neither? Where do the bones come from which Hyena continually cracks in his jaws when he lives in a sterile desert? Why do Hyena and Goat have to separate when they enter the mines? Just how does the Lamb change his victims? Since they help Boy to cross the river in both directions are the dogs agents of good or evil? Who once mined in the desert and for what metals? Why did Lamb have 'a deep and burning hatred of all humans'? And why are there no females?

After the first chapter this book has none of the immediacy or specificity of Gormenghast's weather, architecture, flora and fauna, but then Peake's task is to describe a land of nothingness – a kind of T. S. Eliot Waste Land inhabited by creatures as weird as the hydra or basilisk. The story has jarring elements of pantomime, folk tale, religious parody and the *Boy's Own Paper*, but fatally lacks that distancing irony or humour which informed the Titus books. The style too is irritating. What are we to make of overwrought sentences such as: 'The five words fell almost palpably down the throat of the herbless, lifeless shaft and, echoing their way netherwards, came at last into the orbit of the Lamb's reception.' Even at the level of the clause one wonders why

Peake did not edit out the repetition in 'the Goat would have been savaged mercilessly, if not killed by the merciless Hyena.' In the Titus novels we usually deduce people's characters from their actions and speech, following the novelist's old maxim of show, don't tell, but here in his determination to make us recoil Peake piles on the adjectives: in eight lines describing the Hyena we find 'very foul', 'foulness', 'horrid', 'menace' (twice), 'beastliness', 'unctuous', and 'less stupid, less dirty than the Goat, but bloodier, crueller and with a fierce blood-drive'. The book is short on length, but in places markedly prolix in style.

It is difficult to see which audience Peake might have envisaged for this bleak vision. The interpretations suggested above presuppose a thoughtful and well-read adult reader with a recondite vocabulary, but the central character is a fourteen-year-old boy on an adventure trek who overcomes his enemies by pluck. Perhaps then it could be enjoyed by the same readers as *The Lion, the Witch and the Wardrobe*? One writer for children naïvely argued it was 'the work of a genius and as such, should not be withheld from anyone, even if that genius is twisted and baroque'. The obscure vocabulary (oleaginous, osseous, ulna) will give child readers 'a spectacular insight into how wonderful words can be', and the ways the three villains are described will teach children about body language because 'the way people talk and move is part of the way they are' – and if they know that, then child readers won't be so easily led off into deserted fields by murderous paedophiles.[12] She was apparently aware of some threat implicit in the plot, but had not spotted the frequent references to homosexual sex, masturbation and orgasm which Ronald Binns found when he read the descriptions of the three male predators gloating over their captive Boy. 'These sexual meanings are unmistakably present, though Peake shies away from making them explicit,' Binns claims, and so 'the story ends not in the homosexual rape of a minor but in victory over evil'.[13]

I am not convinced that the victory is so obvious: if, three lines from the end of the book we read, 'by the time the boat touched ground on the far side his adventure had melted from his mind' this is hardly a triumph for Good. My own reservation, as a children's author and former teacher, is that this is a powerful adult nightmare from which there is no awakening. It is possible for books to harm children as well as to heal them, to corrupt their view of the world rather than enhance it, and in this book the evil is so powerfully felt, the desolation so utterly dire, that any fears the child may have had beforehand will be handed back in intensified form. These are the same reservations I expressed earlier about the unrelenting sadism shown by Mr (not Captain)

Slaughterboard. Children can and should enjoy being frightened by stories, but only if they can be reassured that the monster under the bed, the sinister stranger or the blood-sucking ghoul will ultimately be overcome by the hero, even if it's a close-run thing. This restoration of normality was a feature of all the books Peake read as a boy, but he makes only the most perfunctory gesture towards it here. Peake had been drawing and writing about grotesques all his life, but Lamb, Goat and Hyena are a world away from the benign Moccus creatures and those Captain Slaughterboard found on his island and it is clear that something had now darkened in Peake's world view. It is a new genre, perhaps one he had even invented, but *Boy in Darkness* remains a puzzling, unbalanced and very disquieting story and one wonders about the mental health of a person who could engender such a bleak world.

His physical health was certainly in decline and he was visibly ageing, as Francine noticed in their last recorded meeting on 19 May 1956: 'I've been to Mervyn's Studio again. It has been several months since we have been together. He looked much older for his hair is going very grey. He was just off to Spain for a few weeks with his wife and I haven't heard again from him. We had a crazy animal time together. He has had no luck with his plays but was doing some drawing for TV.'

It seems never to have occurred to the Peakes that Maeve might look for a regular job to take the strain off Mervyn a little, but she did try to supplement their meagre income by doing book jackets and selling the occasional picture through mixed exhibitions. She took her painting of children, cats and her surroundings very seriously, as did Mervyn, who was most encouraging. 'He was a fair critic, and honest. Sometimes, I hated what he said, and would fight against it, but knew that he nearly always probed to the essential heart of a painting or drawing.'[14] By now she had shed some of her airy romanticism and in her handsome early forties was beginning to emerge as the stronger character, organizing the household and sheltering her husband from family pressures as much as she could. He seemed pleased to let her. He toiled away in his room amongst pots full of inks and pens (which he frequently lost and Maeve replaced) but he kept the door open and the youngsters could interrupt if need be. The family gathered in the kitchen for morning coffee when they were all home. The boys were now rowdy teenagers, Sebastian drumming in the air-raid shelter with his friends until the roof fell in. He was still being taught by priests in a nearby day school but he was not an ideal pupil and claims: 'I threw in the scholastic towel

once and for all.' Fabian shaved all his hair off like a Red Indian but he was showing artistic promise, while Clare was more biddable and impressed the nuns at St Philomena's with her piety, though not her scholarship.

In spite of their cash problems they acquired another car, a wooden estate car in part exchange for their clapped-out Wolseley Hornet, and in it the family toured the south of England and sometimes slept. On one occasion Mervyn picked up his daughter from school but was surprised that she wasn't in the car when he arrived home. She had been thrown out and concussed without his noticing and Maeve was furious with him. The Peakes had made a curious agreement with a man that he would look after their big garden for six months in exchange for the new car. When the time was up the man claimed his reward but also stole their gardening tools.

Perhaps it was as well that Mervyn stopped driving, because the tremors in his hands and legs were becoming more pronounced. He had never learned to type and it now became more and more difficult to read his writing, whilst drawing must have been a struggle. A curious restlessness afflicted him and he paced from place to place, sometimes through the night. His children noticed that he was curiously clumsy when eating his food and they joked that he should take less wine with it, but he had never been a great drinker of any kind of alcohol and the jokes fell flat. Yet the doctors who examined him could find nothing organically wrong and suggested it was merely overwork and stress.

Of this period Maeve wrote: 'The world seemed to be a series of cold douches.' Then, in the Easter vacation of 1956 they were given a treat. An anonymous friend 'who had known Mervyn since the days when he taught at Westminster School of Art' (Lady Moray, his former student, perhaps?) paid for the couple to fly to Spain for three weeks of rest in the hope that it would do Mervyn good. Maeve was delighted: 'Spain had always been somewhere that we had both wished to see. Goya was the man and the artist that Mervyn most admired, Velasquez, El Greco, other miracle workers, apart from the world of flamenco, and horribly, perhaps bullfighting, poverty and wealth.'[15] Once there she found it dry, red, arid, full of small dark men, rather bleak and, under Franco, not the place of singing and carefree laughter they had imagined. Their first call was to the Prado where they happened to have an introduction which got them in even though it was closed to the public for repairs. There they saw Goya's late dark pictures of witches and carnivorous giants – so close in feeling to *Boy in Darkness*. They dined at the Ritz as guests of rich expatriates, visited Toledo for the El Grecos,

were sickened by the poverty in the villages away from Madrid and felt unexpectedly moved by the beauty and violence of the corrida. Avila 'filled Mervyn with horror, at least the convent where St Teresa had lived and prayed away from the world, and where one of her fingers was on display, with a magnificent ring upon it'. All the time he was drawing – priests, army recruits, lottery sellers, donkeys, Falangist boys; some of these pictures later appeared in *Encounter*. The trip seemed to do him good and he returned to teaching and, with renewed vigour, to writing the play which he was convinced would make all their fortunes.

He also had grand overarching ambitions for his new Titus book and for his paintings, as he wrote to Maeve a few months later when he had digested the Spanish experience:

To canalise my chaos. To pour it out through the gutters of Gormenghast. To make not only tremendous stories in paint that approximate to the visual images in Gormenghast, but to create arabesques, abstracts, of thrilling colour, worlds of their own, landscapes and roofscapes and skyscapes peopled with hierophants and lords – the fantastic and the grotesque, and to use paint as though it were meat and drink.

To restore to painting the giant groupings of the old masters – Tintoretto, Goya, Velasquez.

To make studies and cartoons for each canvas. To find myself by ploughing headlong into a genre, and by so doing to evolve a way of painting ANYTHING, from an angel to an apple.

To incorporate within the canvases, that in themselves would be masterly and original, still-lifes, or boys or buildings, and skies based on perception.[16]

It was an impossible programme, and anyway it was too late. The January 1956 exhibition, Modern Art in the United States, at the Tate Gallery threw progressive British art into turmoil with its huge abstract canvases by Gorky, Kline, de Kooning, Motherwell, Pollock and Rothko in the final room. The 'old' masters Peake so much admired were redundant: from now on the debate amongst progressive painters would be about geometrical or colour field or painterly abstraction, not about painting angels or apples, lords or hierophants.

He made one more journey abroad that year, this time to Dublin in July, where the Waddington Gallery had arranged an exhibition of his drawings. Loyally he tried to interest them in Maeve's work too, but with no success. He was treated as an important artist there ('My name

Blind Lottery Seller, the Retiro Park, Madrid, pen and ink, 24×14cm, 1956

seems well known in Dublin. I can't understand how many people have read Titus, and yet I'm a church mouse') and welcomed by a less sophisticated clientele than the fickle London one. He wrote to tell Maeve that his latest drawings 'are going to be shown to local aesthetes – or rather, horsey Irish women who are very rich and buy signatures – Sickert, John, Innes etc.'[17] As usual when he was away from Maeve he assured her of his love – 'There is something so WRONG about life without you and all other women are cows' – but there is also a hint that their relationship was not always plain sailing: 'When we are together there are only two things for us: discord or harmony. It is within us to choose between them.'[18] Perhaps she had heard about Francine.

From this jaunt he returned home late to Wallington where Maeve was already in bed and told her to close her eyes. He then covered the bed with the crisp £5 notes his drawings had sold for in Dublin. The money would get them through the long summer vacation when there was no money coming in from Mervyn's teaching. It had come in the nick of time.

15 Playwright, 1957

Peake was active throughout the 1950s, but his poems brought in nothing, illustrations were not in demand, radio and television commissions were hard to come by and novels took years to write, though he was working on all of these and still teaching two days a week at the Central School. Could he write a popular play, a witty comedy, he asked himself, and make the kind of profits enjoyed by Fry, Rattigan, Coward or Priestley?

Peake had never appeared on a stage, rarely attended the theatre beyond seeing the Crazy Gang or taking the children to a pantomime, and was not well read in the classical dramatists. However, the Countess of Moray, who lived nearby, did once come to the door in a chauffeur-driven Rolls-Royce and take the family off to see the first night of Agatha Christie's *The Mousetrap*. On his rare trips to the cinema Mervyn loved the Marx Brothers, particularly Groucho whom he would imitate at inappropriate moments in restaurants. True, in 1936 he had designed costumes for the Tavistock Little Theatre's production of *The Insect Play* and for *The Son of the Grand Eunuch* for the Arts Theatre, but of practical stagecraft he had no more than a layman's knowledge and it was clear that in tackling a stage play he would be moving outside his natural genre of symphonic prose and no longer playing to his strengths.

If he needed to know about stage practicalities then he may have consulted some of the theatrical people he knew. Maeve's sister Matty

was married to one, Henry Worthington, who had acted in the West End but had then retired to run a flower shop. Michael Redgrave was one of their Chelsea set and likely to appear at Maeve's parties while the playwright Rodney Ackland (hailed in the 1930s as 'the English Chekhov') was also a friend. Aaron Judah had been Worthington's dresser, and after he came to lodge at Wallington in the late 1950s, Peake illustrated his children's book and the two collaborated on a dramatic piece to be called *Mr Loftus*, though this was never produced. Esmond Knight, an ex-Shakespearian actor friend, came to their parties; to amuse the children he would take out his glass eye, the real one having been lost in a battle at sea during the war. What these people could not tell Peake he would have to make up as he went along. It was against his nature to research dramatic theory or to embark on a wide reading programme to compensate for his deficiencies: instead he would rely on his native wit, love of language and fecund imagination to find the right form for his ideas, as he had in all his other works.

The need to court popularity was not the best motivation with which to begin writing and it led him into trying catchpenny effects such as a heroine in her underwear, a cheeky servant, pellets in the buttocks, jarring colloquialisms (bum, bonce, screw, bloody) and fake cockneyisms ('ouse, weritable, hunapproachable), and to borrow all the clichés of music hall, pantomime and farce to keep the audience tittering. Into his play he threw every artificial device he had heard, seen or read – soliloquies, asides, choruses, addresses direct to the audience, malapropisms, mispronunciations, overhearings, songs, hiding characters in unlikely places (a coffin, a clock, a suit of armour) and fussy 'business' with drinks, flowers, teapots, guns and golliwogs. The puns fizzed and popped: music was 'the milk of amnesia', a corkscrew 'a snake in the glass'; the servant Kite addressed the lovelorn hero Percy with 'So you have returned like a lamb to the daughter? A sheep to the gold', and Percy mildly remarks to his beloved, Sally, 'Peculiar weather for the time of year', to which she replies, 'A trough of slow pleasure. I hope.' The metaphors are pushed as far as they will go: 'She is an indigestion of the soul / For which there is no bicarbonate of soda'; 'I am the dottle of that one time pipe-full / I am the acrid ullage in the keg', whilst Kite's ebullience is expressed by 'I could climb / A flagpole upside down, or swallow sparrows / And spit their beaks into the summer sunlight / Like orange pips.' With Wilde, and perhaps Coward and Wodehouse in mind, he chose to people the stage with the idle rich, a level of society of which he had no experience. All of this

is swept along on a froth of alliterative, and occasionally rhymed, verse. With all these abundant crowd-pleaser ingredients how could he fail to tickle the public palate?

Maeve did not share his optimism and early on began to suspect that he was expending too much energy and hope on this enterprise: 'The play was like a boulder rushing downhill. Nothing could stop him. I was afraid of it, and what it was doing to him. It seemed to carry a sense of doom in it. There were too many people involved in it – whereas in a book, a painting, a poem, you are only answerable to yourself.'[1] Nevertheless, he persisted, revising over and over, though time was not on his side: the trembling was getting worse.

When Peake began to write his play the British theatre was in a creative slump, but by the time he had finished and found a producer, seven years later, it had undergone an astonishing transformation. In the drab exhausted world of postwar London the commercial theatres provided sparkle and escapism. People could sing along with *Salad Days*, *The Boyfriend* and the more vigorous American imports such as *Oklahoma*, *Carousel*, *Kiss Me Kate* and *South Pacific*, or enjoy the numerous drawing-room comedies or mysteries provided by Bridie, Coward, Rattigan, Priestley, Clemence Dane, Anouilh and others. Audiences wanted glamorous actors and actresses, eye-catching costumes, splendid sets, zippy dialogue and a plot which surprised them. British acting seemed to be at its strongest ever with Olivier, Gielgud, Wolfit, Guinness, Richardson, Burton, Schofield, Redgrave, Evans, Ashcroft and Thorndike all treading the boards, but apart from Shakespeare and the classic repertoire there was little of substance to challenge them.

Two playwrights, T. S. Eliot and Christopher Fry, were trying to continue the Shakespearian tradition by writing plays in verse. Eliot's verse was dry and abstract and tried not to draw attention to itself. As C. S. Lewis snidely remarked, 'Eliot's stage verse imitates prose, with remarkable success.' Eliot's hope was that audiences would listen to the message of salvation which underlay his work, with the result that they sometimes went home feeling that they had been inveigled into church rather than the theatre. Fry, on the other hand, had little of serious substance to convey but enormous verbal exuberance in the Dylan Thomas manner and the six plays he wrote between 1948 and 1951 delighted theatregoers all over the country with their linguistic fireworks. Peake must have been one of them.

Then, in 1951, Fry withdrew from the theatre in order to write film scripts and his reputation went into steep decline as critics such as Raymond Williams and Kenneth Tynan began to attack his mannerisms and irrelevance to the contemporary world. Tynan, in a 1952 essay called 'Notes on a Dead Language', wrote that Fry had performed prodigies of artificial respiration, but compared the results to the face-painting of American morticians. Tynan was emerging as the most powerful man in British theatre, feared, hated, idolized, and dedicated to breaking taboos, destroying censorship and getting rid of boring middle-class dramas 'about the inhabitants of country houses in Loamshire (or Berkshire)'. As an advocate of Brecht he insisted that 'Art must go on record' and commit itself. Mervyn Peake, with supremely bad timing, set his uncommitted middle-class drama in a country house in a southern county, and took the now *passé* and uncommitted Fry as his model, as every reviewer of his play was to point out, many adding that the imitation was inferior to the original.

Peake sent the script to all the theatre people he could think of and they gave him a cruel six-year runaround, praising him extravagantly and then dropping the project. Laurence Olivier and Vivien Leigh strung him along most cruelly of all. He sent them a drawn Christmas card in December 1950 and the play two months later in the hope they would play the romantic leads, Percy and Sally, and that Olivier would remember their backstage meeting in Germany. By 13 June Olivier had still not read it, but said that 'my wife is reading it again, she loves it, and indeed she always did'. Nor would he arrange for Mervyn to visit backstage to do some drawings because 'the crush behind the scenes is pretty terrifying'. Olivier wrote again on 2 August 1951 to say the script was being read by Tennent: 'Vivien seems to like the play more than I don't like it, and so there is nothing to do but to offer it round to other producers than myself – producers of her choosing. Therefore, unless you have wishes to the contrary, as soon as Tennent has read it, it will go to Peter Brook, who is the first producer of her choice; from then on round if necessary.' It was necessary. In January 1952 Olivier, then in New York, thanked Peake for another Christmas drawing: 'we can't quite make out which of us it is, but it's jolly beautiful anyway'. Later, still from New York, he thanked Mervyn for his 'delightful letter of the 19ish ultish' and informed him: 'I am afraid our ideas regarding The Wit to Woo came to a natural standstill when the only three producers that we could see handling the job well reluctantly turned it down all

Sketch for the set of *The Wit to Woo*, pen and ink, size and date unknown

one after another, and the answer to your question as to how things stand: "still," is the rather brutal but simple one.' Olivier then washed his hands of it.

Peake sent the script to Anthony Quayle who thought it 'absolutely fascinating . . . I should be very thrilled to produce the play for you if you need a producer', but then he did nothing. Next it went to Orson Welles, who was not interested. John Clements and his actress wife Kay Hammond were very impressed and even passed it on to film producer Robert Hamer, but soon they found other projects to occupy them. Peter Hall was gushing: 'I skimmed through it last night and I must say I found it wonderful. So, please if the Clements don't want to do it, may I have the script back so that we can consider doing it here . . . I think your plays have the most enormous possibilities and I would very much like to do one of them.'[2] But he never did.

Things finally got moving on 8 January 1957 when the young impresario Michael Codron promised to take the play up with the director Peter Wood who had replaced Peter Hall at the Arts Theatre. Given that Peake had deliberately written what he hoped was a popular play it is ironic that it was acquired by a theatre with a restricted membership. Theatre clubs, such as the Arts Theatre at 6–7 Great Newport

Street, had a registered membership and so were not like the commercial theatres of the West End where anyone could buy a ticket on any night they chose. The members expected the Club to provide more experimental fare and indeed the Arts Theatre in the four years before it staged Peake's work had introduced them to such playwrights as Lorca, Pirandello, O'Neill, Ionesco and, in August 1955, to Beckett's *Waiting for Godot*. Peake's play was booked to follow Armand Salacrou's *No Laughing Matter*, translated into English after its Paris triumph, and precede Genet's *The Balcony*. The stage was smaller and costs were lower than in the West End whilst the Lord Chamberlain's censorship was less stringent in club premises, so all this encouraged controversial foreign imports and risk-taking new plays.

Peter Wood was then aged twenty-nine and fresh from the Oxford Playhouse. He and his friend Michael Codron read *The Wit to Woo* and were excited by its off-beat action, the *coup de théâtre* of the bed lowered from the ceiling, and the high-spirited language. Codron also saw that Kite would be a good part for his friend Kenneth Williams. At this time Williams had a reputation as a serious actor following his Dauphin opposite Siobhan McKenna's St Joan in Bernard Shaw's play, produced at the Arts in 1954. Everyone had high hopes that Peake's play would transfer to the commercial theatre and so make a large profit.

They set about recruiting other actors. Peake had written with Olivier and Vivien Leigh in his mind's eye for the lead parts, but given the salaries paid by the Arts Theatre he would have to settle for a less starry company. Zena Walker had read Peake's novels whilst a student at RADA and vowed she would never marry a man who didn't adore them as much as she did. She was only about twenty-two but had already played numerous soubrettes, Juliet at the Old Vic and Hermia at Stratford and so was right for the sexy Sally. Suave Colin Gordon was cast as the male lead, Percy Trellis, and the character actors George Howe and Wensley Pithey as Dr Willy and Old Man Devius respectively. Winifred Braemar as Mrs Lurch had no lines to say but her slovenly scratching was to raise more laughs than many of Peake's Wildean epigrams. They took it on with enthusiasm even though Zena Walker was pregnant at the time and was made nauseous nightly by having to ride a rocking horse. They were not a famous cast, but they were good and if the play failed it would be no fault of theirs. Nor would it be entirely Peake's since there were other forces at work in the theatre during spring 1957 over which he had no control.

Across town in Sloane Square the Royal Court Theatre was also dedicated to experimental plays and to the encouragement of new writers, especially those with contemporary 'relevance' and 'commitment' – the new slogans. On 8 May 1956 John Osborne's *Look Back in Anger* became a sensation with its strident rejection of all the middle-age, middle-class, middle-brow, middle-everythings which society had taken for granted and which the postwar theatre had largely echoed. Almost simultaneously in Stratford East Joan Littlewood staged Brendan Behan's *The Quare Fellow* and the fashion for tough realistic social (and socialist) drama was established. This hard-headed angst-ridden drama had its equivalent in English painting in the drab works of the 'Kitchen Sink' artists such as Bratby, Smith, Greaves and Middleditch. At a time when Peake was painting clowns in pointy hats they were depicting cluttered kitchen tables, a drowned chicken or a scrawny baby being bathed in the sink. Mervyn observed the working class only as an outsider (as his poetry lamented) and in neither drama nor paint was he equipped to fight their battles.

Other new theatrical fashions were emerging in 1956, especially from abroad. Brecht's Berliner Ensemble visited London and introduced the idea of 'alienation' by which the audience's empathy was held at bay, whilst Beckett, Ionesco and Genet had provided an 'Absurd' alternative to realism as a way of exploring the world's deeper anxieties. The year before Peake's play was staged now looks like a theatrical watershed, a divide between the frivolous and the significant. Peake is unlikely to have been deeply engaged with these intellectual debates; if he had been he would have known that he could not have chosen a worse time or setting in which to stage a play with no serious moral, political or psychological content (Percy's search for his authentic personality cannot be taken seriously in the way that Titus Groan's could), and which relied on the stage devices of country-house comedies and epigrammatic dialogue in iambic pentameters for its effects. When he told reporters, 'I wrote it entirely for fun. I was tired of plays with social significance' he was telling the truth, but asking for trouble. And it came.

Maeve records that Peake watched the cast at work and 'often came home late, excited and expectant, full of regeneration'. He wrote to Collis, who was also having a new play produced at this time, 'I am literally without a moment now rehearsals are in full swing for unless I am on the spot I cannot drop in my ideas which the producer seems

to like.'[3] According to Michael Codron, Peake feared to have his precious text questioned or altered. Of course he attended the first night, on 12 March 1957, but the cast found him unsteady, withdrawn and very much protected by Maeve. He wore a hired dinner jacket and the two of them stayed overnight in a hotel rather than face the late journey home to Wallington. The room was paid for by Laura Beckingsale, the old friend who had known the Peake family in Tientsin and who had been present when Mervyn was born. There were family and friends such as Collis in the audience to lend support and lead the applause. The Peakes both took tranquillizers to help them through the ordeal, though Clare remembers them going off 'with great joy'.

The curtain rose on a large drawing room in a country mansion with a sweeping staircase, french windows, a sideboard with decanters, cobwebs, family portraits, stuffed animal heads and numerous doors. An owl hooted to establish the pun of the title. When a slatternly maid entered, the audience must have expected a conventional English comedy revolving round love triumphing over adversity and in a way that's what they got, though Peake was trying to treat the conventions ironically. Percy Trellis' pursuit of Sally Devius has not prospered because he is too reticent and she wants a more dominant and romantic suitor so, at the suggestion of his wily servant, Kite, Percy fakes his own death and funeral, then reappears disguised as his fictitious cousin, the flamboyant artist October Trellis. Sally is being pressed by her father, Old Man Devius, to marry for money before his bankruptcy comes to light and he pretends to take to his deathbed to hurry her along. 'October' proves rather too extrovert for Sally who then wishes she had been kinder to the 'late' Percy. The plot is resolved when Percy is resurrected in his own character, but not before it has been thoroughly entangled by four comic undertakers who double as bailiffs and a drunken libidinous old Dr Willy.

After what seemed like a triumphal evening Maeve's sister Matty and her husband took the couple off for a lobster and champagne supper. However, their hotel breakfast was spoiled by the reviews. Both desperately needed confirmation of Mervyn's genius – nothing less would do after all this effort and anguish – but some critics had wounding reservations.

Oddly, since this was not a play in a commercial theatre, it was widely noticed in both the London and provincial papers and eventually

PERCY TRELLIS
"Now let me gulp this wholesome air again,
This air, this space, which gentle Einstein curved
For our amusement."

ACT. 2.
page 11.

Percy Trellis, watercolour, 29.5×20cm, mid-1950s

Maeve was able to paste fifty-three reviews into her cuttings book. These ranged from the broadsheets through the tabloids to such diverse publications as *Truth*, the *Church of England Newspaper*, the *Queen*, the *Universe*, the *Lady*, the *Jewish Chronicle* and the *Daily Worker*. Several had pictures, usually of the glamorous Zena Walker showing her legs to Dr Willy, or Old Man Devius in his crowded bed. Maeve found them 'neither good nor bad, but mostly condescending and ungenerous. How easily and quickly can a man be disposed of!'[4]

The myth has grown up that the critics slaughtered the play and that the shock contributed to Peake's steep decline into illness and depression from that glum breakfast onwards. This may be half true, but in fact many reviews were enthusiastic.

The local London papers were especially supportive: 'It is a comedy, completely unrestrained by conventional aspects of life and exploiting every opportunity of creating unusual and highly amusing situations . . . the result is a thoroughly entertaining evening's theatre which shouldn't be missed' (*Kensington News*). 'Not that the plot matters; it serves only as a vehicle for a curious mixture of whimsy, goonery, appalling puns and some of the richest turns of phrase I have heard on or off the stage for some time' (*Kensington Post*). 'Mervyn Peake has conjured up a most endearing collection of eccentrics and for them has woven a web of mock classical dialogue made more comic by some startling lapses into the colloquial' (*Hendon and Finchley Times*).

The acting was praised, most reviewers singling out the performance of Kenneth Williams as Kite – 'The play's brilliance is due largely to Kenneth Williams as Percy's valet – perfect Goonery this,' said the *Manchester Evening News*. 'Got some very good notices for my performance last night,' Williams recorded in his diary with some complacency. Later Williams wrote to John Batchelor with his own perspective on the production:

Mervyn Peake's dialogue for the play was full of wonderful verbal conceits, wonderful imagery, natural fluency, and above all, theatrically effective. I had no hesitation in accepting the part of Kite: I thought it glittered with malevolence and vituperative wit and knew that I could encompass it vocally. I was a bit perturbed about the physical side of the role but I know that I managed to get a lot of slithering into it. The play needed wholehearted theatrical bravura acting and vocal relish. In the event it was played in

a modern high comedy manner with considerable 'throw away' technique.[5]

Several critics spotted the reptilian slithering and Kite was compared to Puck, Jeeves and Mosca in his ingenuity on behalf of his master.

Other comparisons were made by reviewers anxious to link the play to something the readers already knew. Understandably the name of Fry came up most frequently, but 'the Crazy Gang gone poetic', Peacock's *Nightmare Abbey*, the Parisian School of Fantasy, Dylan Thomas, Smollett, Charles Addams, the Goons, Beerbohm's *Zuleika Dobson*, Wilde's *The Importance of Being Earnest* and *An Ideal Husband*, and Strindberg's *Dream Play* were all invoked. The actors' trade paper the *Stage* claimed that 'We are in the world of Godot, Ionesco, wittier-then-Fry verbal felicities, and clearer-than-Eliot poetic penetration, with satire and burlesque refreshingly free from the affected preciousness that this kind of thing can so easily descend to.'

Scattered throughout these reviews were nuggets of praise which surely must have offered comfort to the Peakes, and to the theatre management: 'as deft as it is daft'; 'He has a wit as agile as a monkey'; 'a capacity for investing the macabre with rollicking humour'; 'mad but entertaining'; 'a prodigious command of verbal wit and imagery', and 'It is more than a crazy jest. It has polish and an unflagging flow of clever dialogue.' Whilst many of these supporters also had their quibbles four or five said much the same as the *Punch* reviewer: ' The piece may be disjointed, but it shows imagination, and though the language is sub-Fry it pulls off now and then a notable phrase; Mr Peake should have a much better play in him.'

On the other hand those critics who were hostile were very cruel indeed. 'I'm afraid Mr Peake's embellishments in the way of puns and jokes are apt to be pretty tiresome'; 'Puns wither what they touch like ivy clambering round an oak. As for his old men, they are boring'; 'An act was enough'; 'A farce which never fulfils its initial promise'; 'There has been little attempt to make the central situation convincing or even continuous and there is no one "real" person in the play against whom one can savour the eccentricities of the rest'; 'It is not really an evening of delight'; 'Intermittently funny, the play becomes eventually tiresome'; 'The play has nothing adult enough to be called wit, and is wooden and creaking in its stage contrivance'; and 'There is a good hard-working company, containing at least three good actors, buried up to the neck and beyond in verbiage.'

Many of these were short anonymous notices in minor papers but

'October' Trellis, ink and watercolour, 29×15cm, mid-1950s

the major critics could not be shrugged off so easily. Kenneth Tynan in the *Observer* admired the acting and the galvanic pace of the production but, 'Had he [Peake] kept his head I might now be saluting a Gothic masterpiece. As it is the play has an exhilarating oddness, but breaks a salient comic rule: where everyone is eccentric, nobody is funny, because there is no norm against which to measure them.' But surprisingly, given his views, Tynan did add, 'From Mr Peake one demands more plays, but much less playfulness.' Philip Hope-Wallace of the *Manchester Guardian* thought 'It makes a mild evening but not a dull one and may well be liked by those who make up their own clerihews and who respond to anything fantastic from the world of "Ring Around the Moon" . . . This is an unpretentious and tolerable jape from that "writers' theatre" so ardently desired in some quarters.' An anonymous critic in the *Times* wrote: 'eventually it becomes clear that the author can think of no more odd characters and odd happenings. He is left to do what he can with his verse, and the piece gradually turns into painful imitation of Mr Christopher Fry . . . Manfully prepared to make the best of a farce without style, we are inflicted in the end

with a fantasy marred by a bogus style.' T. C. Worsley brutally told *New Statesman* readers: 'the comedy failed for the simplest of reasons – it had a thoroughly badly developed plot'. In the *Evening Standard* Milton Shulman thought 'Mr Peake's verbal acrobatics tend to land on their rumps more often than on their feet', and the influential W. A. Darlington in the *Telegraph* concluded that 'after the middle of the play Mr Peake was so busy piling on farcical business that the story went underground. I no more knew how the course of true love was running than I knew at any time why Percy was being buried from Sally's father's house. In other words, Mr Peake was following the modern fashion – to me a perfectly fatuous one – of letting story-telling go hang and relying for his effects on his incidental decorations.' Nevertheless, he thought Peake 'had a much better play in him'.

A less vulnerable man than Peake might have taken heart from Darlington's last remark and put the rest down to experience. But there would be no next play. Both Mervyn and Maeve had set too great a store by *The Wit to Woo* – it was meant to solve their money problems and establish his genius with a wider public; when it did neither their world crashed about them and every criticism was a wound. On returning home after reading the reviews Peake became delirious and took to his bed, the tremors in his hands and legs increasing alarmingly. His daughter, then eight, remembers the dreadful day:

'He was sitting in a leather armchair, absolutely shaking all over. I did not know what had happened, but I knew that it was terrible. We went out to tea. I don't remember coming back, but I remember going. I thought that by the time I returned everything would be alright again.'[6] Maeve had seen it coming: 'It cannot be laid at any door, but disappointment, built up by hope for too long, can damage a brain already too prolific.'[7] Nevertheless, Maeve was determined to put on a brave face. Next day John Watney and his wife, who had been at the opening night, went to meet the Peakes at the King's Head and Eight Bells pub on the Embankment in Chelsea:

It was a strange meeting, almost entirely silent. He seemed to be walking very slowly, as if lost in some kind of inner conflict, unaware of where he was going. To my wife's hopeful suggestions of future success he made no reply. Maeve was equally silent, but she walked with a kind of buoyancy, a determination and a courage. I wanted to say some words of consolation, but this was taboo, for we all had to keep up the pretence that the evening had been a success, despite the unenthusiastic reviews.[8]

Alarmed by his collapse, Maeve summoned expert help and within days Mervyn was admitted to Virginia Water Hospital. From now on his health and creative powers would be in steep decline.

The play came off after six weeks and the actors dispersed to other jobs, though Colin Gordon who had played Percy remained in touch. A cheque for £17 eventually arrived as Mervyn's share of the profits. Codron and Williams moved on immediately to a new play, *Share my Lettuce*, by Bamber Gascoigne, again starring Kenneth Williams, which was every bit as fey and frivolous as *The Wit to Woo* but which charmed the critics, made Williams a star and confirmed Codron in his career as a producer. Now Peake's play has disappeared entirely from the standard histories of the modern British theatre, buried under the avalanche of works flowing from Bolt, Arden, Simpson, Pinter, Wesker, Delaney, Shaffer and Willis Hall which came immediately after it. Nevertheless, *The Wit to Woo* did receive a few more outings, though all outside London. In 1958 it played for a week in the amateur 86-seater Green Room Theatre in Manchester, though Peake was by then too ill to take up his invitation to the opening night. In 1962 Cambridge Arts Theatre and the Oxford Playhouse hosted the Prospect Players' version for one week each. They had been offered it 'without much hope' by Peake's agent who had kept it in a drawer since 1957. The cast went to see the author, who was so delighted in their interest he lent them a collection of his art works to decorate the Playhouse bar. Once again the reviews were mixed but Kite and Mrs Lurch were popular and the *Oxford Mail* reviewer gibbered: 'He [Peake] regurgitates the words with Goonish glee, makes them bubble and squeak in a Fry-ing pan of verse. Lears over them, Bellocs them, and Carrolls them with a sense of nonsensical felicity that is quite unparalleled on the English stage.' It was last revived at the Edinburgh Festival in 1979 by the Nottingham Theatre Group and the *Scotsman* reviewer thought it owed a lot in language and theme to Ben Jonson's *Volpone* while simultaneously being 'a fine parody of an Edwardian farce'. However, the normally reverential *Mervyn Peake Review* (No. 9, Autumn 1979) carried a review by Edwin Morgan which admitted that, whilst it had its merits, the play was deeply flawed, lacking in homogeneity, too obviously derivative, muddled in plot motivation and containing *longueurs* that only Peake can be blamed for. The play had at last been made accessible to the general public by being printed in full, loose ends and all, in Maeve's *Peake's Progress* in 1978. The critics gave it another bashing then.

Also published in *Peake's Progress* was another play of five short acts, *Noah's Ark*, which Maeve glossed as having been written around 1960 for children. This is a genial romp with songs, dances and three unmenacing villains in Vulture, Hyena and Wolf. It would make a very good end of term production in a primary school, but it does not enhance Peake's reputation as a dramatist. Another attempt at sustained drama was *Mr Loftus*, which must have been written as they were about to leave Wallington. Aaron Judah collaborated with Mervyn on this and perhaps provided the initial idea: to portray a talented writer who refuses to write, or do much else either in spite of the efforts of his friends. The finished four-scene play was professionally typed and bound then sent round the agents. Once more Peake must have had Olivier in mind for the word-drunk Loftus, but Olivier wrote back with more than usual directness:

> I must honestly tell you that in my opinion I do not believe it quite makes the necessary grade. Original and extremely good as is most of the writing I rather fear that the 'Crazy' (horrid word but I can think of no other) – theme is a highly dangerous one and the audience is apt to get irritated by it . . .
>
> Also the rhythm in your writing together with the sort of verbal and onomatopoeic (spelling?) joking is trickily reminiscent of Fry and I do fear the sensation of it being derivative from both this author and Wilde and falling rather short of matching the content of either. Forgive me please if this letter steps over the bounds in the way of frankness, but I admire you so much indeed, that I cannot but be entirely honest with you.[9]

Kenneth Tynan also received a copy and replied: 'I can see in it some fine pointed writing, and a lot of unforced pathos, plus a lovely part for a bravura actor to sink his teeth into. What slightly worries me is what might be called a foothold in reality. Your characters weave some splendid verbal wreaths for themselves, but seem to be figures in a pageant rather than people in a play'; he concluded: 'on the whole while I admire your verbal virtuosity enormously, "Loftus" isn't really my kind of play'.[10] It was a tactful brush-off because in truth *Mr Loftus* is a failure: it concerns trivial two-dimensional people, mere texts on legs, having mild crises the reader cannot be made to care about. There are no laughs, but it cannot be taken seriously either. The whole judders along through static verbal arias of which the following is a snatch, spoken by Loftus when his servant opens a curtain in scene i:

That yellow light. Switch off the stuff at once!
What right have you to let the brightness in
All of a burst? What is it? If you say
It is the sun, I'll sack you.
The sun was made for Pharoes [*sic*], and for beggars
That kneel crutch-deep in dust as warm and soft
As sweet decay. No, no it's not for me.
Cut its gold throat.

The basic problem here and elsewhere is that Peake just did not know enough stagecraft to become a dramatist: he could not get people on and off the stage convincingly or write speakable lines or get them to initiate dramatic actions. It is as if he forgot all his knowledge of real life and his profound insights into human nature when he came to write plays and just shuffled stage clichés: so we have the comic charlady, the resourceful servant, the snobbish humour of lower-class characters dropping their aitches, the boredom of the effete classes who may have money troubles but would never think of working, the eccentric writer or artist who we have to believe is a genius on no evidence, the silly young couples falling in and out of sexless love just to keep the plot going. Then there are the overhearings, the unseen observers, the hidings, the constant entrances and exits all to try and whip up some life in the inert plot. Peake's strength as a writer was in his ability to *see* and to make us see too, but a dramatist also needs to be able to hear, and this he could not do.

One exception to his misguided attempts to write social comedy was a curious play in three acts called *The Cave or Anima Mundi*, written around 1961.[11] A cave is the setting for three very stylized episodes each involving a mother, father, their two sons and an intruder called Mary, but in the first act the cave is a prehistoric shelter from the cold and wolves, in the second a medieval workshop for a sculptor of gargoyles and in the final one, set in the near future, it is a nuclear fallout shelter with every modern convenience. In this Peake is trying to tackle serious questions about man's seeming need for something to both worship and fear; our compulsion to create art; why some individuals conform and others rebel, and the place in all this of the questioning mind represented by Mary the intruder. Her doom is to be eternal and to wake sleepers into questioning, 'but when I wake them out of their deep sleep I have no message for them'. It is a deeply pessimistic play but, exceptionally for Peake, it is one full of swift dramatic speech and action and an ingenious structure.

One son, Harry the eternal artist who 'has the passion to make useless things', utters one great cry from the heart which is strangely prophetic of Peake's own impending doom from his as yet undiagnosed disease:

'Isolated! O more than you with your logistic brain could ever guess or dream. Isolated from those I love. My brain divorced from my body, my body divorced from my soul. My love divorced from colour and the shapes that cry. Isolated from the masterpiece I shall never paint. Isolated from the passion of this panther. O she who could, if she were at my shoulder, propel me to the zenith. Isolation. Isolation. All things are on the other side of an unending window-pane. I see them moving by. All that is my colour, moving by. I . . . I, who in my dreams was a world eater, now find that it's the world that eats me up.'

After the failure of *The Wit to Woo* Peake collapsed as a creative artist. He must have realized he had wasted years working against the grain of his genius: instead of writing dense extended prose or lyric poetry he'd produced frothy stage verse; frantic comic actions in place of slowly developing tragedy; flimsy stereotypes rather than the profound archetypes of the Titus books. In seven years of toil the world had gained one indifferent drawing-room comedy but lost perhaps another major novel or two.

16 Patient, 1957–1960

The year 1957 was dominated for the Peakes by the anxious preparation for *The Wit to Woo*, its opening night in March and the awful months of deflation afterwards. Nevertheless, there was also time for a small exhibition of Mervyn's drawings at the Collectors' Gallery, and two illustrated books appeared this year. The publishers Gollancz tried to repeat the enormous success of their 1944 *Prayers and Graces* as A. M. Laing had collected more pious snippets and Peake's new literary agents, Pearn, Pollinger and Higham, agreed he would do thirty accompanying drawings for a fixed fee and no royalties. For *More Prayers and Graces: A Second Book of Unusual Piety* he employed much the same flexible line as for the earlier book (though with perhaps less zest) but there were to be no 40,000 sales this time and the book soon faded away. Then Peake's old schoolmaster and Clare's godfather, Burgess Drake, asked him to illustrate *The Oxford English Course for Secondary Schools Book 1*, a textbook which would be published by Oxford University Press. For these animal fables Peake invented a very effective pen and ink style which combined cross-hatched shading and a nervy broken outline for the heavily anthropomorphized creatures. Unfortunately, textbooks soon go out of fashion and this one is now a rarity.

*

We have seen how mentally and physically devastated Mervyn was by the lukewarm critical reception of his play and eventually Laura Beckingsale persuaded him to see a specialist. A nervous breakdown was diagnosed but the pills prescribed failed to stop the increasing tremors in his hands or his restlessness. However, by July he had recovered enough to go off alone to Sark in order to work on the third Titus volume. The weather was hot, as he reported to Maeve in very shaky writing: 'we had a light breeze to alleviate (there's no such word but one rather likes it) the sun'. He went swimming with his landlady's daughter: 'the water was jade green and deep and breathtaking and we swam into the dark mouth of the cave and out again into the dazzling sunlight', before returning to toil at the desk: 'I wish I could get my sentences on the paper without the process of writing down every word. The time taken up by the sheer nib-driving is awful.' His ideas were flowing and as usual he asked for Maeve's comments. 'THANK YOU sweet one. What you say about Titus 3 helps me. Titus 3 is for you as they are all for you.' He asks, 'do I deserve you?' and perhaps remembering one of his early Sark adventures answers, 'Even if I don't I'm going to hang on to you like a hundred tentacles of the octopus.'[1]

While he was writing in Sark there was a radio dramatization of *Mr Pye*, though he couldn't tune in to it on the island. This gave him new confidence and he determined to send the script round to TV and film producers. Sark always renewed his energies and he wrote: 'the Robsons were over here at Easter . . . they have never met such people as us. I also think we are pretty unique. But we ain't cashing in on our UNIQUITY. This we will do. When we are together again we will make our plans and come to the surface after too long a submersion.'

They came together in August and the whole family went to Weymouth, but his twitchiness had returned and he was worried about money. It was a relief for everyone when he returned to teaching at the Central in autumn and his salary resumed. Sebastian, who had failed all his examinations three times, was still preoccupied with learning the drums and Fabian had taken up the trombone. They had teamed up with three local lads to form the Wallington Jazz Quintet. This was not the background their father needed when in a creative mood but he was tolerant and Maeve welcomed this sign of creativity in their offspring.

On 25 September 1957 Peake read an article in the *Evening Chronicle* about an American company which was researching ways of subliminally controlling people's minds, presumably so they could be made to buy more goods. This inspired a curious fragment, consisting of a

From *The Adventures of Footfruit* (1957), pen and ink, 6×9cm

synopsis and some dialogue, entitled *The Adventures of Footfruit*, probably intended for radio, and according to Maeve the last thing he wrote.[2] Footfruit is an ugly little man with an even uglier dog who jauntily crosses from an unsophisticated but happy society into one where materialism is the religion and salesmen are its priests. Any natural taste or smell is forbidden since they do not yield a profit and natural singing is banned in favour of 'potted and permanent music'. Footfruit is converted and returns to his tribe, who soon follow him into this 'civilization'. A materialistic society is not a very original target for satire, but in the decade of 'you never had it so good' it was one worth attacking. The pessimism fits in well with Peake's jaundiced view of society in *Boy in Darkness* and *Anima Mundi*, which he was simultaneously expressing in *Titus Alone*.

At the end of the autumn term Peake went off alone to stay at Aylesford Priory, a twelfth-century Catholic foundation in Kent which accepted guests of all denominations who needed a period of quiet to think and work. He stayed there over Christmas and New Year working on the novel and writing regularly to his 'own special beauty queen', teasing her at New Year with 'do you wish you were at a ball with me as your Fairy Prince? No! You'd rather be at the ball.' He reported: 'it ain't half monastic. However I have a tame radiator.' All seemed well until Maeve received a letter from the Prior asking her to take Mervyn home because he was having memory losses and his restless pacing through the night was disturbing the other guests. He was

put on a train, met in London and carefully sent on his way to Wallington because solo travel was now becoming hazardous for him.

Maeve took him to see neurologists at the National Hospital in Queen's Square, Holborn and was not altogether surprised to be told that Mervyn might have Parkinson's disease. Their near neighbour, Goaty Smith's father, had shown the same range of dyskinesia symptoms of athetosis (writhing restlessness of the limbs), and chorea (jerky movements). She did not pass on this grim diagnosis to Mervyn, who continued to believe he could be cured. At the beginning of March 1958 he submitted himself to treatment in the Holloway Hospital at Virginia Water and stayed for six months in all.

Maeve recalled the preparations: 'Rather like a child going to boarding school for the first time, Mervyn was in a state of mind, which was excited at the prospect of a new world, but frightened by the unknown. Almost as for a new boy we packed a case, with some of his treasured possessions – pencils, drawing pads, Indian ink, A. E. Housman's *A Shropshire Lad*, Shakespeare's Sonnets, and a small painting I had done especially for him. A Rolls razor, coloured ties and socks.' The razor was confiscated immediately. Holloway Hospital was 'red-brick, vast and turreted, Gothic, with magnificent gardens. As we were to know over the next ten years, these huge buildings which house so much human sadness, nearly always have gardens that in their very Englishness belie what lies beyond them, in the long corridors, where people pass each other, "remote and islanded", but not always silent.'[3] Mervyn sat in these pretty gardens and wrote:

> My hands are as empty as my blind
> Lob-sided heart!
> Lob-sided, for self-pity like a curse
> Turns all I see to ugliness.

They were both shocked to see that all the nurses were male. Maeve wrote:

Mervyn, particularly, always responded to women, in whatever walk of life. He was a woman's man, and was always happier in their company, than in that of his own sex. For this reason, apart from Gordon Smith, a friend from his Eltham school-days, although a few years older, he had no men-friends. Many male acquaintances, but it would be hard to imagine that he would ever have yearned for evenings out with 'the boys'. Because of this sensitivity to women,

and the feminine streak in his nature, which is shared by other artists and writers, I had no need of women friends, in whom to confide the troubles and complexities which arise in marriages. He fulfilled the closest and most secret questionings of a woman. It was he who taught me how to love, and perhaps more important, how to be loved. The essential fact of liking as well as loving.[4]

On 3 March he wrote home cheerfully enough: 'I am in a ward for 6 but there are only three in it. A rough voiced "heart of gold" one-handed chap opposite. Next to me an old elderly ass who keeps on telling us about Ceylon where he once set foot.' He took his medicine 'one in each buttock' and 'it augurs a sleep like de profundis'. It tickled his vanity that one of the doctors knew his work – 'the doctor says he was proud to meet me,' he boasted to Maeve. Perhaps this was the neurologist, Roger Gilliat, who was also a friend of Ronald Searle's. After hearing from Gilliat of Peake's condition Searle called in and brought a drawing as a present.[5]

Three days later Mervyn was receiving nine injections a day and felt 'like a pin-cushion', but he had passed all the tests of his reasoning and memory and was hoping to practise his Mandarin on a new Chinese patient. 'All will come right and we will storm the citadel together. This is going to be a great spring in our lives.' On the 7th he saw 'two ship-mates' injected and sent down for electroconvulsive therapy (ECT) and realized with some dread that they were feeding him up in readiness for the same treatment. This process involved passing an electric current through the temples to convulse the brain in the hope of jolting it back to normality: it was dangerous and Maeve had to sign forms giving per-mission. She wrote: 'For the nine months which he spent in Holloway hospital, and endured this treatment, he would phone me (transferred charge!) two or three times a day, imploring me to bring him home. He was frightened by the treatment, the cold and clinical apparatus, the wires, and the loss of memory.'

After undergoing ECT repeatedly he became desperate for Maeve's comfort:

More than anything before I want you now. It is beyond falling in love. It is a yearning such as I have never known before making me quite ill and sick. There is something here which I suppose will cure me – but there's something that makes me want to vomit. I have almost lost my identity. I long for your white arms around my neck. The male nurses are pleasant but I am afraid of something

subtler – it is the smell of this place – its miles and miles of corri-
dors – the expression on the faces of some of whom have been here
for years.[6]

In *Titus Alone* those corridors in which people roamed who had lost
their identity would be transformed into a factory and the ECT into a
switch which could be thrown to inflict instant pain. Peake's own crea-
tions were coming back to haunt him and echoing King Lear's cry of
'O! let me not be mad', he vowed:

> I will never write about mad people again Maeve! Never! Never
> again! It has done something to me; or rather it has frightened me
> a bit to be under the same roof with those in other wards – perhaps
> it's because I've played too much round the edge of madness. O I
> could cry to be free . . . I am in a kind of dream – or nightmare
> and I yearn for your touch. If you cannot feel my love for you
> NOW then you never will . . . I am more proud of you than any-
> thing in the world.[7]

During her thrice-weekly visits, on the telephone, and in his frequent
letters he pleaded to be released but Maeve had to harden her heart and
refuse in the belief that the ECT would restore him to the vivacious and
creative man she had married. Between treatments Mervyn had time to
brood and he began to feel guilty that he had paid too little attention
to earning money and providing little luxuries for his family. Now even
his greatest works, the two Titus books, were providing less than £2 in
royalties per year and his other works were out of print. On 18 June
1958 Maeve was interviewed by the Artists' Benevolent Fund commit-
tee and he wrote: 'Today is the day on which you have to go through
the ordeal thanks to me and my lack of normal prudence and looking-
aheadness. God knows I'm ashamed of the ineffectual way I have gone
about the business side of my life.' She was given £155 towards the cost
of Clare's education at St Philomena's Convent, a boarding school at
Carshalton, Surrey, and this was eked out with her share dividends
from the *News of the World*, gifts from friends, Maeve's siblings and
charities. Mervyn tried to convince himself and her that 'great bundles
of filthy lucre' would arrive when he'd organized serializations, film and
TV rights and illustrations for the still unfinished *Titus Alone* and he
had rallied C. S. Lewis, John Brophy and Maurice Collis to publicize
it. And then, he reminded her, there were always his plays – *Mr Loftus*

and *Footfruit* – but Maeve must have listened with a heavy heart and known that none of it would ever happen. From now on she would have the full responsibility for keeping the family afloat.

It was a source of guilt for Mervyn that he was failing in his responsibilities as a father. He wrote to Maeve in June: 'I hope that Sebastian will slowly see that there is only unhappiness ahead until he can conquer his irritability. He is at a moment in his life when he can hardly control himself – and you have the brunt of it all.' Fabian was emerging as an artist and could have used his father's advice at home: 'Your oils? Be your own fiercest critic and you will have so far done splendidly – when I get back I'll be as stringent as I can: pattern rhythm texture shape colour.' Clare gave fewer problems and had organized the nuns and her classmates to pray for her father's recovery. Mervyn knew his wife's difficulties (including 'lack of physical love') in holding the family together alone, 'but over-riding all the vile bickering that clutters up the days, you, whatever happens, are the acknowledged queen – the anchor of all our love'.[8]

Between her hospital visits and her family chores Maeve still found time to paint in the littered attic but, she confessed, she had lost much of her early fey romanticism, both in herself and in her paintings. She wrote: 'I painted a great deal from my children – using their play and their turmoil, boys on stilts, handstands, somersaulting, dressed up in Indian war-dress, trying to achieve the rhythm of their movements in simplified form',[9] but the boys were now modern unruly teenagers and had long outgrown their Red Indian costumes. For all her talent, life was making too many demands on her energies for her ever to become a significant painter and, as with Mervyn, British art had moved on and left her stranded.

Though homesick and heavily drugged, Peake still managed to work on his novel and write short poems. One of these reflects his mental anguish:

> Heads float about me; come and go, absorb me:
> Terrify me that they deny the nightmare
> That they should be, defy me;
> And all the secrecy; the horror
> Of truth, of this intrinsic truth
> Drifting, ah God, along the corridors
> Of the world; hearing the metal
> Clang; and the rolling wheels,

Heads float about me haunted
By solitary sorrows.

This was accompanied by a drawing of grotesque heads in the felt tip
he now favoured because meticulous work with pen and ink was
beyond him. Another poem, not so melancholy perhaps, explores his
hallucinations and the noises in his head:

Out of the overlapping
Leaves of my brain came tapping
Tapping . . . a voice that is not mine alone:
Nor can the woodpecker
Claim it as his own: the flicker
Deep in the foliage belongs to neither
Birds, men or dreams.
It is far away as childhood seems.

Heads float about me, felt pen, 13×15cm, 1958

He told Maeve optimistically 'the golden gates have begun to swing slowly open', but instead it was the hospital gates which opened. On 22 August 1958 he was sent home, the doctors having admitted they could do nothing further and that the electric shocks had not worked any permanent improvement. The whole family went to stay at the Dixcart Hotel on Sark and swam, sunbathed and climbed the cliffs as they had always done. By autumn Mervyn was sufficiently fit again to return to the Central where Morris Kestelman had kept his part-time job open. Mervyn's speech was now slurred and his gait unsteady so that he was mistaken for a drunk on several social occasions, though his students were tolerant of his failings.

The twice-weekly train and Tube journeys from Wallington soon exhausted him and he was vulnerable in London's traffic, but fortunately Susan French, a student, volunteered to give him a lift on his work days. Even with all the support at home and college he could not sustain the effort and by the end of term was back in the hospital in Queen's Square for more tests over a six-week period. While he was in there the Waddington Gallery, now transferred from Dublin to Cork Street, held an exhibition entitled Recent Line Drawings of Mervyn Peake – though they were actually old ones taken from stock. He was allowed out of bed for the opening and eventually in January received a cheque for £100 from the sales, which boosted both funds and hopes.

Maeve pressed the hospital for results and was told to wait in a busy corridor to catch a harassed specialist:

> Was it complete lack of imagination on the doctor's part that he told me the most devastating news that I could hear of my husband, standing in a hall, with the never-ending stream of people who pass and re-pass one almost somnambulistically in all hospitals?
>
> He said, 'Your husband has premature senility.'
>
> He was then forty-six years old.[10]

Under this kind of strain Maeve began to question her faith: 'God has his reasons' and 'God moves in mysterious ways' were no consolation now. 'It may be questioned that it was only when fate pointed her malicious finger at her hitherto favoured daughter that I lost my faith. But this was not so. Over many years I had fumbled with the creed that had cocooned me from the knowledge of sin. I found nothing to replace it but the force of Love, but not the love of God.'[11]

The doctors offered no cure and no explanation of the disease's

origins but, according to John Watney who must have heard it from Maeve, Peake had had pleurisy at the age of nine or ten in China and then aged twenty-two mild *encephalitis lethargica* – which can lead to Parkinson's disease twenty or thirty years later. After Dr Oliver Sacks' book *Awakenings* appeared in 1973 there was speculation that Peake's condition might have had its beginnings even further back in the world-wide epidemic of sleeping sickness which began in 1917 and died away in 1927, though there is no mention of this in Dr Peake's memoirs. The symptoms of Parkinson's disease had first been described in 1817 but it was only in the twentieth century that it was known to be caused by a degenerative condition of the nerve cells in the ganglia at the base of the cerebrum, which causes a lack of dopamine in this part of the brain. Because the basal ganglia cannot modify the nerve pathways that control muscle contraction, the muscles are too tense. Dr Hewitt, Mervyn's doctor on Sark, and Dr Northcliffe-Roberts in London seemed to concur that, whatever its origins, he simply had Parkinson's disease and left it at that, as we must also do for lack of further evidence.

Peake still met friends in London; one of them, Maurice Collis, recorded in his diary in January 1959 that he had met Mervyn for lunch:

He told me that he was exhausted by his work on the third volume of the Titus Groan trilogy to be called *Titus Afar*, he had lost consciousness of the past and was apparently largely oblivious of the present . . . In appearance he was much aged and had the short hesitant step of an old man, though he cannot be as much as fifty. He complained also that his memory was very uncertain and seemed unexpectedly to black out when in ordinary conversation. I had the impression that he was very fragile.[12]

He was indeed, but he struggled back to the Central in spring 1959, though it was now obvious Kestelman could not protect him much longer. However, two publications this year raised the gloom a little. The major one was *Titus Alone*, which appeared in October. The BBC picked up on Eyre and Spottiswoode's advance publicity and asked if Peake would do illustrations to accompany a TV programme on the book. This task was now beyond him: his sluggish speech meant interviews were impossible and so the project was reluctantly abandoned. The book then came out to mixed reviews and had modest sales, as we shall see in the next chapter.

TITUS ALONE

MERVYN PEAKE

Eyre & Spottiswoode

Dust jacket for *Titus Alone* (1959), pen and ink, 22.2 × 14cm

The illustrations for the second, minor publication, he had been working on intermittently for some time. Aaron Judah, the eccentric unmarried friend who lodged with them at Wallington, had encouraged Peake's ambitions to work in the theatre by collaborating on *Mr Loftus* and now asked him to illustrate his children's book, *A Pot of Gold and Two Other Stories* (Faber and Faber, 1959). These Grimm-derived fables are about a boy who encounters a pixie with a pot of gold and learns not to follow gold all his life; a 'Crot' who will never make a fuss and so gets exploited; and a feuding couple who argue about an egg and end up waging war. Peake provided seven ink drawings in a kind of perfunctory broken line but, understandably, they are not his best and the whimsy world of pixies hardly seems to have engaged his imagination. The book condescended to children in a way his own tougher stories never did.

Number 55 Woodcote Road, in spite of its childhood memories for Mervyn, its large garden and spacious Victorian rooms, had never been the family's favourite home. The Wallington neighbours were stand-offish and the journey into London for cultural activities and work had become intolerable. They had tried to sell it many times without success until in 1962 Maeve's brother Roderick offered them a fabulous £8,000 so he could demolish the house and develop modern flats in its place.

By May they had moved to 1 Drayton Gardens, Kensington, a tall narrow house with bedrooms for all and separate workrooms for the two painters so, at last, they could give up the old battered Manresa Road studio. There was a small garden with trees for the cats to climb and a lawn where Mervyn and Goaty could smoke their pipes after a walk round the neighbourhood. On the opposite corner was a pub and they were very near the shops on the Fulham Road. Their battered furniture barely filled the spaces but they gave prominent place to the Sark table, the Chinese piano from Tientsin and Doc's old desk, now full of bills and the review clippings and old letters Maeve collected so assiduously. She saved every scrap Mervyn ever wrote to her but none of her own letters have survived. The whale vertebrae, the books and their own pictures (they seem not to have owned works by other artists) soon made it look like all their other houses – bright, cluttered and comfortably bohemian. It was the children's base but they were often away: Sebastian had already begun his extensive travels, Fabian was at Chelsea College of Art and Clare stayed behind

long enough to finish her schooling in Surrey before joining her parents in London. Maeve claimed they had had sixteen addresses during their married life and she was determined this one would be their last – as indeed it proved to be. But the move came too late for Mervyn to enjoy it, as the illness bit deeper and deeper into the creative centres of his brain.

17 Prophet, 1959

Peake struggled long and hard to complete the third episode in Titus' life. He wrote it as usual in longhand, but increasingly illegibly so that Maeve had to painstakingly type it out, consulting Mervyn as problems arose. When, in summer 1958, it was finally submitted to Maurice Temple-Smith at Eyre and Spottiswoode he was impressed, but suggested some major rewriting. For example, he wanted longer chapters, a less specifically allegorical role for the scientist villain, fewer science-fiction trappings, a shorter cocktail party, a less populated Under-River and for the whole of the final pageant to be seen through Titus' eyes alone.[1] At least some of this advice Mervyn complied with but by the time this was done and the manuscript was retyped, resubmitted and made up into proofs he was incapable of the final editing and cuts were made without his consent. Maeve wrote: 'He wished to resist the deletions which were made, and some of which I agreed with, but his brain was no longer able to grope [*sic*] and, sickened as I was at the thought of anyone touching what he had done, it was, or seemed to be, a question of necessity.'[2] And so the hardback edition came out in 1959 in less than ideal form. This text was used again for the American editions of 1967 and 1968, but for the 1970 reissue in the UK Penguin and Eyre and Spottiswoode employed the science-fiction writer Langdon Jones to go back to the original manuscripts in order to build up a text closer to what Peake

might have had in mind. Jones found discrepancies between the two in punctuation, omissions, repetitions, bowdlerizations, tense changes and altered images. Even whole scenes and characters had gone astray, all of which could shade the meaning, and these differences have provided rich pickings for academic text-sifters ever since. He also made major improvements to the ending, all based on Peake's manuscripts.

At the foot of one manuscript page in Peake's shaky hand is written: 'I want to wake up dead.' Obviously Parkinson's disease caused Peake physical frustration in getting the book from his brain out to the readers, but it is a moot point whether it also influenced the author's world view and hence the book's content or style. It might be charitable to see some of the book's fragmentation as due to the progressive degeneration and warping of Peake's mind, but John Watney believed Peake's genius stayed intact behind his outward incoherence and lack of co-ordination and that on good days it emerged and he created as well as ever.[3] Dr Oliver Sacks demonstrates in *Awakenings* (1973) that Parkinson sufferers preserve their higher faculties (intelligence, humour, imagination, judgement) while having a different perception of time and space, which might relate to Peake's treatment of these things in his novel. The scurrying pace of the narrative may not be a literary device alone but an unconscious parallel to the author's own 'festination' or shuffling run.[4] We shall never know, but it is clear that this work emerged in terrible personal circumstances. As Maeve saw it:

> There is no such thing as a Caesarean of the brain. It is not a perfect way of giving birth, but in most cases there *is* the child, and *there* the mother. No surgeon could lift out of that teeming, confused brain the living foetus of Titus (Alone). His conception had all the love needed for an easy birth, but the carrying and the labour had about it all the harsh reality of nature at its worst. He could see and he knew what had to be done, but it was as difficult as teaching an elephant to tap dance. It could be done, with infinite patience, and blind faith.[5]

Patience and calm were in short supply. '"Rock around the Clock", quiffs – drain-pipe trousers – the strident voice of adolescence, male adolescence permeated the house. The drum-kit in the next room, the sudden almost animal laughter, and the seedy silence following, were not the ingredients for the ushering into life of Titus Alone. Too much

was alive in that house, lightning and fire, tempests, whirlwinds, and seldom a green pasture.'[6]

The book opens with an exhausted, twenty-one-year-old Titus arriving in a new country by boat and collapsing by a river where the fishermen, like the Chinese, use cormorants. Narrowly he avoids arrest by two robotic policemen, the Helmeteers, because he is helped by Muzzlehatch, an eccentric mix of SAS soldier, eco-warrior, father figure, word-spinner and hater of all 'the pip-headed, trash-bellied, putrid scrannel of earth', especially those in charge of its science and technology. He whisks Titus away in a motor car to his home and zoo but Titus soon leaves after being treated with less respect than he thinks he deserves as heir to Gormenghast. Soon he discovers no one in this country has heard of his home or believes in its existence. As a talisman he has brought with him a single piece of flint from the castle's tower, his last tangible link with home, but he smashes a spy machine with it and it is lost. While on the run he climbs on to the roof of a building where a society party is in progress but falls through the skylight on to Juno, an older, voluptuous ('snowball-breasted') woman who is Muzzlehatch's former lover. Titus is captured, imprisoned and tried as a vagrant, but Juno volunteers to make him her ward. They become lovers, but Titus finds her possessiveness cloying and leaves. He ends in the Under-River, a dreary subterranean place of misfits and refugees where he fights Veil, the sadistic keeper of the degraded woman Black Rose, though Muzzlehatch has to intervene and kill Veil. Meanwhile, Muzzlehatch's beloved zoo animals have been slaughtered by a death ray and he sets off to destroy the factory where such things are made. Titus meets Cheeta, the icy but beautiful daughter of the factory's chief scientist. She nurses him to health, listening to his delirious ravings about Gormenghast and its inhabitants. Cheeta indulges him in everything but withholds her sexual favours – the only thing he wants from her – and in revenge for his rejection of her benefactions she plans to destroy Titus' sanity and identity by staging a charade in which the Gormenghast characters she has heard about will prove to be fantasies and his memories of home false. This mocks the tenth birthday party he had in *Gormenghast*. Everyone arrives at this cruel 'farewell party' – Muzzlehatch who by now has planted a bomb in the factory, Juno and her new lover Anchor, and people from the town and Under-River. Cheeta's plan is foiled and she is reduced to inarticulate screaming; Muzzlehatch is killed by the ubiquitous Helmeteers; and

Titus is whisked away by Juno and Anchor. Later he parachutes from their plane and at last reaches the borders of his own land, though the view of the castle is still hidden by a boulder. Again 'a cave yawned on his right hand. A cave where an infinity ago he had struggled with a nymph.' Then:

> His heart beat more rapidly, for something was growing . . . some kind of knowledge. A thrill of the brain. A synthesis. For Titus was recognizing in a flash of retrospect that a new phase of which he was only half aware, had been reached. It was a sense of maturity, almost of fulfilment. He had no longer any need for home, for he carried his Gormenghast within him. All that he sought was jostling within himself. He had grown up. What a boy had set out to seek a man had found, found by the act of living.

He turns his back on his birthplace and runs down a track he had not known before.

To the reader who has followed Titus through the two earlier books *Titus Alone* administers a profound jolt, and many have not liked it. We have unconsciously assumed that since Gormenghast lacked modern technology, science, arts or politics then the Groans ruled a medieval society, or at least one as benighted as Doc Peake found in Hunan at the turn of the century. So too had Titus, who now reels with shock in a world of cars, jet planes, electronic surveillance, androids, cocktails, factories, cosmetics, helicopters and buildings which are 'fantasies of glass and metal' rather like the high-rise blocks of the 1950s. It is as disorientating as it would be to read that Beowulf had killed Grendel with a Kalashnikov. Muzzlehatch's blood-red car is the first major shock, though Peake makes its technology less brutal by describing it always in terms of a female animal ('she's a bitch and smells like one'), giving it a crocodile skull mascot, tethering it to a tree, and later ceremonially 'killing' it by pushing it over a cliff. The urbane inhabitants of this new land cannot conceive of a place as benighted as Gormenghast and after a time Titus also begins to wonder: 'were they coeval; were they simultaneous? These worlds; these realms – could they *both* be true? Were there no bridges? Was there no common land? Did the same sun shine on them?'

Gormenghast has been so much on Titus' mind throughout the book that his turning away from it once he has reached its borders came as a

shock to readers expecting a folk tale ending. Colin Manlove for one, who states emphatically: 'It is unacceptable, a complete and opaque denial of all that has gone before.'[7] Others, however, have seen it as the logical tying together of the book's themes.[8] Maeve herself justified this second desertion of his Earldom on grounds of the plot since she knew this was not the end of Titus' search for his identity:

> Mervyn never intended to write a trilogy, nor were the books only to be about Gormenghast. There was to be the developing theme: the life-story of one person; perhaps loosely based on his own life. I think he intended to take Titus on to old age and death. I don't think he ever intended Titus to return to Gormenghast, just as he, himself, could never see himself returning to China. But, just as he retained always a memory of his distant childhood in China, so Titus would always have kept with him the memory of his childhood at Gormenghast.[9]

She also gives an insight into Titus' passivity – he is the victim of events and frequently has to be rescued from them: 'Titus outside the restrictions of Gormenghast, was to be a catalyst – to absorb all that he could of a new world, but not change it, as he had wished to change the restrictions of his childhood. He did not ride forth with the fervour of a missionary, but with the eyes of a blind man, who had been granted sight. But what he saw, was it any less repressive than the credo of the castle?'[10]

This idea of a growth through exposure to experience to be carried over several volumes is borne out by Titus' immaturity at the end of this third volume and the notes Peake left on how he might complete the whole gigantic birth-to-death saga. Titus would travel new terrains (snows, mountains, islands, forests), meet new social groups (soldiers, actors, psychiatrists, lepers), endure new natural disasters (typhoons, doldrums, pestilences, famines), encounter supernatural beings (angels, devils, mermaids, monsters) and all the while learn through shapes, echoes, textures, sounds, tones, colours and scents.[11] Peake even completed a couple of pages, a 'Preadventure' showing the Countess staring from her window with Prunesquallor still in attendance, and a scene of Titus sleeping rough in a barn and dreaming of Swelter and Flay, but then the writing dwindles into illegibility.[12]

Over two volumes Gormenghast had acquired a density and credibility achieved by a slow oratorical style which built it, stone by stone,

before our eyes. Now, in *Titus Alone*, events whiz past, we jump to new locations, characters enter and exit with dispatch – many only once. The book is half the length of either of its two predecessors but it has 122 chapters compared to *Titus Groan*'s 69 – which, it will be remembered, took nearly 400 pages to span two years and many of those pages covered just one day. Now the reader is confronted by telegraphic sentences, chapters only one paragraph long, truncated syntax, snatches of unattributed conversation, stichomythia, passages of delirium, streams of consciousness – all of which keep us on the hop. The main characters lack the slow revelation and realistic motivation of Steerpike or Prunesquallor and behave jerkily in unpredictable ways. In the humour there is none of the geniality of Bellgrove's courtship, and an uneasy feeling arises that we are being fed a message as well as a plot. If the first two novels created a new genre – Peakean fantasy – then this third volume zigzags between several: the *Bildungsroman*, science fiction, social satire, morality tale and dystopian prophecy.

There are still felicities of observation, for example: 'within a span of Titus' foot, a beetle minute and heraldic, reflected the moonbeams from its glossy back. Its shadow, three times as long as itself, skirted a pebble and then climbed a grassblade', or the long description of Cheeta's room and granite dressing table. Muzzlehatch dressed only in a fireman's helmet, hosing down a fighting mule and camel, the bumbling magistrate and the seller of tickets to view the sunset remain amongst Peake's quirkiest inventions. It has been shown too that a sophisticated coherence of imagery runs through the book – of water and mirrors, for example – which betokens a creative mind still very much in control.[13]

Apart from the tragic Keda episodes in *Titus Groan* and Tintagieu in *Mr Pye* Peake had not treated sexual relationships in an overt or extended way in his books, though sexual innuendo and imagery are certainly present just below the surface in several of them. Now, a reader who has come thus far with Peake is startled by Titus' response on seeing Juno's 'marvellous bosom'. 'A pang of greed, green carnal to the quick, sang, rang like a bell, his scrotum tightening; skedaddled through his loins and qualming tissues and began to burn like ice, the trembling fig on fire,' and later, 'his wits fell awake. His cock trembled like a harp string'. After Juno has taken Titus's virginity, Muzzlehatch accuses her of letting Titus become 'lord of that tropical ravine between your midnight breasts: that home of moss and verdure: that sumptuous cleft'. Titus accosts Cheeta: 'You are a woman! That's what you are. So let me suck your breasts, like little apples, and play upon

your nipples with my tongue.' A year later, after the *Lady Chatterley* trial in 1960, the newly unconfined Peake would have been able to express himself even more frankly, had he wished, or been able.

Juno with her mature carnality shows Titus the pleasures of love, but before long he finds her a smothering mother figure and deserts her, as he had his own mother. She had been deserted by Muzzlehatch for much the same reason: the immature male's need to be free of obligations. When at last Juno finds the man to give her stability she appropriately calls him Anchor. Meanwhile Titus cannot apply what he has learned from Juno about physical love in his next relationship, with Cheeta:

'Take your hand away,' said Cheeta. 'I don't like it. To be touched makes me sick. You understand don't you?'

'No, I bloody well don't,' said Titus, jumping to his feet. 'You're as cold as meat.'

Manuscript page of *Titus Alone*, pen and ink, 20×26cm, mid-1950s

Cheeta is virginal, hard, lithe, tiny, austere, intelligent, ruthless and modern, in all ways the opposite of Juno's classical voluptuousness. She is 'frozen at the tap root' and 'prim as the mantis that gobbles up the heads of her admirers', using her sex as bait. Titus lusts only for her body: 'love was elsewhere. His thoughts were fastidious. Only his body was indiscriminate.' Once scorned, Cheeta plans a terrible revenge by destroying everything which makes him different from all others in this brittle society – his previous life in Gormenghast. She sets about planning this with a cold cunning worthy of Steerpike.

Titus is made to feel guilt for his heartless desertion of Juno and shame for lusting after Cheeta. He also squeamishly deserts Black Rose in her hour of need, being repelled by her naked pain. Feminist readers might accuse Peake of presenting three rather stereotypical females here: the lover-mother, the deadly siren and the passive victim. Elsewhere in the book there are two self-absorbed lesbians, the flirts and harpies of the cocktail party and a peasant girl Titus casually sleeps with, so his encounters with the opposite sex have not been happy ones, and he has not learned from them how to give or receive love with an equal. Presumably that might have happened in future volumes of Titus' adventures.

Gormenghast was remote in time and place, but now the hero is thrust into a milieu the reader is meant to recognize as his or her own, or at least what it might become if present dangerous trends continue. Part of the book's purpose is to warn us against the rising power and amoral ingenuity of science and technology. This was timely, since the previous two decades had seen Nazi experiments in eugenics, germ warfare, social engineering, the manufacture of soap from human fat, gas chambers, pilotless V2 rockets and the dropping of atomic bombs on civilian populations. Peake was not a political man but he could not avoid knowing how precarious was the balance of power between East and West throughout the 1950s and that both sides continued to test and amass nuclear weapons. Dangerous confrontations occurred in Korea, Hungary and Suez while Peake was writing this book and by 1952 British expenditure on defence was second only to that of the Soviet Union. Significantly, the denouement of *Titus Alone* is a cataclysmic explosion:

'That would be the death of many men,' said Muzzlehatch. 'That would be the last roar of the golden fauna: the red of the world's blood: doom is one step closer. It was the fuse that did it. The blue fuse. My dear man,' he said, turning to Anchor, 'only look at the sky.'

Sure enough it was taking on a life of its own. Unhealthy as a neglected sore, skeins of transparent fabric wavered across the night sky, peeling off, one after another to reveal yet fouler tissues in a fouler empyrean.

Peake had visited Fascist Spain and Communist Yugoslavia but taken little interest in their ideologies, nor had he shown any obvious curiosity about scientific research. However, he realized that science could best pursue its most deadly ends in a political regime equipped with secret police, electronic surveillance, sophisticated communications, slave labour and human guinea-pigs. In such a society a scientist devoid of moral sense would flourish, and it could happen either side of the Iron Curtain.

Maurice Temple-Smith on reading the original manuscript did not see the urgency of Peake's prophecy but was distracted by the science-fiction trappings which he saw as 'a lower level of imagination than the myth of Titus and Gormenghast'. He advised: 'In general, I do think you should cut out all or nearly all the "science fiction" elements in the second half of the book: the glass houses in the early part are an effective image, but when people start buzzing around in helicopters and shooting down conveyor belts, the spell is broken.'[14] Maybe he had in mind Dan Dare, 'Pilot of the Future', who had, since 1950, been

Muzzlehatch and Titus, pen and ink, 22.5 × 35cm, date unknown

battling the evil Mekon on the front page of the *Eagle* comic. Peake responded to Temple-Smith's suggestions by making the factory's actual products vague, but there remain enough hints in the green smoke from the chimneys, the smell of putrefaction, the grey sludge, the ash, the machine which causes pain at the throw of a switch and the numerous identical faces at the windows to show that Peake was drawing on memories of his visit to Belsen, perhaps now with an overlay of his own sufferings in mental hospitals.

Literary warnings against unfettered technology were not new: H. G. Wells had used the theme before Peake was born. *Frankenstein* and *Dr Jekyll and Mr Hyde* were familiar to Peake, and he surely knew of Aldous Huxley's *Brave New World* (1932) which employs a similar device to his own in thrusting a naïve hero into a technologically advanced society whose values and sexual mores are totally at odds with the primitive ones he has brought with him. Orwell's *Nineteen Eighty-Four* (1949) also portrayed a world under constant surveillance, where pain can be inflicted at will and love is impossible. Published to great acclaim while Peake was at work on *Titus Alone*, William Golding's *Lord of the Flies* (1954) shows how man, left to himself, will abuse the power of science for evil ends, and leave Paradise in flames. No benign God appears in any of these dystopias to save humanity from its own insatiable curiosity and consequent self-destruction, though Titus lives to learn another day and Gormenghast is evidently still intact. This gleam of hope in the continuity of the human spirit had earlier been expressed in Peake's poem 'Break Through Naked':

> Break through naked:
> Break through bloody:
> Break through Child
>
> As the fire
> Breaks the mountain
> And the living limbs of lava
> Lace the world
> While the atom
> Casts its shadow
> Round the terror
> Sated planet
> And the continents
> of gooseflesh

Bare their bosoms
To the wild

Break through naked!
Break through bloody!
Break through Child!

Science had its terrifying implications, but during the 1950s it also gained in prestige with dogs and monkeys orbiting in space, the development of a polio vaccine, Jodrell Bank radio telescope, the contraceptive pill, nuclear power stations, the hovercraft, early computers and, soon after, the unravelling of the DNA's double helix. Science fiction gained in literary status as writers and readers became more excited by these developments, good and bad. Today the technology and weaponry have become more credible and the settings more bizarre, but had Peake lived it seems unlikely he would have become a specialist writer of this kind of science fiction for, as one critic pointed out:

He uses the properties of science fiction, as William Burroughs, Kurt Vonnegut, Angela Carter, or Doris Lessing have used them, to create a fictional realm which is a distortion of our own, the distortion offering various strange reflections upon and insights into reality (however defined). The distorted landscape, the exile abroad in it, not so much on a quest as struggling to make sense of his own wanderings – the pattern is central to the disrupted and alienated fiction we read today.[15]

In an interview in 1981, Maeve accounted for this choice of genre in more personal terms:

Titus Alone is a contemporary satire, with the most powerful ideas in the world. It was written after his journey through a devastated Europe and the visit to Belsen. It is a much surer novel, dealing with the impact of what was happening to him and the world and in this sense it touches the imagination and the heart . . . Peake saw something awful ahead. By the time he wrote it, really a contemporary satire, the dreadful implications of Belsen had sunk in as time went on. His illness was beginning, and this heightened things.[16]

But just how contemporary is it and what is being satirized? Apart from the cocktail party it doesn't seem a particularly British or even Western

society that he depicts. Capitalism, liberal democracy, socialism or *laissez-faire* governments do not seem to be the issues. Nor does totalitarianism – then the dominant mode of government in half the world. If Peake 'saw something awful ahead' it would seem to be a state run by scientists and social engineers and in this vision there is a clear link back to his experiences in Germany.

This is not a war book in the way that Mailer's *The Naked and the Dead* or Heller's *Catch-22* are war books, but it could not have been written without Peake's experiences of war. The refugees in the Under-River probably derive from those he had seen on the roads of Germany and their sleeping arrangements mirror those of Londoners dossing down in the Underground or beneath the Arches during the blitz. The factory whose product is death is obviously a kind of concentration camp, and Muzzlehatch's dying words: 'Something of a holocaust, ain't it?' show that Peake knew this dreadful word just coming into wider circulation. But it is in the interlocking characters of Veil and Black Rose that Peake explores the psychological horrors of war most explicitly. Veil, dressed in Nazi black, is described as a spider or mantis man with a lipless mouth and eyes like beads of glass: 'he was born with a skull so shaped that only evil could inhabit it' as if he were predestined to malevolence – a point, it will be remembered, that the author had made about another criminal in a poem called 'Sin' or 'His Head and Hands Were Built for Sin':

That skull, those eyes, that lipless mouth,
That frozen jaw, that ruthless palm
Leave him no option but to harm
His fellows and be harmed by them

It was the defence he had heard offered for the Nazi criminal Back (also 'lipless') on his German trip. Veil was a death camp guard who escaped with an inmate, Black Rose; he reminds her: 'They whipped you and they broke your pride. You grew thinner and thinner. Your limbs became tubes. Your head was shaved. You did not look like a woman.' He is now the oppressor to her victim, the sadist to her masochist, the pimp to her whore.

Black Rose's only wish now is to die, but with her head on clean white linen. This is an obvious harking back to the dying consumptive girl in Belsen hospital and in writing it Peake has in a way compounded his guilt at making poetry out of her suffering. His hero is made to express that remorse: '"She goes through hell," muttered Titus. "She wades in

it, and the thicker and deeper it is, the more I long to escape. Grief can be boring." Titus was immediately sickened by his own words. They tasted foul on the tongue.' And then, '"I can't, I can't," he thought. "I can't sustain her. I can't comfort her. I can't love her. Her suffering is far too clear to see. There is no veil across it: no mystery: no romance."' Titus cannot cope with such naked anguish – and perhaps Peake couldn't either.

The novel is not all existential angst and suffering, but the humour is by no means as genial as in the previous two books. The world Titus left behind had no middle class, but this one does and it comes in for some heavy-handed satire. The zoomorphs Peake had delighted to create from schooldays and the Moccus books onward now have a Swiftian disgust to them. His tolerance of man's eccentricities in the two previous books has drained away. As Titus spies on the cocktail party Peake assembles his targets.

> They were all there. The giraffe-men and the hippopotamus-men. The serpent-ladies and the heron-ladies. The aspens and the oaks: the thistles and the ferns – the beetles and the moths – the croco-diles and the parrots: the tigers and the lambs: the vultures with pearls around their necks and bisons in tails.

In this cramped menagerie of grotesques Mrs Grass intimidates men with her conical breasts, and her husband is understandably cynical about love and marriage: 'What is the point of getting married if one is always bumping into one's wife? . . . Cold love's the loveliest love of all. So clear, so crisp, so empty. In short, so civilized.' The egotistical poet spouts overwrought nonsense while bald heads, gold teeth, sapphire earrings, toupees, a lion's mane, a Lady, a Duke, a detective are glimpsed, and face after overlapping face pass before us like those Peake recorded in so many sketchbooks. No principles or virtues are shown and no worthwhile person appears until Titus falls on top of Juno. Muzzlehatch sums them all up: 'Your Soul smells – your collective *soul* – your little dried up turd of a Soul.' One wonders just what London's cocktail set had done to Peake to deserve such odium because it is clear that the venom is in the narrator's voice and not Titus' at this point. Much the same vapid crowd appeared in *The Wit to Woo*, and they derive more from literature than real life in Kensington and Chelsea. A literally lower level of society is paraded before us in the Under-River, amongst them the failed author, Crabcalf, whose epic has sold only twelve copies over the last thirty years and now the remaindered copies

form his mildewed bed. Peake knew all about remaindered books. A literary patron, Foux-Foux passes through, his family once having supported Morzch while he created his masterpiece PSSSS. But this is heavy-handed stuff if it is meant to be a scathing send-up of the literary world.

From the real literary world reviews of *Titus Alone* trickled in. The *Times Literary Supplement* (30 November 1959) had one of the most favourable:

> The trouble is that, in an age of consolidation and poker-faced conformity, such prose as Mr Peake's is apt to induce a slight embarrassment: it is rather as though somebody should assume the cloak, sombrero and flowing tie of an old-fashioned artist – a perfectly acceptable gesture in itself, but depending for its success upon whether the wearer has the sort of personality which can carry it off. It must be said at once that Mr Peake does, on the whole, carry it off very well indeed. He has a magnificently haunted imagination, and his writing, in certain passages, rises to an astonishing pitch of intensity. His weakness lies in the structure of the work as a whole, which is too diffuse and episodic: it is unlikely that anyone ever remembers the plot – such as it is – of a Mervyn Peake novel; what stay in the memory are isolated scenes, perceived with the terrifying vividness of nightmare, and the descriptive details which go to make up Mr Peake's dreamlike but strangely convincing world.

R. G. Price in *Punch* (18 November 1959) still played the reviewers' old space-filling game of spot-the-influence. 'Attempts to pick out ancestors for Mr Peake lead to wildness but are irresistible. Walpole? Fuseli? Beckford? Melville? Arthur Rackham or James Joyce? For that matter even Beerbohm or Beachcomber?' The *Observer* (1 November) critic noted that Peake's trilogy was completed at the same time that T. H. White was bringing his Arthurian series, *The Once and Future King*, to a noble conclusion – a similarly rambling *Bildungsroman* and a better comparison to make than the usual one with Tolkien. He concludes:

> Gormenghast is not everyone's glass of laudanum. A taste for opium once acquired is almost impossible to shake off, and Mr Peake's admirers will be happily intoxicated by *Titus Alone*, which

may conceivably create fresh addicts . . . Childhood is over, the notes are elegiac: the prospect is as bleak as the newly revealed backside of the moon . . . it is a desolate vision. In the words of Muzzlehatch: 'Once there were islands all a-sprout with palms; and coral reefs and sand as white as milk. What is there now but a vast shambles of the heart. Filth, squalor, and a world of little men.'

Perhaps this was not a message most readers were prepared to hear. On 2 January 1960 the *Cork Examiner* reviewer had the last and truest word: 'The public at large will, I imagine, take a while to warm to Peake's disconcerting vision. The trilogy is a work of art so far outstripping the fashionable that it will be some time before a popular audience can adjust itself to its particular world.' Unfortunately, Peake was in no condition to wait that long.

18 Invalid, 1960–1968

Apart from Peake's worrying lack of physical co-ordination, circumstances seemed to take an upward turn when Charles Ede of the Folio Society got in touch in February 1960 to ask if he would be interested in illustrating Balzac's *Contes drôlatiques*, translated by Alec Brown as *Droll Stories*. This was another masterpiece where Gustave Doré had set the standard. Twenty-four full-page drawings using black line and flat pastel green, pink or blue were needed and the fee would be 10 guineas each though, disappointingly, the publishers would retain the originals which meant Peake could not show or sell them. Ede wanted something 'rumbustious', which would normally have intrigued Mervyn, but now there were problems, as Maeve reported:

> He could read, but no longer fully comprehend what he saw on the page. I read all the stories for him, and chose the passages which I felt he would be able to see in his own idiosyncratic way. It was a kind of nightmare. I was with him each day as he floundered, trying to draw what would have been second nature to him, a gift for his humour and power of insight into another writer's mind.[1]

The brush fell from his hand repeatedly and he had to be led back time and again to the work table. Costume research was out of the question and it is amazing that the illustrations, whilst clearly not his best, are

as light and delicate as they turned out to be. Understandably, they have none of the bravura of Michael Ayrton's illustrations for the Folio Society's edition of Lucius Apuleius' *Golden Ass* of the same year, nor do they possess Ayrton's sly eroticism. Peake was not at ease with the overtly sexual in his published graphic work (he could never have undertaken Ayrton's scandalous Verlaine Suite *Femmes/Hombres*, of 1972). His instinct, like Rowlandson's, was to turn sex into the grotesque or the comic and in this, of course, he was perfectly in tune with Balzac.

The fees from the Folio Society meant that Peake could now avoid the National Health Service waiting lists and go directly to the Maudsley Hospital in London for surgery on his brain. Immediately after Christmas 1960 he was booked in as a private patient. He hoped that if the surgeons severed the basal ganglion this would give him back the steadiness of hand he needed to put down all the teeming ideas waiting for expression in line and prose. The risks were explained to them both but Maeve had to take the final agonizing decision. While Mervyn was on the operating table she and Mervyn's brother Lonnie went off to a cinema, staring unseeingly at the fribble of *Pollyanna* until it was time to report to the hospital. They were told the operation had been a success, and indeed for a time it did still the tremors. But soon these returned and another neurologist depressed them all by declaring that the operation had been totally unnecessary. Mervyn now had a large dent in his forehead; he seemed not to mind this – but he did mind that he was still recuperating in hospital when Sebastian had his 21st birthday party at Drayton Gardens on 7 January 1961.

He returned home calmer, but teaching was now beyond him – he couldn't even climb the stairs to the top-floor life room at the Central. Morris Kestelman and his colleagues Cecil Collins and Hans Tisdall could no longer cover up his inadequacies in the classroom, so the family's only steady source of income ceased. By now Peake was also out of touch and sympathy with the sex, drugs and rock 'n' roll culture of his students and the kind of art they wanted to produce. London had begun to swing and painting was about to go into a convulsive period of experimentation when Pop, Post-painterly Abstraction, Minimalism, Conceptualism, kinetic art, cybernetic art, happenings, behavioural art, video, body art, environmental art and several more would briefly flash across the artistic firmament. None of them involved oil paint, brushes, canvases and a knowledge of life drawing.

By summer he was well enough to stay with Lonnie at Reed Thatch when Maeve was away on some unexplained family business in Germany. He wrote lovingly, but shakily, to her every day begging, 'come to me, sweetheart, with your hair of barley'. He also managed a birthday poem for her:

> Now, with the rain about her, I can see
> This is her climate, O my aqueous one
> How you do scorn the bright beams of the sun!
> How you do drink the wet beams of the sky!
>
> Her head is glimmering in the slanting strands
> It is her climate for the storm is making:
> While others bask, she wanders to her slaking,
> How rare she is, her brow, her breast, her hands.

On her return from Germany Maeve began negotiations with Dent to publish Mervyn's ballad *The Rhyme of the Flying Bomb*. This had been

Droll Stories (1961), pen, ink and single colour, 24.5×15cm

written on Sark in 1947 and then lost until it turned up when Mervyn
was rooting about in a cupboard in Drayton Gardens. It is a curious
story of a sailor who finds an orphaned newborn baby in a bombed
house and takes it into a church for shelter. The baby warns him he
must die, the church is hit by a flying bomb and the sailor is killed:

> And the dust rose up from the hills of brick
> And hung over London town,
> And a thousand roofs grew soft and thick
> With the dust as it settled down.
>
> And the morning light shone clear and bright
> On a city as gold as grain,
> While the babe that was born in the reign of George
> Lay coiled in the womb again.

There are echoes of *The Ancient Mariner* in the mixture of real and
supernatural and of Wilde's language in *The Ballad of Reading Gaol*
(1898), but in one or two places the thumping rhythms are more akin
to *The Hunting of the Snark*.

Dent would publish it only if the poet provided black and white illus-
trations; they evidently did not know what an onerous condition this
was to impose on him. The £45 advance was needed, so Maeve sat
Mervyn down with his black felt pens and read his poem to him:

'Once again, I tried to work out where the illustrations (if that is what
they were) should go, and I sat with him, until we were both exhausted,
trying to make the salient picture. Seeing them in the book, I doubt if
anyone could know the pain with which those drawings were imbued.'[2]
Indeed the twenty jagged, almost crude, pictures suit the poem wonder-
fully well. It was to prove his last published book but when it appeared
in 1962 it achieved only modest sales, even at 15 shillings, perhaps
because most people were now glad to forget the war. However, a fellow
poet, Laurie Lee, wrote on 16 May:

> Dear Mervyn, I just wanted to tell you how much I admire your
> Flying Bomb poem for its power and simplicity, and for its being
> like nobody else's. And also for the luminous drawings.
> I hope you know how good it is.
> Yours ever Laurie

The *Arts Review* critic was impressed too: 'the vivid style and the
hypnotic rhythm of this epic rhyming poem make it as hard to put aside

as a Chandler novel', and so was the reviewer in *Books and Bookmen*: 'an epigrammatic ballad in which words are used almost as pigments. Upon the dark canvas of blacked-out, air-raid battered London are picked out spears of ice-bright glass, little red monkey flames, and the blood of the London kerb. There are great dabs of fire-gold, soft mists of brick dust, charcoal debris and sky kindled to a scarlet sea of flame.' On 24 August 1964 the Peakes received another fee when it was read on the BBC Third Programme with Marius Goring playing the part of the sailor. Tristram Cary had provided a musical setting and the *Glasgow Echo* pronounced it: 'one of the happiest marriages of spoken word and music that the Third has yet produced'. It was reissued in 1973 by a different publisher, but by then it was over twenty-five years old and looking dated, as the *Guardian* reviewer pointed out:

perhaps it is difficult nowadays for a poet to commit himself to the rumbustious poeticalities of Mervyn Peake's *Rhyme of the Flying Bomb*, which, complete with its illustrations, admirably subdued to their task, has just been reissued by Colin Smythe. It's a period piece in ballad form, wombs, tombs, stars, blood and all but it has in it the best not the worst, of the 'Forties style . . . its surreal picture of war-blasted London exaggerates, its hopefulness is wrung desperately from religiosity as much as from faith, but it does envisage and work for a sense of common humanity and the decencies of human love.[3]

Maeve was finding her husband increasingly difficult to handle. She had persuaded the local café, tobacconist and barber to give him things she would later pay for and the address tag on his wrist meant that he was brought back home if he strayed, but he needed to be bathed, dressed, shaved and fed now and he could not be trusted on stairs or near fires or smoking cigarettes unsupervised. Their GP, Dr Northcliffe-Roberts, who played a key role in this phase of their lives, managed to obtain temporary sitters and occasional stays in NHS hospitals to take the pressure off Maeve. Over the next couple of years Mervyn had spells in a nursing home near Brighton, a place run by nuns in Lambeth, Westminster Hospital (where his room-mate was in a coma), Friern Barnet where he was confined in a padded cell, and Northampton Hospital where the mentally ill poet John Clare (one of Peake's favourites) had written his great cry from the heart, expressing what so many mentally sick people must have felt through the ages:

The Rhyme of the Flying Bomb (1962), felt pen, 15.5×10cm

I am: yet what I am none cares or knows,
 My friends forsake me like a memory lost;
I am the self-consumer of my woes,
 They rise and vanish in oblivious host,
Like shades in love and death's oblivion lost;
And yet I am . . .

Peake also stayed in Banstead Psychiatric Hospital, where he was confined with genuinely insane people. Lonnie visited on one occasion and was so upset by the locked doors, the dormitories, the male nurses, the incoherent shouts and Mervyn's dribble-soaked shirt that he had a mild heart attack on the spot. Restless pacing kept Mervyn fit and lean, but disrupted the various hospitals' routines and disturbed other patients so they never kept him for long. Maeve, Goaty, the children and friends were all distressed by their visits to these institutions but Maeve persisted in her twice- or thrice-weekly visits no matter what the distance and cost. During this period she endured a terrible burden with dignity.

Sebastian had now gone off round Europe learning languages and playing his drums with a group, but it was a struggle finding money to support Fabian at Chelsea Art College, as well as Clare who found secretarial school uncongenial and then worked as a waitress but lived at home. Maurice Collis looked through Mervyn's doodled-over manuscripts and about a thousand of Peake's original drawings and suggested that some American collectors might be interested in buying them all. Maeve began negotiations with an American university for these papers, but when they were valued at only £1,555 she felt insulted and withdrew. She also turned down an unexpected invitation from the University of Indiana to become their 'artist in residence' on the grounds that she could neither leave her husband nor take him with her. Collis also glanced at the poetry Mervyn was still struggling to write but he realized it was now mostly fragmentary nonsense. Maeve continued to submit older unpublished poems and drawings to editors but was rebuffed, once by Stephen Spender at *Encounter* who declined to reproduce a portrait of Augustus John on the frivolous grounds that it looked too much like his co-editor and he casually regretted that 'through some unexplained misfortune two excellent drawings that your husband sent us of Dylan Thomas got lost or stolen from this office some years ago'.[4]

Others were more supportive. When Graham Greene was in London he took Maeve out to dinner, put her in touch with his doctor brother in Harley Street and sorted through the manuscripts with her in the hope of finding something to publish. In November 1962 he wrote to

scotch a more ambitious money-raising scheme to sell the film rights of *Titus Groan* – there was no hope, he told Maeve, especially from Carol Reed since the book did not fit with current film fashions. Nor did it fit in with current literary ones, so that in 1961 Kingsley Amis could dismiss Peake as merely 'a bad fantasy writer of maverick status'.[5]

In spite of the general public's indifference there was still a trickle of fan mail coming into Drayton Gardens as new readers discovered Peake's Titus books and other works. Maeve replied to all these and often invited the writers to come round and look at his works and meet Mervyn if he was home. Edwin Mullins, now an art critic, but then a young literary editor of a magazine based in Paris and London called *The Two Cities*, was one. He described his visit:

> Mervyn eventually shuffled into the room, a stooped, lean man with greying hair, looking rather bewildered. He held out a hand, muttering something I could not catch. Maeve led him over to a chair and kept up a conversation. Mervyn contributed nothing for a long time, while we felt increasingly uneasy at being there at all. Then he did say something – I have forgotten precisely what it was – but I remember it was so startlingly funny that we all burst out laughing, whereupon Mervyn relaxed into that marvellous smile of his which, all the time I was to know him, was always liable to break through the fog of his illness and pain at the most unexpected moments.[6]

Maurice Temple-Smith, Mervyn's editor at Eyre and Spottiswoode, and his wife spent a similar evening with the Peakes and found it was not all gloom. Mervyn was unreachable in his private world, 'Yet the strange thing was that it was an extraordinarily gay evening. After dinner we pushed the table back into a corner and danced for hours. If I remember right, even Mervyn was drawn into the dancing as one would draw a child into some activity he isn't yet quite able to manage. I don't think this was the hectic gaiety of people covering up despair. They must often have felt despair but my impression that evening was that in the face of it all they were capable of creating for a few hours an atmosphere of simple, spontaneous fun.'[7]

A 1963 selling exhibition of Peake's work at the Collectors' Gallery reminded people of his graphic skills. The *Arts Review*'s critic enthused but noted: 'These three factors combined: skilled drawing, romance and fantasy, are nicely calculated to discourage the fashion buyers.' He

admired the portraits of celebrities, the fey children, cats, clowns and nudes ('living, vital beings trapped for all time in a few strokes of a brush, pen or pencil').[8] In the same month there was another show at the Portobello Road Gallery at which Maeve turned up early to sweep the place out and Maurice Collis contributed three bottles of whisky to get things moving. Collis wrote in his diary: 'Maeve was in amusing high spirits. Mervyn moved about with the quiet abstracted expression he had, not all there, but able to follow something of what he heard. It was very strange to think of him as the artist who had made the drawings on the walls.'[9]

The following April, Maeve, who had doggedly continued to paint amidst all the disruption at home, showed her own oils and drawings in the Woodstock Gallery off Bond Street. According to Michael Moorcock, another young writer who had made contact with Maeve at this time,

> her work became darker, angrier and more intense. Agonised figures stared helplessly from useless bodies; female forms supported male forms frequently crucified or tortured; terrified lovers embraced. All Maeve's thoughts and feelings emerged in those canvases which were so powerful, so directly a record of the horror of what was happening, that the galleries which had earlier taken an interest in her work now began to recoil, virtually demanding that she return to a more modest or delicate style, something perhaps in tune with their preferred image of her as the wounded hand-maiden to Genius.[10]

The sales from these three exhibitions brought little relief to their financial desperation; and a letter from Eyre and Spottiswoode on 4 December 1964 saying that the rising costs of printing meant that the Titus trilogy could not be reissued and would soon go out of print must have been a body blow. Fortunately, the Royal Literary Fund helped with a grant of £250 and Maeve's sister Ruth contributed £450 towards the continuing hospital fees. John Brophy, their writer friend, set up a collection fund but in the end there were only four contributors and £400 was raised. Proudly Maeve returned it all and there were hurt feelings all round.[11]

Sebastian remembers that his father, when mentally well, had always been stoical about illness and never swore beyond the occasional

'Jehoshaphat!' Now his frustration at being incomprehensible made him lash out verbally and physically. This man, who had always been noted for his old-fashioned courtesy, became unpredictable and would abruptly abandon visitors. 'He would walk all over the house, up and down the stairs, get into bed and out again, get dressed and undressed, want a pencil to draw, paint and then not want to, call my mother the moment she had just put him to bed at 2.30 in the afternoon, asking to be put back in the clothes she had just taken off and so on.' The tensions in the house were awful and the family felt some relief when Mervyn was sent away to one of the various institutions: 'When the arbitrary shouting and loud cries which would echo around the house, and the constant and debilitating demands upon my mother became no longer tenable, it was a strange sort of relief and sadness that came to settle over us all.'[12]

While Mervyn was in one of these places in March 1965 Maeve managed to have a break in the USA, staying part of the time with an old friend Dorothy Webster Gordon who then lectured at Yale University. She must have been taught by Mervyn at some time before

The Rhyme of the Flying Bomb (1962), felt pen, 16×16.5cm

Maeve appeared since she reminisced in a letter about 'Mervyn's obscene
drawings on tablecloths and menus at the Café Royal', and recalled how
'he taught me all I knew about painting – long afternoons at the Tate'.
She too had a husband, Ed, who was hospitalized with psychological
problems (though, unlike Maeve, she did not visit him) and in a later
letter to Maeve wrote: 'if only the physique would disintegrate with the
mind! Poor Mervyn. Poor Ed.' In the same year Maeve took a solo break
in Jamaica at the invitation of a West Indian friend in London.

Mervyn by now was a full-time resident in the Priory, Roehampton,
a building described variously as 'a cut-price Victorian version of
Gormenghast'[13] and 'like something out of a novel by Mrs Radcliffe,
or a pastiche of Strawberry Hill'.[14] Now it is a luxury detox clinic for
pop stars and footballers, but then it charged just under £120 per
month and was clean, comfortable and had beautiful grounds to walk
in. Clare recalled: 'all the time he was ill, my mother would get ready
to visit him as if she was going to see her prince. She would go to see a
man who looked 90, yet her eyes would still light up. It was natural to
me then, but now I realise she was so young.'[15] She took a basket of
sweets, pencils and sketchbooks and on good days he would recognize
her and they might even have a little shuffling dance, but mostly he was
deeply withdrawn. The pathetic little drawings he produced she
brought away and kept – he was still playing with grotesque profiles and
noses, but with no control. She was talking to an empty shell and it
finally destroyed her lifelong faith in a benevolent Saviour: 'I've forgot-
ten about God. Once he was part of our universe, but he has gone, and
the thin line has gone, and there is nothing left but what I know of you.
Dark man . . . funny man . . . gentle man . . . man that made something
new each day. Where are you?'[16] Maurice Collis, who was twenty-two
years older than Mervyn, found him a tired ancient man and when
Goaty Smith visited an attendant assumed Peake was his father. As
Goaty left for the last time Mervyn 'lifted his face to be kissed, like a
good child, a little to our embarrassment. I am not sure he knew quite
who I was, but he knew I was friendly. I never saw him again.'[17]

A new friend of Maeve's helped her with lifts to the Priory most
Saturday mornings, though he tactfully stayed in the car park. This was
John Watney, who had met her in a mutual friend's studio during the
time his marriage was breaking up. He wrote:

> We would drive in silence to the Priory. I was reminded sometimes
> of somebody going on a special treat. She would spend about an
> hour there. Sometimes she looked quite happy when she came out

– they were the good days, but more often she looked upset and distressed. 'He had a terrible mark on his head where he fell down.' 'I wonder whether the nurses look after him properly.' 'The other patients steal his things all the time.' 'It costs so much.' An impossible burden when nothing was selling, no publisher would reprint his books, no London gallery would give either him or her an exhibition. There were kind friends who helped, but you can't and don't want to live on charity for ever.[18]

A short interview with Maeve appeared in the *Evening News* on 11 May 1965 under the heading: A SAD PLEA FROM MAEVE. 'I need part-time work,' says Miss Gilmore. 'With some knowledge of books I would be pleased to work – but only part-time – in a bookshop . . . I would welcome some work involving languages, perhaps helping foreign visitors to London. I speak French and have a knowledge of German and Spanish.' Nothing came of this so in desperation she had to sell yet more of Mervyn's works in another Portobello Road Gallery show in May 1966, and again at the Upper Grosvenor Gallery in July. The latter gallery was run by the Duchess of St Albans and attracted a fashionable crowd – the novelist C. P. Snow came, and Peggy Guggenheim's sister, Hazel McKinlay, who befriended Maeve there, bought some pictures, and became a correspondent when she moved back to New Orleans – though with the years her letters became increasingly incoherent as she slipped into senility and her Peakes were stolen.

There were eight oils and forty books in that show alongside ninety-six drawings – none of them priced at more than 10 guineas. This drastic price-cutting raised £850 towards the Priory fees. The reviewers were kind: 'what comes through is the love, touched with wit, of which Peake's work is full' (*Daily Telegraph*) and the *Arts Review* critic thought them good but unfashionably 'about the vulnerability of children; about the wild nature which broods beneath the fur of the most docile tiger on the hearth; about the beauty of the human being at his or her daily business; about the essential goodness and grace of ordinary folk, despite the victims of Belsen, the torturers and mockers, whom he by no means ignores'.[19] If Maeve found time to read the notices she would have been pleased, but she was busy at that time with the arrangement for Fabian's marriage to Phyllida Barlow, a fellow student at Chelsea College of Art.

If the 1966 exhibitions had served to remind the fickle public of Mervyn's painterly and graphic skills, then the following year brought

his prose and poetry back to their notice. His children's book *Captain Slaughterboard Drops Anchor* was reissued by Macmillan in New York and both Nelson and Academy Editions in England, but in such an insensitively scrambled form and lurid orange-yellow colour scheme that even Mervyn surfaced from his trance and pushed it away in disgust. Nevertheless, Maeve was glad to receive the £167 fee.

Published for the first time in 1967 was a poem originally composed in 1941 when Private Peake was on his theodolite course on Salisbury Plain. This was the title poem in an anthology of his poems called *A Reverie of Bone*, published by Bertram Rota in a limited edition of 300 copies, and now very hard to track down.

The title poem is a long dream vision of a waste land, a desert strewn with bones. It probably owes some of its flavour to Shelley's 'Ozymandias' and one of Peake's favourite books, C. M. Doughty's *Travels in Arabia Deserta* (1888; republished in 1921). It begins and ends with the same stanza:

> I sometimes think about old tombs and weeds
> That interwreathe among the bones of Kings
> With cold and poisonous berry and black flower:
> Or ruminate upon the skulls of steeds,
> Frailer than shells, or on those luminous wings
> The shoulder blades of Princes of fled power,
> Which now the unrecorded sandstorms grind
> Into so wraith-like a translucency
> Of tissue-thin and aqueous-bone.

Who in the Swinging Sixties wanted to read a creepy *ubi sunt* reverie on bones and death? However, one critic in *Contemporary Review* did notice it: 'These twenty-four poems, written between 1940 and 1959, are in the same powerful, slightly melancholic vein as those included in Mr Peake's previous books of verse. It is a haunted poetry written by moonlight in a hermit's grotto – sad, whimsical and compassionate . . . This is the poetry of a man of our time.'[20]

Then came the best news of all: the Titus trilogy was to be reissued, not just by one publisher but by four! In New York Weybright and Talley brought out a hardback version in 1967 followed by Ballantine's paper-back of 1968, and in the UK Eyre and Spottiswoode published the tril-ogy in hardback with an admiring Introduction by Anthony Burgess, while Oliver Caldecott at Penguin issued the paperback. Both used the restored text of *Titus Alone*. Maeve showed the English editions with

Mervyn's drawings to him and 'he recognised them. He knew they were his work. He kept fondling them as if they were precious stones. I think he realises that interest in his work is really being awakened.'[21] The American editions had illustrated covers which would have made Mervyn cringe – Maeve called them Hieronymus Disney and did not show them to him. This was the beginning of the rise in Peake's status as a writer and the books have gone into numerous new editions since. The publishers' advances and subsequent royalties also meant that medical fees could now be comfortably taken care of. In autumn 1968 Maeve and Clare, now nineteen, went to New York to publicize the books. Again Maeve met her friend Dorothy Gordon and stayed with the very rich publishers, the Ballantines, near Woodstock. It became clear that Peake was about to acquire a new following across the Atlantic.

This time the critics were very welcoming. Hilary Spurling in the *Financial Times* compared Peake to Dickens and Kafka, the *Times* man thought it 'a very funny and serious novel' and many agreed with Anthony Burgess in his new Introduction to the trilogy: 'There is really no close relative to it in all our prose literature. It is uniquely brilliant.' According to the *Cork Examiner*: 'Once one enters this massively delineated world, encounters its equally massively delineated characters, a great door of thickness and finality slams shut behind one and there is a compulsion to carry on right to the end of the road, moving through a prose the rhythms and periods of which have the deep-shouldered and manual dexterity of sculptured form.' John Spurling, writing as 'Henry Tube' in the *Spectator* hailed Peake as 'a genius with two nibs', but was frank about his perceived weaknesses: 'characters who command our deepest respect, visually and in action, wither away at the touch of speech, amid uneasy echoes of Lewis Carroll'; he saw Peake as 'unable to throw open his characters mentally and psychologically', and thought he lapsed into sentimentality in the Keda episodes. Only the *Irish Times* critic hated all of it – but then he hated Lear, Carroll, Tolkien and Peacock who, like Peake, 'seem to me to suffer from a broad, ultra-Engish streak of whimsy'. The American reviews were also supportive, perhaps the *Saturday Review* being the most judicious:

What then is this massive novel? Peake's affinities are not Lewis Carroll, E. R. Eddison, or J. R. R. Tolkien, but rather Joyce, William Golding, Max Frisch, and Samuel Beckett. The Gormenghast trilogy is a *nouveau roman* using fantasy as one of its many devices, and an experimental confluence of several novelistic conventions. Some aspects seem unsuccessful, and the

meaning is not always or even finally clear. But the trilogy is worthwhile and rewarding. In spite of its ostensible setting and atmosphere it is part of the mainstream of mid-century fiction, and I recommend it to both scholar and the general reader.[22]

The critical tide had turned.

In January 1968 there was another boost for Maeve's morale when Mervyn's books and illustrations were exhibited in Westminster Public Library on Buckingham Palace Road. Paul Chown, a young librarian there, who had begun to collect Peake illustrations and books, got the Peakes' address from Collis and wrote to Maeve. She replied promptly in her characteristic brown ink ('like dried blood') and invited him round to see some originals. He found her trusting, generous and glamorous. 'I read *The Wit to Woo* in this way and remember being struck by a description in it of a woman who was said to be "upstairs, creating eyebrows." It struck me because Maeve herself had high, arched eyebrows pencilled on and they made her look slightly surprised all the time. Her voice (she spoke well) also sounded rather surprised. It was soft and slightly muffled and had what I can only describe as a surprised intonation.' He noted the white cats, the Chinese stone dragons, the whale bones, the packed bookcase and the numerous pictures. Then came the refreshments: 'It was always gin (which she could never remember or perhaps quite believe that I didn't like) and a lump of cheese cut into little squares. I think I began to assume she lived on gin and cheese. I would have believed anything: it was all magic to me.'[23]

Under her spell he organized everything, including the printing and distribution of posters. Crowds came, Maeve was interviewed by the press and she began to believe that, at last, people were beginning to give Mervyn the attention he deserved. Edwin Mullins did his best to boost the show and the books in the *Sunday Telegraph*, concluding: 'It is the greatest sadness that an incurable illness should have snuffed so rare and strange a talent, in which humour and horror jostle one another, observation of real life suddenly escapes into fantasy, the grotesque into sentimentality, terror into laughter. I am moved, and a little scared.'[24]

For each rise in hope there was a fall. The administrators of the Priory informed Maeve that they would be closing down the wing where Mervyn lived and selling part of the grounds for redevelopment. Would she find somewhere else for him to go, and quickly? She turned

for help in this crisis to her eldest brother, Dr James Gilmore. He was the black sheep of the Gilmore family because he had had an affair with his secretary, Sylvia; subsequently they both divorced their spouses and married outside the Catholic Church. The scandal got into the papers and Dr Gilmore could no longer practise as a GP, so in 1960 the pair of them set up a home for elderly patients who needed full-time nursing at the Close, near Abingdon in Oxfordshire. There was a full and part-time staff of thirty to care for forty-two patients and fees were around £50 per week, though most patients were paid for by social security and nobody was ever turned away. The nursing was sympathetic and the setting idyllic with five acres of ground bordering the Thames, but even though Peake became by far the youngest patient there he no longer took any interest in his surroundings. In spite of being well cared for he soon deteriorated further. He had now been ill for twelve years and confined to hospitals full-time for four. When Henry Worthington visited Mervyn he rallied sufficiently to say clearly, 'Henry I'm a tragedy', before sinking back into his drugged introversion. Even Maeve had now to admit: 'He's given up. He's not fighting any more. I don't think he wants to go on living.'

On 16 November 1968 she was summoned to the Close by her brother to find Mervyn unconscious. She returned to Drayton Gardens and played on Doc's old piano all the tunes Mervyn had enjoyed listening to and after breakfast next morning she heard that he was dead. On his death certificate it states his age as fifty-seven; Dr Gilmore was present at the death, and the official cause was 'encephalitis lethargica'. Maeve and the children took it calmly for, as Watney observed, 'he had, so far as his family and friends were concerned, died years before. Their lives had been reshaped then. His physical death was a confirmation of an earlier spiritual one.'[25]

He was buried at Burpham alongside his parents with a line from his own poem carved on the stone: 'to live at all is miracle enough'. On 6 December a memorial service was held in St James's church, Piccadilly, where Tony Bridge, now Dean of Guildford, addressed a congregation of 400 friends, art school models, actors, publishers, artists, gallery owners, former students, aristocrats, poets, critics and novelists. It was obvious that Mervyn Peake had been a much-loved man.

19 Cult Figure, 1968–1983

In 1966 Fabian Peake married Phyllida Barlow, a fellow student at Chelsea Art College. In 1963 she had gone on to study at the Slade; he went on to the Royal College and both became professional artists and lecturers in art, though neither was the traditional kind of artist that Mervyn and Maeve had been. Phyllida found Maeve a vivacious, romantically minded woman whose chief preoccupation was with getting her husband's work better known: it was her crusade, and family and friends were expected to be wholeheartedly supportive. Phyllida came from an intellectual, free-thinking Cambridge family where she had been taught to question everything, especially religion, art and politics. Religion was the first problem since the Gilmore side of the family refused to attend a non-Catholic wedding. At Chelsea Art College students were encouraged to challenge the previous generation's values and heroes and since Phyllida was already sceptical about representational art and crafts skills there were tensions here too. That subjects should be closed to discussion irritated Maeve's daughter-in-law, who was interested in airing the issues of the day – the Campaign for Nuclear Disarmament, communism, squatters, changing sexual mores, Oxfam – and shocked to find that Maeve had adopted most of the standard positions of the Church and the *Daily Express*.

Sebastian returned from his adventures abroad and in June 1969 married Susan Bardsley-Heywood, another graduate; again their

Church of England wedding was boycotted by the Gilmores, now led by the strict Aunt Ruth. Susan was warned by Sebastian not to raise her current enthusiasms for T. S. Eliot and Tolkien during the Sunday family gatherings at Drayton Gardens. Maeve was plumper now but still took a lot of pride in her appearance and was never seen without smart clothes, immaculate hair and full make-up: her daughters-in-law took a more relaxed attitude. John Watney recorded: 'Maeve is not very much drawn to women's lib ideas. "I love men," she said, "I think they're marvellous",'[1] and indeed she seemed more at ease with attentive intelligent men around her, just as Mervyn had been with women.

Clare was about thirteen when her father became institutionalized and so most of her teens were spent in her mother's company and the two were very close. Clare read avidly but claims to have been hopeless at all academic subjects. However, at twenty-two she was creative enough to write a novel which attracted publishers, but when a jealous friend told her it was rubbish she threw it into a litter bin in the Fulham Road. She worked in various bookshops, including Foyles, without anyone remarking that she had the same surname as one of the authors on display. Then, when working as a waitress, she met and married Charles Penate, a fruit importer, in 1975.

Soon grandchildren appeared, ten in all (an eleventh appeared after Maeve's death) but none of them were raised as Catholics. When they were older she created a playroom for them at Drayton Gardens with murals – in fact she painted whimsical pictures of cats, owls, penguins, boats, children shooting arrows and Sark beach scenes throughout the whole house, even on the boiler. The families gathered for Sunday lunch and when they rang the bell Maeve invented a scary ritual where she put her hands through the letterbox and clasped the children's fingers. The grandchildren remember the strict manners she insisted on at the table and the odours of gin and mothballs. The girls enjoyed exotic shopping trips, when she bought them glamorous dresses. Maeve also knitted them dolls and in 1981 she collaborated on a book, *Captain Eustace and the Magic Room* (Methuen) in which the dolls and murals were photographed by Ken Welfare to enact her story – a much more benign one than Peake would ever have written. She continued to paint her cats, harlequins, animals and grandchildren and occasionally sold a work, but her career had lost impetus during the long years of nursing Mervyn. She also admitted, during a trip with Watney to Norman Adams' studio in Yorkshire, that she was not dedicated enough: 'Perhaps I'm not really single-minded. Not many women are and there is always a need to be a womanly woman – to

enjoy attractive clothes and scent and more worldly things that cannot go with aesthetic purity.'[2]

What she was single-minded about was enhancing Mervyn's posthumous reputation. His republished books seemed now to be attracting younger readers (there was even a pop group called Titus Groan), and they were usually male. Several wrote to her and were invited round to see original drawings and manuscripts. In this way Michael Moorcock the science fiction writer became a friend along with Edwin Mullins the art critic, Brian Sibley at the BBC, Peter Winnington an English lecturer, Paul Chown the librarian, and several more. One was a young Oxford don who invited her to be an overnight guest at University College. She found the dinner conversation arid and many of the dons as woman-shy and unworldly as Bellgrove's staff, which confirmed her prejudices against Oxbridge 'intellectuals'. To her they had always seemed in a different and rather hostile camp from her intuitive and spontaneous Mervyn.

Sebastian and Fabian brought home old schoolfriends or new acquaintances who were attracted by the easy bohemian atmosphere and their vivacious hostess who fed them well and organized great parties. Older friends came too: Esmond Knight the actor, Quentin Crisp, Maurice Collis and his daughter Louise, the writer John Brophy with his novelist daughter Brigid, Maurice Michael the Peakes' literary agent, Hilary and John Spurling, Graham Greene and John Watney, Maeve's constant companion in these later years. On these occasions Maeve was the star, telling ghost stories at Hallowe'en and climbing on the old pine table from Sark to do her Marlene Dietrich impression, singing 'Falling in Love Again' in German and kicking her shapely legs. Otherwise much of her time was spent battling with dealers, publishers and curators on Mervyn's behalf, or writing letters to ex-nannies, old colleagues of her husband and to her American contacts. The replies she kept show she counselled one woman through several emotional crises and subsidized her even though she had little money herself. She also became the confidante of Eric Gill's wayward adopted son, Gordian Gill, whom she would meet in the pub across the road.

Whilst Mervyn was still alive but in the Priory, Maeve had begun an intimate account of her life with him from that first meeting in the Westminster sculpture room in September 1936. It was a book not of scholarship or accurate research but of tender homage to the man she loved. *A World Away* (Gollancz, 1970) depicts Peake as an innocent set

loose in an inimical world of sergeant-majors, dealers and bank managers, but his brother, Lonnie, thought this unworldliness exaggerated. Maeve conveys the sheer fun it was to share his early days when his life was full of pranks, good health, optimism and non-stop creativity. Anthony Burgess reviewed Maeve's book in the *Spectator* and found it moving and, unlike Dylan Thomas' widow, Caitlin's, similar book, *Left Over Life to Kill*, he thought it 'highly articulate but it does not essay artifice'. He rightly observed: 'the Peakes, like the Thomases were not skilled in the sordid craft of living in a society full of bureaucrats and paperwork and no major rewards came their way'. He concludes: 'the moral of Maeve Gilmore's exquisite and poignant book is what we already know – that life is hell, but we had better be grateful for the consolations of love and art, human creations that owe nothing either to the State or the Destroyer. There is probably nothing else in the world worth bothering about.'[3] *A World Away* was widely reviewed, but since there were no sordid revelations of wife-beating, alcoholism, drugs or sexual scandals to hang the headlines on, reviewers tended to play up Mervyn's tragic last few years rather than celebrate his lifetime's achievements as Maeve had tried to do.

Maeve's next venture, in 1974, was *The Drawings of Mervyn Peake*, a collection of 110 black and white illustrations. The book was well produced and had a perceptive introduction by Hilary Spurling who had been a fan since her student days. She thought 'drawing for Peake was an essential discipline, a daily effort to subdue the workings of a disorderly and prodigal imagination' and a search for accuracy – which did not mean, of course, dead documentary description. Citing examples, she relates his written descriptions to the chiaroscuro and shifting perspectives of the drawings and claims: 'One may say roughly that the drawings, being less dramatic, less concerned to explore the furthest limits of action or emotion, provided often the hard factual foundation for extravagant development in the novels.'[4] In short, they took the place of more conventional research in books.

In the same year Maeve collaborated with Shelagh Johnson on *Mervyn Peake: Writings and Drawings* (Academy Editions) which was carelessly produced but contained brief biographical notes and a wealth of family photographs as well as new drawings and generous extracts from most of Peake's works, many previously unpublished. She also wrote the introduction to a reissue of the *Shapes and Sounds* poems. Sebastian recalls that in an effort to gain prestige and some money Maeve offered to sell Mervyn's entire graphic *oeuvre* to the Tate Gallery, but when they offered only £1,500 for the lot she closed the

portfolio and walked home in tears, 'vowing never again to compromise his dignity'. Another venture was her attempt to continue the Titus books, starting from Mervyn's notes and taking the hero into new experiences in a story she planned to call 'Search without End'. She wrote a substantial part of this but it remained unfinished at her death.

In all her proselytizing activities Maeve was stoutly supported by John Watney (1915–95). He was an interesting companion: after the early death of his father and Danish mother he was brought up in Normandy, appointed Churchill's bodyguard in the war, wounded and deafened by a bomb during the Normandy landings, and worked variously as beachcomber, Oxford University editor of *Isis*, postman, bookkeeper, amateur painter, teacher and bursar at the London City and Guilds Art School and secretary to the British Ski Foundation. He was also a successful autobiographer, novelist, thriller writer, biographer and published expert on beer and gin. Watney was handsome, humorous, a good dancer and extremely attentive to Maeve's wishes. His first sight of her had been on the opening night of *The Wit to Woo*, when he was accompanied by his wife and did not speak to Maeve. The next day he was also at the strained gathering in a Chelsea pub where Maeve was bravely pretending all was well, and Mervyn was shell-shocked by the reviews. After Mervyn had gone to the Priory and Watney's marriage had failed he drove Maeve out there most Saturdays, as already mentioned.

After Peake's death and Watney's divorce in 1970 their friendship grew and by 1974 Maeve was accompanying him on his research trips (he was then writing a biography of Lady Hester Stanhope). When Mervyn was first married he began a 'Book of Maeve' which was to contain all the poems, letters, drawings and paintings she had inspired, but this was later lost or stolen. Watney and Maeve now began a new one and put in it her account of her schooling, her short stories, the description of Clare's birth and extracts from both their diaries. From this source we know they went together to France, Norfolk, Scotland, Wales, the Isle of Wight, Yorkshire, the Lakes, several times to Selsey and explored most of the southern counties of England. They visited the Peake family graves in the graveyard in Burpham, where Lonnie and his wife Ruth were now buried alongside Mervyn and his parents. They meandered their way to comfy hotels, or hired cottages where the journeys ended with several 'nigs' or 'gin sandwiches', a good meal, 'and so to bed'. Both had found comfortable companionship and it

seemed only natural that Watney should write the first biography of Mervyn Peake since Maeve had all the documents and could prompt him and control the picture of Mervyn which would emerge. His *Mervyn Peake* was published by Michael Joseph in 1976 and served to bring Peake's name before the public once more. The *Times Literary Supplement*'s comment that it was 'thorough, sympathetic and straight-forward . . . the book is well researched, well illustrated and free from speculative nonsense' gives something of its flavour.

Watney also provided a long biographical introduction (in which he called Peake 'Blake with a sense of humour') for Maeve's next venture, which was to collect previously unpublished writings and drawings in *Peake's Progress* (Allen Lane, 1978). This 576-page anthology is a mar-vellous mix of juvenilia such as a 1921 drawing of a mandarin and 'The White Chief of the Umzimbooboo Kaffirs' of 1923 with later short stories, nonsense poems, war poems, the texts of the radio play *Mr Pye*, *Boy in Darkness* and *The Wit to Woo*, Sita illustrations, the Moccus poems and notes for a projected autobiography. It is a crucial source for any Peake enthusiast who wants more than just the Titus books. But, as one reviewer put it: 'There are two kinds of people: those who wallow in the murky shadows of Gormenghast like hippos in the mud, and those who listlessly let *Titus Groan* fall from their fingers in the middle of the first sentence.'[5] The English and American press review-ers seemed to come equally from both camps. Several expressed admi-ration and surprise at how varied Peake's talents were, but few were impressed by *The Wit to Woo* now they could read the text. Michael Moorcock was a loyal exception ('splendidly performable . . . an actor's delight'); 'for me,' he wrote, 'this book is the best possible representa-tion of the "whole" Peake. He was my friend, inspiration, model: a man of amiable generosity who died too soon – before his talent had reached its full flowering, perhaps; certainly before his potentially large audience had discovered him.'[6]

Other reviewers were distinctly rude about the verse: 'for the most part the verse is too amorphous, hectic, flaccid',[7] and Jonathan Keates found the longer poems 'like practically everything else Peake ever wrote – portentous, hyper-literary, magniloquent and ultimately empty of life', whilst in his prose 'language won't do what he wants' but 'as an artist with brush and pencil nothing comes between him and his subject: the medium is triumphantly established as his own'.[8] Even Maeve's friend Hilary Spurling noted his limitations: 'a tendency to mawkishness and whimsy, accompanied by a certain self-indulgent prolixity or linear slackness'. Cruelly she summed up this collection of

left-over fragments in Percy Trellis' words from *The Wit to Woo*: 'I am the dottle in that one-time pipe-full: I am the acrid ullage in the keg.'[9] Maeve was deeply hurt.

The Peake estate was under Maeve's control and anyone wishing to use the material had to come to her for permission. She found that many of them wished to translate Mervyn's creations into other media – as he himself had tried to do in his radio and television work. In a 1947 letter to Peter Collis Peake wrote:

> I'm beginning to think that it's quite hopeless, and even silly to look for a similarity between a book and whatever new medium it is transported into. The thing is, a book can influence the mind of a dramatist, actor, film director or choreographer but once he gets to work, goodbye to the original – because in creating a new work of art he dare not glance back at the original for fear of compromise and the jeopardising of his own creative itch. How does one jeopardise an itch?[10]

Since his death the itch has been widespread.

An interesting attempt to turn *Mr Pye* into a musical was made in the 1970s by Michael Hazlewood, an Englishman then working in Hollywood where he first read the book and fell under its spell. He toiled away until he was ready to present the songs to Maeve, an ordeal he was nervous about, but: 'I was astonished by her; I expected to meet someone on the conservative side but Maeve was hot, blonde, wore knee-length high boots and draped back over the chair was a leopard coat. She had a careless air about her and was used to lots of attention but she made me feel at ease at once.' She gave him contacts to follow up in Sark and approved the final lyrics. There were delays in developing the full libretto and, because other companies were pressing Peake's agent, Hazlewood had to surrender the film and TV rights. 'It made my *My Pye* a lame duck: who would invest hundreds of thousands of dollars in a musical without the film rights? I stumbled on and returned to America crestfallen.'[11] Having heard the witty songs he wrote, I can only conclude this was a great opportunity missed.

A more successful treatment of *Mr Pye* was the 1986 television dramatization with Derek Jacobi playing the lead. This was filmed on Sark and the show provoked an enthusiastic response. Other ambitious plans in other media were afoot, though the rumoured 1978 film of

Titus Groan with John Hurt as Steerpike and Peter Sellers as Prunesquallor never did materialize.[12] There were several short-run dramatizations in the UK and in America based on *Titus Groan*, *Titus Alone* and *Boy in Darkness*, while Peake's *Rhymes without Reason* were set to music and sung, and *Captain Slaughterboard* was taken back to China as a puppet play.

The various adaptations both fed and fed off the growing audience for Peake's works, especially the trilogy. It is usually the Titus books that attract new readers and they have gone into a bewildering series of editions, reprints, hardbacks, paperbacks, braille, audio and omnibus editions on both sides of the Atlantic. There have been more than twenty publications of each of the books in the trilogy and half a dozen publications of them bound together, with more planned. Such reprintings show just how Peake's readership has burgeoned since his death. His earlier publishers have been merged and re-merged several times and accurate sales records are impossible to find, but in 1998–99 the Random House/Vintage edition alone sold 19,000. This upsurge in readership has occurred not just amongst Anglophones: there have been translations into Swedish, Catalan, Spanish, French, German, Polish, Dutch, Italian and Turkish, with Portuguese soon to follow.

In response to this new readership's curiosity several of the other books were reissued. There have been posthumous editions of *Shapes and Sounds* (1978), *Rhymes without Reason* (1974, 1978), *Letters from a Lost Uncle* (1976), *The Rhyme of the Flying Bomb* (1973), *A Reverie of Bone* (1979) and *Boy in Darkness* (1976, 1996). A hardback *Selected Poems* appeared in 1972 with a paperback reprint in 1976 and *A Book of Nonsense* (1972) was popular enough to be reissued in 1974, 1983 and 1998. Peake's illustrated *Ancient Mariner* came out again in 1978. Not only the books that were published in Peake's lifetime reappeared: his previously unseen illustrations for the early poems of Oscar Wilde appeared in 1980 and the wonderful sketches for *Bleak House* were collected and published in 1983.[13] Book exhibitions were held at Eltham College, the National Book League, the Bodleian Library and a national touring exhibition set off in 1979.

In December 1974 one of the many enthusiastic young readers placed an advertisement in the *Times Literary Supplement* inviting other fans to form a Mervyn Peake Society, on the lines of the Tolkien Society founded in 1969. A small group met, appointed Maeve as Honorary President, John Watney as chairman and Peter Winnington, an English lecturer at the University of Lausanne, as editor of the newsletter. The first newsletter appeared in autumn 1975 but within a

Sketches from Bleak House (1983). Mr Chadband, chalk and wash,
22.5×15cm, *c.*1945

year it had expanded to become the *Mervyn Peake Review*, with the avowed intention to 'promote the understanding of Peake's achievement; encourage publication of his works; and gather a responsible corpus of criticism'. The Society published a mixture of reviews, notices of new books and events, drawings, reminiscences and serious essays. All went well until in 1981 Peter Winnington was asked to edit out all the misprints and inconsistencies in previous texts for the new King Penguin English paperback edition of the Titus trilogy. In the publicity for these it said he had 'corrected' the texts and Maeve was offended by any suggestion that Mervyn's originals could be 'put right'. She withdrew from the Society, though by then she was also very ill. On her death in August 1983 Watney brought in Sebastian Peake as Honorary President, a role he has enjoyed ever since.

In November 1983 Winnington resigned as editor and after two more editions the *MPR* ceased with Number 20 in 1986. Like Maeve, the Society itself had never been particularly keen on 'academic' contributions and consequently it decided to issue only newsletters, occasional 'Peake Papers' and to print or reprint shorter works by Peake. Winnington felt there should still be an outlet for all the scholarly work now being carried out around the world on Peake's prose, poetry, drama and illustrations and so he set up *Peake Studies*, a biannual publication based in Switzerland. The first appeared in November 1988 on the twentieth anniversary of Peake's death and the journal has continued to attract contributions from researchers of all kinds.

It seems ironic that the unscholarly Peake should become a favourite of the academic community. Over the last twenty-five years the Titus books have grown into a kind of academic flea-market with MA and Ph.D. students turning them over for bargains. In the UK, the United States, Canada, France, Italy, Switzerland, Australia, Belgium, Spain, Poland and South Africa researchers have struggled to define the books' genre, plumb their archetypes, tease out the author's moral vision, and to elucidate his depiction of nature, space, eccentricity, loneliness, isolation, evil, alienation, ritual, females and sex. Semiologists and structuralists have decoded and deconstructed meanings implicit in the texts which would have startled the author himself and outraged Maeve. His style has been anatomized, and comparisons made with other authors; his opus related to both Modernism and Postmodernism; and heavyweight authorities such as Freud, Jung, Lévi-Strauss, Barthes, Jakobson, Todorov, Lacan,

Sketches from Bleak House (1983). Lady Dedlock, chalk, 19×12cm, *c*.1945

Derrida, Kristeva, Hutcheon, McHale, Lodge, Kugler and Calvino have all been evoked in ponderous articles and hefty footnotes. The poetry and illustrations have received less attention, and the paintings none at all.

Peake is mentioned in dozens of surveys of modern literature, science fiction, fantasy, dictionaries of literary biography, children's books, illustrators, war poets and in assorted biographies and auto-biographies. There have also been full-length books on the man and his work by, for example, John Batchelor (1974), Tanya Gardiner-Scott (1989) and Peter Winnington (2000) while C. N. Manlove in *Modern Fantasy: Five Studies* (1975) compares Peake to Kingsley, George MacDonald, C. S. Lewis, and Tolkien. It is a tribute to Peake's *oeuvre* that it continues to yield up riches the deeper it is mined.

As well as being Maeve's right-hand man in the campaign to get Peake recognized by public and scholars alike, John Watney also became an accepted part of the family as godfather to Clare's daughter, organizer of the grandchildren's parties, and joint host at the Drayton Garden soirées. He retained his separate flat in Chelsea where he lived with his son Marcus and there seems to have been no serious talk of marriage, but he was close enough to Maeve to insist he accompany her to the doctor's in June 1979. They were told she had breast cancer, and then went off to solemnly drink a bottle of champagne together. The family were supportive but from now on Watney behaved like a devoted spouse as the disease alternately intensified and went into remission over the next three years. His diary records the harrowing details of Maeve's treatments, but also her courage and unflagging humour. She spent Christmas 1981 in hospital having an appendectomy, and again over Christmas 1982 when she needed an operation on her cancer-eroded femur. Whilst in hospital she began the account of Clare's birth on Sark and finished it during her five months' convalescence in Watney's flat. To her frustration a second leg operation was necessary that summer – 'There's still so much to do for Mervyn,' she complained. On 28 July 1983 the doctors told Watney there was nothing more they could do:

I took her hand. It was very white and cold. I could feel tears in my eyes. 'I love you,' I said. 'We've had a jokey relationship, never going down to fundamentals, but I've always loved you.' 'Thank you darling Johnny, I love you too, in a different way.' 'You love Mervyn,' I said, 'I've never wished to intrude there.' 'Give me a kiss,' she said.[14]

Mrs Pardiggle from *Bleak House* (1983), chalk and wash, 18 × 11.5cm, *c.*1945

Maeve's religion had lapsed during the period of Mervyn's suffering, but now Watney records that on 2 August 'a nun came in, and stayed alone with Maeve. She came out and said, "She wants a priest." A priest came and stayed alone with Maeve. I don't know what happened. We thanked the priest when he left.'[15]

She died next day, aged sixty-five. There was a service at Burpham and she was buried beside Mervyn and later, on 1 November, came a memorial service at St James, Piccadilly, where Tony Bridge gave the address, as he had done for Mervyn in 1968.

20 Revival, 1983–2000

After his mother's death Sebastian Peake felt that it was his duty to carry on the campaign to perpetuate his father's name. He wrote a book about his early life, *A Child of Bliss* (Lennard, 1989), which is frank about both the joys and burdens of being the eldest child of a genius and an emotionally dominant mother. It begins:

> The intense love that I have for my parents, with its resultant anguish and emotional ramifications, lives on for me. Although my father died in 1968 and my mother in 1983, the all-pervading atmosphere of their influence still envelops me, like a wonderful but harmless leprosy. I wish they would go away sometimes and leave me alone. Their own glamorous early life together, like a dream idyll, was something from which I felt totally excluded, and the frequent violent attacks I made on my father as a child and as a youth, swinging my fists and grappling him to the floor, were just the physical manifestations of my profound jealousy.[1]

Overall, the book tells us more about Sebastian than it does about his father.

A richly illustrated and vigorously written book which appeared in 1984 was Gordon Smith's *Mervyn Peake: A Personal Memoir* (Gollancz), which shows us the eternal schoolboy side of Peake's char-

acter, irreverent, scatological and clowning. Goaty also pays generous tribute to Maeve's influence on Mervyn and on his posthumous reputation. Then things seemed to go quiet for a long period, with the Titus trilogy maintaining a steady cult following, but most of the other books out of print. Things began to improve in the mid-1990s: by 1995 sales of the Titus trilogy had crept up to 90,000 a year, in 1996 a blue plaque was placed on the wall of 1 Drayton Gardens proclaiming that Peake had lived there, and then on 25 July 1998 BBC2's *Bookmark* programme was devoted to Peake's life story. Old friends such as Tony Bridge, Morris Kestelman, and assorted Sarkese contributed their distant memories and the three offspring added theirs. Vanessa Engle, the producer, found some evocative Chinese film material from the early years of the century to show viewers the exotic but disease-ridden and ritual-bound society Peake remembered all his life. Around the same time a six-and-a-half-hour reading of *Titus Groan* by Michael Williams was issued on audiotape and no doubt there will be more tapes to come which will bring Peake's works to the attention of the blind, commuters, long-distance drivers and those daunted by a 1,000-page trilogy.

The itch to translate Peake's works into other media continued and on 14 November 1998 the three-act avant-garde opera *Gormenghast* had its première in Wuppertal, Germany. The 'gloriously, unashamedly lush score', as the *Times'* admiring reviewer called it, was by Irmin Schmidt and it was sung, in English, by a mixture of rock and opera stars.[2] Swelter's abuse was seen as the primary motivation for Steerpike's plotting and the library fire was the pivotal event of the evening. In a witty piece of staging the twins occupied one dress and Swelter was given an aria 'Be a Happy Carnivore' which contained the memorable lines:

> I swoon at the thought
> Of thighs simmered in port
> Or a quivering portion
> Of pallid abortion
> (Because veal to be right
> Must be unborn and white)
> With veg round the edge
> To assist the excreta
> Of this humble meat-eater

The librettist, Duncan Fallowell, wrote in *Opera* magazine in November 1998: 'this libretto is not an adaptation of *Gormenghast*

but a reinvention of it' – indeed Fallowell was working from memories of his last reading of the trilogy in the early 1970s and only one original Peake phrase is uttered by the performers. The orchestral score was taped and projected electronically but a live string quartet played in the pit. English audiences await its transfer with some curiosity.

Other Peake fans preferred to stay with the printed texts, but if they wanted to buy original editions it could be expensive. Peake himself probably never earned more than £1,000 in any one year from his writing and would have been astonished to know that a first edition copy of his first book, *Captain Slaughterboard Drops Anchor* sold in December 1998 for £3,025. Even *Letters from a Lost Uncle*, which he thought so badly produced, may now cost £100 if it is in good condition. The books Peake illustrated, often for very poor rewards, have similarly enjoyed a boom on the specialist book market – so *Quest for Sita*, published at 4 guineas in 1946, is now worth around £300.[3]

It seems inevitable that prices will rise yet higher now that a BBC Television serialization of *Gormenghast* has brought Peake to a worldwide audience. The year 2000 has been something of an *annus*

Oscar Wilde (1980). 'Pan', ink and Chinese brush, 21 × 29cm

mirabilis for Peake's reputation and it has very largely been due to this production.

The idea of filming the first two books in Peake's trilogy was not new. Orson Welles glanced at it, Terry Gilliam toyed with it and the millionaire pop singer Sting held the rights for a time – he was so Peake-besotted he called his daughter Fuchsia and both his horse and his company Steerpike. He played the villain in the 1985 Radio Four version by Brian Sibley, but his film plan came to nothing. The television producer Estelle Daniel realized that in a two-hour feature film you would inevitably be left 'with a ridiculous story about an ambitious young man who murders a few old lunatics'. Besides, the fickle but financially vital American cinema audience would be baffled by a film which had no hero, no romance and an ambiguous ending. What was needed was a four-hour-long, four-part television series and Ms Daniel single-mindedly set about bringing this into being.

The BBC acquired the film rights to the trilogy in 1994 and decided to make it their prestige millennium production. This meant an unusually long period was available to develop a script, though it was not until 17 November 1998 that permission to begin filming was given – fortuitously on the thirtieth anniversary of Peake's death. From the start those involved – producer Estelle Daniel, director Andy Wilson, scriptwriter Malcolm McKay and executive producer Michael Wearing – were determined to show that the plot had a contemporary relevance. Wearing wrote:

> The time is right: it's a story about aging institutions, how they should move on and keep abreast of change, about how our rulers aren't always in touch with the world. It's about a reluctant prince who doesn't believe in the institution he's born to rule. It's about fascism, and how easy it is for a nation to allow itself to be dictated to. There are any number of resonances in the story that chimed in with our concerns at the start of our century.[4]

Peake may have had other concerns fifty years ago when he wrote the books, but each successive generation will read them with its own preoccupations in mind.

The crucial American TV links were made and sales achieved in half a dozen other countries to raise the production costs, variously reported as between £6 and £10 million. Four hangars at Shepperton

Studios were booked for eight weeks and a staff of around 300 recruited – enough for a feature film on Hollywood lines. Most of the actors had asked to be included because they had been Peake fans since youth and one, Christopher Lee, even knew Peake socially in the 1940s. In order to attract a broad audience the cast was a mixture of classic stage actors, soap opera stalwarts, old and new popular comedians and less famous but rapidly rising young stars. The main roles were taken by Celia Imrie (Gertrude), John Sessions (Prunesquallor), Warren Mitchell (Barquentine), Ian Richardson (Sepulchrave), Neve McIntosh (Fuchsia), June Brown (Nannie Slagg) Christopher Lee (Flay), Richard Griffiths (Swelter), Zoë Wanamaker (Clarice), Lynsey Baxter (Cora), Fiona Shaw (Irma), Stephen Fry (Bellgrove), Spike Milligan (De'ath). The young Irishman, Jonathan Rhys Meyers, played Steerpike, and six babies, a boy and Andrew Robertson were needed to embody the growing Titus over four episodes. People who had never heard of Peake would watch the production just to see such an astonishing cast at work.

Malcolm McKay's script was crucial to the success of the project. He told me that his first idea was to frame the narrative events of the two Gormenghast books with material from *Titus Alone*, so they would be seen in flashback from a future place called Europa. Wisely, this was abandoned. After boning out the plot and dialogue from the novels he had to sort out Peake's inconsistencies of time, for example why doesn't the Fuchsia–Steerpike relationship advance for seventeen years, and just how long are the twins incarcerated? The dialogue written to be read on the page needed adaptation to the demands of the pacier, more realistic medium of television. McKay fused certain characters (Sourdust and Barquentine), dropped others (Rottcodd) and simplified the Keda sub-plot without doing noticeable damage. He saw the whole book as the equivalent of a Brueghel painting in its richness of incident and colouring.

Central to McKay's reading of the book was his idea of Steerpike as a meritocrat. The kitchen boy felt he had as much right to power as Titus or Fuchsia because he had superior talents, courage and cunning, even though he lacked their breeding. The books were written at a time when the monarchy was so entrenched nobody questioned it, but when Prince Charles has no clear role and the old hierarchies are crumbling Steerpike's rebellion looks prescient. Peake's genius is to place these liberal, egalitarian, sentiments in the mouth of a murderer and so leave the reader with no clear message. McKay has Fuchsia commit suicide (her end is more ambiguous in the book) because she cannot resolve

Oscar Wilde (1980). 'Requiescat', ink and Chinese brush, 15 × 11 cm

her dilemma in loving the man who is intent on destroying her family and all its values. Gertrude as a kind of Mother of the Nation embodies those values to the monomaniacal extreme: Gormenghast shall remain as it always has been, headed by an Earl of Groan. Titus therefore has to leave if he is to develop into anything other than a figurehead like his father and he cannot return if he is to grow into full adulthood: in this light his 'Good-bye Mother' at the end becomes an emphatic declaration of independence. McKay was careful to keep these ideas implicit in the script rather than preaching and believed that, like *Hamlet*, Peake's creation would bear all manner of valid interpretations without being diminished.

Gormenghast now needed to be brought off the page and made tangible. Where was it? The director thought it would look like Max Ernst's painting *The Petrified City* and the producer, who had just visited a monastery in Ladakh, thought it would resemble a Himalayan kingdom. Gormenghast was not a place of squalor and gloom for her but of 'exquisite beauty', which is why Titus would always feel drawn back to it. Christopher Hobbs, the designer, picked up on Peake's Chinese childhood and added touches from India, Africa, Mount Athos, Persia, Spain, Tibet and Italy to make a place 'which is everywhere and nowhere, otherworldly but accessible'. Deliberately he ensured there were no pointed Gothic arches anywhere in sight. He had worked with Derek Jarman, Dennis Potter and Ken Russell and so had several tricks up his sleeve to help make 120 exotic sets as cheaply as possible. 'It's a designer's dream,' Hobbs wrote. 'I can't think of a more visual book in the English language.' The costumes would be similarly eclectic, gathered from all times and places. Clarice and Cora, who moved like Siamese twins, were hobbled like geishas, the poet wore an Elizabethan doublet and hose, the boys and teachers dressed as for Eltham College in the 1920s and when Steerpike was in the ascendant he wore jackboots and Nazi black as he strutted amongst his filing cabinets. All this was true to the spirit both of Peake's drawings and of his descriptive prose.

The BBC publicity machine was cranked up, the actors did interviews – 'It's Dickens on crack,' declared John Sessions; Steerpike 'is about wanting to be cuddled more than anything else,' thought Rhys Meyers – the Peake siblings reminisced about their father on all media; the *Radio Times* produced a glossy brochure; web sites were opened; Gormenghast jewellery was available in Harrods and in Dickins and Jones and the producer wrote a lavishly illustrated book on all aspects of the series' creation.[5] Even the albino crow who played Gertrude's Mr

Chalk merited an article in the *Times*. Perhaps all this pitched expectations too high – one critic thought 'it would be a kind of Jane Austen with wizards in it'.

An audience of 4.2 million people tuned in to the first episode (though this tailed off by the second) and virtually every newspaper in the country published a review and readers' letters about it. No printed book ever receives this kind of attention! Although viewers were reacting to Peake's work filtered through other minds and another medium, it provided some measure of how Titus' story had stood the test of time. As one might have predicted, critical reaction was polarized. The *Evening Standard* thought it 'a really stonking stinker', the *Daily Telegraph* ran the headline 'Blimey What Was All That About?' while the *Sunday Telegraph* reviewer wrote that 'the characterisation is pretty skimpy and no one, including the central character, Steerpike, is sufficiently motivated. Nothing seems to happen for a reason – it just happens. This can get wearying, especially as there's no variation in tone, just a constant note of frantic whimsy' – though it's not clear whether this charge is aimed at the production, the book or at both. A few who knew the book protested that Steerpike, though brilliantly acted and menacing enough, had been prettified, so that instead of a malformed body, cropped hair and a face 'pale like clay and, save for his eyes, masklike. Those eyes were set very close together, and were small, dark red, and of startling concentration', we see a long-haired, blue-eyed charmer. In his poems, such as 'His head and hands were built for sin / As though predestined from the womb / They had no choice' Peake seemed to believe that a man's physiognomy was his destiny, so this change seems to be against the grain of his ideas.

The *New Statesman* critic admitted: 'we are so used to the kind of classics television favours for adaptation that when one comes along that is not built on thwarted young love, period detail and drawing-room conversation, we are likely to feel a little lost. With "Gormenghast" you have to wait until episode three before you see a man on a horse.' Others missed the strong female lead they had become accustomed to in recent Austen, Gaskell, Dickens, Defoe and Thackeray adaptations, as well as the lack of any clear genre pigeon-hole into which it could conveniently be dropped. The director had a circus background and encouraged a vigorous, physical style of acting, so much so that some viewers complained of the violence – even though it lacked the guns, rape, drugs, car crashes, emergency wards,

prison cells, bad language, sex or nudity which are the staples of most realistic television drama.

Viewers, vehemently pro or con, took issue with the critics in correspondence columns and web sites. Few had quibbles about the 'groaning buffet of eye-candy' on offer in the settings and costumes, and the recorded music by Richard Rodney Bennett and John Tavener became a bestseller alongside the video of the series. The *Times* declared it 'landmark television with knobs on', though described it as 'a story which engages your mind and eyes, rather more than it does your heart'. Hilary Spurling went back to the books and claimed 'the closer you look at Peake's fictional castle, the more clearly you see that, far from being surrealist or supernatural, this is the real world viewed at an odd angle from a sharply tilted perspective with unnerving, even hallucinogenic intensity'. She feared the TV version had missed the 'underlying currents of wholly adult lust and depravity. For the Gormenghast novels, written in the 1940s have their roots in a Europe that saw the rise of another mesmeric loner who came from nowhere like Steerpike, and who also started by burning books, went on to impose his will unilaterally through multiple murder, and ended up by destroying a whole world and its way of life.'[6] One wonders if the contemporary parallels were as clear in Peake's mind, or whether we benefit from hindsight in this interpretation. Other critics indulged private vendettas by pretending to see the 'vast and labyrinthine citadel' of Gormenghast as a metaphor for the hierarchical BBC itself, an idea which could never have entered Peake's head.

Mervyn Peake's reputation will not live or die on the success or otherwise of a television series, though it will undoubtedly bring him thousands more readers, especially in America where the critics were very welcoming. The trilogy was reprinted twice in 1999 and other works and illustrated books such as *Captain Slaughterboard Drops Anchor*, *The Hunting of the Snark*, *Peake's Progress*, *Alice Through the Looking-Glass* and *Letters from a Lost Uncle* appeared in the bookshops within months of the television showing.

At last, forty years after he stopped writing, it seems that Peake is about to reach the wider audience he craved, and undoubtedly deserves. Maeve always knew it would happen some day.

Notes

Abbreviations

In the references I have abbreviated the most frequently quoted documents. For primary sources these are:

'Maeve's Book' An unpublished, undated, unbound, 333-page collection of letters, diary entries and writings by Maeve Gilmore and John Watney. It is now in the collection of Watney's son.

PP *Peake's Progress*, edited by Maeve Gilmore, Allen Lane 1978.

Secondary sources:

Batchelor *Mervyn Peake: a Biographical and Critical Exploration* by John Batchelor, Duckworth, 1974.

Gilmore *A World Away: a Memoir of Mervyn Peake*, by Maeve Gilmore, originally published by Victor Gollancz, 1970; page references are to the Mandarin Paperback edition of 1992.

MPR *Mervyn Peake Review*, journal of the Mervyn Peake Society published under various editors between 1975 and 1986.

PS *Peake Studies*, biannual journal edited by G. Peter Winnington from autumn 1988 onwards.

Smith *Mervyn Peake: A Personal Memoir*, by Gordon Smith, Victor Gollancz, 1984.

Watney *Mervyn Peake* by John Watney, original published by Michael Joseph 1976; page references are to the Abacus paperback of 1977.

1: Boy, 1911–1923

1. There are different methods of representing Chinese syllables in the Roman alphabet. When the Peakes were in China the system used was called the Wade–Giles and in this their town was 'Tientsin' and Peake's birthplace 'Kuling'. Now in Pinyin these are written Tianjin and Guling. I have retained the earlier forms that the Peake family used in their own writing.

2. These handwritten notes are in a red-covered exercise book now owned by Sebastian Peake. The 'key' words and other notes on his schooling are on nine typewritten sheets together with five sheets of explanations by his brother Leslie. They were printed in *Peake's Progress*, pp. 471–487.

3. The *Observer* magazine, 2 December 1979.
4. E. C. Peake, 'Memoirs of a Doctor in China', unpublished typescript, undated but probably late 1940s, p. 160. In the possession of Sebastian Peake.
5. I have drawn much of the Tientsin information from Frances Woods' *No Dogs and Not Many Chinese. Treaty Port Life in China 1843–1943* (John Murray, 1998).
6. E. C. Peake, 'Memoirs', p. 142.
7. Smith, p. 23.
8. 'A Letter from China' discovered by G. P. Winnington, *MPR*, No. 11, Autumn 1980, p. 4.
9. G. P. Winnington, 'News Roundup', *PS*, Vol. 4, No. 1, Winter 1994, p. 55.
10. E. L. Peake, 'Young Mervyn', *MPR*, No. 20, Summer 1986, p. 6.
11. E. L. Peake, 'My Brother Mervyn', *MPR*, No. 7, Autumn 1978, p. 6.

2: *Youth, 1923–1929*

1. Smith, p. 33.
2. C. Frame, in the *London Evening News*, 20 November 1968.
3. Batchelor, p. 13.
4. D. Jones, Archivist at Eltham College, Letter to author 26 January 1999.
5. M. Peake, 'Book Illustration'. BBC Radio talk recorded 20 May 1947, *MPR*, No. 9, Autumn 1979, p. 15. The author of *Under the Serpent's Fang* was J. Claverdon Wood, who also wrote for the *Boy's Own Paper*. Cf. the notes on Peake's schoolboy reading by G. P. Winnington in *MPR*, No. 9, Autumn 1979, pp. 17–23.
6. Watney, p. 37.
7. Smith, p. 29.
8. Watney, p. 26.
9. E. Drake, 'A Wonderful Friendship', *MPR*, No. 18, Spring 1984, p. 33.
10. W. J. Thorne, 'The Visitors' Book', *MPR*, No. 14, Spring 1982, p. 11.
11. It is now in the Bodleian Library, Oxford, but the text is reprinted in *PP*, pp. 35–39.
12. G. P. Winnington managed to track down the literary source of this story to *The White Chief of the Umzimvubu Caffres* by Major-General A. W. Dyson, which appeared in twelve instalments in *Everybody's Annual* for 1885 and as a book in 1887. Peake's story has many similarities as well as sharing the title. See 'Tracking Down the Umzimbuvu Kaffirs,' *MPR*, No. 8, Spring 1979, pp. 25–26.
13. Smith, p. 29.
14. L. Peake, 'My Brother Mervyn', *MPR*, No. 7, Autumn 1978, p. 8.
15. Smith, p. 32.
16. Ibid., 30.

3: *Student, 1929–1933*

1. Watney, p. 31.
2. Prospectus of the Croydon School of Art, 1928–29.
3. Smith, p. 40.
4. Ibid., p. 44.
5. Ibid.
6. *PP*, pp. 18, 27.
7. Watney, p. 33.

8. Smith, p. 34.
9. Letter displayed in Chris Beetle's Gallery, Ryder Street, St James's, London, February 2000.
10. Smith, p. 15. The two men were fond of extravagant exclamations. 'Goats and monkeys' is from *Othello*, Act IV, scene i.
11. Smith, p. 20.
12. Ibid., p. 48.
13. Ibid., p. 45.

4: Bachelor, 1933–1935

1. Smith, p. 41.
2. Watney, p. 40.
3. Ibid.
4. E. Drake, Letter to G.P. Winnington, 19 September 1977.
5. D. Gardner, 'Mervyn Peake at the Westminster Art School', *MPR*, No. 10, Spring 1980, p. 18.
6. Watney, p. 42.
7. *Daily Herald*, 2 May 1934.
8. *Sunday Times*, 27 May 1934.
9. *Christian Science Monitor*, 9 June 1934.
10. *PS*, Vol. 2, No. 4, Summer 1992, p. 20.

5: Husband, 1935–1939

1. Westminster Technical Institute art prospectus 1939–40.
2. D. Gardner, 'Mervyn Peake at the Westminster School of Art 1936–39', *MPR*, No. 10, Spring 1980, p. 18.
3. Ibid., p. 20.
4. Smith, p. 52.
5. A large collection of Peake's letters to Smith is in private hands, and I have had no access to it. Publication of these letters would provide valuable insights into Peake's views at all periods of his life.
6. Gilmore, p. 1.
7. Ibid., p. 4.
8. Ibid., p. 7.
9. Ibid., p. 8.
10. *The Times*, 26 June 1936.
11. *Daily Sketch*, 20 June 1936.
12. 'Maeve's Book', p. 3.
13. Gardner, D. 'Mervyn Peake', p. 20.
14. Walter de la Mare (ed.) *Love*, Faber and Faber, 1943.
15. Smith, p. 60.
16. *PP*, p. 83.
17. Ibid., p. 75.
18. Watney, p. 64.
19. A. Mills, 'Queer Creatures in "Captain Slaughterboard" and "Mr Slaughterboard",' in *Peake Papers*, The Mervyn Peake Society, 1994, pp. 49–59.

20. Mervyn Peake, 'The Artist's World', broadcast on the BBC Pacific Service, on 26 May 1947 and reproduced in *MPR*, No. 8, Spring 1979, p. 5.
21. *PP*, pp. 105–109.
22. Smith, p. 79.

6: *Soldier, 1940–1942*

1. Gilmore, p. 28.
2. M. Peake, 'Fort Darland', in *Mervyn Peake: Writings and Drawings*, ed. M. Gilmore and S. Johnson, Academy Editions, 1974, p. 30.
3. M. Peake, 'How a Romantic Novel Was Evolved', in *A New Romantic Anthology*, ed. S. Schimanski and H. Treece, Grey Walls Press, 1949, p. 80.
4. Peake's correspondence with the War Artists' Advisory Committee is preserved in the Imperial War Museum, and is also published in *PS*, Vol. 2, No. 2, Summer 1991.
5. J. Best, 'Gunner Peake', *London Magazine*, April–May 1985, pp. 279–281.
6. Watney, p. 69.
7. Smith, p. 82.
8. W. de la Mare, Letter preserved in University College (D. M. S. Watson) Library, London.
9. Peake's full correspondence with Chatto and Windus was published in *PS*, Vol. 6, No. 2, April 1999. This quotation is from p. 20.
10. R. Steadman, *The Hunting of the Snark*, Dempsey, 1975.
11. M. Peake, Letter to Chatto and Windus art editor, Miss Walford, 29 April 1941, *PS*, Vol. 6, No. 2, April 1999, p. 14.
12. *The New Apocalypse: An Anthology of Criticism, Poems and Stories*, ed. James Findlay Hendry, 1940. *The White Horseman: Prose and Verse of the New Apocalypse*, ed. J. F. Hendry and Henry Treece, 1941, *The Crown and the Sickle*, ed. J. F. Hendry and Henry Treece, 1945.
13. Gilmore, p. 38.
14. Smith, p. 77.
15. M. Peake, Letter to Chatto and Windus 28 May 1942, *PS*, Vol. 6, No. 2, April 1999, p. 31.
16. Smith, p. 88.

7: *Illustrator, 1942–1945*

1. WAAC Minutes for 20 January 1943, Imperial War Museum; reproduced in *PS*, Vol. 2, Summer 1991, p. 20.
2. G. Watts, 'A Poet in the Glasshouse', *Journal of the Glass Association*, Vol. 3, 1990, pp. 41–45.
3. M. Peake 'The Glassblowers', *Convoy*, No. 4, 1946, pp. 3–7.
4. Q. Crisp, *The Naked Civil Servant*, Flamingo, 1985, p. 143.
5. Ibid., p. 145.
6. Q. Crisp, 'The Genius of Mervyn Peake', *Facet*, October 1946, pp. 8–12.
7. Batchelor, p. 32.
8. Peake's correspondence with Chatto and Windus is reproduced in *PS*, Vol. 6, No. 2, April 1999.

9. R. Woof and S. Hebron, *The Rime of the Ancient Mariner: The Poem and its Setting*, Wordsworth Trust, 1997.
10. W. de la Mare, Letter of 20 November 1943 in University College (D. M. S. Watson) Library, London.
11. C. S. Lewis, Letter of 20 June 1959, ibid.
12. K. Webb, 'Peake Remembered', *MPR*, No. 20, 1986, p. 16.
13. K. Fuller, 'Mervyn at the Microphone', *MPR*, No. 9, Autumn 1979, p. 25.
14. M. Peake, Undated letter in the collection of Clare Penate.
15. 'Maeve's Book', diary entry, 27 February 1945, p. 20.
16. Ibid., diary entry, 25 May 1945, p. 27.
17. M. Gilmore, 'Memories of Bohemian Chelsea', *MPR*, No. 19, 1985, p. 9.
18. Gilmore, p. 55.
19. Ibid., p. 56.
20. M. Peake, 'Alice and Tenniel and Me', broadcast on BBC Home Service, 12 December 1954, reproduced in *MPR*, No. 6, Spring 1978, p. 22.
21. Batchelor, p. 32.
22. H. Brogan, 'Where Have All the Drawings Gone?' *MPR*, No. 5, Autumn 1977, pp. 26–30.
23. Gilmore, p. 58.
24. 'Maeve's Book', diary entry, 16 February 1945, p. 18.
25. *Sketches from Bleak House*, text selected and introduced by Leon Garfield and Edward Blishen, Methuen, 1983.
26. Cf. M. Yorke, *The Spirit of Place: Nine Neo-Romantic Artists and Their Times*, Constable, 1988.
27. Gilmore, p. 58.
28. Watney, p. 85.
29. T. Bridge, speaking on a BBC TV *Kaleidoscope* programme, quoted *MPR*, No. 4, Spring 1977, p. 23.

8: Reporter, June 1945

1. Smith, p. 102.
2. Watney, p. 89.
3. Gilmore, p. 54.
4. 'Maeve's Book', diary entry for 11 April 1945, p. 21.
5. M. Peake: this and all other unreferenced quotations from Peake in this chapter are taken from undated letters now in the possession of his daughter, Clare Penate.
6. T. Pocock, *The Dawn Came Up Like Thunder*, Collins, 1983, p. 126.
7. M. Peake, Letter of 12 June 1945, from Bad Neuenahr, Germany.
8. All statistics from the Imperial War Museum, London.
9. M. Peake, Letter of 21 June [1945], near Kiel.
10. Quoted in J. Isaacson, *Observation and Reflection: Claude Monet*, Phaidon, 1978, p. 210.
11. S. Peake, *A Child of Bliss*, Lennard, 1989, p. 47.

9: Novelist, 1946

1. G. Greene, Undated letter in University College (D.M.S. Watson) Library, London.

2. M. Smith, Undated letter, ibid.
3. A. Burgess, in *Spectator*, 20 June 1970, p. 819.
4. J. R. R. Tolkien, *Tree and Leaf*, Allen and Unwin, 1964, p. 67.
5. L. Drake Beer, Letter of 4 December 1946, in the possession of Sebastian Peake.
6. An obvious paraphrase of the Browning quotation used by Eric Drake on his Sark Gallery brochure. Cf. Chapter 4, p. 61.
7. M. Peake, 'The Reader Takes Over', published in *MPR*, No. 10, Spring 1980, pp. 5–15.
8. M. Peake, 'How a Romantic Novel Was Evolved', in *A New Romantic Anthology*, ed. S. Schimansky and H. Treece, Grey Walls Press, 1949, p. 80.
9. M. Peake, introduction to *Drawings by Mervyn Peake*, Grey Walls Press, 1949, reproduced in *PP*, pp. 237–241.

10: Family Man, 1947–1950

1. Gilmore, 64.
2. M. Peake, Undated letter in the possession of Clare Penate.
3. The house is now called Le Clos de Vin and is thoroughly modernized.
4. M. Peake, 'I Bought a Palm Tree', in *PP*, pp. 126–130.
5. A. Mills, 'Desire and Disappointment in *Letters from a Lost Uncle*,' *PS*, Vol. 4, No. 3 Autumn 1995, pp. 7–28.
6. M. Peake, *The Craft of the Lead Pencil*, Wingate, 1946, p. 14.
7. J. Wood, 'Mervyn Peake: A Pupil Remembers', *MPR*, No. 12, Spring 1981, p. 23.
8. R. L. Stevenson, *Treasure Island*, World Classics, 1992, p. 195.
9. 'Maeve's Book', p. 313.
10. Gilmore, p. 302.
11. M. Peake, Introduction to *Drawings by Mervyn Peake*, Grey Walls Press, 1949.
12. J. Berger, Letter of 2 November 1950 in the possession of Sebastian Peake.
13. M. Peake, 'The Artist's World', BBC radio talk recorded 29 April 1947, reproduced in *MPR*, No. 8, Spring 1979, pp. 3–5.
14. M. Peake, 'Book Illustration', BBC radio talk recorded 20 May 1947, reproduced in *MPR*, Autumn 1979, pp. 14–16.
15. S. Peake, *A Child of Bliss*, Lennard, 1989, p. 60.
16. M. Peake, *Mr Pye*, Penguin, 1972 edn, p. 167.
17. M. Peake, Letter dated 7 December 1947, reproduced in *MPR*, No. 19, Summer 1985, p. 16.
18. R. Searle, Letter to author, 14 August 1999. Subsequent quotations are from the same source.

11: Householder, 1950

1. Gilmore, p. 71.
2. M. Peake, Letter of 4 March 1947, reproduced in *MPR*, No. 19, Summer 1985, p. 15.
3. M. Peake, Unpublished letter in 'Maeve's Book', p. 37.
4. M. Peake, quoted in *PS*, Vol. 2, No. 4, p. 25.
5. M. Peake, Unpublished letter to Collis, 20 February 1950, 'Maeve's Book', p. 46.

6. M. Collis, *Diaries 1949–1969*, Heinemann, 1977, p. 30.
7. M. Peake, Unpublished letter to Maeve, 4 February 1950 in the possession of Clare Penate.
8. Cf. Batchelor, pp. 91, 98, 99.
9. H. Brogan, 'The Gutters of Gormenghast', *Cambridge Review*, 23 November 1973, p. 42.
10. M. Peake, Unpublished letter to Collis, 17 October 1950, 'Maeve's Book', p. 49.
11. Watney, p. 114.
12. M. Peake, Unpublished letter to Collis, 17 October 1950, 'Maeve's Book', p. 49.
13. Watney, p. 112.
14. Ibid., p. 117.
15. Gilmore, p. 99.
16. M. Peake, Letter to Collis, 15 June 1951, reproduced in *MPR*, No. 19, Summer 1985, p. 23.
17. C. S. Lewis, Letter to Peake, 10 February 1958, in University College (D. M. S. Watson) Library, London.

12: *Poet, 1950–1953*

1. Smith, p. 114.
2. Gilmore, p. 98.
3. Ibid., p. 99.
4. K. Peake, Unpublished letter to author, 16 November 1998.
5. *Lilliput*, Vol. 26, No. 5, May 1950, pp. 37–40.
6. P. Hogarth, Unpublished letter to author, 14 June 1999.
7. J. Wood, 'Mervyn Peake: A Pupil Remembers', *MPR*, No. 12, Spring 1981, p. 5.
8. Ibid., p. 28.
9. *Lilliput*, Vol. 26, No. 1, January 1950, pp. 58–59.
10. Watney, p. 118.
11. C. Greenland, 'The Smashing of the Central Vase', *MPR*, No. 4, Spring 1977, pp. 27–29.
12. *Science Fantasy*, Vol. 20, No. 60, 1963, pp. 57–65.
13. *Science Fantasy*, Vol. 21, No. 61, 1963, pp. 46–55.
14. J. Batchelor, 'Mervyn Peake, Poet', in *Peake Papers*, Mervyn Peake Society, 1994, p. 10.
15. M. Peake, 'London Fantasy', *World Review*, No. 6, August 1949, pp. 55–59.
16. Batchelor, p. 14.

13: *Amorist, 1953*

1. Manuscript of 'Mr Pye' in University College (D. M. S. Watson) Library, London.
2. Watney, p. 166.
3. M. Peake, Notebook 2, UCL Library.
4. Ibid.
5. Batchelor, p. 44.
6. M. Moorcock, in the *Sunday Telegraph*, Arts Review, 16 January 2000.
7. These diaries are unpublished and in private hands.

14: Traveller, 1954–1956

1. G. Greene, Letter of 10 September 1954, University College (D. M. S. Watson) Library, London.
2. Watney, p. 126.
3. M. Peake, 'Alice and Tenniel and Me', broadcast on BBC Home Service, 12 December 1954, reproduced in *MPR*, No. 6, Spring 1978, pp. 20–22.
4. A. Sander, *Men: A Dialogue between Women*, trans. V. Holland, Cresset Press, 1955.
5. Watney, p. 130.
6. M. Gilmore and S. Johnson, *Mervyn Peake: Writings and Drawings*, Academy Editions, 1974, pp. 93–96.
7. Watney, p. 127.
8. M. Peake, *The Eye of the Beholder*, reprinted in Gilmore and Johnson *Mervyn Peake: Writings and Drawings*, pp. 106–118.
9. Watney, p. 126.
10. D. Benedictus, in *Queen*, 28 May 1969.
11. Batchelor, p. 131.
12. D. Wynne Jones, 'Is it for Children?' *PS*, Vol. 5, No. 2, Spring 1997, pp. 43–45.
13. R. Binns, 'The Meaning of *Boy in Darkness*,' *MPR*, No. 14, Spring 1982, p. 8.
14. Gilmore, p. 118.
15. Ibid., p. 100.
16. M. Peake, Undated letter, probably July 1956, in the collection of Clare Penate.
17. Gilmore, p. 108.
18. M. Peake, Undated letter, probably July 1956, in the collection of Clare Penate.

15: Playwright, 1957

1. Watney, p. 124.
2. P. Hall, Unpublished letter, 26 May 1955, University College (D. M. S. Watson) Library, London. The other letters quoted here are in the same collection.
3. M. Peake, Letter to M. Collis, 26 February 1957, in 'Maeve's Book'.
4. Gilmore, p. 21.
5. Batchelor, p. 48.
6. Watney, p. 136.
7. Gilmore, p. 130.
8. J. Watney, Unpublished letter, in 'Maeve's Book', p. 56.
9. L. Olivier, Unpublished letter, 2 July 1956, UCL Library.
10. Gilmore, p. 123.
11. M. Peake, *The Cave, or Anima Mundi*, c. 1961, published by the Mervyn Peake Society, 1996, with an introduction by Brian Sibley.

16: Patient, 1957–1960

1. All Peake letters quoted in this chapter are in the possession of Clare Penate.
2. M. Peake, 'Footfruit' in *A Book of Nonsense*, Peter Owen, 1998, pp. 82–87.
3. 'Maeve's Book', p. 63.
4. Ibid.

5. R. Searle, Letter to author, 14 August 1999.
6. M. Peake, Undated letter, possibly March 1958.
7. Ibid.
8. M. Peake, Letter dated 9 June 1958.
9. Gilmore, p. 119.
10. Ibid., p. 137.
11. 'Maeve's Book', p. 65.
12. M. Collis, *Diaries 1949–1969*, Heinemann, 1977, 1 January 1959, p. 120.

17: Prophet, 1959

1. M. Temple-Smith, Letter of 29 July 1958, University College (D. M. S. Watson) Library, London.
2. Gilmore, p. 139.
3. Watney, p. 216.
4. D. Barford, 'Creativity and Disease: the Parkinsonian Imagination of Mervyn Peake', *PS*, Vol. 3, No. 1, Winter 1992, pp. 5–15.
5. 'Maeve's Book', p. 70.
6. Ibid., p. 71.
7. C. Manlove, *Modern Fantasy: Five Studies*, Cambridge University Press, 1975, p. 256.
8. L. Bristow-Smith, 'A Critical Conclusion: the End of *Titus Alone*', *MPR*, No. 12, Spring 1981, pp. 10–13.
9. Watney, p. 144.
10. 'Maeve's Book', p. 69.
11. Loose sheet in UCL Library. The full list is reproduced in Watney, p. 161.
12. Published by the Mervyn Peake Society in 200 copies, 1990.
13. A. Mills, 'Mirrors, Waters and Smells in *Titus Alone*', *PS*, Vol. 5, No. 2, Spring 1997, pp. 7–22.
14. M. Temple-Smith, Letter of 29 July 1958, UCL Library.
15. C. Greenland, 'From *Beowulf* to Kafka: the Difficulty of *Titus Alone*,' *MPR*, No. 12, Spring 1981, p. 8.
16. Quoted in T. Gardiner-Scott, *Mervyn Peake: The Evolution of a Dark Romantic*, Lang, 1990 p. 261.

18: Invalid, 1960–1968

1. Gilmore, p. 144.
2. Ibid., p. 147.
3. M. Dodsworth, in the *Guardian*, 29 November 1973.
4. S. Spender, Letter to Maeve Gilmore, 10 November 1961.
5. K. Amis, *New Maps of Hell: A Survey of Science Fiction*, Gollancz, 1961, p. 152.
6. Watney, p. 149.
7. M. Temple-Smith, in *PS*, Vol. 1, No. 4, Summer 1990, p. 27.
8. M. Wykes-Jones, in the *Arts Review*, 21 September 1963.
9. M. Collis, *Diaries 1949–1969*, Heinemann, 1977, entry for 20 September 1963.
10. M. Moorcock, *Casablanca*, Gollancz, 1989, p. 138.
11. Watney, p. 160.

12. S. Peake, *A Child of Bliss*, Lennard, 1989, p. 134.
13. Watney, p. 164.
14. Smith, p. 125.
15. C. Penate, 'Growing up in the House of Groan', the *Guardian*, 23 July 1998.
16. Gilmore, p. 150.
17. Smith, p. 128.
18. 'Maeve's Book,' p. 85.
19. M. Wykes-Jones, in the *Arts Review*, 9 July 1966.
20. R. Whittington-Egan, in *Contemporary Review*, April 1968, pp. 222–223.
21. Watney, p. 172.
22. B. Beatie in *Saturday Review*, No. 50, New York, 16 December 1967, p. 31.
23. P. Chown, Letter to the author, 11 November 1998.
24. E. Mullins, in *Sunday Telegraph*, 4 February 1968.
25. Watney, p. 175.

19: Cult Figure, 1968–1983

1. 'Maeve's Book', p. 212.
2. Ibid., p. 219.
3. A. Burgess, in the *Spectator*, 20 June 1970.
4. H. Spurling, *The Drawings of Mervyn Peake*, Davis-Poynter, 1974, p. 4.
5. A. Langley, in the *Bath and West Evening Chronicle*, 10 February 1979.
6. M. Moorcock, in *Books and Bookmen*, April 1979.
7. F. King, in the *Sunday Telegraph*, 29 January 1979.
8. J. Keats, in *New Statesman*, 16 February 1979.
9. H. Spurling, in the *Observer*, 28 January 1979.
10. M. Peake, Letter to M. Collis, 4 March 1947, in 'Maeve's Book', p. 34.
11. M. Hazlewood, Letter to author, 12 January 1999.
12. *Sunday Times*, 12 November 1978.
13. M. Peake, *Sketches for Bleak House*, Selected and introduced by L. Garfield and E. Blishen, Methuen, 1983.
14. 'Maeve's Book,' p. 327.
15. Ibid., p. 331.

20: Revival, 1983–2000

1. S. Peake, *A Child of Bliss*, Lennard, 1989, p. 1.
2. R. Milnes, 'Fine Peake-time Viewing', *The Times*, 24 November 1998.
3. All prices taken from *Book and Magazine Collector*, No. 191, February 2000, pp. 86–103.
4. M. Wearing, 'Behind the Scenes: *Gormenghast*,' *Radio Times*, January–February 2000, p. 52.
5. E. Daniel, *The Art of Gormenghast*, BBC Publications, 2000.
6. H. Spurling, in the *Sunday Telegraph*, 23 January 2000.

Index

INDEX